CW00544036

The hidden consumer

MANCHESTER
UNIVERSITY PRESS

STUDIES IN
DESIGN
AND
MATERIAL
CULTURE

general editor
Christopher Breward

The hidden consumer

Masculinities, fashion and city life
1860–1914

Christopher Breward

distributed exclusively
in the USA by
St. Martin's Press

Manchester University Press

Manchester and New York

Copyright © Christopher Breward, 1999

The right of Christopher Breward to be identified as the author of this work has been asserted by him in accordance with the Copyright, Designs and Patents Act 1988

Published by Manchester University Press
Oxford Road, Manchester M13 9NR, UK
and Room 400, 175 Fifth Avenue, New York, NY 10010, USA
http://www.man.ac.uk/mup

Distributed exclusively in the USA by
St. Martin's Press, Inc., 175 Fifth Avenue, New York,
NY 10010, USA

Distributed exclusively in Canada by
UBC Press, University of British Columbia, 6344 Memorial Road,
Vancouver, BC, Canada V6T 1Z2

British Library Cataloguing-in-Publication Data
A catalogue record for this book is available from the British Library

Library of Congress Cataloging-in-Publication Data applied for

ISBN 0 7190 4798 6 *hardback*
 0 7190 4799 4 *paperback*

First published 1999

06 05 04 03 02 01 00 99 10 9 8 7 6 5 4 3 2 1

Typeset in Stone Serif with Sans display
by Carnegie Publishing, Lancaster
Printed in Great Britain
by Bell & Bain Ltd, Glasgow

Contents

Illustrations

Acknowledgements

Over the course of the six years during which this work was conceived, researched and written up I benefited from the support and advice of many individuals and the resources and professional assistance of several institutions. To the best of my memory I would like to acknowledge that help here, with apologies to those whose names may have slipped the net.

First I must thank my Ph.D. supervisors John Styles and Gillian Naylor whose patience and wisdom ensured the smooth completion of the project and whose rigorous comments encouraged me to extend and question its boundaries. My colleagues at the School of Humanities, Royal College of Art and the Research Department, Victoria & Albert Museum were both understanding at those times when the pressures of writing impinged on the duties of teaching, and constructive in their comments at various stages along the way. Penny Sparke, Jeremy Aynsley, Marta Ajmar, Helen Clifford, Marius Kwint, Christopher Frayling and Paul Greenhalgh have all been supportive in this context. Barbara Berry and Sarah Dodman of the School of Humanities offered valued assistance in the practicalities of transferring reams of text from disk to paper and tactfully understood that this work often lay behind my more manic and pessimistic moments. The Research Policy Committee at the Royal College and the Research Department at the V&A provided financial support and sabbatical leave without which the project would probably not have happened.

Beyond the staff at my work place, successive cohorts of students on the V&A/RCA Postgraduate Course in the History of Design have inspired my work on masculinity, fashion and nineteenth-century culture both through their reactions to my courses and in their own research. In particular I would like to thank Hannah Andrassy, Victoria Kelley, Lisa Hirst, Dipti Bhagat, Sarah Milan, Louise Ward, Jacqueline Durran, Frank Cartledge, Carol Tulloch, Bronwen Edwards, Lorna Goldsmith, Melanie Unwin, Anne Caron Delion, Fiona Anderson, Andrea Peach, Lisa Godson, Martin King, Lizzie Currie, Lisa Hockmeyer, Emma Gieben-Gamal, Marie Louise Bowallius, Ergun Yildis, Mary Guyatt and Michelle Jones for their various contributions. Jennifer Salahub, Suzie McKellar, Rick Poyner, Nic Maffei, Viviana Narotsky and Adam Briggs have all been inspirational fellow travellers.

Outside of South Kensington I have benefited from the advice of countless historians, writers and curators at conferences and seminars, as well as in museums and archives. David Peters Corbett, Louise Purbrick, Diana Donald and John Hewitt at Manchester Metropolitan University played a vital role in the early formation of ideas. Between then and now Moira Donald, Lou Taylor, Madeleine Ginsburg, Beatrice Behlen, Sacha Llewellyn, Rachel Worth, David Crowley, Dorothy Bodomworth, Amy de la Haye, Avril Harte, Maureen Dillon, Andrew Davies, Elizabeth Wilson, Mica Nava, Aileen Ribeiro, Richard Martin, Valerie Steele, Katherine Earle, Djurdja Mi-

lanovich, Pauline Ridley, Caroline Evans, Kelly Boyd, Sally Alexander, Neil Bartlett, Iain Sinclair, Lynn Nead, Barbara Burman, John Tosh, Judy Attfield, Lesley Miller, Edwina Ehrman, Lara Parry, Judith Williamson, Lisa Tickner, Jo Kerr, Deborah and James Ryan, Felix Driver, David Gilbert, Miles Lambert, Peter Mandler, Stephen Hayward, Michael Bracewell, Philip Hoare and many others have played a part in shaping my thoughts.

Katherine Reeve, Rebecca Crum, Vanessa Graham, Matthew Frost and Lauren McAllister at Manchester University Press have been very helpful during the process of publication. A great deal of my time during weekends and holidays has been spent in the British Library, and besides the staff there I am grateful to the community of academics and fellow readers who were prepared to listen to my questions over coffee in Bloomsbury or, more recently, King's Cross. Among them Sean Nixon, Frank Mort and Tim Barringer have made a real impact on the final form that the book takes. Many of those cited so far are friends as well as colleagues in the former category I should also offer thanks to those who have supported me in my personal life and sustained an interest in what to the outside world must seem a fairly esoteric endeavour. Amongst these I should end by affirming a huge debt to Rupert Thomas, Daniel Scott, Rachel North, Josephine Matthews, Michael and Wendy Breward and James Brook. I dedicate this book to the memory of my grandfathers, Ronald Higby and Oliver Breward who, in common with many men of their generation, always stressed the importance of dressing well.

1 Introduction: in search of the hidden consumer

'I always hold in having it if you fancy it!' sang the variety performer Marie Lloyd during the 1890s. Through her ambiguous words it is possible to discern a clarion call for a popular consumption of luxury products across the broad class spectrum of a music-hall-attending public. Furthermore, Lloyd's is a call that paraphrases the claims made for new forms of consumer behaviour by recent investigations into the nature of late nineteenth-century consumer culture. However, the character of the surviving evidence and much of the analysis surrounding Victorian and Edwardian shopping practices also suggests that the pleasures of consumption were prioritised for one half of the population but stigmatised for the other. The acquisition of fashion items in particular has been presented in both historical and more recent texts as an activity defined and divided largely through gender difference. From the late eighteenth century through to the mid twentieth it has been assumed that middle-class women either retained the prerogative or fulfilled a social duty in determining the practice of family consumption in this arena. This book sets out to explore those claims through reference to the consumption habits and fashionable identities of men.

The later half of the nineteenth century has presented a fruitful field for tracking the formation of 'modern' gendered identities within the market place. The years between 1860 and 1914 encompass several developments that have been isolated as pivotal moments in the history of mass consumption. The consolidation of department-store marketing and retail techniques, the establishment of an organised couture and ready-made clothing industry, and the culmination of a system of publicity that redefined the role played by women in the representation of consumption, all provide examples of the ways in which the acquisition and display of clothing took on heightened feminine connotations during the period. It comes as no surprise that recent examinations of the 'new consumer' have tended to concentrate on the effects these changes held for radical constructions of metropolitan femininity. The role of men within a burgeoning culture of city shops and fashionable spaces has not yet been

studied in its own right, presumably because the majority of males are assumed to have been absent from this sphere of activity. It has been supposed that men either were relieved of their sartorial obligations through an appropriation of the activity by women, or were convinced of its unworthiness by a social doctrine which equated fashionability with feminine 'vanity' or 'susceptibility'.

There is much evidence to sustain the notion that a feminisation of 'fashionable' consumption relegated its moral worth, endorsing the idea that fashion and femininity were profoundly linked for economic, social, ideological and cultural reasons during the period. However, this book seeks to question those explanations which conflate such theoretical processes with the day-to-day activities of women and men. It challenges the understanding through which a large proportion of the consuming population have been written out of a history of modernity and urban life. To put it another way, the fact that manufacturers, advertisers, retailers and commentators on clothing directed much of their energy towards engaging the attention of women does not imply in itself that men were excluded from the experience of fashion. On the contrary, the constraining of possibilities in terms of the narrower range of masculine sartorial models on offer, and an underlying insistence on the un-manliness of the whole clothing business in general, actually positioned men right at the centre of a debate concerning fashion and modern life while apparently denying their participation in its wider cultural ramifications. A proper recognition of this tension, between the broad denial of masculine fashion and the detail offered up by the evidence of clothing practice for men, begins to reveal a more subtle perspective on the nature of late nineteenth-century attitudes to dress and identity, while offering another view of the developing relationship between gender, consumption and its publicity.

The act of consuming in such a context was a fraught one, and its implications held effects for all who engaged with the process of dressing, whether male or female, consciously fashionable or standing outside the recognised fashion system. Indeed, in order to understand the role played by fashion consumption in the development of modern sensibilities and gender identities, the absence of fashion-literate men in the historiography of clothing practices demands greater elucidation. In the course of this introductory chapter I therefore aim to review material drawn from a range of critical and historical disciplines which offer explanations for omission, and a variety of methods that might be used for a fresh analysis of historical consumption habits. The chapters which follow propose a series of overlooked contexts in which masculine forms of fashionable consumption established a legitimacy and

cultural power integral to an understanding of the evolution of urban modernity in the twentieth century: an investigation of the material context of menswear retailing and consumption in London between 1860 and 1914, which fleshes out the aspirations, tastes and opinions of those men who might have agreed with Marie Lloyd's proposal that 'a little of what you fancy does you good!'

Accounting for nineteenth-century fashionable consumption

Many historians have attempted to explain the social roles taken by men and women during the nineteenth century through recourse to the idea of 'separate spheres', defining the broad processes of production and consumption as respectively masculine and feminine. In their influential work *Family Fortunes*, Leonore Davidoff and Catherine Hall trace the formation of separate feminine and masculine, private and public spheres which they suggest came to symbolise the foundation of middle-class morality, family structures and domestic economy from the late eighteenth century onwards.[1] Through their work it has become generally accepted that a powerful concept of domestic and decorative femininity was informed by the rise of a vehement nonconformist Protestantism, which disregarded the complexities of a female position compromised by the mounting pressures of changing business practices and the growth of suburban segregation, in favour of an idealised spiritual vision of womanhood as pure and angelic. This model, it is claimed, was encoded in middle-class social behaviour by various means from religious education through to popular literature until the late 1850s. Within its dictates there arose a central contradiction between the transcendental innocence of the model wife and mother, and the demands of material display made of the feminine sphere in a broader scenario of expanding consumer choice. This was further entrenched by a linked understanding of ideal forms of masculinity that stressed a strict denouncement of worldly comfort and self-indulgence in the face of a vengeful God, whose terrifying plans dictated a harsh and domineering outward attitude that had little to do with domestic or private pleasures.[2]

A perceived shift in the popular construction of middle- and lower-middle-class femininity, which occurred through the 1860s as a result of changes in the structure of the publishing and retailing industries, alongside a renegotiation of public morality in legislation relating to areas including divorce and prostitution, and a decline in the influence of evangelical religious strictures,

has dictated a refocusing of the relationship between public and private spheres.[3] It also suggests, as Boyd Hilton has argued, a similar transformation in attitudes towards appropriate models of masculinity. Attention shifted from a prevalent ideal of atonement towards 'a religious temper much less robust than that of the older evangelicalism'. Christians were now exhorted to 'overcome … enemies by meekness and loving tenderness' for 'the manliness of Christ' signified an ideal that was more feminine than masculine.[4] The concurrent expansion of a metropolitan department-store culture, backed by the growth of advertising and family magazines who promoted luxury as a virtue, has led many recent commentators to make grand claims for a new feminised public sphere, revolving around the act of acquiring fashionable goods.[5] This is, however, a change whose effects historians have charted only with relation to the urban experiences of women. The sort of 'feminisation' that Boyd Hilton invokes has been discussed only in terms of its reflection in official religious and educational texts or government policy-making. A history of the transformation which these changes wrought in the broader material culture of the third quarter of the nineteenth century, particularly in relation to the social, rather than the political behaviour of middle-class men *and* women, has yet to be written.

Women have then been positioned more clearly as the sex most affected by the reformation of the spheres through the 'triumphs' of consumer culture in the 1860s. But this has not involved any inference that an increased engagement with the world of fashion magazines, advertising hoardings and department-store counters implied an equal sense of social and political emancipation. Indeed, Thomas Richards argues that such constructions, rather than signifying a relative freedom, actually enforced the division of sexual labour in which women acted as ciphers for the passive, forbidden or invisible consumption of men, an extension of the Veblenesque reading of feminine magnificence as a symbol for patriarchal power:[6]

> Advertising managed to establish a female model for consumption without ceding the activity entirely to women. Advertisers defined consumption as an extension of the sexual division of labour enshrined in the Victorian household. Shopping was an errand to be run rather than a choice to be made, and advertising was eager to avoid identifying itself too closely with the needs and desires of women. So consumption became something that women undertook on behalf of men.[7]

Nevertheless, regardless of the motivations attached to fashionable consumption, the pioneering selling policies of West End

shops, who from the 1850s onwards built on the innovations of eighteenth- and early nineteenth-century retailers ,[8] together with the increased availability of illustrated women's fashion magazines to consumers other than the elite,[9] offered a new arena of acquisition based on an escapist language of display and spectacle directed, so we have been led to assume, specifically towards women.[10] It follows that the visual world of the department store, like the rhetoric of the magazine, was one that did not necessarily rely on the supply and demand rationale of the market system, or on predominantly restrictive social and cultural ideals, prioritising as it did the fantastic and desirable surfaces of newly abundant fashionable commodities. Accordingly, recent texts dealing with the rise of a feminised consumer culture, while rejecting the overly determined narratives of expansion put forward by earlier writers on retail history, or the dismissive judgements of Marxist and feminist critiques of fashion and its acquisition, have tended to emphasise the spectral and otherworldly aspects of the shopping experience. This sets any attempt to define the 'material' nature of consumer demand off-balance, obscuring those historical practices which appear to be more 'mundane'. Elaine Abelson in her work on Victorian shoplifters states that: 'Women had to walk a tightrope between real needs, defined by practical use, and simulated wants created by a suggestive ambience ... confusion about what was in fact a real need or a symbolic one was encouraged'.[11]

Similarly, Rachel Bowlby, in her study of the representation of consumer culture in the late nineteenth-century novel, provides a useful analogy with the myth of Narcissus in order to explain the subjective and beguiling nature of the promotional image:

> The consumer is equally hooked on images which she takes for her own identity, but does not recognise as not of her own making ... The private solipsistic fascination of the lady at home in her boudoir, or Narcissus at one with his image in the lake, moves out into the worldly public allure of publicite, the outside solicitations of advertising.[12]

Interpretations such as these, which aim to elucidate the increasing social worth of fashionable images and items to women, while recognising the tensions between pleasure and duty implicit in such processes, draw the study of fashionable consumption into a new arena, one that is explicitly concerned with drawing links between a 'spectacular' consumption and its role in defining modes of gendered behaviour through the acquisition of goods. However, the connections that such works trace, while providing intriguing evidence of inner motivations, or escapist fantasies fuelled by new markets and the forging of imagined identities, also strengthen the problematic notion of a clearly demarcated sexual division of

labour in which the parallel motivations of men as consumers are deemed irrelevant.

Masculinity between the spheres

So, while historians have been relatively successful in establishing models for new forms of female consumption, the repercussions for an understanding of masculinity within the market place are not so positive. It is perhaps ironic that the psychoanalytical method of Bowlby should take the male-identified figure of Narcissus as a metaphor for the construction of nineteenth-century consumption patterns, when the feminisation of shopping in that period apparently relegated and stigmatised the act for men. The continued acceptance of this renunciatory reading is further endorsed by the lack of attention given in the literature on Victorian consumption to material considerations in the new shopping spaces beyond the more nebulous actions associated with the desire to look. A more comprehensive argument might underpin those observations on the feminising passivity of window shopping and browsing by assessing the concrete components of fashionable acquisition. It might include within its remit an attention to qualitative differences, or similarities, in the arrangement of floor space and stock display between female- and male-identified goods and departments, the respective roles and status awarded to men and women employed as shopwalkers, window dressers or sales assistants and their mode of address to male as well as female customers, or the manner in which the class of customer, or the function and location of the shop, complicated any straight reading of its characteristics as simply or exclusively gendered.

In a related field Eve Kosofsky Sedgwick has proposed a series of questions arising out of the separate spheres debate that set the problem of the misplaced male protagonist in clearer focus – as part of, rather than adjacent to the reformulation of female identities. Her interest lies primarily in issues of literary production and their relationship to the hegemonic power of the public/private, masculine/feminine dialectic, but her repositioning of men within the fraught field of gender representations has equal validity in discussions relating to consumption. Any supposed male renunciation of the pleasures or responsibilities of fashionable consumption must be linked to that historical development which apparently removed middle-class women from the sphere of 'industrial' production and forged religious and moral explanations for such a separation. Indeed, the foundations of a theory of 'separate spheres' rests on an acceptance of that chronology as

valid. Thus, any closer examination of the consumption practices of men (and women) whose results undermine the established narrative represents a contestation of previous explanations of historical change in the field:

> In the recent give and take between Marxist and radical feminism an important crux has been the issue of priority - chronological priority, explanatory priority or functional/teleological priority - between industrial capitalism and the male dependent family household. The following questions, coarsely formulated as they are, are among the immediate, practical feminist issues at stake in this discussion of priority. Is it men as a group, or capitalists as a class that chiefly benefit from the modern sexual division of labour? How close is the fit between the function of the gendered family and the needs of capitalism? ... Will changes in one necessarily effect changes in the other and if so how? [13]

In succeeding evaluations of such priorities it has become apparent that assumptions surrounding the symbiotic relationship between men, capitalism and the public sphere require an analysis as incisive as that formerly applied to the domestic role of women. Where the two converge, on the shifting borders between public and private, the need for careful deconstruction is even greater, and it is in this space that fashionable consumption lies. One of the ways in which useful questions have been raised has been through the study of the role of men within the organisation of the family and in relation to the cultural and economic management of middle-class households. [14] Margaret Marsh, in her work on suburban men in late nineteenth-century America, has illuminated the manner in which the process of suburbanisation, rather than simply separating women off into an enclosed private sphere in which the traces of a 'public' masculinity were largely absent, also served as a forum in which men could enact some of those largely domestic and paternal values obliquely described under later Victorian notions of 'manliness'. At the same time, the prescriptive duties of householder, spouse and father also allowed for the playing out of escapist fantasies not so dissimilar from the imaginative and psychological gains that recent historians have acknowledged were acquired through women's espousal of magazine romance and consumerist aspirations during the same period. In other words restrictive modes of social and sexual organisation should be viewed as models fit for negotiation, rather than immovable edicts. However, it should also be noted that the higher incidence of home ownership in the United States may have encouraged a less compromised masculine tie to the 'stage' of family life than the more contingent pressures of renting which marked the English housing market at the time:

The concepts of masculine domesticity and 'manliness' were in many ways more complementary than antithetical: one might hypothesise that men, as their behaviour within the family became less aloof or patriarchal and more nurturing and companionable, would develop a fantasy life that was more aggressive. The rage for football and boxing, and the reading of adventure novels, might have provided that vigorous fantasy life, masking but not contradicting masculine domesticity.[15]

In a similar vein, the growing importance of home decorating, structural maintenance and gardening to male householders of the middle and lower middle classes could both describe the surviving prevalence of traditional concepts of masculine duty and provision for the family, while also allowing free rein to those 'softer' processes of taste or aesthetic discrimination more commonly associated with the supposedly 'feminine' skills employed during the execution of shopping activities. These pleasures were often perceived to be beyond the reach of respectable men, yet their accomplishment constituted a defining characteristic of urban, and especially suburban, life by the turn of the century. The adoption of historical approaches which aim to uncover areas of masculine experience previously obscured by the separate spheres discourse should not, however, be read as competing with, or overturning, more established work on the historical construction of femininity. On the contrary, much recent work on the social and material culture of masculinity shares the same preoccupations. For example, there has been a long-standing interest amongst cultural, art and design historians over the past twenty years in charting shifting attitudes towards the female body, its representation, its associated commodities and its relationship to political and sexual power. This has held particular resonances for the study of fashion and clothing and has succeeded in questioning reductive correlations between the exercising of patriarchal control and the co-operation of consumers in playing out its intended divisions.[16] In the broader social sphere Sara Delamont and Lorna Duffin have used existing feminist theory to move beyond a single model of male oppression as the only explanatory device for women's history, arguing:

> ... that studies of the position of women frequently illustrate how women are placed in an inferior category in the predominant system of a given society compared to the men of the society. However, even after the relative position of women in the structure has been documented and established, there is another fruitful area for research. This is the whole topic of the unclear, vague and probably repressed theories which women have about the world, and perhaps even more interesting, about themselves.[17]

This kind of approach has been extended through more recent work on the historical structuring of masculinity, itself arising

from, and in part reacting to, the political agenda of second-wave feminism, by suggesting a more problematic and negotiated reading of competing forms of masculinity. These, it is now recognised, may variously have endorsed prevailing power structures, worked against them, or more probably existed in a shifting and ambiguous relationship with versions of patriarchy that require a precise historical definition and contextualisation. In rejecting 'a monolithic understanding of men as agents of domination', the very notion of patriarchy has been held up for closer scrutiny by historians including John Tosh and Michael Roper as a largely unhelpful diagnostic term which promoted an over-unified and ahistorical notion of masculinity as an essentialised given, unproblematised by contingent external pressures, internal tensions, transgressive intentions and concepts of racial, sexual and social difference.[18] Similarly those working in the field of cultural studies, in extending their remit to examine the contemporary representation of masculinity in the media, have exposed male protagonists as being subject to cultural forces previously associated wholly with the fitting up of women for the scrutiny of the gaze. Jonathan Rutherford, though postulating a problematic understanding of patriarchy as a stable cultural force, sustained by its capacity to remain beyond question and out of sight, has revealed its strategy of creating a category of 'otherness' through the circulation of misogynistic, racist and homophobic signifiers which coerce men as well as women to conform to 'normative' interpretations of gendered behaviour.[19] Utilising a structuralist definition of 'myth' to explain the continuing ability of patriarchal models of masculinity to pass themselves off as pre-existing and universal, Rutherford provides some explanation for the long-standing failure of historians to identify the existence of masculine forms of consumption or the male performance of activities more usually identified as 'feminised'. His readings are also useful for the entry they provide towards an interrogation of a 'mythical' masculinity that exposes its interior constructions at historical moments other than the present or the recent past. In the widely quoted statement by Roland Barthes:

> Myth does not deny things, on the contrary, its function is to talk about them; simply it purifies them, it makes them innocent, it gives them natural and eternal justification, it gives them clarity which is not that of explanation but that of a statement of fact.[20]

The limitations of fashion history

So, masculine consumption habits have been effectively obscured by an uncritical explanation of the separate-spheres ideology as

social fact rather than pervasive mythology, and by a blanket
acceptance of patriarchy as the only key for understanding mas-
culine motivations. Added to this the lack of primary sources and
secondary interpretation pertaining to the appearance of men
below the ranks of the well-recorded elite has also contributed to
an assumption that sartorial renunciation was the norm. This is
particularly the case with the slim and narrowly focused coverage
afforded to men's dress by the majority of fashion history public-
ations to date. It is undoubtedly more difficult to gain access to
images, texts and objects which compare quantitatively with the
wide variety of sources that have inspired much of the innovative
work on nineteenth-century feminine dress culture and consump-
tion. The limited number of surviving men's fashion magazines of
the same period for example, alongside those more generalised but
equally rare 'male interest' periodicals which included some pro-
motion of masculine sartorial choice and an attention to
self-presentation, remain unthumbed and untheorised. They are
overshadowed by the massive expansion of women's magazines
from the 1860s onwards, which have drawn academic attention
and reduced any subsequent examination of men's fashionable
reading matter to the level of an over-specialised esotericism. The
representation of masculinity in popular periodicals and related
commercial imagery, when it has been addressed by the broader
disciplines of social and gender history, has tended to include only
the examination of the formation of empire, public school educa-
tion, religion and sport.[21] This is possibly because these more
hegemonic issues were the ones whose circulation in visual and
textual forms carried the greatest and least problematic currency
with publishers and readers, and thus survive as representative
ciphers for nineteenth-century codes of 'normative' manliness.
Unsurprisingly these were precisely the fields where overt associ-
ations with fashion were considered in a negative light.

In similar terms the few items of male dress present in contem-
porary museum collections and the more common though
apparently random survival of a range of visual representations
reproduced through photography, paint or other commercial
means, together with the variety of objects associated with male
grooming or the cultivation of a personal identity through patron-
age of the retail sphere, have also been overlooked or narrowly
interpreted. Masculine fashion items have been subsumed by the
familiar assumption that the discourse of separate spheres enforced
a model of masculinity in which an overt interest in clothing and
appearances automatically implied a tendency towards unmanli-
ness and effeminacy. The lack of space devoted to male dress in
the historical record is thus 'naturalised' as an entirely appropriate

reflection of the minimal time and attention assumed to have been lavished on sartorial matters by nineteenth-century men. Other explanations for this physical and metaphorical lack have been offered, one of the most convincing being that men's clothing, in its adherence to a less frenetic fashion cycle and with its greater propensity for recycling, tends to end its life in the second-hand market or exhausted in the rag bin rather than in the attic or the museum case. But these have so far failed to make any impact on received notions of renunciation. The invisibility of nineteenth-century male garments in the late twentieth century has simply strengthened the argument for denial in the nineteenth.[22] Such precariously founded interpretations have been used to explain the rise of those ultra-conservative, non-expressive male dress codes that prioritised the uniformity of the City suit as a model for the respectable middle classes for most of the nineteenth and twentieth centuries. Thus moral rhetoric and an apparent absence of evidence for anything more nuanced in its communication of the nature of male fashionability have provided the basis for fashion histories which uphold a slow moving rate of style change, functional utility and a well-mannered observance of propriety as the defining, indeed the only, features of late modern masculine clothing patterns.[23]

Such limited histories, hemmed in by a misinterpretation of the validity of the surviving evidence and a too eager acceptance of the uniform effectiveness of symbolic codes, have failed to take account of what might have been lost or resisted. They can provide useful 'time lines' for those menswear journalists who wish to argue over change, consolidation or stagnation in the development of masculine style, and they offer some material to those costume collectors and curators with a keen eye for shifts in construction and materials. But they cannot hope to explain the ways in which men also consumed clothing by constantly basing their interpretations on or against a definition of 'fashion' rooted in nineteenth-century constructions of femininity. However, fashion history, with its fetishistic attention to surfaces, abhors a vacuum, and much recent work predicated from a fashion studies perspective has attempted to provide an alternative reading of renunciation which looks for solace in the 'timeless' details rather than the contingency of male dress. Influenced by a contemporary commercial climate in which masculine vanity is now perceived unproblematically as an asset for retailers, advertisers and publishers,[24] several fashion writers have striven to carve out a history of men's fashion which purportedly offers new versions of a long-standing, immutable, but temporarily obscured 'masculine' fashionability. As unrepresentative in their way as the established

renunciatory texts, these celebrations of 'the dandy sensibility' view renunciation as the positive effect of informed discretion. Tracing its lineage from the postwar fascination of a metropolitan cognoscenti with Regency elegance, through the elitist and cravenly celebratory tone adopted by curators and designers in the 1960s and 1970s, current representatives of the genre present a reading of male dress that revels in the cultural capital of wearer and interpreter and the 'classic' status of its artefacts. A seemingly ad-hoc series of 'fashion leaders' from Beau Brummel to Cary Grant are presented as custodians of a finely modulated style anchored in unproblematised traditions of Englishness, acceptable eccentricity and bespoke 'quality' that ultimately betrays an uncritical essentialism and crude snobbery on the part of the author.[25] Fascinating though this may be as a case study of a late twentieth-century version of masculine subjectivity, it is virtually useless as a tool for unpacking the more complex strands of nineteenth-century fashionable masculinities or concurrent historical attitudes towards the gendered nature of consumption.

Masculine identity and its historical representation

Frank Mort presents a more positive gloss on the connections between contemporary concerns and historical interpretations of masculine consumption. He offers a bridge between the reductionism encouraged by current commercial and political imperatives and a longer historiographical and material development of the relationship between men and the market place:

> In the most obvious sense the probing of young men's relationship to traditionally feminine areas, such as shopping or consumer journalism, which took place during the [1980s], did produce an extended enquiry into the nature of masculinity. This initiative was not as new as was claimed at the time. It had its origins in earlier moments of consumer expansion, notably in the 1950s and early 1960s. But the 1980s did see an intensification of these processes. One theme to emerge out of a study of the material is a by now familiar ... point. Masculinity is multi-form, rather than unitary and monolithic ... late twentieth century promotional culture has been extremely active in the construction of more plural versions of identity for men.[26]

Mort's work has done much to problematise the limited assumptions which have marked explanations for men's relationships with clothing and fashionable commodities, particularly in fashion history. But many of the sources and methods which he draws upon, specifically oral histories and ethnographical techniques, are closed to investigations of earlier periods. Thus his own interrogation of the formation of masculine consumer identities

'theorised as an effect of a range of social programmes – a discursive space marked out within the commercial field' can entail an un-problematic attention to issues of 'subjectivity as it is enacted at the level of self-understanding or self-dramatisation' by including 'some engagement with the personal testimonies of the young men who participated in city life'.[27] Deprived of this opportunity to interrogate the living, the historian of 'commercial under-takings' which impinged on male self-dramatisation in the past must look instead to the wealth of work completed by art and literary historians on the relationship between masculinity and representation in the Victorian period for help in understanding concurrent formulations of masculine subjectivity. Drawing fur-ther models of approach from the unpacking of contemporary systems of representation directed at male consumers which Mort's project has encouraged.[28] This is a positive position with rich potential, for, as cultural theorist Ed Cohen has suggested in a review essay on Roper and Tosh's volume *Manful Assertions*, it is precisely when the historical converges with the theoretical in its questioning of highly complex cultural processes that the most fruitful progress is made in understanding past and present constitutions of gender and its material culture:

> these pieces illustrate the complex imbrication of institutions, practices, desires, ideologies, beliefs, and representations that must be made to cohere in order to sustain even the most commonsensical notions of what men are – or more importantly, notions of what men should be. For this reason, it comes as little surprise that recent, highly detailed historiographies ... provide some of the best 'theoretical' insights into the complex dynamics that mark out the somatic terrains mapped by gender and sexuality. Indeed, attempts to account for such assignments of qualitative attributes to bodily signifiers of difference (e.g., mascu-linity or femininity) frequently belie the epistemological distinctions between 'theory' and 'history' per se, precisely in so far as they ask us to reconsider the 'embodied' materiality of these 'imaginary' mappings. Hence it is often when discussions of masculinity seem to veer most precipitously towards the 'historical' that they most suggestively lead us toward the 'theoretical' in ways that provocatively trouble both epistemological distinctions and gendered categories.[29]

The disrupting of 'gendered categories' is a task that literary and art historians have taken to heart in their unpacking of historical representations of masculinity and femininity, seeking to read evolving elements of nineteenth-century creative production, from the novel to the narrative painting, as a 'site for the uncover-ing of iconographic readings of a culture which had attitudes and mores tantalisingly close to our own. Narrative paintings in partic-ular have been seen almost exclusively in relation to discourses

about power, gender and difference.'[30] As the art historian Colin Cruise affirms,

> images of women have absorbed art historians in recent years in terms of these feints and illusions of power ... these images are read for signs of an all-defining, all pervading male power ... until recently too little corresponding work has been done on images of men as actively informing this discourse ... Since the start of the 1990s we have seen a spate of works on masculinity. But certain questions still arise about the relationship between men and their representation. If the history of art is a branch of the history of male power then in what ways are men the subjects of their own art; in what ways is an ideal masculinity offered to both the female and the male viewer, and with what consequences?[31]

The formulation of these questions plays a direct bearing on any project attempting to examine parallel developments in the shifting sartorial identities and consumption habits of men. In the attention to issues of representation and self-dramatisation that work predicated from a new art and literary history prioritises, there is much to be gained by the fashion or design historian working in the field, both in terms of the necessary focus on images and representation that a lack of surviving objects dictates, and through the profitable examination of consumer motivations that such work should entail. Graham Dawson, in his essay on the impact of Lawrence of Arabia and other heroic figures on the popular imagination of the interwar years, is cognisant of the ways in which masculine representations both act to give meaning to consumer's relationships with commodities and other consumers, and draw their power from the motivations associated with the act of consumption itself. His work proposes a clear model for the historian of male clothing to emulate:

> An imagined identity is something that has been 'made up' in the positive sense of active creation but has real effects in the world of everyday relationships, which it invests with meaning and makes intelligible in specific ways. It organises a form that a masculine self can assume in the world (its bodily appearance and dress, its conduct and mode of relating) as well as its values and aspirations, its tastes and desires ... Representations furnish a repertoire of cultural forms that can be drawn upon in the imagining of lived identities. These may be aspired to rather than actually being achieved ... into this gap flows the element of desire. The forms furnished by representations often figure ideal and desirable masculinities, which men strive after in their efforts to make themselves into the man they want to be. Imagined identities are shot through with wish fulfilling fantasies.[32]

As Colin Cruise has suggested, the relationship between representation and the formation of identity is one suffused with the operation of social power, and this is a connection that has been

explored by recent investigations of the appearance and promotion of masculine ideals in the nineteenth century, though sometimes with limited success. In the sphere of clothing, John Harvey has interpreted the black business suit as the appropriate cloak for the ascendancy of an efficient, professionalised and patriarchal new public order: a literal projection of a middle-class desire for self- discipline and the deployment of suppressed sexual and libertinous energy in productive masculine labour.[33] However, while such a reading may well account for the predominance of black-suited characters in prescriptive literature, any transference of its content to the actions of consumers is more complicated and open to the same attacks that the assumed hegemony of a discourse of separate spheres has found itself prey to in the field of women's history. Here, in particular, the stress on mediation, subjectivity and those 'practices of the self' that the new historicism has brought to bear on gender debates reveals the difficulties inherent in simple and closed explanations of power and its material representation. Herbert Sussman's book on Victorian masculinities, in bringing together the circulation of rhetorical masculine positions in text and image, authorial biography and the political economy of mid- nineteenth-century industrial society, offers some pointers through these problems:

> Any study of ... Victorian masculinities faces several crucial issues that must be confronted at the outset. One of the chief difficulties lies ... in the question of power. If women's studies as well as lesbian and gay studies derive their energy and purpose from engaging a history of oppression ... a study of masculinities examines the history of the oppressors, of the hegemonic discourse, of the patriarchy. This justifiable anxiety ... must be acknowledged and may be addressed in several ways. For one, the emphasis on the constructed rather than the innate, and on the multiple rather than the unitary view of the masculine calls attention to the historical contingency of such formations of manliness and of male power itself, thus questioning male dominance and supporting the possibility of altering the configuration of what is marked as masculine. Furthermore ... the problem of power and patriarchy calls for a double awareness, a sensitivity both to the ways in which these social formations of the masculine created conflict, anxiety, tension in men, while acknowledging that, in spite of the stress, men accepted these formations as a form of self-policing crucial to patriarchal domination.[34]

As I have implied, accounts of the appearance of men and their role as consuming subjects have not so far grappled with the implications of a 'double awareness', or fully appreciated the myriad ways in which representations of all kinds informed the formation of gender identities. But it seems, from the direction that studies in historical and contemporary masculinities are taking, that this

is the most profitable way forward and one in which the status of fashion could play a revelatory role. Surprisingly perhaps, given the controversies surrounding its usefulness as a historical explanation, this pulls the study of masculine consumption habits back into the orbit of the separate spheres. For, in constituting men as gendered beings, open to the same systems, objects, spaces and social processes as women, their relationship to public and private contexts becomes just as troubled. This throws into question all our assumptions regarding the sexual profile of nineteenth-century social life, forcing a re-examination of the fixedness of production and consumption during a period of great cultural flux. As social historian Nancy Cott concludes:

> Finding gender the decisive variable, a history of men as gendered subjects may promise to be truly transformative, making known elements fall together – as in a kaleidoscope – in an entirely new pattern. An alternative reasoning is that acknowledging the gendered nature of men's activities will illuminate all their arenas of life, but emphasise the contingency of gender determination making it one influential variable among others. A third possible justification, stressing method more than narrative, might be to argue that emphasis on the gendered nature of male beings is the best way to bridge the categories of the private and the public … The public and the private are more obviously inseparable when we look at men's lives … if only because we tend more readily to focus on men's participation in public, while admitting they have private character. If the boundary between private and public does become more elusive when men are studied as gendered subjects, that may focus needed attention on it. Demarcation between public and private has been a basic premise of modern life, but without consistent or unanimously shared definitions or boundaries … For historians to subject this vexed area to historical scrutiny through the sign system of gender would be a great leap forward.[35]

Reading the male fashion subject through an ephemeral record

In taking Cott's reading of gender as a 'sign system' further, and positioning the display of clothing as an essential signifier in its operation, I support the idea that notions of language and performance have played a central role in defining and critiquing fashionable gendered identities. However, any attempt to extract meaning from nineteenth-century representations of male fashionability whose authorship is generally obscure and status usually 'ephemeral' is beset with methodological problems. As has already been noted, recent work on historical masculinities emerging from cultural studies, art history and literary criticism has provided some entry for unwrapping and excavating the sig-

nificance of clothing, its acquisition, use and cultural status. The emphasis in these works has been to articulate the free play made of such texts in the evolution of sexual and psychological formations, while resisting the sense of closure that an exclusively empirical investigation of their production and circulation would entail.[36] Yet, any examination of consumption, particularly one orientated around design historical concerns with the meaning and life of commodities, clearly calls for an empirical understanding of the structures which might have underpinned such radical cultural and social shifts in the status of shopping as a gendered practice. The crucial aim here must be to reconcile oppositional methodological positions and sources in order to uncover hidden patterns of consumer behaviour whose 'physical' objects have been lost over time. Cultural historian Charles Bernheimer in his work on Parisian prostitution and sexual identity during the Second Empire approaches a similar problem by conflating the differences between discreet disciplines, their methods and their texts, proclaiming that:

> There is no necessary break between the texts we recognise as 'literary' and those we designate officially as social, historical, political or legal. The fantasmatic dimension that we acknowledge as inherent to literary production also constitutes a generative force in the creation of public discourses that purport to have erased the traces of unconscious desire. I believe that those traces, once uncovered, will frequently be found to display fantasies of gender and power strikingly similar to those underlying literary fictions. Such continuities demonstrate both the force of ideology in the unconscious and the force of sexual fantasies in ideological formations.[37]

Bernheimer's bid to collapse the distinctions that have grown up between the fictions of literary production, the prescriptions of official sources and recordings, and the more subjective reactions of the individual psyche offers a clear precedent for the combining of evidence from popular novels, shop catalogues, trade directories, *carte de visite* and street photographs, diaries and vaudeville reminiscences that marks the content of this book. In pulling their traces together to arrive at a coherent understanding of the social and sexual roleplay that constituted the male world of *fin de siècle* London, I remain acutely aware that, until very recently, social and economic historians have retained a profound suspicion of fiction and artistic representation as a source, while dress historians have plundered the surfaces of novels and paintings too uncritically for descriptions of historical appearances. Bernheimer's work suggests a third perspective which, while acknowledging the subtlety required in recognising the status and reliability of a source (the recognition that authors and their audi-

ences have different intentions, that their works conform to the
restrictions of the genre in which they are conceived and that
subsequently their texts require differing analytical treatments),
also celebrates the suggestive connections to be made between
them.

This is an approach taken up in Raphael Samuel's exploration
of the shifting importance placed on photography as a source for
social historians. He deftly suggests those tensions which have
arisen between the theoretical and resolutely non-visual prejudices
of 'established' historical practice, the biased and 'romantic' use
made of photographic sources by those historians 'from below'
who have attempted to view the past unproblematically through
the lenses of nineteenth-century photographers, and the emerging
(though perhaps constricting) sophistication with which photo-
graphic historians have framed the complex origins, uses and
meanings of their primary material. In the spaces between, how-
ever, Samuel's interests identify more subtle possibilities, equally
applicable to the 'corporeal' constructions of the social-realist
novel, the trade magazine or the copy of an advertising slogan:

> Deconstruction, using photographs in conjunction with oral testimony
> and written documents, splicing together different classes of evidence,
> or using one to expose the silences and absences of the other, is one
> procedure which historians can bring to bear on the explication and
> interpretation of old photographs. Family historians ... are past masters
> at this ... they have to learn to date 'heirloom' photography by reference
> to adult fashions, children's clothes, photographer's props ... and not
> least the quality of the paper and print ... As the inquiry extends from
> genealogy and family trees, to family fortunes, an astonishing number
> of different funds of knowledge can be brought into play around an
> apparently limited set of images. It would be a great pity if old photo-
> graphs were merely used as a further source of information about the
> small details of everyday life ... they can [also] bear on questions of high
> politics, even on epistemology and the history of ideas ...
>
> Photography, if we were to call on it as a primary source, or as a
> principal point of address, might subvert those compartmentalizations
> of inquiry which consign our subjects to separate spheres. The whole
> idea of body politics ... would look a great deal less hermetic if it were
> approached not through medical treatises, or notions of surveillance and
> control, but through the fantastic wealth of imagery in which notions
> of masculinity and femininity, or male and female beauty, are refracted
> through notions of family and community, youth and age, culture and
> class.[38]

In a suggestive methodology that contains many of the charac-
teristics which define the ideal practice of design history itself,
from a sensitivity to the circumstances of production, circulation
and consumption through to an embracing of the interdiscipli-

nary endeavour necessary for a tracing of the shifting meanings that such a trajectory entails, Samuel provides much reassurance for the validity of a project which is based on primary sources previously attacked for their lack of integrity in other academic circles. Ultimately all historical evidence is unstable, but those representational forms which have been viewed as the most shaky offer their own rewards. George Chauncey, the historian of American gay culture, outlines the way in which it is precisely that configuration of loaded political intention, reflective and creative texts, and the sometimes contradictory nature of mundane lived experience, which offers a more rounded understanding of historical processes and identities. His model shows how social strategies have been acted out, interpreted and often reformed by historical actors:

> The most powerful elements of American Society devised the official maps of the culture: inscribing meaning in each part of the body, designating some bodily practices as sexual and others as asexual, some as acceptable and others as not, designating some urban spaces as public and others as private. Many histories of sex and sexuality have focused on these official maps, the ones drawn up by doctors, municipal authorities, the police, religious figures and legislators, the ones announced at city council meetings and in medical journals. Those maps require attention because they had real social power, but they did not guide the practices or self-understanding of everyone who saw them ... [My argument] is more interested in reconstructing the maps etched in the city streets by daily habit, the paths that guided men's practices even if they were never published or otherwise formalised. It argues that maps of meaning not only guide social practices but inhere in and constitute those practices, and it argues for the significance of such socially meaningful everyday practices in the construction of identities.[39]

In one sense this is a reiteration of earlier Marxist/culturalist attempts to acknowledge the manner in which subordinate groups repossess control of their self-characterisation in struggles with the power of capital. As Paul Willis remarked in his influential culturalist study of postwar shop-floor masculinity in the north of England,

> despite the external directions, despite the subjective ravages, people do look for meaning, they do impose frameworks, they do seek enjoyment in activity ... They repossess, symbolically and really, aspects of their experiences and capacities ... This culture is ... a positive transformation of experience and a celebration of shared values in symbols, artefacts and objects. It allows people to recognise and even develop themselves.[40]

In a development of that acknowledgement which would probably surprise its earlier authors, it is incumbent upon the fashion historian to pursue those alternative maps and self-realisations if

connections between clothing, consumption and gender identities
are to be made. It is significant that the best way of achieving this
appears to be through the popular novels, music hall dramatis-
ations, store promotions and *cartes de visite* previously condemned
as false and misleading in their image-making potential.

In a final analysis of the significance of masculine forms of
fashionability in broader explanations of nineteenth-century
consumer culture, the influence of the social historian Peter Bailey
should be mentioned. In his article on the comic paper *Ally Sloper's
Half Holiday* he sets up a series of questions for future research,
some of which this book sets out to address. Beyond the strategic
problems suggested by the location of my work between the dis-
ciplines of fashion history, cultural studies, social history, urban
history, consumption and gender studies, or the challenges posed
by the nature of its primary material, Bailey's demands enforce a
welcome discipline that seems to dissolve the smaller concerns of
academic positioning and the hierarchies of sources. They cer-
tainly impart a credibility to the necessity of undertaking such a
project:

> How exactly did the artefacts of this new age capture not only the mass,
> but the individual within the mass, for this was the difficult double
> mechanism necessary for success. What too was the nature of the popu-
> lar mentality with which the artefact engaged? In studying leisure as a
> prime focus for this transformation of culture it is necessary not only
> to inventorise the changes in its forms, organisation, economics and
> technology, but changes in the consciousness of its participants. What
> particular models of identity or behaviour were the most compelling
> among those purveyed? What social roles and rituals were most
> frequently reproduced in leisure, and what resources and expectations
> were brought to bear in their performance? How did people impart
> significance and meaning to such experience? How did older cultural
> forms colour the new and what were the more particular configurations
> within the broad outlines of this mass culture? [41]

The parameters of this book then, restrict themselves to an ex-
ploration of the clothing and related consumption habits of young
men in London between 1860 and 1914. As stated, the period corre-
sponds directly to a historical moment that has already been
identified by historians as crucial to the development of a modern
consumer society. This choice of period also reflects a desire to
track connections between developments in fashionable mascu-
line identities and the reorganisation of the menswear industry
along mass-production lines at this time. Similarly, London is
isolated in order to test the specific relationship between mascu-
line fashionability and the capital that blossomed during the
metropolis's pre-eminence as an imperial, cultural and economic

world centre (though many of my comments on urban life are applicable to other cities). The nature of clothing in use as an element of self-realisation remains at the core of the book, but fashion and fashionable consumption also take their place within the context of mass leisure as it is interpreted by Bailey. In this sense I am not concerned with clothing as a simple utilitarian object, with reducing it to the status of an economic indicator, or with its technological production, but define it within the context of fashion, as a shifting and spectacular sign prone to the transformative effects of commerce. This entails a consideration of the material qualities of clothing, its sale and its promotion, its use and its representation, and the order of the chapters follows that trajectory accordingly - object: retail: consumption.

Rather than ascribing fixed interpretations to changing cultural forms, this book favours a more open recognition of the fundamental incoherence of culture and its internal tensions. It supports the possibility which that position presents for the pulling out of tangled explanatory threads that cannot provide clear-cut answers to the nature of the past, but do give some indication for the prevalence of particular structures and modes of behaviour which both feed the power of ongoing social norms and reflect concurrent pre-occupations. As the social historian Patrick Joyce notes in his comments on recent historiographical trends: 'what has become evident is the dissolution of the old assurances of a formative link between social structure and culture ... identities and discourses are ... never coherent but always cross cutting and contradictory.'[42] This is not a cause for despair or an intimation that clear political and social lessons cannot be drawn from the practice of history, for in a review of recent texts on historical masculinities James Eli Adams endorses

> an understanding of masculine identity as an intersection of numerous and often-conflicting contexts and axes of meaning ... And if a particular analysis of masculine identity is inevitably influenced by the critic's own subject position, it is not reducible to that position, which is itself neither fixed nor unitary. To assume otherwise is to embrace a mode of cynicism, which assumes that the reflection to which we devote so much of our lives ultimately has no power to change our minds.[43]

The study of historical attitudes towards clothing and the gendering of consumer behaviour has never been so open to such an interpretation as it is now, in a period when traditional images of masculinity, and by extension masculine subjectivities themselves, appear so vulnerable to fracture and change.

Notes

1 L. Davidoff and C. Hall, *Family Fortunes: Men and Women of the English Middle Class 1780-1850* (London: Hutchinson, 1987).

2 B. Hilton, *The Age of Atonement: The Influence of Evangelicalism on Social and Economic Thought 1785-1865* (Oxford: Clarendon Press, 1991); N. Vance, *The Sinews of the Spirit: The Ideal of Christian Manliness in Victorian Literature and Religious Thought* (Cambridge: Cambridge University Press, 1985).

3 L. Nead, *Myths of Sexuality* (Oxford: Blackwell, 1988); E. Trudgill, *Madonnas and Magdalens* (London: Heinemann, 1976).

4 Hilton, *Age of Atonement*, p. 392.

5 E. Wilson, *The Sphinx in the City* (London: Virago, 1991), pp. 58-60.

6 T. Veblen, *The Theory of the Leisure Class: An Economic Study in the Evolution of Institutions* (New York: Macmillan, 1899).

7 T. Richards, *The Commodity Culture of Victorian England: Advertising and Spectacle 1851-1914* (London: Verso, 1991), p. 206.

8 A. Adburgham, *Shops and Shopping 1800-1914* (London: Allen & Unwin, 1981), pp. 137-48.

9 C. White, *Women's Magazines 1693-1968* (London: Michael Joseph, 1970).

10 R. Williams, *Dream Worlds: Mass Consumption in Late Nineteenth Century France* (Berkeley: University of California Press, 1982).

11 E. Abelson, *When Ladies Go A-Thieving: Middle-class Shoplifters in the Victorian Department Store* (Oxford: Oxford University Press, 1989), p. 35.

12 R. Bowlby, *Just Looking: Consumer Culture in Dreiser, Gissing and Zola* (London: Methuen, 1985).

13 E. Kosofsky Sedgwick, *Between Men: English Literature and Male Homosocial Desire* (New York: Columbia University Press, 1985), pp. 135-6.

14 C. Nelson, *Invisible Men: Fatherhood in Victorian Periodicals 1850-1910* (Athens and London: University of Georgia Press, 1995).

15 M. Marsh, 'Suburban Men and Masculine Domesticity 1870-1915' in M. Carnes and C. Griffen (eds), *Meanings for Manhood: Constructions of Masculinity in Victorian America* (Chicago: University of Chicago Press, 1990), p. 122.

16 E. Wilson, *Adorned in Dreams* (London, Virago and Berkeley: University of California Press, 1987); G. Pollock, *Vision and Difference: Femininity, Feminism and Histories of Art* (London: Thames & Hudson, 1988); C. Evans and M. Thornton, *Women and Fashion: A New Look* (London: Quartet, 1989); J. Gaines & C. Herzog, *Fabrications: Costume and the Female Body* (London: Routledge, 1990); J. Craik, *The Face of Fashion* (London: Routledge, 1994); P. Sparke, *As Long As It's Pink: The Sexual Politics of Taste* (London: Pandora, 1996).

17 S. Delamont and L. Duffin, *The Nineteenth Century Woman: Her Cultural and Physical World* (London: Croom Helm, 1978).

18 M. Roper and J. Tosh (eds), *Manful Assertions: Masculinities in Britain since 1800* (London: Routledge, 1991).

19 J. Rutherford, 'Who's That Man?' in R. Chapman and J. Rutherford (eds), *Male Order: Unwrapping Masculinity* (London: Lawrence & Wishart, 1988).

20 R. Barthes, *Mythologies* (Harmondsworth: Penguin, 1972), p. 143.

21 A. Mangan and J. Walvin (eds), *Manliness and Morality: Middle-class Masculinity in Britain and America 1800-1940* (Manchester: Manchester University Press, 1987).

22 Conversation with S. Leavitt, curator Gunnersbury Park Museum, January 1995.

23 D. de Marly, *Fashion for Men: An Illustrated History* (London: Batsford, 1985), pp. 94-6.

24 S. Nixon, *Hard Looks* (London: University College Press, 1997).

25 C. McDowell, *The Man of Fashion: Peacock Males and the Perfect Gentleman* (London: Thames & Hudson, 1997).

26 F. Mort, *Cultures of Consumption* (London: Routledge, 1996), p. 10.

27 *Ibid.*, p. 183.

28 Nixon, *Hard Looks.*

29 E. Cohen, 'Ma(r)king Men', *Victorian Studies*, vol. 36, no. 2 winter 1993, p. 218.

30 C. Cruise, 'Building Men, Constructing Images', *Oxford Art Journal*, vol. 19, no. 2 (1996), p. 116.

31 *Ibid.*

32 G. Dawson, 'The Blond Bedouin' in Roper and Tosh, *Manful Assertions*, pp. 118-19.

33 J. Harvey, *Men in Black* (London: Reaktion, 1995).

34 H. Sussman, *Victorian Masculinities: Manhood and Masculine Poetics in Early Victorian Literature and Art* (Cambridge: Cambridge University Press, 1995), pp. 8-9.

35 N. Cott, 'On Men's History and Women's History' in Carnes and Griffen, *Meanings for Manhood*, pp. 208-9.

36 J. Still and M. Worton (eds), *Textuality and Sexuality: Reading Theories and Practices* (Manchester: Manchester University Press, 1993), pp. 2-7.

37 C. Bernheimer, *Figures of Ill Repute: Representing Prostitution in Nineteenth Century France* (Cambridge, Mass.: Harvard University Press, 1989), pp. 2-3.

38 R. Samuel, *Theatres of Memory: Past and Present in Contemporary Culture* (London: Verso, 1996), pp. 332-3.

39 G. Chauncey, *Gay New York: Gender, Urban Culture and the Making of the Gay Male World 1890-1940* (London: Flamingo. 1994), p. 26.

40 P. Willis, 'Shop Floor Culture, Masculinity and the Wage Form' in J. Clarke, C. Critcher and R. Johnson (eds), *Working Class Culture: Studies in History and Theory* (London: Hutchinson & Co., 1979), p. 188.

41 P. Bailey, 'Ally Sloper's Half Holiday: Comic Art in the 1880s', *History Workshop Journal*, vol. 16 (autumn 1983), p. 6.

42 P. Joyce, *Democratic Subjects: The Self and the Social in Nineteenth Century England* (Cambridge: Cambridge University Press, 1994).

43 J. Eli Adams, 'The Banality of Transgression? Recent Works on Masculinity', *Victorian Studies*, vol. 36, no. 2 (Winter 1993), p. 213.

Unpacking the wardrobe: the grammar of male clothing

2

Men may be said to have suffered a great defeat in the sudden reduction of male sartorial decorativeness which took place at the end of the eighteenth century. At about that time there occurred one of the most remarkable events in the whole history of dress, one under the influence of which we are still living, one, moreover, which has attracted far less attention than it deserves: men gave up their right to all the brighter, gayer, more elaborate, and more varied forms of ornamentation, leaving these entirely to the use of women, and thereby making their own tailoring the most austere and ascetic of the arts. Sartorially, this event has surely the right to be considered as 'The Great Masculine Renunciation'. Man abandoned his claim to be considered beautiful. He henceforth aimed at being only useful. So far as clothes remained of importance to him, his utmost endeavours could lie only in the direction of being 'correctly' attired, not of being elegantly or elaborately attired.[1]

Writing in 1930, the psychologist J. C. Flugel (a modernist whose political and personal relationship to fashion led him to espouse the revolutionary sartorial philosophies of the British Men's Dress Reform Movement),[2] identified the turn of the nineteenth century as the historical moment at which men relinquished aesthetic control over their clothing, replacing a rule of taste with a more rigid adherence to the dictates of propriety. This he saw as a natural outcome of social and political revolution, both through the overthrow of *ancien régime* ceremonial splendour and the institution of new visual and sartorial ideals encouraged by a bourgeois celebration of the workshop and the market place as fitting arenas for the playing out of appropriate masculine identities. Flugel's perspective on nineteenth-century fashion history was ambivalent. As a supporter of cultural formations which embraced the sexual, psychological and physical release of the body from 'Victorian' constraints, the black suit represented for him a depressing denial of human nature. At the same time, however, its democratic connotations, together with a blandness that paradoxically revealed much through the details, proved fascinating. Modern man he claimed, had adopted this 'relatively fixed system of … clothing' which 'is, in fact, an outward and visible sign of the strictness of

his adherence to the social code (though at the same time, through its phallic attributes, it symbolises the most fundamental features of his sexual nature)'[3] It is surprising then, given Flugel's heavy investment in a reading which condemned the unexpressiveness of nineteenth-century men's dress, that his interpretations have been taken at face value by succeeding fashion historians. 'The Great Masculine Renunciation' has provided both a convenient shorthand for a stylistic progression of cut and colour that is undoubtedly rather limiting and impenetrable when compared with the wilder fluctuations of female dress at the time,[4] and a starting point for further philosophical explorations of the meanings surrounding an assumed resistance to brightness and differentiation by male consumers.[5]

The first section of this book aims to question the assumption of absence and denial that Flugel's comments have engendered in more recent treatments of masculine appearance. In focusing on the tailoring journals and etiquette guides that attempted to direct a 'gentlemanly' ideal, recording and influencing the consumption habits of fashion-literate men, I hope to draw out the possibilities in terms of colour, cut and texture that were available to middle-class and aristocratic consumers in London and those centres that followed a metropolitan lead between 1860 and 1914. A Flugellian reading of nineteenth-century masculinity supposes an easy relationship between 'powerful psychical inhibitions' and 'austere' clothing habits without really examining the full spectrum of sartorial choices and their material implications for the period. While agreeing that priorities in fashionable consumption underwent a profound shift during the century, focusing much attention on the female body as a site for consuming practices, I would argue for the survival of 'elaboration' and 'elegance' in masculine models of physical beauty. These qualities were promoted by the clothing industry, and eagerly consumed by men conscious of a desire to approximate the appearance of modernity and cultivate associations with particular social positions as the century drew to a close. To track this survival, it becomes necessary to reconstruct ideal and typical wardrobes which illustrate the scope and varied language of clothing and style at the time. The authoritative voice of the trade press for men's clothing is of great importance here, in that it provides a constant referencing to stylistic innovation in visual and textual form that would otherwise remain obscured by a lack of evidence that has often been interpreted as a lack of substantive change. Journals oriented towards the interests of the tailoring trade, of which *The Tailor and Cutter* (established in 1866 and published by J. Williamson) and *The London Tailor* (established in 1875 and published by T. H. Holding)

were the dominant titles, presented their contents as an objective record of change in a manner that was more difficult to substantiate in women's fashion magazines of the period.[6] Commenting on the authority of fashion plates, the editor of *The London Tailor* claimed that:

> In men's fashions there are essential differences from women's. Anything is authoritative that is a new invention in women's fashions, but nothing is authentic in men's fashions until it has been SEEN ..It is an adage with a fashion publisher in London of forty years standing, that he shall never illustrate what he has not himself seen ... Fashion illustrations which have no other existence are not permanent, but when the garments have been worn in life, they are more likely to stick, and therefore we have in the issue of such plates ... the treble authority of first knowing through seeing, then of making and getting them accepted, and thirdly, of seeing them as such.[7]

By recognising the very real uses to which the characteristic visual rhetoric and practical potential of tailoring representations and reportage were put, this chapter aims to build up a picture of cumulative development and detailed differentiation in the appearance and use of menswear. Having set out a broad fashion vocabulary for the period, it will then be necessary to isolate the boundaries established to define three key modes of dressing according to class, pecuniary position and occupation. Appearances played a central role in establishing social hierarchies in late Victorian London, and, while Flugel's masculine renunciation seems to hold for all men, the nineteenth-century commentator would have defined clearer distinctions between the visual identity of classes. The historian Harold Perkin, in his work on professional distinctions in English society, isolates the years around the turn of the century as 'the zenith of class society' and calls for a reading of the period that acknowledges the importance of social distinction in interpretations of material culture and domestic life:

> Between 1880 and 1914 class society in Britain reached its zenith. During this period the major classes achieved their advanced capitalistic form ... In the process they became more sharply differentiated from each other than ever before ... The middle classes, ever more graduated in income and status, came to express those finer distinctions physically, both in outward appearance, in dress, furnishings and habitations, and even in physique, and in their geographical segregation from one another and the rest of society in carefully differentiated suburbs. So too did the working classes, in part voluntarily because they could not afford what their social betters left for them but also, within that constraint, because those working families who could chose to differentiate themselves equally, by Sunday if not everyday dress, and by better and better furnished houses in marginally superior areas ... Segregation, by income,

status, appearance, physical health, speech, education, and opportunity in life, as well as by work and residential area, was the symbolic mark of class society at its highest point of development.[8]

A powerful sensitivity to social difference in male dress amongst retailers and consumers will be acknowledged through an examination of three clearly differentiated types who featured constantly in popular and commercial forms. Their ubiquity helps to anchor cross-cutting interpretations of class and gender and forms a focus throughout this book. The circulation of stereotypical representations of the West End aristocrat, the City professional and the East End rough in late nineteenth-century urban culture illustrates a complex playing out of subjective consumer positions that belies any simple reading of Victorian and Edwardian masculinities as univalent or static in their visual or sartorial manifestations. This and the following chapter are then, primarily an attempt to provide a lexicon of sartorial habits and objects that substantiate Perkin's broader identification of clothing consumption as a clear indication of status. They also chart a stylistic chronology against which more generalising or reductive assumptions regarding the social meanings of male dress can be tested.

From the raffish to the restrained and back: stylistic change

> Surely it is not logical to imagine that the present century, which in general progress promises to make the greatest strides in the history of the world, will be content to continue the negative fashions and the drab and dreary colours which are the legacy of a century admittedly decadent in the art of dress. The fashions of the men of the eighteenth century were, from an artistic point of view, almost perfect. Why then did they decay during the nineteenth century to a degree of hideousness which was a positive offence to the eye - to a retrograde ugliness without parallel in any era? ... The spirit and character of each age is shown in its dress, and the spirit of the Victorian era, despite its industrial progress, was sombre, narrow, and deplorably inartistic. The tailors of the day were unimaginative; they lacked creative art, and their productions, in their endeavour to cater for utility, lost all sense of symmetry and style.[9]

Pre-empting Flugel by almost twenty years, though encouraged by a similar expectation of reform and renewal, the Bond Street tailor H. Dennis Bradley, in his introduction to a catalogue of men's clothing styles for 1912, offered a jaundiced view of the achievements of his nineteenth-century forebears. He viewed his own products both as exemplars of a modernising spirit and as a conscious return to pre-Victorian notions of elegance. In the process

of promoting the new, the output of a century of technological innovation and sartorial expertise was dismissed voguishly as 'sombre, narrow, and deplorably inartistic'. Yet hidden behind the 'prosaic depths' of the Victorian wardrobe lay the construction of a formal and stylistic language that was modified, but never wholly rejected by the clothing pioneers of the early twentieth century.

Before unpacking choice as it existed in and beyond the final quarter of the last century, it is important to comprehend the formative nature of the male wardrobe as it evolved through preceding decades. While I would suggest that the period after 1870 witnessed a modernisation and renegotiation of male fashion-ability that underpinned twentieth-century attitudes to manliness and its appropriate clothing, the structures for this process were well in place by 1850 and can even be traced back to the late eighteenth century. Both Stanley Chapman's work on the mid-century ready-made clothing emporium of E. Moses & Son of Aldgate, and John Styles's revelations regarding the supply of cloth-ing to labourers and the middling sort in northern counties during the early modern period point to the widespread production and consumption of ready-made men's clothing before the intro-duction of mechanisation via the sewing machine in the late 1860s.[10] Economic and manufacturing imperatives thus ensured simplification in the construction and pattern of dress, together with a more rapid turnover in the stylistic form of items in quick response to fashion-led market demands. Ready-mades alone did not, however, 'revolutionise' clothing habits in the way Chapman seems to suggest, and bespoke methods continued to provide a greater guarantee of fit across a range of tailoring establishments serving a broad swathe of the market, well into the twentieth century.[11] In fact bespoke, made-to-measure or 'cash tailor' trans-actions, and ready-made items in combination appear to have offered the best of all worlds to late nineteenth-century consumers, for, as *The Tailor and Cutter* asserted, 'it is well known that while many, moving in the higher circles of society, have their coats and vests from our West End houses, they patronise without com-punction those firms who advertise trousers made to measure for 13s. 6d.'.[12]

This issue centring on quality, price and construction is one that fits most comfortably in a discussion of nineteenth-century cloth-ing production, the details of which must lie outside of the remit of this book. For the moment though it is fair to deduce that mass-manufacturing methods, together with a rationalisation of traditional tailoring technique, made some impact on a male silhouette generally marked by the comfort of a tubular looseness

and a subdued conformity of colour and texture in the 1860s, together with an ever widening range of location and function-specific garments. This stood in marked contrast to the popular look that predominated from the 1830s through to the 1850s. Romantic in inspiration with only a residual reference to the tightness and restrained bravura of early nineteenth-century dandyism, the fashionable male figure of the first part of Victoria's reign celebrated a loudness in pattern and colour alien even to the music hall habitués of the 1890s (whose clothing and comic turns often referred back nostalgically to this lost period of 'bohemianism'). Fashion plates and portraits record a preference for light checked trousers which veer from the skin-tight to the balloon-like in shape, colourfully eccentric waistcoats and richly textured velvet jackets in a continental style that gripped around the shoulders and arms and clinched in at the waist. This was a look espoused by the leisured metropolitan man of letters, which found its most celebrated adherents in Charles Dickens, Edward Bulwer Lytton and Benjamin Disraeli in London, and Restoration dandies including the Count D'Orsay, Balzac and Baudelaire in Paris.[13]

If any decade deserves a reputation for 'renunciation' then the 1860s represented something of a come-down after such exuberance. While loud checks and plaids continued to predominate in the dress of the fashionable urban aristocrat or the 'heavy swell', mainstream forms of clothing displayed a tendency towards concealment: high buttoning at the neck, lowering waistlines and deep or bagged sleeves and trousers, mostly in softer dulled textiles. An emphasis on comfort and the simplification of cut that marked the period continued into the 1870s with the survival of such construction techniques as the three-seam coat, whose loose, streamlined contours continued to attract admiration in the 1880s and 1890s. For young consumers in particular, tailoring propagandists attested that 'We do not know of any garment which gives the same amount of ease and freedom, and at the same time imparts to youth so stylish an appearance; their lithe figures not being cut into sections by seams, nor their free motion impeded by tightness'.[14] The tailoring legacy of the 1860s could then be said to have prioritised an emphasis on producing clothing marked by ease of fit to the exclusion of stylistic or decorative considerations. Indeed from the vantage point of 1883, a columnist for *The Tailor and Cutter* was able to claim that:

> For nearly the last twenty years or more, the changes in gentlemen's dress have been at the lowest possible ebb. Fresh styles have been entirely at a discount, and the variations on the old, seem to have but travelled between the boundary limits of a button more or less on the front of a coat, and from the maximum of width in a pair of pants, to

the least possible minimum. Why should it be so? Is the genius of our trade so dead as all that? We think not.[15]

The Tailor and Cutter may have been over-confident in its predictions that the 1880s and 1890s would witness a return to sartorial inventiveness based on realignment within the trade (the resurgent 'genius' that the journalist spoke of would lie more in the field of marketing and retailing than in tailoring and cutting). However, its assessment of preceding years is borne out by the confusing refusal of surviving representations of fashionable men's clothes, especially those anonymous and undated portrait photographs which form the staple source for many fashion history texts, to indicate any clear evidence of a consistent stylistic evolution between *c.*1870 and 1885.[16] While buttons, bindings, seams and lengths shift in a fairly spontaneous manner, the 'boundary limits' of cut, and possibilities concerning the combination of garments, remain stubbornly static. The fashion plates and descriptions of prevailing trends put out monthly by *The Tailor and Cutter*, nevertheless allow some comprehension of changing templates and their mediation on the ground. 'Plainness' was chosen as a favourite adjective in tailoring journalism during the early 1870s, though the term was generally meant to imply an attention to neatness in finish and the provision of an uncompromised setting against which accessories and detail could be

1] Fashion plate, *The Tailor and Cutter*, November 1872. Dress suit, boy's reefer jacket and frock coat, 'cut and made up … plain and neat'.

2] Fashion plate, *The Tailor and Cutter*, January 1873. Short jacket with angular contours and facings which displays innovative features whilst conforming to a concern for visual tidiness.

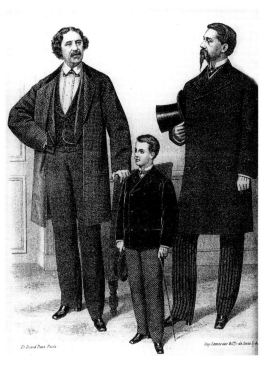

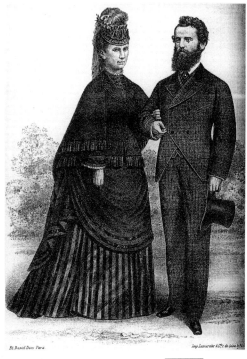

more clearly displayed, rather than a complete disavowal of surface interest. A report on evening dress for November 1872 stated that:

> The season is now commencing when gentlemen examine the state of their wardrobe and see after their dress garments. We have nothing very new to notice in connection with the form in which dress coats are made, except that they are cut and made up plain and neat, and to appear as light as they well can be - skirts short and narrow, and the front, though worn very open and to roll to the waist, the turn over is not quite so heavy as worn last season. Corded silk of lavantine is worn on the lapel, and the skirts lined with silk. The sleeves are full upwards but small at the hands, and finished with cuffs and two holes and buttons. Young men have a decided fancy to have their sleeves made very short, so that they can shew their fancy cuffs and elaborately emblazoned sleeve studs. Dress vests are not made very open on the breast ... This change of style is made to suit the elaborately embroidered vestings ... likely to be extensively patronised during the Winter ... Dress trousers are made of the straight form, easy to the figure, about the body and legs, but small at the foot and hollowed over the instep.[17]

This overwhelming concern with visual tidiness was continued in descriptions of day dress, though distinctions were made with regard to the appropriateness of more experimental cutting, trimming or use of fabrics in 'fashionable' or 'fast' dress and clothing reserved for official occasions. A short jacket promoted in January 1873 (see figure 2) displayed a novel, geometrical front 'which is made to button two holes, and to run by a direct line to bottom corner which is left square, so also are the lapels and collar ends'. The resulting item thus took on a distinctively 'modern' glamour through its angular contours and facings, yet though finished in 'fancy check' it still conformed to expectations of neatness through its combination with trousers 'exceedingly plain, and of the straight form'. Indeed, so pervasive was the general resistance to change for its own sake by the early 1870s that the journalist went on to report that 'several houses have attempted to introduce some change in the shape of trousers but without success'.[18] The slower introduction of novel forms continued through the decade, resulting in the rather exasperated tone of *The Tailor and Cutter's* correspondent whose responsibility lay in conveying the prevailing styles worn in the City and 'About Town'. In January 1877 he stated:

> We look in vain at the West-End for any important novelties in the shapes of gentleman's garments, and although Morning coats apart from Frock coats, are worn more now than at any period, there is little or no change to chronicle, save in the matter of some slight innovations of our own. Having noticed carefully the styles of Morning coats made at some of the chief establishments, we note that the single breasted three

button garment is still the prevailing style, the only variation from this being in favour of a single breasted University buttoning two buttons only, but not cut away so decidedly in front. This latter style is not much in favour however, for the Prince of Wales, Lord Carrington, Lord Suffield and other noblemen who may be said to influence the fashions for gentlemen, are wearing the first named shape.[19]

By 1880, though styles unchanged for over a decade were still presented as viable options in the fashion plates of the journal, the predominant fashionable look had developed perceptibly to favour a leaner, longer silhouette, hanging less squarely on the figure and accentuating the waist with the reintroduction of a horizontal seam around the middle of the body. The spring and summer plate in *The Tailor and Cutter* for that year (Figure 3) took the trouble of presenting three variations of frock coat representing various degrees of fashionable taste. The most advanced was marked by its enveloping closed fit, and the copy warned that the style would 'be regarded as somewhat in the extreme; but this is exactly as they will be seen daily in Regent Street, and Rotten Row'. While the more adventurous option was presented in carefully measured tones, its juxtaposition with the rather staid and open coat 'still worn by some professional gentlemen … clinging

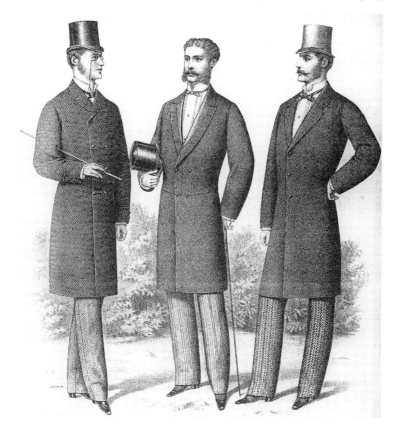

3] Fashion plate, *The Tailor and Cutter*, summer 1880. Three frock coats showing the simple lean shape of the period and the degree of choice possible in the design of one staple item.

to what is now an old fashion' threw into relief the manner in which fashionable progression for men was at this point a matter of small steps and conservative innovations rather than complete seasonal readjustments. Fashionability at the close of the 1870s lay in a careful assessment of extremes and a combination of innovative and traditional characteristics which were embodied in the composite and supremely 'plain' third figure of the plate. The presentation of all three betrayed a sense of negotiation much rarer in the reporting of women's dress at the time, which tended to prioritise particular Paris models every month. Men's tailoring texts implicitly suggested that the overt exercising of taste was most acceptable when left to the discernment of the individual tailor and customer rather than residing in a coherent journalistic or trade-based approximation of received style:

> These three figures illustrate the Frock in its various styles; so that when a gentleman calls to have a Frock coat made, here are the means of his being enabled to see at once the style in which he prefers it. Possibly some may prefer a medium style – something between the close buttoning up of the first and the open front of the second; the customer can easily be assured that he can have it so.[20]

A more concerted attempt on the part of the clothing industry to influence the direction of fashionable form was being reported in 1882, by which time the slimmer, more streamlined look, isolated as progressive two years previously, was well established. The Manchester correspondent in the December issue of *The Tailor and Cutter* was encouraged that

> the designers of costume have now before them an opportunity of which they might avail themselves with profit. Of course one does not usually expect to find the wholesale houses taking the lead in styles, but they, as well as the private trades seem to have been impressed with the necessity of making some move in the direction of introducing something new.[21]

That wholesale houses, purveyors of the ready-made to clothiers, hosiers and outfitters, rather than tailors, were now earning the credit for introducing new lines marks a significant turning point in the modernisation of the field, and this passage is highly revealing in the attention it plays both to the desire for evolution in clothing design and the wider possibilities opened up through marketing and retail initiatives. In terms of style, 'smartness' rather than a superseded 'plainness' connotes the new sense of modernity in men's fashion:

> The tendency of the change, so far as I can learn, is in coats, to give a very full length to the body, carrying it a little below natural waist, while imparting to the coat when on, the appearance of being shorter,

and at the same time smarter in style than hitherto worn. Trousers I understand will continue narrow, with a slight spring at the bottom, and to give an appearance of greater length of leg and more stylish cut, they will be brought well up in the fork.[22]

The resulting tightness that distinguished fashionable men's clothing during the 1880s offered up much potential for debate in the trade press, especially when close fit and lighter textiles were combined with the growing popularity of the lounge suit for more informal occasions. Greater latitude for extreme effect was even discernible in descriptions of formal clothing as worn in provincial Reading in December 1882 where

> The Covert Coat ... is worn by, I should think a majority of the younger representatives of what has been called the backbone of the country, and they back up this tasteful and useful garment with suits, that for style, in material and make would not disgrace a West End clad exquisite. Fancy worsted suitings in very small checks and microscopic spots are largely worn, in fact the rougher makes of materials are for the nonce lying idly on the shelves ... Trousers are worn tight and tighter; and in some instances, where straps are used, to strain them down, their very existence must be threatened if the wearer moves ever so slightly from the perpendicular.[23]

The lounge suit itself, with its brevity, adaptability to a variety of social occasions and connotations of informal youth, illustrated the changes that had affected the evolution of menswear since the 1860s and was well represented in the summer plate of 1886 provided with the April edition of *The Tailor and Cutter* (Figure 4). Able to incorporate the dandyish allusions of the West End promenade as much as it suggested the boisterous leisure time of holidays, the simple combination of short jacket, high vest and tapered trousers, together with a bowler hat, inferred a disrespectful jauntiness entirely lacking from the staple top hat, frock and morning coats of official life. Ready-made manufacturers capitalised on the popularity of the lounge by introducing the three-pieced combination in one textile, though the practice drew condemnation from the bespoke trade during the late 1880s:

> Let me state that suits of 'dittos' that is to say, lounge suits of one material are now rarely or ever made in the best houses. The cheap houses have made dittos so common that the higher circles have ceased to wear them. Morning coat suits are frequently made of one material – a fine cashmere of small stripes or subdued checks mostly in greys or browns. The lounge jacket and vest are almost invariably made of one material and the trousers of another.[24]

That shorter, lighter jackets represented a relaxation of established sartorial knowledge was attested to in the mid-1880s by the

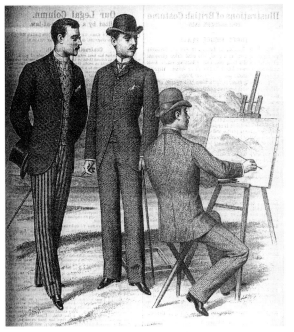

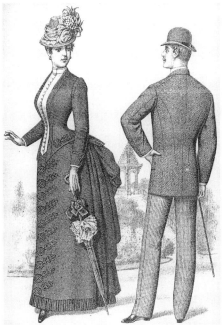

4] Fashion plate, *The Tailor and Cutter*, summer 1886. By the late 1880s the formality of earlier styles had given way to the youthful informality of the lounge suit.

5] Fashion plate, *The Tailor and Cutter*, summer 1885. In a bid to attract the interests of a younger market, this model shows a lounge jacket, cut to fit more tightly with five seams. The hip buttons accentuate shoulders and waist in the manner of a morning coat.

appearance of items which failed to conform to respected patterns or presented hybrids of different forms. For summer 1885 *The Tailor and Cutter* was recommending 'a decided novelty, embodying the features of a Morning coat and a Lounge. In the back above the hip buttons we have the Morning coat … while the lower part is in the style of the Lounge … Doubtless, many of our readers will give this new coat a trial for their own wear, and will, we think, have little difficulty in persuading the young gent class of their customers to go in for it'.[25] (Figure 5). The contrast between old and new was not lost on the tailoring trade, whose conservative tendencies associated the physical characteristics of the lounge with the incursions of popular taste, or the waning of discreet rules and decencies:

> It seems to me that the shape of coat known as Lounge, or three seamer as now worn, is fashioned fully too close to the figure to be neat: the style or character of the garment is of the free and easy class, and if made too close fitting, much of that which constitutes this character, is sacrificed to the whims of those who cut them, or the customers who are in the habit of wearing them. A short, close fitting garment, has a screwed up, mean appearance, and is totally wanting in that which makes a thing of beauty, and a graceful production. The class of customers for whom I have to cut, are of a mixed kind; the majority being what is called City men, or business gentlemen, whose taste and fancies are well settled and who can seldom be induced to change the shape or style of garments they have been accustomed to - wear mostly Frock coats. The younger class of customers are as a rule more changeable and erratic in their ideas,

and must have their notions as regards neatness shown in the shape of the garments they wear. It is here where tailoring as an art is shown, and skill and tact are wanted to humour the customers, to give them what they want, and to avoid falling into extremes.[26]

While frock and morning coats provided a stable benchmark of decency through the 1880s, evening dress, in tandem with the lounge, provided surprising scope for individual intervention, and discussion of its form offered opportunities for reflection on the nature of masculine display and its history in the pages of *The Tailor and Cutter*. Its outward appearance suggested the hierarchies of taste and unspoken restrictions that governed fashionable male dress, and those who associated its dense texture and colour and understated cut with the patriotic qualities of British cultural life resisted a growing pressure to pull it into the sphere of fashion. The author of the article 'Suggestions for Dress Suits' of January 1885 clearly understood evening dress as a badge of stability, impervious to change, stating that

> many are the attempts which have been made to introduce a radical and decided change in the whole character of the ancient style of what is distinctly the old British Dress Suit, but to no purpose; and so wedded are those who dress well, and hold old British institutions and customs in such high veneration, that we may safely predict that the old swallow tail, in a modified shape, will coexist in the future as in the past with British festivities, roast beef and plum pudding.[27]

In following years, reports made more precise references to the historicising tendencies apparent in contemporary evening wear, including a return to notions of eighteenth-century colour in Paris.[28] These drew attention to the manner in which padding and a close cutting to bodily contours produced a fluid, hugging line that also positioned men's dress suits with the more typically avant-garde in masculine style:

> There is, it is true, latitude enough in the style and general character of the Dress suit as it is usually made, for the display of taste, skill and judgement; and it must be admitted that a comparison of the style now current, with the old make of Dress suits, will bear the most complete evidence that the modern tailor has introduced such changes and improvements in the style as to make the Dress suit a thing of beauty. It is within the radius of our own experience … to have worked on a Dress coat in which the waist seam was not included, and the collar and lapels were padded firmly and thickly with well twisted double thread. The days have not long passed away when blue dress coats and bright buttons were worn, a buff (single breasted) stand collar vest and knee breeches with split falls completed the dress. The modern 'Masher' makes a vain attempt to ape the old British aristocrat, and it may be, in the near future, tailors will have to consult old works on cutting, to

learn the way to make garments, with certain modifications, as they were worn in the last century.[29]

Rather than remaining in the stultifying field of tradition, some elements of the dress suit actually presaged the defining qualities of both formal and popular fashionable dress in the 1890s – that is, a striking rethinking of the effects of a monochrome palette worn in combination with the brighter colours offered through a broader range of accessories; an attention to the surface finish of the cloth, prioritising sheen over depth or a deliberate juxtaposition of rough and smooth; and a sentimental referencing of late eighteenth- and early nineteenth-century fashionable styles. By November 1890 such was the rate of development that the tailoring press was prepared to celebrate elegant effect and individual panache over neatness, plainness or conformity:

> I refer to these rough unfinished materials being so highly popular at the present time among the highest classes. The material abstractly does not look very attractive, and on business or other gentlemen, without the usual trimming and accompaniments would look somewhat seedy after a few days wear. These rough materials as seen upon one of those fine military figures in Regent Street or the Row look simply perfection. There is the style of cut and make, the silk facings and silk buttons, the cashmere trousers, at the bottom of which are prettily made patent shoes or boots, looking as if they had just come out of shop; the hat with its narrow band and shine that bespeaks the finest quality – just the smallest thing tipped, satin scarf, collar and cuffs all of the latest. In such a setting, cheviot, vicuna or hopsack looks A1.[30]

Bespoke tailors anxious to compete with the pioneering marketing ploys adopted by the ready-made sector often found their trade journal turning to a celebration of anecdotal displays by dandies in the early part of the century and promoting a modern look geared towards public display. A report of August 1889 drew attention to an increased tendency to dress for visual effect, 'A few gents appear in the tall, narrow hat, with a two inch band, and almost at once, fashionable gents are seen wearing nothing else. The same may be said of the Reefer with silk fronts, and now during the present season we have the light grey suit becoming universally popular.' The promenade in Hyde Park or Piccadilly now formed a focus for reports that had previously looked to the more restrained settings of the provincial town, the trade society meeting, or the financial institutions of the City for inspiration. Self-promotion had assumed the status of a valued rhetoric for dresser and dressed alike and promised a further resurgence in the health of the men's clothing business. The brash Regency partnership of Beau Brummel and his tailor encapsulated much of this energy in the text of *The Tailor and Cutter*, both as a symbol of the

importance of image and connections in commercial life and as a newly acceptable model for sartorial trends:

> It is only after a new style of garment or material has been well introduced, and is more or less seen on every fashionable promenade, that it really begins to become popular. The case of Stultz and Beau Brummel has often been quoted, and it never had a more direct application than just here. Stultz, showing an enterprise foreign to the present generation of high-class tailors, conceived the idea of making a coat for Brummel ... The coat was sent with a £100 note in the pocket. Brummel acknowledged the receipt of the coat, adding that the lining was very acceptable. An arrangement was made whereby Stultz sent Brummel a new coat in a new style the beginning of each month, each having a £100 note in the pocket ... The enterprise of the present day is found in the ready-made firms ... and into these channels much of what was wont to be regarded as high-class trade is finding its way.[31]

Thus the 1890s witnessed the culmination of two trends that had dominated the reporting of style at *The Tailor and Cutter* over the previous twenty years; a progressive movement towards a 'rational' or 'artistic' mode of tailoring that favoured a spare and self-consciously elegant line, together with a growing reliance on

6] Fashion plate, *The London Tailor*, July 1897. 'A decidedly 1897 lounge suit' adorning the confident and athletic figure of the newly fashionable 'bachelor' type.

7] Fashion plate, *The Tailor and Cutter*, summer 1892. The addition of hat, gloves, tie and waistcoat accentuated the modernity of the latest ensemble.

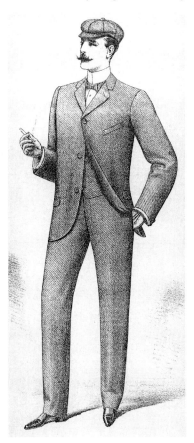

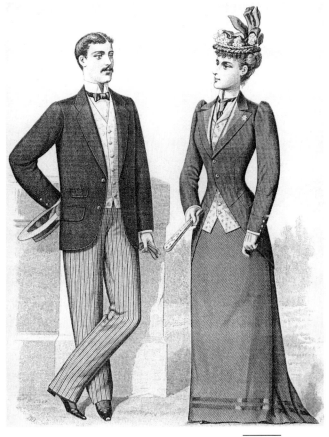

accesorisation and the incorporation of the ready-made as a means of marking fashionability in dress. The latter trend might incorporate minor changes in the choice of hat, gloves, shirt or tie according to function or season, or a more obvious switching between garments to signify a knowledge of prevailing tastes. In combination these modes of dressing suggested a speeding up of the male fashion cycle and a fresh concentration on younger consumers who identified with this new spirit. It is no coincidence that the physical appearance of models in the journal became more representative of the athletic bachelor or young married after 1890 than the bearded, bulky and patriarchal templates who predominated in the 1870s. A typical illustration of a lounge suit included in *The London Tailor* was announced as 'a decidedly 1897 Lounge suit: sprightly figure, lively, full of confidence, style, a man of refinement, position and education, and in the early period of life',[32] and its light grey, loosely structured though gracefully cut forms with three buttoned opening, long waistcoat and narrow trousers, worn with a golfing cap and high collar with bow tie must have epitomised the 'very latest style' (Figure 6). Separately, a concentration on tailoring effects and the creation of a fashionable identity through deft use of ready-made accessories came to represent a distinct class of customer, as the tone of a description of a summer outfit incorporating boater, tie, shirt, striped trousers and lounge jacket of July 1892 conveyed (Figure 7):

> Unlike suits of Dittos with which the Lounge is frequently associated, this [outfit] takes the form of 'dress'. The Lounge, with its long roll, made of black Vicuna or other kindred materials, the white figured vest, and light fancy trousers, constitute stylish promenade dress for a young gent. The full blown masher, as seen in the Park or Regent Street, is of course attired in a Frock coat. There are many however equally stylish in their dress, who will not wear a Frock, but come out in attire, as is here illustrated, and which, for the hot weather, is certainly much more appropriate than the Frock ... Vests are usually made without collar, to open low enough to show a fashionable scarf or shirt front when cross tie is worn.[33]

Further discussion of style change in the first decade of the twentieth century jettisoned many of those concerns regarding appropriate form and construction which had dominated the men's fashion press in previous decades and confined itself to relating the trend towards fuller, more dramatic outer clothing and the persistence of informality in other forms of day wear. This trend was influenced by the soft loose shapes of fashions designed primarily for sport and leisure, from boating to bicycling, and marked a further move from the tight attenuation of male dress in the 1880s and early 90s. There was a resigned sense of battles

having been fought and largely lost in the pages of *The Tailor and Cutter* and its competitor *The London Tailor* around the turn of the century which implied the establishment of new attitudes: 'Behold the golden age of democracy - in dress - is upon us ... there never was a time in history when everybody was dressed so alike,' bemoaned the latter in 1899.[34] Lounge suits in one fabric and of a boxy, uniform fit no longer suggested a cheap and carefree appreciation of novelty, but represented a genuine move towards a more democratic style. By October 1896, *The Tailor and Cutter* reported that it was

> struck with the popularity of whole back Lounges. Many of those who wore them were professional gentlemen, moving in the best circles of Society, and their garments were neatness personified; for instance, a Lounge suit made of a very dark grey cheviot, finished with a single row of sewing on the edge, black ivory buttons, and the usual four out-pockets to the jackets; and this is but a type of dozens.[35]

Similarly, the formerly fixed status of the frock coat was increasingly presented as floating, fallen victim to the whims of the consumer and the forces of appropriation: 'Not very long ago a Frock coat was considered the thing to wear at a wedding, at a flower show or at a ceremony at which either a Morning coat was considered too negligee and a Dress coat too starchy. But alas it has now come to be the proper coat in which to parade about London ... with its trailing skirts down to the calf.'[36] At the same time the admittance into bespoke clothing journals of columns detailing outfitting stock and commenting on fashions in collars and ties denoted the expansion of market choice as far as menswear was concerned.

The internal rhetoric and visual grammar of the men's fashion press, while superficially conservative and rather self-limiting in its recording of style change, thus offers a clear sense of evolving form, with some indication of the continuously shifting range and appearance of clothes as they were presented by subscribers to their customers at an important moment of consolidation and development for the menswear industry. The tracing of stylistic features has been viewed by recent dress and design historians as a reductive act,[37] but in this context, where received wisdom has contested evidence of change, and where the elusiveness of surviving examples of men's clothing has restricted the possibilities for rereading the male wardrobe in a 'material' sense, it becomes necessary to establish and unpack the visual parameters within which male consumers exercised their choices using other available sources. The pages of *The Tailor and Cutter* and *The London Tailor*, viewed in this way offer a finely delineated, complex

narrative of mainstream masculine taste that historians of fashion-
able consumption have chosen to overlook, but they also represent
a specific perspective and particular concerns, linked to fluctu-
ations in trade and the forces of competition. Besides their status
as reflections of economic, technological and business circum-
stance, it is also important to consider the moral and political
structures through which the items described accrued meaning.
Frock coats and lounge suits represented more than the meeting
of seams or the selection of specified textiles. Their adoption sig-
nified an adherence not only to the fashion system promoted by
the trade press but to a broader conjunction of function and taste
that resided in the sphere of 'manners'. Before turning to consider
the relationships between male consumers and the phenomenon
of fashion that forms the central focus of this book, I would like
to remain with the discourse of clothing itself for a little longer;
pushing beyond the representation and changing form of fashion
at the hands of the tailor and the journalist to establish its place
in debates surrounding the practice of dressing itself.

The elements and meanings of the male wardrobe

> We regard dress not merely as an envelope of broadcloth, cassimere, silk,
> satin or velvet, wrought up in more or less taste after the model of a
> prevailing pattern, but as one of the most significant expressions of
> character and sustaining an intimate relation with manners and morals.
> It is universally admitted that nothing marks the gentleman more than
> the style of his dress. The elegance, propriety and good taste which are
> conspicuous in that, at once create a presumption in his favour. They
> form a perpetual letter of recommendation whose validity is every-
> where acknowledged. A rich and becoming costume answers as a
> passport to the traveller; opens the door of hospitable courtesy to the
> stranger; gives the citizen a free ticket to the best places in society; forms
> a decorous ornament to wealth, and where wealth is wanting, in many
> respects supplies its place.[38]

G. P. Fox, in his guide to the elements of the wardrobe, published
in New York and London in 1872, betrayed a mid-century concern
both with the moral import of garments as translations of inner
worth and with the role of guide books such as his, which offered
(cynically perhaps given Fox's reputation as a retailer and advert-
iser of great skill) to lead the consumer through a labyrinth of
perilous social and pecuniary choices. His text emerged at a
moment that several recent historians of manners have identified
as the climactic point in a long history of conduct, courtesy and
etiquette books.[39] Andrew St George, though noting that 'etiquette
books continued to amass sales in the 1880s and 1890s', locates
their heyday during the middle years of the century, when they

'introduced the mid-Victorians to themselves at their ideal best, advising and encouraging them in moral conduct, finance, furnishing, literary consumption or personal hygiene. These books provided self-help and self-therapy for a society which had changed itself beyond recognition'. By the final decades of the century, he believes that 'the etiquette book felt the pressures which had begun to mould late-Victorian consciousness: social dissent in the form of Decadence, and intellectual change in the form of the revolution brought by scientific thinking'.[40] As a result such texts lost their close relationship with the inner workings of social life. This negates their value as historical evidence of real practices, though they still retain a sociological relevance as records of attitudes and templates for an idealised mode of living.

The guides which this chapter uses to break down the compartments of a fiercely stratified wardrobe had then moved beyond a rhetorical function that marked them out as important social props in the decades when 'the notion and prosecution of manners combined the Victorian distrust of government with a devotion to legislation ... united the individuality of nonconformism with the community of belief ... stood as witnesses to the search for a workable culture, and ... were the surest evidence of class emulation rather than class envy'.[41] If we are to follow St George's argument that such texts have a rich symbolic and active social currency, whose empirical worth declines in the context of the more turbulent *fin-de-siècle* years, then their descriptions of correct attire which I hope to use as a basis for thinking about the synchronic richness of menswear at that time are reduced to anecdotal irrelevancies. Furthermore, in Leonore Davidoff's words 'caution must be exercised in using sources such as housekeeping books, manuals of etiquette and the advice columns in magazines as evidence of existing attitudes and behaviour. These publications often seem to be sheer fantasy peddling for profit.'[42]

However, in her influential examination of the functioning of high society in nineteenth and early twentieth-century Britain, Davidoff goes on to draw convincing parallels with both written and unwritten codes and their reflection in material culture across the period using just such sources. Thus it seems that the fullest historical picture is gained when considerations of agency and influence are set against the market worth and descriptive depth of the texts themselves. As Davidoff states in her introduction: 'The blueprint of Society outlined here, then, is not a complete picture of social reality, but is a description of the framework of constraints within which individuals ... lived out their lives.'[43] Indeed, if what St George suggests is correct, that society after 1880 betrayed an unease and instability markedly changed from the

confident recognition of boundaries which characterised the 1850s and 1860s, then in the context of this change perhaps the listings and hectorings of etiquette writers, rather than losing their reflective relevance, actually took on a heightened value for consumers easily wrong footed by shifting circumstance. Their continuing high sales at least imply a degree of success and a broad relevance.[44] In this sense their content becomes invaluable as a tool for uncovering the generalised social meanings attached to clothing practice in the period.

The parameters of the ideal male wardrobe were clearly mapped out for those lacking social confidence by G. P. Fox in 1872. Fox, who specialised in hosiery, presented himself as a high class clothier to government officials in Washington during the 1860s and 1870s. The London-based *Saturday Review* noted that 'Englishmen may admire their own Moses so long as they remain in Europe, but they must cross the Atlantic if they would behold the highest triumphs of the art of puffing. The President of Fashion, Mr George P. Fox of New York, does this sort of thing in a style which ought to teach Moses & Sons humility'.[45] His book, like many others of its kind acts both as a form of self-promotion for the author's business, a voyeuristic glimpse into the dressing rooms of the rich and powerful, and an extended discussion of the moral values inherent in the dress and deportment of 'gentlemen'. The final chapter contains a 'memorandum schedule of gentlemen's furnishing goods & c.' which in its entirety offers the fullest record of the elaboration and distinction in dress that it was possible to achieve for a moneyed consumer of the 1870s. As Fox noted by way of an addenda: 'it would be preposterous to suppose that a refined gentleman of elegant leisure would have a wardrobe the size of a merchant tailor's shop & c. "cut your coat according to your cloth" and by all means live within your means. Enough said to the rich and poor of all the world.'[46] Nevertheless, taking into account its status as an example of extreme accommodation, the list stands as a useful reminder of what a complete male wardrobe stood for in terms of descriptive and actual space (even when, as here, suits and trousers are omitted):

White cambric ties plain, white cambric ties embroidered, white corded silk ties, black corded silk ties, fancy coloured Windsor scarves, black silk scarves - pointed and fringed ends, morning breakfast jackets, French cardigan jackets, morning robe de chambres, Prince Arthur colored shirts, embroidered white linen shirts, plain white linen shirts, white muslin fine shirts, linen night shirts (ruffled), muslin night shirts (plain), excelsior linen collars - assorted colors, Van Buest and other mode - in colors, reversible linen cuffs, Oxford linen cuffs, Oxford scarf - plain and fancy colors, Prince Teck scarf - plain and fancy colors, silk pocket

handkerchiefs, white linen cambrick handkerchiefs, Balbrigan half hose, the best merino half hose – assorted shades, light kid gloves a la mode, dark kid gloves a la mode, castor and buckskin gloves a la mode, 6 thread double breasted merino white undershirts, gauze merino drawers, 18 thread silk drawers, 3 thread silk drawers, 8 & 12 ribbed twilled silk umbrella, pemento mode walking sticks, English travelling rugs, Scotch travelling shawls, sets plain gold and agate studs, sets stone cameo sleeve buttons, plain gold neck studs, fancy coral scarf pins, Besantien scarf pins, stone cameo scarf pins, suspenders according to taste or requirement, 12 thread silk half hose, 3 thread silk half hose, mode silk gloves, Viesma portmonaies (Russia leather), glove boxes, handkerchief boxes, cigar cases and match boxes, toilet dressing case complete, card cases a la mode.[47]

The list suggests that Fox was undertaking a public stock check of his own merchandise, rather than detailing the purchases of a particular customer, though by the time hats and shoes are covered the guise of objective reportage has been reinstituted through reference to the assistance of firms besides the author's own:

The author expected in the outset to confine himself more particularly to the subject of outer garments, viz., clothing, but submits the following as a list of the latest description of styles of foot and head covering for a gentleman of wealth and refinement who is about taking a voyage 'round the world' and who, during his absence from his home … and not wishing to be short of any needed attire … on board his own steam yacht, provides his valet de chambre with the essentials of a polished gentleman's wardrobe … furnished us by Meurs and Dunenbury … Importers & Dealers in hats … New York: Canvas oil souwester with oilskin storm jacket, overcoat, overall trousers to match; the same in India rubber water-proof fabric, cloth travelling caps with oil silk covers in U.S.N. old regulation pattern, cloth boat race caps, black silk pocket caps, corduroy duck shooting caps, fancy coloured silk horse racing caps, dark and light coloured felt soft travelling hats, ordinary straw hats, fine Panama straw hats, dark and light shades of cloth soft hats, morning and evening dress hats – felt, silk and beaver. Gentleman's Bootmaker 23rd St. Broadway: House slippers, gaiter, Oxford tie shoe, broad strap shoe, Balmoral laced English shoe, buckled English shoe, Webster tie shoe, Congress gaiter shoe, hunting gaiter shoe, low buttoned shoe, imitation button shoe, Scotch gaiter, dress calf boot, patent leather boots, riding boot, Napoleon boot, dress and dancing pumps, sea going salt water boots, hunting boots.[48]

A closer assessment of Fox's memorandum would need to take account not only of the circumstances of its publication, its function as advertisement and advice, but also of its relationship to an American, rather than an English context. Fashion journalists and authors of etiquette guides based in London often took great pains to distance their understanding of English style from the perceived

brashness of transatlantic dressing, and while American tailors
looked to England for guidance on the prerequisites of a gentle-
manly wardrobe, the cultivation of a more expansive 'flashy'
appearance marked a young man out as hailing from New York,
Washington or Chicago, or at the least sympathetic to the energy
of those cities. The dress historian Jo Barraclough Paoletti has
traced the rise of such American 'dudes' to the turn of the century
when 'his appearance was neat but casual, clean but not fussily
immaculate, and versatile, not occasion specific'. This contrivedly
modern look she views as a development from, and improvement
on, the wardrobe of 1880 which was 'appropriate for a very com-
partmentalised life ... modelled on that of the "perfect gentleman"
described in etiquette books: inconspicuous to the casual observer,
but perfect in its attention to quality, fit and correctness'.[49] While
this basic evolution also held for English men, other American
voices, from Edith Wharton through to Fox, provide evidence of
a greater propensity amongst the entrepreneurs of the New World
to display their wealth through ostentatious wardrobes that be-
trayed a knowledge of 'form'. As Wharton recalled

> Lawrence Lefferts was on the whole, the foremost authority on 'form'
> in New York. He had probably devoted more time than anyone else to
> the study of this intricate and fascinating question ... As a young ad-
> mirer had once said of him 'If anybody can tell a fellow just when to
> wear a black tie with evening clothes and when not to, it's Larry Lefferts.'
> And on the question of pumps versus patent-leather 'Oxfords' his auth-
> ority had never been disputed.[50]

Yet besides its rather un-English flaunting of plenitude and
excessive differentiation, excused by an ambition to 'make the
American citizen as renowned for his garments as for his institu-
tions ... and to adorn the Doric simplicity of American principles
by the inimitable grace and elegance of an appropriate cosmo-
politan costume',[51] Fox's list certainly underlined a common
concern with compartmentalisation and offers further scope for
the discussion of choice, rather than restraint, by nineteenth-
century male consumers. At least that was the case for underwear,
shirts and accessories.

The strategies surrounding the selection of outerwear between
1870 and 1914 were probably more circumscribed than those asso-
ciated with the offerings of the hosier, particularly in London. The
fashionable and respectable wardrobe fell into rigidly defined com-
partments that expressed occupation and function throughout the
day and night, in both form and name. The terms morning suit,
lounge suit and evening dress came complete with temporal and
functional meanings even before their particular cut or colour

were announced. It is, though, significant that the occupations alluded to in such monikers were leisured in nature rather than professional. As Paoletti suggests, the term 'business suit' did not gain general currency until after the turn of the century. The vocabulary of tailoring adhered closely to 'gentlemanly' ethics for most of the nineteenth century. Even Samuel Beeton (a prolific author of lifestyle advice books, who was rather ironically revealed as no strict supporter of social hierarchies and firmly anti-establishment in outlook at the time of writing in 1876,[52]) made passing reference to the tendency of men's wear to reflect a social function and time that disguised more prosaic, salaried pursuits, though he failed to stipulate the specific clothing items which suggested the purpose of the wearer. The items that Beeton chose to disregard had by the 1870s established a predominance bordering on tradition in the texts of tailoring manuals and etiquette books:

> An English gentleman ... is never seen in the morning (which means all that portion of the twenty four hours devoted to business, out of door amusements and pursuits etc.; it is always morning until the late dinner hour has passed) in the half-worn coat of fine black cloth that so inevitably gives a man a sort of shabby genteel look; but in some strong looking, rough knock-about clothes, frequently of non-descript form and fashion, but admirably adapted both in shape and material for use – for work ... its only distinctive marks are the most scrupulous cleanliness and the invariable accompaniment of linen.[53]

In E. Cheadle's *Manners of Modern Society* of 1872, the morning dress loosely glossed by Beeton was already closely associated with the frock coat. This was an item that had accrued an iconic status for those enemies of Victorian formality writing early in the twentieth century. In Cheadle's description it is fraught with a confusing variety of appropriate and inappropriate uses that undermine its later reputation as a sartorial straitjacket:

> Suitability' equally applies to [men's] costumes as to that of the ladies. For instance, when it is said that a grey suit is worn in the country, it must not be supposed that the costume is therefore suitable for every occupation and at all times of the day. You may have an invitation to a three o' clock dinner ... or to a social tea at six pm. On these occasions neither the tweed costume nor the evening dress suit would be appropriate, but the intermediate dress should be worn – a suit such as is usually donned on Sundays either in town or country – black frock coat, coloured trousers, and black tie or scarf. No attempt should ever be made to combine morning and evening dress; they should always be quite distinct, the one from the other. A black frock coat worn with black trousers is in reality as incorrect as a tail coat and coloured trousers would be.[54]

8, *facing, left*] Studio portrait, *c.* 1895. The form of the frock coat descended from the eighteenth-century dress coat. It provided a convenient cover-all for formal occasions and was ubiquitous as a symbol of middle class respectability. By the 1890s its rigid outlines stood in marked contrast to the informality of the lounge suit.

9, *facing, centre*] Fashion plate, *La Mode*, Paris, 1911. The morning coat, although arguably more flattering than the frock, carried connotations of elite fashionability and social decorum. It was increasingly at odds with the move towards democratisation in dress.

10, *facing, right*] Fashion plate, *La Mode*, Paris, 1911. By the turn of the century, the lounge suit was associated with the functional world of work and had no place within the social hierarchies of the 'gentleman's' wardrobe.

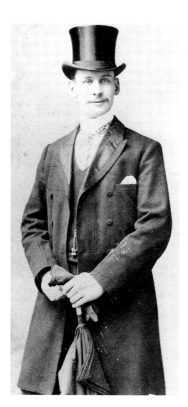
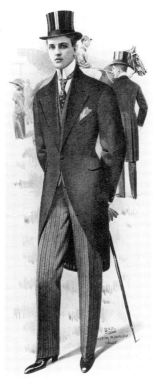
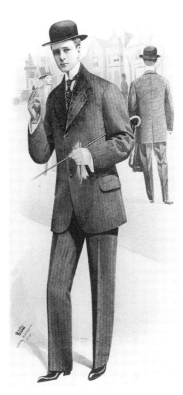

Square-shouldered, single- or double-breasted and either fitted to accentuate broad chest and narrow hips, or left loose and open, the frock coat fell to the knees and bore a vestigial relationship to the formal eighteenth-century dress coat. The 'Major', an advice columnist of the popular interest journal *To-day* provided an epitaph for the garment at the start of its demise in 1900:

> At the present time ... the frock coat is not quite so fashionable for young men as it was two years ago. When it last came into fashion as a coat for young men - about ten years ago - even men who did not as a rule pay much attention to the fashions or to their personal appearance, ordered frock coats and wore them on all possible occasions ... The coats reached nearly to the ankles; they were worn unbuttoned; they flapped about in the wind when their wearers walked, and generally got in the way when their wearers sat down ... These coats were certainly not smart. They were made of loosely woven black materials with rough surfaces, and they soon got out of shape ... But within the last ten years there has been a great change in the style of frock coats, and now a good frock coat is made of a hard worsted material with a perfectly smooth surface. This material, of course, is old fashioned, but sufficiently old to be new for the present generation.[55]

By 1912 the society tailor H. Dennis Bradley finally dismissed the usefulness of the frock coat in favour of the newer morning coat, a more tightly fitting version of the frock, cut away below the

waist to form tails at the back and buttoned with only two fasten-
ings at the front. There is a sense in Bradley's description of the
morning coat itself representing a passing tradition, its formal and
rather inconvenient appearance undermined by the functional
appeal of the lounge suit. He states that:

> For formal business wear as well as social use, the Morning coat is pre-
> eminent, although the business man is apt to chafe at the lack of pockets
> worn, for it is useless to deny that it is absolutely impossible to carry
> anything whatever in any part of the pockets of the fashionable Morn-
> ing coat without disastrously affecting its hang. To overcome this
> unavoidable handicap it will be found an excellent plan to have a
> lounge jacket made from the same material ... for use in travelling to
> and from one's office.[56]

The gradations of formality that survive through to the first
decade of the twentieth century in ghostly encouragements of
sartorial correctness stood in sharper relief at the opening of the
period. George Fox was careful to isolate elements of dress as ap-
propriate for particular times of the day, meanings and layers of
clothing achieving greater complexity as the hourly rounds
moved towards evening in an echo of *ancien régime* aristocratic
practice. Thus 'it is always best that the morning dress be in a
manner negligee, and the rule which prohibits the introduction of
every portion of full dress in the early part of the day, is also
imperative in rendering in-admissible the appearance of the
morning frock coat upon promenade, or after dinner'.[57] Full morn-
ing dress aimed at an approximation of refined gentility without
ostentation, so that

> sack and frock coats of various colours and forms to suit the complexion
> of the wearer, with vest and pantaloons to match in shade, or of the
> same or similar material, forming an agreeable contrast; scrupulously
> white linen, black or coloured necktie of modest pattern ... form the
> morning costume of the gentleman under fifty years of age.[58]

However, while aspiring to aristocratic detachment, Fox's morning
ensemble already carried with it the association of work. True
nobility, 'those who accompany ladies of refined taste and educa-
tion, should not appear in office suits, but should assume a dress
more comfortable to the respect which they owe the opposite sex.
A blue fancy dark colour, mixed or black frock coat, a silk or velvet
vest ... would be appropriate.'[59]

For Fox the lounge jacket was indecorous. He admitted that
'young men often appear at the breakfast table in a tasty, easy
fitting and fancy trimmed lounging or smoking room jacket', but
warned that 'it is not correct to wear this garment at any other
meal, and certainly not in the drawing rooms or parlours, in

presence of polite society'.[60] By 1900 its easy informality signalled the apparent demise of such social rules and offered a style of dressing where distinction could be gained only through the patronising of a more expensive tailor or an ability to anticipate fashionable trends, rather than the ownership of a vast wardrobe or a keen knowledge of the etiquette of dress usage. As Dennis Bradley attested, when 'worn alike by all classes, the necessity of having one's lounge suits well cut is obvious. The subtle details which elevate the expert cutter to a plane above the lesser lights of the profession are never more pronounced than in this important garment.'[61] And the 'Major' warned that 'if it is too short, you will have the satisfaction of knowing that people will think one of two things about you – either that you are wearing the coat of your young brother or a ready made'.[62] Further advice by the same author revealed that, by the tenets of high society, the use of the lounge in terms of timing, season, city and country was highly ambiguous, its democratic form almost impossible to accommodate in more hierarchical structures:

> When you are in town you mustn't appear in a lounge suit and a bowler hat after lunch, and of course if you had any business appointment in the morning, you would wear a frock or morning coat ... and silk hat. You may make an exception to these rules in the summer. In August and September society people are not supposed to be in town, and therefore if you happen to be in town, you can wear country clothes – a light thin lounge suit and a straw hat. If you are in town in August or September, you are supposed to be there only because you are passing through on your way to the country.[63]

Truly informal dress, designed for country wear or those moments in the week not governed by work or the metropolitan social calendar, appears to have offered one of the few areas where greater latitude was permissible in the formation of a more personalised, less rule-bound look. Even here though the appearance and suitability of particular items was strongly tied to an understanding of fitness for purpose and social correctness. The popular writer on the history of social manners W. MacQueen Pope, in his reminiscence of a middle-class London childhood at the turn of the century, provides memories as marked by the grammar of respectability as any etiquette author:

> One dressed for a holiday then, one did not undress. One kept up one's station and showed one's position in life as much by the Sea as in Queens Road, Finsbury Park ... Your attire could be less formal, slightly more colourful, a little easier ... A man could wear flannel shirts and a blazer ... his straw boater, but he did that in town; he might, if middle aged, wear a Panama, or sometimes he wore a cricket cap perched rakishly on the back of his head ... A man could wear brown boots by the sea, or even

shoes, white with brown toecaps and crossovers ... His trousers were supported by a belt (usually club colours) ... Not on Sundays, however; then the holiday attire was shed and men reverted to lounge suits of sober hue, but not to bowlers or toppers. There were some advanced people who still wore flannels on a Sunday, but that was really only permissible on the river ...[64]

While the texture and colour of weekend or holiday clothing offered respite from the 'minefield' of correct attire adopted in town, and pointed towards the relaxation of such codes in the interwar years, the spectre of personal choice introduced new opportunities for social embarrassment even as it revealed to male consumers the potential of clothing for providing more than a simple badge of class and occupation. The 'Major' reassured readers that

11] Cabinet photograph, late 1880s. Forms of dress associated with leisure pursuits rather than work or formal occassions allowed greater latitude in the choice of accessories, textures and colours and more opportunities for the display of individual tastes.

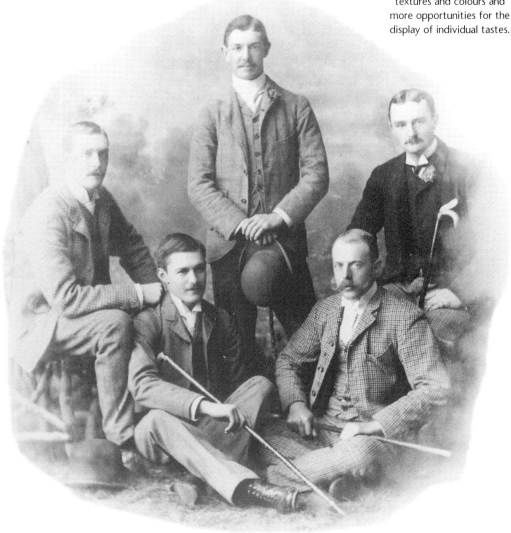

I know that Harris tweeds have been objected to because of their pat-
terns and colourings, which are rather loud. Well, what would you have
in a suit that is intended for country wear? There is a kind of rough and
ready look about the pattern which you cannot help liking when you
get used to it, and there is this advantage about the Harris tweed - each
pattern is distinctive from the rest.

In offering such bold opinions, the author revealed codings of taste
and highly subjective physical associations in nineteenth-century
male clothing that escaped even the observations of the etiquette
books. The garments themselves embodied a set of distinctions and
characteristics, residing beyond formal fashion systems and the
circulation of manners, that repay further examination if their
interpretation is to move beyond the parameters set for them
thirty years later by J. C. Flugel. In this sense their significance is
thrown into sharper definition once the historian recognises the
existence of those hidden relationships engendered between men
and their clothes (the physical formings of identities and trends)
rather than relying on abstract explanations of a doubtful denial.
The Major's reliance on the anecdotal, the romantic and even the
prejudicial literary turn as aids to substantiate his sartorial advice
provides assurances that such subjective connections and pleasures
were given space to thrive:

You could always tell Harris tweed by the peculiar peaty smell attached
to it, but within the last few years unscrupulous manufacturers have
imitated Harris tweed to such an extent that they have even imitated
this peculiar smell ... If you want a material that will last you, with fair
wear, until you get absolutely tired of it, buy Harris tweed. I knew a man
once who had a suit for eleven years, and then didn't wear it out.[65]

Notes

1 J. C. Flugel, *The Psychology of Clothes* (London: Hogarth Press, 1966), pp. 110–11.

2 J. Bourke, 'The Great Male Renunciation: Men's Dress Reform in Inter-war Britain',
 Journal of Design History, vol. 9, no. 1 (1996), p. 23.

3 Flugel, *Psychology*, p. 113.

4 P. Perrot, *Fashioning the Bourgeoisie: A History of Clothing in the Nineteenth Century*
 (Princeton, NJ: Princeton University Press, 1994), pp. 29–34, 112–23.

5 J. Harvey, *Men in Black* (London: Reaktion, 1995).

6 C. Breward, *Images of Desire: The Construction of the Feminine Consumer in
 Women's Fashion Journals 1875-1890*, unpublished MA Dissertation (London,
 Royal College of Art, 1992), pp. 40–65. M. Beetham, *A Magazine of Her Own: Do-
 mesticity and Desire in the Woman's Magazine 1800-1914* (London: Routledge,
 1996), pp. 100–6.

7 *The London Tailor*, 2 September, 1899.

8 H. Perkin, *The Rise of Professional Society: England since 1880* (London: Routledge,
 1989), p. 27.

9 H. Dennis Bradley, *Vogue: A Clothing Catalogue for Pope and Bradley* (London, 1912), pp. 12-13.

10 S. Chapman, 'The Innovating Entrepreneurs in the British Ready-made Clothing Industry', *Textile History*, vol. 24, no. 1 (1993), pp. 5-25; J. Styles, 'Clothing the North: The Supply of Non-elite Clothing in the Eighteenth-century North of England', *Textile History*, vol. 25, no. 2 (1994), pp. 139-66.

11 F. Mort, *Cultures of Consumption: Masculinities and Social Space in Late Twentieth Century Britain* (London: Routledge, 1996), pp. 134-44.

12 *The Tailor and Cutter*, 8 April, 1880, p. 155.

13 M. Lambert, 'The Dandy in Thackeray's *Vanity Fair* and *Pendennis, Costume*, vol. 22 (1988), pp. 61-2. J. Siegel, *Bohemian Paris: Culture, Politics and the Boundaries of Bourgeois Life 1830-1890* (New York: Viking, 1986).

14 *The Tailor and Cutter*, 12 June 1874, p. 434.

15 *Ibid.*, 17 May 1883, p. 193.

16 A. Landsell, *Fashion a la Carte 1860-1900* (Princes Risborough: Shire, 1985); M. Ginsburg, *Victorian Dress in Photographs* (London: Batsford, 1982); A. Landsell, *The Victorians: Photographic Portraits* (London: Tauris Parke, 1993).

17 *The Tailor and Cutter*, 25 October 1872, p. 40.

18 *Ibid.*, 27 December 1872, p. 148.

19 *Ibid.*, January 1877.

20 *Ibid.*, 13 May 1880, p. 191.

21 *Ibid.*, 14 December 1882, p. 58.

22 *Ibid.*

23 *Ibid.*, 7 December 1882, p. 52.

24 *Ibid.*, 19 April 1888, p. 215.

25 *Ibid.*, 21 May 1885, p. 205.

26 *Ibid.*, 28 January 1886, p. 113.

27 *Ibid.*, 1 January 1885, p. 76.

28 *Ibid.*, 13 June 1889, p. 234.

29 *Ibid.*, 1 December 1886, p. 260.

30 *Ibid.*, 13 November 1890, p. 376.

31 *Ibid.*, 1 August 1889, p. 283.

32 *The London Tailor*, 31 July 1897.

33 *The Tailor and Cutter*, 14 July 1892, p. 257.

34 *The London Tailor*, 30 September 1899, p. 305.

35 *The Tailor and Cutter*, October 1896, p. 23.

36 *The London Tailor*, 7 September 1895.

37 J. Craik, *The Face of Fashion* (London: Routledge, 1994), p. 6.

38 G. P. Fox, *Fashion, The Power that Influences the World* (New York: & London, Sheldon & Co. 1872), pp. 17-18.

39 M. Morgan, *Manners, Morals & Class in England 1774-1858* (New York: St Martin's Press, 1994); J. Carre, *The Crisis of Courtesy: Studies in the Conduct Book in Britain 1600-1900* (Leiden: E. J. Brill, 1994); M. Curtin, *Propriety and Position: A Study of Victorian Manners* (New York: Garland, 1987).

40 A. St George, *The Descent of Manners: Etiquette, Rules and the Victorians* (London: Chatto & Windus. 1993), pp. 286-7.

41 *Ibid.*, p. xiv.

42 L. Davidoff, *The Best Circles: Society, Etiquette and the Season* (London: Century Hutchinson, 1986), p. 18.

43 *Ibid.*

44 J. A. Banks, *Prosperity and Parenthood: A Study of Family Planning among the Victorian Middle Classes* (London: Routledge, Kegan & Paul, 1954), p. 56.

45 Fox, *Fashion*, p. 239.

46 *Ibid.*, p. 254.

47 *Ibid.*, pp. 250-1.

48 *Ibid.*, pp. 252-3.

49 J. Barraclough Paoletti, 'Ridicule and Role Models as Factors in American Men's Fashion Change, 1880-1910'. *Costume*, vol. 19 (1985), p. 121.

50 E. Wharton, *The Age of Innocence* (London: Wordsworth, 1994), p. 6.

51 Fox, *Fashion*, p. 23.

52 H. Montgomery Hyde, *Mr and Mrs Beeton* (London: Harrap, 1951), pp. 144-57.

53 S. Beeton, *Beeton's Complete Etiquette for Gentlemen* (London: Ward, Lock & Tyler, 1876), p. 22.

54 E. Cheadle, *Manners of Modern Society* (London: Cassell, 1872), pp. 87-8.

55 The Major, *Clothes and the Man: Hints on the Wearing and Caring of Clothes* (London: Grant Richards, 1900), pp. 19-21.

56 Bradley, *Vogue*, p. 18.

57 Fox, *Fashion*, pp. 45-6.

58 *Ibid.*

59 *Ibid.*, pp. 46-7.

60 *Ibid.*, p. 44.

61 Bradley, *Vogue*, p. 22.

62 The Major, *Clothes*, p. 54.

63 *Ibid.*, p. 192.

64 W. McQueen Pope, *Twenty Shillings in the Pound* (London: Hutchinson, 1948), p. 100.

65 The Major, *Clothes*, pp. 122-3.

'Each man to his station': clothing, stereotypes and the patterns of class

3

It was such a sight - civilization in a nutshell - that was what made me pause. I was a part of it, and Apollo was taking a peep at his own legs ... What a scene! The Exchange I had just left, with its groups of millionaires gossiping, Baghdad and the Irawaddy, Chicago and the Cape; dividend day over at the bank yonder, and the well known sight of the Blessed going to take their quarterly reward; a sheriff's coach turning the angle of the Mansion House (breakfast to an African pro-consul I believe), a vanishing splendour of satin and plush and gold; dandy clerks making for Birch's with the sure and certain hope of a partnership in their early grace; shabby clerks making for the bun shops; spry brokers going to take the odds against Egyptians, and with an appropriate horsiness of air, a parson ... itinerant salesmen of studs, pocket combs and universal watch keys; flower girls at the foot of the statue, a patch of colour; beggar at the foot of the steps, another patch, the red shirt beautifully toned down in wear ... eruption of noisy crowd from the Cornhill corner (East End marching West to demonstrate for the right to a day's toil for a day's crust); thieves and bludgeon men, and stone men in attendance on demonstration; detectives in attendance on thieves; shutters up at the Jeweller's as they pass ... And, for background, the nondescript thousands in black and brown and russet and every neutral hue, with the sun over all, and between the sun and the thousands the London mist. It was something as a picture, but so much more as a thought. What a wonder of parts and whole! What a bit of machinery! The beggars and occasionally the stock jobbers and the nondescripts to go wrong; the policeman to take them up; the parson to show the way of repentance; and the sheriff to hang them, if need be, when all was done. With this, the dandies to adorn the scene - myself not altogether unornamental - the merchants, the clerks, and the dividend takers, all but cog and fly and crank of the same general scene. What a bit of machinery![1]

In 1888 the social-realist writer Richard Whiteing published a novel *The Island: Or an Adventure of a Person of Quality* that presaged many of the concerns that would engulf cultural debate during the following decade. The title suggests common concerns with that genre of literature produced around 1900 by authors including Rudyard Kippling, Rider Haggard and H. G. Wells. These were explicitly male romance epics offering spectacular yet safely

removed geographical and psychic spaces for the negotiation of pressing or taboo contemporary subjects, particularly those concerning developing sexual and social identities. What is significant for this chapter, however, is the contrived familiarity of Whiteing's opening paragraph, which, in its vivid portrayal of the hub of London's financial district, offers a more commonplace, 'democratic' setting than the tailoring journal or the etiquette guide, for those themes of tradition and modernity which underpinned the development of masculine fashionable style as outlined in the previous chapter. I wish to examine here how that rather abstract, stylistic history related to the experience and representation of the urban everyday and to the formation of distinct sartorial identities.

In their orientation towards specific social contexts, the fashionable ideals promoted by the clothing trade shared a common language with other more imaginative texts, in which the identification and assessment of urban 'types' through visual codings was of central importance. This is a connection which has been utilised to great effect by Daniel Roche in his recent account of French fashion systems in the eighteenth century. He has shown how the textual communication of status and character in the novel can be of enormous use to the fashion historian seeking opinions and attitudes which may have been obscured by the partial or 'functional' nature of documentary and 'official' archival sources. As he states

> the novelist provides information about ways of life because he places objects in a context, so conferring on them a different truth from that discovered by the deciphering of archives ... fiction achieves authentic effects both by the truth of the descriptions and by their location within a story which reveals forms of reasoning and structures of the imagination of an age. In the amicable quarrel over the use of texts between literary scholars and historians, this median position must be retained.[2]

Literary scholar Lynn Hapgood alludes to Whiteing's espousal of a process that she defines as 'textual disorientation' in his proto-cinematic and self-consciously sublime introductory passage. This pivotal narrative moment, when the author looks back from his island refuge to the day of his decision to leave the corruption of the City, achieves through the staccato register of reportage and the glancing imagery of impressionism a complex sense of distance through geographical and chronological space. What is not distanced, according to Hapgood, is the psychic impact of the experience, though the two are closely implicated with each other. She goes on to argue that

Whiteing suggests that topographical viewpoint - from where one looks - is inseparable from mental viewpoint - what one is open to seeing ... This symbiotic relationship between the physical eye and the inner eye gives sharpness and precision to the concept of social determinism and reveals both the collective nature of social experience and the struggle of individuals to transcend it.[3]

In this sense, and following Roche's suggestive method, though the provenance of the passage belongs to the imaginative world of the novelist, its descriptions offer a privileged view of the manner in which the social spectrum and psychological make-up of late Victorian society might have been perceived. Furthermore, its self-conscious debt to the new traditions of 'objective' journalism and its avant-garde control of the authorial voice provide a more nuanced reading of sartorial image 'in motion' than the more cloistered writer on trade, modes or manners. All was disorientating in Whiteing's London at the close of the nineteenth century. The ordered commercial machine of empire barely containing those notes of social unrest and moral apprehensiveness evidenced through the ever shifting direction of the crowd and the world-weary ennui of the narrator. Yet at the same time the characters isolated in its mêlée were fixed in a precise hierarchy, marked by an outward appearance that confirmed the spectator's preconceptions of class. The year 1888 may have been the time of 'dittos' for the masses and 'subdued checks' for the aristocracy in *The Tailor and Cutter*,[4] but Whiteing captured in stereotypes the repercussions of such style dictats, from their reflection in the gossiping groups of millionaires and spry brokers, their approximation in the figures of dandy and shabby clerks and their refraction in the red shirts and russet suits of beggars and hooligans. As the historian of theatrical performance J. S. Bratton has shown, such stereotyping offers a useful, if conceptually problematic, means of assessing historical attitudes to social (and racial) hierarchies and relationships. These might be extended beyond the stage to encompass the communication of class positions through clothing in the 'performances' offered and recorded by popular literature and social reportage:

> Important to the function of theatre in negotiating identity ... is the formalisation and conventionalising of the concept of character, via the mechanism of the stereotype. Stereotyping is a mental activity condemned by ... moralising modern critical arguments, as the root of almost all the evils of ... injustice and oppression from which we suffer ... The difficulty is that without the mental activity of discrimination of which stereotyping is the first tool we learn, we would be without any sense of a real self with which to begin ... Performance offers audiences ... a rich assortment of stereotypes and a locus for relating to them which has greatly varied potential. The emotional response elicited may be blindly, pathologically crude, or, at the other extreme, the complex-

ities of the performance may offer a unique opportunity for the individual to become aware of stereotyping as a mental activity rather than a reflection of reality, and so to acquire the beginnings of detachment and understanding.[5]

By drawing on the power of discursive fictions such as stereotyping to explain the organisation of social relations, art historians and literary scholars contradict recent readings of nineteenth-century class formations by social and economic historians. These have stressed a greater fluidity between and within supposed class groupings than was previously acknowledged. From an emphasis on 'top down' coercion and subordination accepted in the early phases of social history in the 1960s, historians now prioritise a diversity of competing 'popular identities'. Alastair Reid usefully identifies 'the inadequacy of simple horizontal divisions ... and an emphasis instead on the importance of vertical divisions within both the ruling classes and the working classes: between branches of economic activity, between regions, and between religious and political affiliations'. The outcome of such a shift has, inevitably, moved discussion towards the nature of social difference, for, as Reid continues: 'Perhaps a society held together by coercion or control would become more homogenous under pressure from above, but one held together mainly by consent is likely to contain a variety of popular identities.'[6] On this basis the circulation of widely recognised class stereotypes represents not so much a reductive framework for understanding the 'frozen' structures of society but an acknowledgement of a constantly shifting interplay of role models, types and identities. The figures I introduce in this chapter, should therefore be seen not simply as all-embracing representations of lived experience but as indicative of the several ways in which consumers were encouraged to imagine, identify and interpret a range of social models.

While the previous chapter aimed to quantify the relationship between masculinity and dress according to the development and status of the clothing itself, this chapter shifts its focus to the status of the wearer. The categorisation of dress employed here has more in common with current debates concerning the nature of class definition and social mobility than the totalising interpretations of dress adopted by recent fashion history texts which have taken masculinity as their subject.[7] In the latter it has been taken for granted that aristocratic dress codes provided an all-encompassing gentlemanly template against which other men could arrive at an approximation of fashionable taste. To be fashionable, in other words, was to adopt the sartorial rules of the social and economic elite. Such a reading assumes a coherent interpretation of the aristocracy as a single social grouping and a clear, unchanging

relationship between that group and its supposed imitators (also defined as fixed in their self-image and aspirations). As Reid's comments have illustrated, in both methodological and historiographical terms such assumptions no longer convince. The economic historians Andrew Miles and David Vincent, for example, have shown how even arriving at a common definition of class is not straightforward:

> In both the conceptual and technical senses there are essentially two approaches to the construction of occupationally based classification schemes. While virtually all students ... start from Sorokin's premise that 'any organised social group is always a stratified social body', they then separate into those who view society as either class or status based. The former assume fundamental lines of division in society based on Marxist distinctions concerning the differing relationships of groups to the means of production, or, adopting a Weberian model, on their work and market positions. The latter conceive of the social spectrum as an ascending ladder, or seamless continuum, of ever more prestigious occupations, unbroken by any marked distinction.[8]

To speak of a seamless continuum suggests more than an appropriate metaphor for fashion historians, for it is undoubtedly in this context that the unchanging, undemonstrative and undifferentiated nature of male dress has been conceived, explained through recourse to a prevailing hegemony of 'gentlemanliness' propagated by the landed classes.[9] Contemporary rhetoric appears to uphold such readings. Commentators from *The Tailor and Cutter* through to George Fox presented the consumption habits of the 'upper ten' as an appropriate model for emulation, and on one level Whiteing's conception of the City posits a familiar metaphor of smoothly functioning machinery, an 'ascending' ladder linking the occupations of millionaire and beggar in the same mutually beneficial configuration. However, Whiteing's position was heavily imbued with the perspective of the critic: the socially variegated crowd that he described was also a harbinger of moral unease and signified the recognition of difference in a more problematic sense. New work on class formations has begun to unpack the manner in which seemingly powerless or disregarded social groups, refuted the stereotypes set up for them in such representations, choosing instead to establish cultural forms and practices that related more closely to their own set of economic, political or moral circumstances. G. Crossick and H. G. Haupt note that

> as we turn from contemporary novels and cartoons to the image in historical writings, we find the petit bourgeoisie presented as an essentially imitative social group ... It is a powerful image, with small businessmen, minor civil servants and office workers driven by a com-

bination of anxiety and aspirations to imitate a bourgeois culture whose substance they could barely grasp ... The ... image is nonetheless more difficult to sustain once we explore the realities of petit bourgeois life.[10]

This recognition of the tension between stereotype and 'reality' implies that a more robust playing off of contradictory images, role models, aspirations and boundaries took place through processes of self-presentation than the stricter parameters of more didactic texts allow.

In a related vein, the easy association between power, money and lineage that underpinned the social system was also yielding to increasing pressure for change by the closing decades of the century, further undermining any simple reading of the stereotype as a stable hegemonic cipher. Recent studies of the aristocracy have taught us that such associations can never be taken as given. Economic historians Cain and Hopkins characterise the period as 'one of precarious equipoise, when the power of finance, growing increasingly cosmopolitan, reached a transitory equality with that of land, whose agricultural base was being slowly undermined by the free trade internationalism on which the City flourished'.[11] In a controversial thesis Martin Wiener has translated this economic shift into a cultural equation whereby aristocratic traditions in institutionalised forms maintained a symbolic hold over government, education, finance and industry, ensuring in the process that progressive commercial and technological imperatives in Britain remained safely in check.[12] Seen in this light, the English gentleman's sartorial image becomes not so much a badge of unchanging social stability but rather a contested site for the playing out of struggles for pre-eminence between waning and rising social groups and outlooks.[13] That forms of self-presentation for men seemed to remain largely static over the period does not necessarily suggest a consensus in these matters, but offers room for debate 'about whether the continued prominence of the landed elite reflected a real aristocratic dominance or whether aristocratic government and cultural norms were merely convenient veils behind which the "bourgeoisie" could work its will undisturbed'.[14] The fact that these tensions were communicated through the medium of popular literature, personal testimony and journalistic observation means that a closer scrutiny of the ways in which class positions and sartorial presentations interrelated should be attempted. Only by acknowledging the fluid manner of their operation is it possible to arrive at a clearer view of the varied meanings attached to men's clothing, its complex systems of stylistic change and finely tuned gradations during the late nineteenth and early twentieth centuries.

The glamour of the aristocratic image

Whatever the parameters for contesting the ownership and meaning of the image of the English gentleman during the period, there is no doubt that the material accoutrements of such an ensemble cost a great deal of money and were engineered to communicate that fact. As power passed from the old order to the new, sartorial display retained an important sociological function. According to David Cannadine, its cachet increased in value as the established rules of the London Season fell into decline.

> From the 1880s onwards, this carefully integrated and functionally significant system began to break down. In London high society, the aristocratic monopoly was broken, as the new super rich stormed the citadels of social exclusiveness, and flaunted their parvenu wealth with opulent and irresistible vulgarity ... Edward VII preferred the company of the smart set - self made plutocrats and Jewish adventurers – to the old fashioned grandees, who seemed so dull and staid by comparison.[15]

An emergent plutocracy, in setting new fashionable standards retained a semblance of aristocratic decorum while simultaneously announcing the renewed importance they placed on the material trappings of success through the increased consumption of particular kinds of self-aggrandising objects: houses, yachts, portraits, race horses, food and clothing. Jamie Camplin quotes the economist Arthur L. Bowley, who studied the change in the distribution of national income between 1880 and 1913 and 'was prepared to suggest that wealth without increasing as a whole more rapidly than population, was passing into the possession of persons who enjoyed ostentatious expenditure'.[16] Such expenditure, Camplin suggests, was aided by

> the opportunities available. At the beginning of the twentieth century a bachelor in London with only £1,000 a year could still manage a flat in Mayfair and a servant (which might account for £150); he could dine at his club for 4s, at a good restaurant for perhaps 10s; his evening clothes would not cost him more than 11 guineas from the best tailor in Saville Row. Even his week of admittance to the Royal Enclosure at Ascot could be obtained for only £2.[17]

Set against top-rate incomes of £10,000 a year and expenditure on clothing of up to £450, the margins within which it was possible to achieve an aristocratic appearance were very wide, inflationary even. Indeed Lady Agnew, contributing suggestions for expenditure in the wealthy household to a series of family budgets published in *The Cornhill Magazine* during 1901, suggested that the higher the income, the greater the danger of debt, owing to the necessity of translating wealth into possessions whose gorgeous

transparency would make their high value clear to onlookers. In her view ostentation was a domestic duty rather than a public vice:

> With £10,000 a year you will neither be able to take a very large house nor, on the other hand, can you take a very small one, as unless you have an unusually strong individuality, you cannot elect to live with three maids in a small house in Kensington Square when you are known to have £10,000 a year. What do you do with your money? ... You give a dinner with a bowl of roses, a roast chicken, and an ice from Gunter, in a little white panelled room. It is all charming, and costs the proverbial two pence half penny. But this is not the case in the larger house, where spending is the spirit of the household. There, your dinner-party will be a very different affair. The moderately good dinner, which is excusable in the small house with a limited household, is not admissible in a large house with plenty of servants, where the dinner must be perfectly cooked, the waiting must be perfect, and the flowers and et-ceteras must all be in keeping.[18]

The Tailor and Cutter expanded in a similarly effusive manner on the details of aristocratic expenditure on dress. Articles outlining the clothing budgets of leading society figures offered frequent opportunities for moral discourse on the duty to dress, and wishful thinking on the part of those suburban or provincial readers whose customers' outlay on clothing paled in comparison. A correspondent of November 1890 recalled how:

> I visited two or three of the crack tailors of The West end last week to get some figures about the cost of gentlemen's wardrobes. One of them told me that their smartest customers spent from £300 to £400 a year on clothes. It seems incredible that finery for a man could amount to that sum in one short year. Such a sum would dress a city clerk in fine style for life.
>
> The tailor explained how the thing was done. The smart man about town never repeats himself; he has a fresh coat for every day in the week. He will start the season with about twenty new suits. These cost about 5 guineas a suit. So there's £100 gone at one fell swoop. Then there are fine waistcoats and smoking and evening suits for the young gentleman. The crack price for an evening suit is £20, and a man who goes much into society needs two of these in a year ... Why dressing is quite a serious business in the life of a fashionable man. Thrice does he array himself in different clothes each day. A tweed suit is his morning wear. In the afternoon he dons a Frock coat, a smarter waistcoat and a bigger tie. Then in the evening he has to dress for dinner. Perhaps his dinner clothes will be exchanged for a smoking suit later ...
>
> In Hanover Street I came across a tailor who told me that £100 a year would be ample for a society man to dress upon. This in fact, he said, was about the average amount spent. The middle class young man manages to keep up a creditable appearance on £15 a year. Out of that sum he gets about four new suits a year.[19]

Richard Whiteing captured a contemporary interest in the ma-

terial differences between classes in his novel *No 5 John Street*, published in 1899. In presenting the stark contrast between a leisured upper-class lifestyle and the day-to-day disappointments of an 18-shilling-a-week minor clerk, lodging in one of the slums that hid between the affluent thoroughfares of the West End, the author injected descriptive passages of opulence and degradation that reach beyond melodramatic caricature in their detailed inventorising of masculine accoutrements. A valet's introduction to the contents of his master's dressing room offers clear and persuasive evidence of the place of excessive and conspicuous display in constructing the stereotype of an 'aristocratic' bachelor gentleman:

> Mr Seton likes to have things right ... You can have pretty nigh every kind of bath you want here, by touchin' the right sort of 'andle ... The little jars is essences to freshen up the skin. That yonder's electricity. The same current 'eats the irons for the moustache.
>
> The dressing room was what you might call a problem. There was no room for Mr Seton's things, do what you would. We brought in our own rosewood presses and lined the walls with 'em ... I keep this room only for the things in wear, accordin' to the season. The things in waitin' is in the next.
>
> The worst of it is, Mr Seton don't give a thought to storage. The goods comes in from the tailors almost too fast to put 'em away. My poor 'ead! Then there's the body linen ... it's fearful, now they've brought in the coloured shirt fronts, and all them fads in silk and fancy wool – Burmese floss, Chinese Imperial Dragon, watered in the web ... A fad every week at the 'osiers shops ... and if you don't watch it a new rig out for every fad ...
>
> These glass cases for the boots was my invention. They keep the dust off, and show the pattern at a glance. He's got a fancy for cloth uppers in the same style as his trousers. That means a new pair of boots for every pair of the other things. The worst of it is, the moment the trousers go out of fashion, out goes the boots ...
>
> He's the best dressed man in town, by a long way ... Mr Seton's got such an eye for colour; and to match him throughout, right down to his very gloves and scarf pin, in two or three suits a day, is a fearful strain on the mind.[20]

Whiteing's evocation of the idle aristocrat, obsessed by appearances, exercised by the rigours of taste and condemned to a life of rose wood and fancy wools, threw the cramped grey existence of the underclass into sharp relief. It was not the only stereotype of aristocracy that held currency with a reading public. Other versions including the sporting rural landlord, the military martinet or the patrician politician could also claim a wide circulation in the popular imagination and offered competing sartorial strategies to offset the dandy aristocrat's flamboyance. In terms of representing attitudes towards class and clothing however, the latter

incarnation as sketched by Whiteing retained a particular dominance. It also stands as more than literary effect, when its caressing descriptions of studiously wasteful consumption are compared with the trappings of real wealth from which it drew its potency. Seven years before the publication of *No 5 John Street*, the nation had mourned the passing of a Prince whose indolence and languorous public image offered a fully rounded and highly controversial encapsulation of the fashionable aristocratic type.

Albert Victor, Duke of Clarence and Avondale, first grandson to Queen Victoria and heir presumptive to the British throne, died a month before his wedding to Princess May of Teck, in January 1892, aged twenty-eight, of influenza aggravated by incipient pneumonia; and his passing was constructed by obituarists and the popular press as a moment of national tragedy.[21] The sudden circumstances of his death, however, conveniently veiled an escalating series of sexual scandals and a dawning disappointment in ruling circles with the Prince's intellectual and practical capabilities as future figurehead for the Empire that paralleled public disquiet regarding the ostentatious activities of young aristocratic men generally. Official records concerning his career and personal history have accordingly 'not survived' or exist in heavily edited forms.[22] However, what does remain is a wealth of visual evidence recording his appearance from which it is possible to construct the development of one elite wardrobe over the wearer's lifetime. Photographs, sculptures and engravings, alongside journalistic and biographical descriptions, evoke a character engrossed with his self-image, though even here the details were seemingly disguised and distorted. Theo Aronson delivers an evocative portrait in his recent biography:

> He had inherited from both parents a passion for clothes. With his slender figure and exceptionally slim waist, he had the perfection of, and about as much animation as a tailor's dummy. He was certainly a dandy. To minimise the length of his neck ('a neck like a swan' wrote one relation) he wore high starch collars. This led to the family nickname of 'Collars and Cuffs' ... This bandbox appearance, allied to his languid manner and hooded gaze, afforded Prince Eddy a mysterious, curiously seductive aura. As he smoked almost continuously, both Turkish cigarettes and cigars, he was usually seen through a haze of slowly drifting smoke.[23]

Here was an ambiguous figure, apparently devoid of the usual physical or muscular attributes associated with respectable manliness, defined largely through the cut of his clothing and the posture of his body. Though initially unpromising, his short life stands as a point of elucidation for the playing out of aristocratic fashionable signifiers; and, while it would be too reductive to use

his image as an illustration of a monolithic elite sartorial identity that cut across all the lines of distinction that went to make up that class,[24] it seems fair to claim that his public persona epitomised for the majority of the reading and viewing masses a familiar approximation of ruling-class bearing. This was, however, an approximation complicated by an uneasy relationship between definitions of aristocracy and royalty that marked attitudes towards an evolving monarchy throughout the nineteenth century, accounting for many of the spectacular contradictions apparent in Albert Victor's problematic public image.[25] Taking these problems on board I aim to use his figure as a way of fleshing out a negative stereotype that nevertheless came to represent a dominant model of late Victorian fashionability.

Born two months prematurely in January 1864, Albert Victor spent a cosseted infancy, immersed in an atmosphere of high living dominated by his parents, Albert Edward, Prince of Wales and Princess Alexandra. The fashion historian Valerie Cumming notes the contrast between this young couple and the example of the grandparents, who during, and partially in response to, the political unrest and popular evangelical tone of the 1840s had pioneered the 'bourgeois values of a sound happy home life ... allied to the idea of a kindly but glamorous regality which took charitable work and formal court ritual in its stride'.[26] The tenor of London society in the 1860s and 1870s underwent a period of fundamental change in which the younger generation of the royal family were closely implicated.[27] The Wales's had rejected the staid reverence surrounding Windsor and Osborne, and established Marlborough House and Sandringham as modish magnets for the emergent plutocratic smart set. The season for them was more firmly focused on the expensive consumption associated with Park Lane balls, Monte Carlo casinos and estate shoots than the archaic formality of court presentations and diplomatic audiences. At the centre of this social whirl, Cumming identifies the personal progression from youthful swell to cosmopolitan roué that marked the Prince of Wales's sartorial biography, a narrative of exuberant excess that foreshadows Albert Victor's own obsessions in the 1880s:

Although he lacked the height and physique to be the perfect model for the art of English tailoring, he was always keen to try new styles. From 1859, when as a student he had worn his first bowler hat, he was seen in every type of new clothing for men: the softer 'lounge suit' of the 1860s; the new black evening coat and trousers; tweedy Norfolk jackets and knicker-bockers for country sports; trousers with creases; and Homburg hats. He was married wearing garter robes over military uniform and, until the end of his life, was happily addicted to every uniform available to him. He was rigorous in applying his extensive

knowledge of correct uniform and insignia, chiding those who had the temerity to appear before him with the minutest detail incorrect. He was not handsome, but after he had grown a beard and moustache in the 1860s ... he acquired an air of distinction which won praise throughout Europe.[28]

The columnists of *The Tailor and Cutter* became fairly exercised about the Prince's taste and expenditure on clothing, announcing his choice of tailors as 'Messrs Davis, Hanover Square; Pulford, St James's Street; Poole, Saville Row; Cookes, Hanover Square; Tautz and many others'.[29] They estimated that while the 'Prince does not pay unusually big prices for his clothes, a Frock coat costing some £12, a Dress suit £15, a Tweed suit £8 to £10', the huge quantities of garments dictated an annual outlay of 'probably not less than £2000'.[30] To an even greater extent Albert Victor's mother rapidly established herself as a fashion leader, both in a symbolic sense and as an individual consumer. She was adept at modifying her dress to suit both grand ceremonial events and informal family occasions, choreographed to meet a public appetite for suitable royal spectacle and tailored to answer the carping criticisms of the establishment in the Queen's office. In his future career, if not in his private life, the Prince was obliged to extend this dynastic desire to communicate both virtue and glamour through public image, a desire shared beyond royal circles and echoed in aristocratic attempts to suggest the power of breeding through consumption and grooming. Albert Victor was aided in this venture by a strong physical resemblance to Alexandra and his grandfather Prince Albert, and any attempt to read his appearance, or that of any aristocrat, needs to be placed firmly in a familial context as this was almost certainly the way that contemporaries were encouraged to interpret the promotion and prominence of their first families. As *The Ceylon Observer* remarked during the Prince's later visit to India in 1882:

> The resemblance of the elder Prince to his grandfather Prince Albert as well as to his mother the Princess Alexandra was remarked as he stood reading the reply to the address. Physical robustness does not distinguish his appearance which contrasts in this respect to his more jolly looking brother, a capital representative of a good humoured 'middie' with a striking resemblance to his father and royal grandmother, Her Majesty the Queen. 'Refinement' is perhaps the chief characteristic of the countenance of Prince Albert Victor, while a prevailing sense of fun marks that of Prince George.[31]

Surviving representations of Albert Victor as a child are marked both by their conformity to typical notions of respectable Victorian infancy more generally associated with a middle-class fetishisation of domestic life, and the conflicting pressures of a

PRINCE ALBERT VICTOR,

ALBERT VICTOR DRESS

12] Fashion plate, *The Tailor and Cutter*, March 1877. Albert Victor's role as fashion leader was cemented early in his life, as evidenced through this promotion of 'The Albert Victor Dress'. A fashion plate image of the young prince is printed on the reverse of a fold-out paper pattern for the same costume.

childhood conducted in the heightened atmosphere of royal privilege and decorum.[32] In the March 1877 edition of *The Tailor and Cutter* the Prince appeared as a model for the Albert Victor Dress, a military-style, double-breasted riding suit with embroidered frogging motifs and a peaked cap (Figure 12). Whether or not the sitter actually wore the precise costume illustrated (the plate was more probably an example of the established tradition for adding recognisable likenesses to models to increase the saleability of the promoted product,[33]) the image established the Prince as a sartorial icon. It was also no coincidence that the illustrator depicted Albert Victor engaging in acceptably aristocratic masculine pursuits. Horsemanship and skill with a gun were attributes usefully suggested in images and descriptions of an heir to the throne whose lack of robustness and minimal taste for exertion were already privately causing concern, an early indication that public image and its careful manipulation of sartorial codes tended to mask rather than reveal. In aristocratic dress generally, the earthiness and hardwearing quality of country or sporting gear

offered a similarly compensatory function, offsetting the effete refinement of clothing designed for town. As the royal biographer noted:

> The essential things which conduced to the making of his character were the home life at Sandringham, the life in the woods and on the stubbles and on horseback ... As a horseman of high order, as a shot of real brilliancy, having regard to his age, the Prince possessed two manly accomplishments, calculated to endear him to a very large section of the British nation ... It is permissible to say that we like our Princes to be 'hard Englishmen' active of body, skilled in the chase, masters of horse and gun, and that to many of us the knowledge that the Prince possessed the manly instincts and tastes of an English gentleman was perhaps unreasonably pleasant.[34]

Hardness was one of the traits that the Prince's parents and tutor aimed to instil in Albert Victor and his brother George by dispatching them in 1877 on a naval education, firstly as cadets on board the training ship *Britannia*, moored near Dartmouth, and then from 1879 as participants in a series of cruises on HMS *Bacchante*. While withdrawing the boys from the more orthodox public school education originally planned for them, but discarded owing to Albert Victor's learning difficulties, the experience was not out of kilter with wider trends for international travel amongst the aristocracy. Images of the brothers produced during their time at sea depicted them kitted out in naval dress (Figure 13). The propaganda value of uniform, having been established in the late eighteenth century, was one that continued to underpin the presentation of the aristocratic self throughout the nineteenth.[35] The sculptor Von Gleichen presented Queen Victoria with a bronze of the Princes as cadets in 1878. Their relaxed, almost negligent appearance was entirely appropriate to the state of naval uniform during the 1870s, and the lack of clear directions given by the Admiralty for the make-up of officers' uniforms was seen to influence the disrespect shown to dress regulations by ratings.[36] The single-breasted cadet's jacket with small upright collar and archaic cuff arrangement and the distinctive close-fitting cap had been introduced in 1856 and gave some indication of uniformity, but otherwise there was little to distinguish the clothing from the plain and rather formless character of civilian working dress at the time. A lithograph appearing in *The Whitehall Review* of 1879 showed the Princes, initial training complete, more smartly presented in a version of the rating's double-breasted round jacket. The year 1879 had seen the publication of new illustrated dress regulations for naval officers, and Albert Victor certainly assumed the appearance of authority, secure with the resulting formality in

a self-assured pose far removed from the sense of boyish distraction that had characterised the previous, more intimate representation.

On his return to England, Albert Victor spent a brief period out of uniform, passing through Trinity College, Cambridge. A fashion plate presented with the Christmas issue of *The Tailor and Cutter* of 1882 showed the Prince and his brother in a fitting academic setting, even if the frock and morning coats seemed to have little of the university about them (Figure 14). At the time of printing, the Princes were attending a short language course in Lausanne, and, betraying the manner in which such publications aimed to construct ideal images for modern royals, the journal commented that

> the present location – in Switzerland – of the two Princes represented on our plate, indicates their still subordinate position, and the necessity, at whatever sacrifice, of their acquiring the education which is to fit them for the high position assigned them years hence ... Being a special plate, and one likely to be preserved by our readers, we have attired them in the leading popular styles of the period. [37]

The elegiac reminiscences of a fellow former undergraduate evoked a contrasting private picture of an unpressured and resolutely homosocial academe, one whose detachment from the industrious world beyond informed many similar evocations of university life as one of aristocratic indolence, extending the

13] Lithograph, *The Whitehall Review*, 1879. By Courtesy of the National Portrait Gallery, London. Albert Victor and his brother participated in a number of diplomatic cruises during their education which offered ample opportunity for the display of naval uniform.

14] Fashion plate, *The Tailor and Cutter*, December 1882. On his return from abroad, Albert Victor spent some time at Trinity College, Cambridge. *The Tailor and Cutter* continued to present him as a fashion model, placing him in a suitably academic setting.

The Princes Albert Victor & George Frederick of Wales

15] Commemorative engraving, *The Illustrated London News*, January 1892. The 10th Hussars, whose regiment Albert Victor joined in 1885, was the most fashionable company in the army. The uniform, fitted and made by the wearer's own tailor, accentuated Albert Victor's developing image as a dandy.

aesthetics of public school and symbolised through clothing by dress suits, boating jackets and cricket flannels:

There had been a ball at St John's Lodge - one of the most successful functions of a brilliant May week - and we had all danced until the sun was high in the sky and we could dance no more. Prince Albert Victor walked back to Trinity with my brother and myself and two or three other men, and when we reached the Great Court, the charms of the fresh summer morning made the thought of bed impossible. It struck someone that it would be a good idea to turn into the Bowling Green and have a final cigar before we separated ... How clearly I recall the very sounds and scents of that delicious June day - the gay squealing of the swifts as they circled round the old towers, and the moist odours of the shaven turf at our feet. It was as though the quintessence of our

happy life at Cambridge had been distilled into a golden cup and offered as a final draught to our regretful lips.[38]

While college provided a brief respite from the pressures of impending official responsibility, Albert Victor found some continuing solace on graduation, in a sartorial sense at least, during his commission as an officer in the 10th Hussars. Founded in 1715, the regiment held a reputation as the most aristocratic in the army, and in the 1780s had achieved a lasting gloss of fashionability when the Prince of Wales was appointed Colonel Commandant, later attracting Beau Brummel as a member of the ranks. By 1885, the uniform was considered among the most exquisite in the forces. William Cairnes, the author of *Social Life in the British Army*, commented in 1900 that

> opinions differ very much … as to which regiment can lay claim to be the smartest regiment in the army, though the palm is usually awarded to the 10th Hussars, of which regiment the Prince of Wales is colonel, and which included among its officers the late Duke of Clarence. Admission to the commissioned ranks of the 10th is, as might be imagined, more difficult than to those of any other regiment, the social position of the candidate being a matter of much importance, while considerable private means are also an essential'.[39]

J. E. Vincent summarised the social atmosphere of the regiment in one sentence when he recorded that Albert Victor was fined 'half a dozen of champagne for appearing on duty without a belt'.[40]

Aside from ensuring exclusivity, considerable private means were necessary also to procure the extravagant uniform: a brown sable busby with scarlet cloth bag, gimp cockade, ostrich and vulture plumes and gilt chain. A deep blue cloth tunic fronted with six pieces of lace ending in caps and drops, fastening down the front with gimp lace olivets. The collar edged with gold lace, and the back and cuffs ornamented with Austrian knots in gold gimp lace. Shoulder cords of plaited chain gimp lace and trousers of blue cloth with two gold lace stripes.[41] As Cairnes recorded:

> each member of cavalry has its own tailor, and the young officer joining will find it essential to ascertain the names of the artists in tunics and breeches who happen to possess the confidence of his new corps. These tradesmen will be found to be the most accommodating in every way; but civility of this high order is occasionally an expensive luxury, and it may be taken as a rough estimate that it will not be an easy matter to get a complete cavalry outfit, exclusive of horses, under, at the least £300.[42]

Aronson suggests that Albert Victor was a hopeless soldier, but engrossed by the splendour of the trappings, commissioned his tailor to extend the collar, nip in the waist and lengthen the

tunic.[43] Five years before, Gilbert and Sullivan had capitalised on the manly glamour of army drag as a counter to the 'lank limbs' and 'dirty greens' of aesthetic posture and dress in their popular comic opera *Patience*, and when their stage colonel celebrated 'a uniform that has been as successful in the courts of Venus as on the fields of Mars'[44] its charms were perceived as being resolutely manly. The combination of aristocratic dandyism and martial pretensions inherent in the public image of regiments such as Albert Victor's however, imbued gold lace and patent leather with less wholesome connotations. The dress historian Peter Farrer has uncovered a series of scurrilous letters printed in the correspondence columns of the journal *Modern Society*, which partially corroborate oral and legal testimony of the central role played by more junior and plebeian guardsmen in the twilight world of male prostitution and homosexual pornography.[45] A correspondent writing in June 1889 reports:

> On the first occasion of our seeing the Prince, he was attired in a tight fitting frock coat, and as soon as my wife saw him, she whispered to me 'Doesn't he look as if he had stays on?' I laughed at the idea of such a thing, but on the next occasion we saw him, which was the military parade, and he had on the uniform of the 10th Hussars, the fact of his having a corset on was too apparent for anyone to doubt. I can assure you, that whoever had the office of lacing the Prince's stays, must have required no small muscle to pull him into the pitch he was tightened ...
>
> I do hope sir, you will use your influence to prevent such effeminate habits from spreading among our young men. If Prince Albert Victor has picked up the habit of tight lacing in the hussars, one can easily understand the origin of the saying 'The 10th don't dance'. If they all laced as tightly as young Wales, they simply couldn't dance, even if they wished to. The Lord preserve the nation from a generation of male corset wearers.[46]

Whether Albert Victor's tall, slim frame even required the assistance of a corset remains debatable, and waist supports for men were, in any case, advertised freely in the columns of many family newspapers during the period. What was significant in the attention paid to his figure is the light it sheds on popular attitudes to aristocratic physical and sartorial traits that were largely martial in derivation. The accentuating tendencies of elite military dress translated well into the civilian aristocratic image that Albert Victor chose to project in the few years of adulthood left to him. Devoid of frogging and gold lace, the Savile Row morning coat nevertheless retained the stiff lines and restrained pomp of the parade ground.

Having failed to shine in the accepted career route for aristocratic sons with limited intellectual potential, the Duke of Clarence

and Avondale, as he became known after his investiture in May 1890, left the Hussars and entered into the service of the royal family. This was a position that required a scrupulous attention to issues of social etiquette and sartorial correctness, skills which Albert Victor finally excelled at but which gained little recognition from political commentators or historians. However while the trend in social history has been to prioritise the popular at the expense of the elite, recent work has established that, far from being marginal, the royal family and its carefully honed image played a central role in formations of culture across all levels of society. The historian H. Cunningham claims that

> a national leisure culture ... did not in any natural way evolve out of an initially working class urban popular culture; nor on the other hand, was it simply imposed from above. It was, rather, the shifting outcome of ongoing tensions and negotiations between urban popular culture and the media ... Royal events indeed, were a key element of this culture, for they were deliberately national, and they were holidays.[47]

Thomas Richards goes further, locating the renewed understanding of a highly visible and visual monarchy at the centre of nineteenth-century commodity culture. He says, referring specifically to the figure of the Queen:

> By the 1890s advertisers seemed to have forgotten that Victoria had ever been anything than a commodity. In 'The Art of Advertising' (1899) William Stead is quick to assert that 'the Monarchy ... advertises itself everywhere' ... The Queen's movements are chronicled in the Court Circular. The Royal standard, which announces the arrival of the Queen, is 'no bad substitute for the sandwichman.' The peerage pages of Burke's and Debrett's are 'almost as essential to the maintenance of position in the country and society as advertisement is to the prosperity of Pear's Soap or Cadbury's Cocoa' ... In his mind the elaborate spectacle of monarchy cannot be dissociated from the collateral spectacle of advertising ... the monarchy and the commodity are one and the same thing.[48]

Though falling within the remit of popular spectacle, Albert Victor's predilection towards dandyism was extreme, even by the standards of raucous Victorian advertisers and publicists. Photographs from his final years showed him too perfectly enacting his public role, from young man about town to country squire, symbolic dignitary and husband to be. But the over-riding sensation on viewing the clothes and attitudes is theatrical, the self-conscious posing echoing the posturing of pantomime. Indeed, the playing out of a double role, or a lack of substance behind the performance, has led some biographers to suggest that the Prince was a visitor to the male brothel in Cleveland Street, staffed by telegraph boys and patronised by members of society and

government, that in 1889 became the focus of an aristocratic scandal and the cause of one of the first prosecutions for homosexual acts under the Criminal Law Amendment Bill of 1885. *The New York Times*, safely distanced from the libel courts, linked Albert Victor's physical appearance to his moral deficiencies in a manner familiar to music hall purveyors of low-living, high-consuming aristocrats. Its editor stated that

> there has come to be within the last few days a general conviction that this long necked, narrow headed young dullard was mixed up in the scandal ... What this really mirrors is a public awakening to the fact that this stupid, perverse boy has become a man and has only two highly precious lives between him and the ... throne and is an utter blackguard and ruffian.[49]

To claim that Albert Victor's clothing choices marked him out for specific criticism would be overly simplistic. His father's tendency towards dandyism certainly didn't compromise an aggressively red-blooded reputation and, as Cannadine suggests, the image adopted by both men was a seemingly uncomplicated one to the journal-reading public: 'by the 1890s, the aristocratic "man about town" was a well known phenomenon. He spent his days and nights in sporting clubs and near the stage door, mixed with book keepers and racing journalists, squandered his allowance and got into all kinds of mischief'.[50] Albert Victor's name had been

16] Commemorative engraving, *The Illustrated London News*, January 1892. During his visit to India, Albert Victor was able to indulge a taste for unusual clothing through his adoption of colonial attire.

R. Caton Woodville

connected, somewhat desperately perhaps, with various unsuitable Catholic princesses and actresses. But his seeming lack of interest in any sphere other than that of leisure, allied to a growing sense of hysteria surrounding the proclivities of London's shadier and more dissipated bon viveurs, lent the Prince's sudden departure on a tour of India at the time of the Cleveland Street trial an added sense of convenience. Even in Bombay, though, his sartorial obsessions gave cause for concern. His hosts the Duke and Duchess of Connaught were 'astonished at the trunkloads of clothes Prince Eddy had brought with him. He had an impeccably tailored outfit for every public occasion. Whatever his shortcomings this future Emperor of India certainly looked the part. He spent so long dressing that he once kept the punctilious Duke ... waiting for twenty minutes before they could set out on their morning ride.'[51]

The return to Britain in 1890, once the scandal had passed, witnessed a consolidated effort by the Royal Household to mould Albert Victor more forcibly into its vision of imperial respectability. His engagement to Princess May in December 1891 helped to impart a semblance of propriety, and a schedule of unrelenting civic openings and audiences left little time for self-indulgence. Yet even here the official biographers seemed to find it difficult to mention anything beyond the cut of the Prince's jacket or the polish on his medals. At the opening of the Grand Parade in Scarborough, according to Vincent, 'the picture which comes back to me ... is that of a graceful and well built young man in evening dress ... with the blue ribbon of the garter on his chest ... watching with eager delight the gorgeous illumination of the crescent shaped bay'.[52] And at the reception of the German Emperor at Sheerness 'two officers of the Emperor's Red Hussars hurried forward to greet the illustrious visitor. They were the Prince of Wales and the Duke of Clarence, and the latter in that splendid uniform, looked every inch the soldier.'[53]

Here was a mirage of royalty, visually perfect but little more than an empty vessel for the expectations of a population which had come to expect public pomp as a sign of worldly power and domestic stability. Beyond the realms of Windsor, Albert Victor's body and clothing also confirmed the symbolic capital afforded the trappings of aristocratic power and privilege, a system of appropriately luxurious images and sartorial references that steer very close to the emulative engravings and descriptions of the fashion press. Indicative of the ongoing tensions apparent in Albert Victor's espousal of aristocratic modes, between the demands made for the visibility of wealth and primogeniture, the fraught status of clothing as a suitable preoccupation of the manly, and the contested degree to which private morals were manifested through

public persona, was the final comment on the Prince's life made by *The Tailor and Cutter* on his premature death. As an entirely fitting memorial to 'Collars and Cuffs', the editors hastily made use of a conventional fashion plate image of the Prince edged in black (Figure 17). Most telling though were the lines they added to its description: 'It were sacrilege to describe the garments on this picture.'[54]

The performance of professionalism

If, as the discussion of the Duke of Clarence's wardrobe has suggested, the evidence of tailoring journals and etiquette guides concurred closely with the fashionable choices of the aristocratic elite, then the clothing consumption of middle-class men and those below them offered more scope for the contesting of sartorial identities – a sign perhaps of the greater fluidity and lack of consensus afforded descriptions of social rank below the upper ten. Whereas the construction of aristocratic modes of fashionable taste implied assurances of quality and expense and an

17] Memorial engraving, *The Tailor and Cutter*, January 1892. Media reactions to Albert Victor's death ensured that his posthumous reputation remained that of an ineffectual clothes horse. *The Tailor and Cutter* presented its own memorial in the guise of a fashion plate.

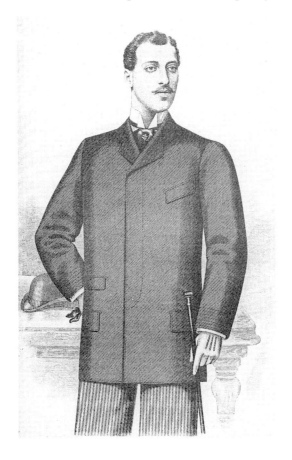

unquestioning assumption of control, the clothing of the professional or middle-class man was suggestive of more paranoid attempts to access some of those qualities while carefully distancing the bourgeois image from the excesses of those sartorial stereotypes that abutted it. The journalist Thomas Burke exposed those concerns with aspiration, differentiation and respectability which appear to fix middle- and lower-middle-class attitudes to dress in the period:

> When I was a small child I was as other children of our set. I played their games in the street. I talked their language. I shared their ambitions. I worshipped their gods. Life was a business of board school, breakfast, dinner, tea, struggled for and eaten casually, either at the table or at the door ... I should grow up. I should be I hoped, a city clerk. I should wear stand up collars. I might have a moustache. For Sunday I might have a frock coat and silk hat, and if I were very clever and got on well, a white waistcoat. I should have a house - six rooms and a garden, and I might be able to go to the West end theatre sometimes and sit in the pit instead of the gallery. And some day I might even ride in a hansom cab, though I should have to succeed wonderfully to do that. I hoped I should succeed wonderfully, because then the other boys at the board school would look up to me.[55]

Recent studies of the middle classes, by social and economic historians reliant on Marxist interpretations of class relationships, have retained scant sympathy for exploring the internal aspirations and imaginative culture of a broad swathe of the English population. Such a lack of analysis concurs with MacQueen Pope's self-serving assertion that

> The middle class has always been inarticulate. It has never been very interested in itself. Its members have been known to disown it. But there it was - a most important section of the community - working, playing, marrying, dying ... paying its rates and taxes and always supplying that great gift of balance, common sense and respectability which kept the prosperity of the country on an even keel.[56]

Unsurprisingly, more effort has been directed at arriving at objective definitions of the strata of a silent majority resting between the ruling classes and the proletariat. Ownership of property, occupation and proximity to the labour market have been the most common features used to identify class position in a bewildering array of possibilities.[57] This rather reductive approach, while useful in supplying a loose framework for the positioning of particular occupations, offers few clues to the sense of self engendered by an outlook supposedly dogged by 'a sense of precariousness, of contingency ... of life as struggle ... menaced from above and below'.[58] In its insistence on viewing the middle classes only in relation to those 'above and below' in an assumed

ranking, of finding evidence for 'false consciousness' and 'class traitorship', this is a position in danger of losing sight of the specific qualities that identified people as belonging to a particular grouping in the first place. Clothing and the maintenance of a public persona were one area of 'cultural' production much less fixed and far more subjective than those fields associated with property or employment, yet central to the definition of social standing across the middle-class spectrum from shopkeeper to stockbroker, which explains Thomas Burke's clear recollection of its transformative potential. The sartorial presentation of self allowed for a negotiation with those more static class indicators, providing the possibility of movement from, or acquiescence, with the prevailing social stereotypes of what it meant to be middle-class.

A central tenet in that construction of the male middle-class ideal, across all its strata, was the notion of professionalism. While the aristocratic image presumed a natural propensity towards social supremacy and its attendant responsibilities, manifested through the military bearing of morning dress or the material and visual credentials of land ownership (from the tweed shooting jacket to the pink melton hunting coat), professional standing was presented as a position to be striven for and earned. The onus on duty and respectability that it entailed ensured a greater concentration on the correctness of its physical manifestations. The historical sociologists Gourvish and O'Day place this trend within the development of particular occupational roles that found their roots among the middling sort of the eighteenth century. They maintain that

> by the middle of the nineteenth century certain occupations had acquired a fairly high social status by mastering a core of esoteric knowledge and offering it to society for financial reward. However, it was the notion of service to the community which was held to justify a privileged position of trust ... A promise of integrity and codes of conduct, identified with the established professions of religion, law, medicine and education, differentiated 'professional' from 'non-professional'.[59]

Contingent on the development of professional models, the increasing attention paid to the economic rewards of business by the late nineteenth century saw an uneasy fusing of aristocratic and middle-class models, the arising tensions of which commentators observed in the material trappings of upper-middle-class life. T. H. Escott, writing in 1885, reserved particular admiration for 'the great merchant or banker of today ... an English gentleman of a finished type':

> If he is not a peer, the chances are that he is a member of the House of Commons. He is a man of wide culture, an authority upon paintings, or

china, or black-letter books, upon some branch of natural science, upon the politics of Europe ... he goes into the City as punctually as his junior clerks; and when he returns from the City he drops for a few minutes into the most exclusive of West End clubs. His grandfather would have lived with his family above the counting house and regarded a trip to Hyde park as a summer day's journey. As for the descendant, his town house is in Belgravia or Mayfair. He occupies it for little more than six months out of the twelve, and during the rest of the year lives in his palace in the country ... There is in fact, but one standard of 'social position' in England, and it is that which is formed by a blending of the plutocratic and aristocratic elements.[60]

This meeting of duty, self-improvement and moral display was rooted in a form of long-established gentlemanly mercantilism that stood in stark contrast to the showier pretensions of those whose fortunes derived from more recent excursions in the money markets, whose social backgrounds displayed a wider range of origins than those whose wealth depended on the more gradual attainment of 'good connections' or a thorough training in the traditions of trade or the professions. As Escott noted

> There is a rush now equally on the part of patrician and plebeian parents to get their sons into business, and noblemen with illustrious titles ... eagerly embrace any good opening in the City ... It is perhaps the younger son of an earl or a duke who sees you when you call on your broker to transact business; it may be the heir to a peerage himself who is head partner in the firm which supplies the middle class household with tea, puts a ring fence around the park of the Yorkshire squire, or erects a trim conservatory in one of the villa gardens of suburban Surrey.[61]

Between the two models, merchant and stockbroker, status was seen to be either deserved and refined in character or fortuitous and over-opulent 'the life of the ideal stockbroker is one of display, that of the ideal merchant, one of dignified grandeur'.[62] Positioning oneself publicly between these extremes through the consumption of commodities ranging from furniture through literature or leisure to clothing was therefore a precarious act, one that relied increasingly on precisely the sort of professional discretion that underpinned the boundaries of the class in the first place. Carr Saunders and Wilson, writing with the benefits of hindsight in the 1930s, referred directly to this propensity of the professional classes to assess the parameters of the acceptable or the correct:

> The professional man knows what is acceptable to the world as it is, and therefore how much out of the theoretical possibilities can be put into effect and in what manner ... Nor is this all. Professional men are craftsmen, and all craftsmen are distressed to see bad workmanship and to

observe that opportunities for the employment of their craft have been neglected ... There is an inescapable desire, though it may be latent, to see the fullest and most efficient use made of professional techniques in the service of the community. In other words one function of the professions is to bring knowledge to the service of power.[63]

In sartorial terms, contemporary observers translated professional discretion into an overriding obsession with 'good form' in middle-class male dress. The columns of family journals and popular novels resound with discussions of fashionable faux-pas, recollections of instances where the fraudulently respectable betrayed their ulterior motives through a doubtful haircut, inappropriate trousers or a too perfect demeanour. 'Keeping up appearances' was a recurring concern of the humorist Reginald Smith, who published his 'Londoner's Log Book' at the turn of the century in *The Cornhill Magazine*. Purporting to relay the domestic experiences of a young couple in Bayswater, it provided an upper middle-class equivalent of the Grossmith brothers' more frequently quoted *Diary of a Nobody*[64] and maintained a focused interest in the idiosyncrasies of male dress:

> Last month I ventured to express dislike of the epithet 'well groomed' as applied by Pennialinus to the young Tories in the House of Commons, and I affirmed ... that it meant nothing more than 'well dressed'. But the editor of 'Hiccadocius' in a letter which bears the Cambridge postmark, takes me to task, and says 'The odious expression in my mind, implies also that particular neatness and glossiness of hair which you notice in A D C's, Guardsmen, 10th Hussars, and a few of the younger nobility and Eton boys ... I therefore retire from a conflict for which I am imperfectly equipped and concede my critic's proposition that well groomed involves a well brushed head as well as a well cut coat and well creased trousers and well varnished boots. I turn from the abstract to the concrete, and ask myself and my wife whether we can lay our finger on a well groomed man in stuccovia ... It is sometimes easiest to illustrate one's meaning by negative examples, and our excellent MP, Mr Barrington Bounderly, whom I have just met in Stucco Gardens (Progressive Conservative) is neither well dressed nor even well groomed. He wears a turned down collar of the new type, much too high for his short neck, and a red tie in a sailor's knot. He has celebrated the return of Spring by putting on a white waistcoat and brown boots; but as the air is chilly, he wears a great coat with a fur collar, and thick trousers of a conspicuous check. I protest that I would rather be apparelled like our curate, young Bumpstead, whom I saw returning from his Easter Monday trip in a college 'blazer', a Roman collar, grey knickerbockers, and a straw hat.[65]

'Good form' for Smith erred on the side of a manly negligence or sporty simplicity, eschewing the more polished glamour of aristocratic swagger. The ridiculous inappropriateness of Piccadilly

fashion-plate dressing was thrown into sharper relief in a later
discussion of the curate's sartorial transformation at the hands of
his new fiancée:

> His hair, which aforetime looked as if he had been dragged through a
> quickset hedge backwards is now carefully parted and smoothly
> brushed, while a faint odour of lime juice glycerine pervades the boudoir
> in which he spends most of his time. His hands ... I fancy, have been
> submitted to a process of manicure and are thrust, all unwillingly into
> gants de suede. He has discarded the greased shooting boots ... in favour
> of buttoned elegancies from the Burlington Arcade; and I have even
> heard rumours of possible developments in the way of patent leather.
> The shapeless jacket ... is now reserved for parochial visitation. When
> he comes to see Bertha he wears a well cut frock coat with braided
> edgings ... The whole edifice is crowned by a 'topper' of unusual bril-
> liancy, and a neatly folded umbrella with a hooked handle of bamboo
> completes the transformation.[66]

This aping of aristocratic trappings commonly formed the focus
for the invective of conservative social commentators, including
T. W. H. Crosland, who in his *The Wicked Life* of 1905 displayed an
uncritical admiration for the 'discretion' of the landed rich while
exposing a deep-rooted prejudice against the conspicuous con-
sumption associated with an increasingly commercial society. The
middle class, incorporating 'the successful traders, the stock-
brokers, the company promoters, the insurers and financiers,
snobbish doctors and solicitors, strutting actors and music hall
agents, and retired brewers and tailors', he claimed, 'knows nothing
about noblesse oblige, having no noblesse to oblige, he has money
without position, land without ancestry, servants without auth-
ority, lust without discrimination, ice in his champagne, college
colours on his hand bags'.[67] Economic historians have identified
the last quarter of the nineteenth century as a period of falling
prices accompanied by higher living standards, temporary for the
working classes but maintained into the opening years of the
twentieth century by professional and entrepreneurial groups
whose salaries remained constant.[68] Paradoxically, rather than
engendering a sense of ease with regard to appropriate levels of
consumption and the fluidity of social status, this climate encour-
aged precisely the kind of paranoid jeremiads which Crosland's
writing typifies. Those at the precarious borders between the work-
ing and lower middle classes, the shopkeepers and small
businessmen, were hit by the fierce competition of department
stores and co-operative movements, while also benefiting from the
increased custom of the affluent group above them. The fear of
bankruptcy and attendant social ruin epidemic amongst the petit
bourgeoisie also infected the professional classes, who as Harold

Perkin points out were dangerously under insured during the period, preferring to devote their income and savings to outward show.[69] The only outright winners in a situation marked by a lack of financial confidence alongside a headlong rush to prove status through spending were those plutocrats, the owners of the shopping emporia, stock companies, comestible factories and leisure outfits whose products fuelled that competition. Perkin summarises a phenomenon which he claims stretched to influence class demographics, and which certainly underpinned a marked ambivalence towards middle-class display:

> The rising standard of living ... increased the competition for status in every field, in dress, housing and furniture, education, leisure and entertainment, and the like. This in turn raised the costs, against the trend of prices, of keeping up appearances ... The competition for status ... rather than any decline in material resources, was the major reason for the decline in the middle class birth rate which began in the 1870s.[70]

How then did the middle classes articulate social position through clothing in such a fraught arena? And is it even possible to define an encompassing middle-class manner of dressing in the face of such conflicting social pressures? It would seem appropriate here to present the constraints, financial and material, within which such practices could take place. *The Cornhill Magazine* budgets of 1901 offered a range of representative examples of which G. Colmore's 'Eight Hundred a Year' presented the benchmark for a comfortable middle-class lifestyle:

> To the toiling clerk it seems unbounded wealth; to the woman of fashion a poor thing in pin-money; to those who usually start marriage on such an income, the professional man, or the younger son with a narrow berth in the Civil Service, it is a sum upon which the two ends can be made to meet with comfortable success or inconvenient uncertainty, according to the requirements and habits of the people who have the spending of it.[71]

Setting aside expenditure on rent, taxes, food and servants' wages, the husband's allowance was set at £70 a year, of which £40 was reserved for clothing bills. Of greater concern to Colmore than the necessary payments to the tailor was the consumption of commodities that suggested status in a rather more reckless manner 'which means wine and tobacco'. The priority for the woman of the household was more clearly directed towards clothing, with £50 reserved for dressmaker's bills.

G. S. Layard in his description of the minimum expenditure of households earning 'A Hundred and Fifty a Year', isolated those occupations most readily associated with the 'uneasy stratum':

> certain skilled mechanics; bank clerks; managing clerks to solicitors;

teachers in the London Board Schools; the younger reporters on the best metropolitan papers; the senior reporters on the best local papers; second division clerks in the Colonial, Home and India Offices; senior telegraphists; sanitary inspectors; relieving officers; clerks under the County Councils; many vestry officials; police inspectors; barristers' clerks, organists, and curates in priest's orders.[72]

He drew attention to the greater concentration paid to the clothing of male members of these households with respect to their standing in the community and the demands of their employers:

> The unit of the class with which we are concerning ourselves is in a very different position from the skilled mechanic who may be earning a like income. It is more and more recognized as an axiom in those businesses and professions which are in immediate touch with the client, that the employees, whether they be salesmen in shops or clerks in banks or offices, must be habited in what may be called a decent professional garb. The bank clerk who looks needy, or the solicitor's clerk who is out at elbows, will find that he has little chance of retaining his position. Here he is clearly at a disadvantage compared with the man who works with his hands and who has only to keep a black coat for high days and holidays. Thus the 'lower middle' bread-winner is forced into an extravagance in the matter of clothes out of all proportion to his income.[73]

The relationship between remuneration, expenditure and outward show among the lower middle classes was the focus of much discussion and dissent during this transitional period. The limits imposed by tight wages and prescriptions of appropriate behaviour by employers and social peers set the parameters for the kind of moral position and sartorial image the clerk, the teacher or the shopworker was expected to achieve and sometimes wished to transcend. These influences certainly bore more direct, practical relation to the circumstances of lower-middle-class life than tales of aristocratic excess. A growing tension between the falling salaries associated with over-expanding employment sectors such as banking or retail, a seeming rise in living standards elsewhere and the stress on 'respectability' demanded by moral and religious teaching, led to significant pressures. J. A. Banks notes that men of the middle and lower middle classes were marrying at an increasingly late age after 1840, simply in order to achieve the kind of position and income that would bear the expense of running a 'respectable' household.[74] *The Clerks of Liverpool*, a pamphlet published in 1871 was representative of many similar appeals for greater understanding from employers towards the clerk's fiscal predicament and provides a more focused range of material relating to income and budgets than the generalising assumptions of *The Cornhill Magazine*. B. J. Orchard, the author of the pamphlet,

quoted a series of letters to *The Liverpool Journal*, arguing the case both for and against clerks who were attempting to set up home in their mid-twenties on a starting salary of £80 a year. The following correspondent attacked what he saw as a tendency to aspirational drive:

> Whether clerks can marry on £80 a year is a question which needs only one answer. They can. What respectable artisans do on every side, and do with comfort, is not beyond the capacity of respectable clerks, especially as the income of the latter, unlike that of artisans, is in almost every case sure to steadily increase if industry and fair talent are exerted. True, that income will not allow them to lunch at Fisk's or Gibbon's, to pass the evenings at the Queen's or in the pit of a theatre, to wear £4 coats, and buy three breast pins in a year. Neither will it permit their wives and children to rival those of their employers. But must a clerk indulge in more display than an artisan? By what strange impulse is he driven to spend more than he makes?[75]

Orchard presented a more considered and sympathetic reading than his source of the material requirements of clerks at different levels in widely varying institutions. At the top of the salary scale on £150 he identified employees of 'the more stylish offices' who 'mostly have means beyond their salaries, and do not expect to remain clerks'. J. P. Blake in his novel *The Money God - A Tale of City Life* of 1904 provided a fictional example in his character sketch of the racing fanatic Roden Pole, an office acquaintance of the narrator, whose privileged appearance and flaunted possessions provide some evidence of a forum in which plutocratic magnificence rubbed up against subaltern conservatism. He described

> a smart young man, who drove up [to work] in his own private hansom with a brilliant tiger on the seat. Master Pole was the son of Mr Pole MP, the banker, and he had a stool in the office to gain experience for himself and to gain the firm the influence of his connection. 'Morning Lads' he said drawing off his gloves and glancing around the office, 'My fancy today is Gold Jug and don't you forget it.'[76]

Those less lucky, relying wholly on the upper salary, Orchard located within 'banks, insurance offices and other public companies, who ... reside in fairly genteel neighbourhoods, wear good clothes, mix in respectable society, go sometimes to the opera, shrink from letting their wives do household work, and incur as unavoidable, the numerous personal expenses connected with an endeavour to maintain their status'.[77]

Of more concern to the philanthropist were those who 'still are not in society, place little value on gloves, lunch in the office on bread and cheese, clean their own boots, and are not alarmed by the prospect of doing without a servant when married, of lighting

the fire each morning before they go out, and of never entering a
theatre or buying a bottle of wine'.[78] Men of this calibre, on £80 a
year, made up the majority of the clerking workforce. Their predi-
cament informed those familiar descriptions of genteel poverty,
narrow vision and desire for propriety which characterised the
lower middle classes for writers such as H. G. Wells and E. M. Forster.
Historians from Carey[79] to Crossick and Haupt[80] have condemned
these literary representations as 'unflattering' and prone to 'distor-
tion', and have used their hostility as proof of a barely disguised
disgust for the class among the intellectual elite. Yet while the
caricatured descriptions put forward by novelists and playwrights
probably did incorporate these tendencies, such representations
also offered creative mirror images in which the clerk class could
recognise and concur with depictions of their own kind, however
slanted. As Michael Hayes suggests, the young male working- and
lower-middle-class population of the period immediately preced-
ing the First World War provided a foundation for the huge
expansion of popular reading that took place during the interwar
years.[81] Their custom was vitally important to publishers, who
could not afford to alienate them completely with overly dispara-
ging or unrealistic portraits. St John Adcock, a less well-remembered
novelist belonging to the 'cockney school' of self-conscious social
realism, delineated the pathetic figure of Andrew Jessop in his 1898
melodrama, *In the Image of God – A Tale of Lower London*, as an
example of the penury incurred by a constant drive towards pro-
fessional respectability. His sympathetic pen portrait must have
elicited a resigned recognition from his intended readership:

> He made his daily journeys to and from the City a foot with a view to
> economy; he lived sparely and dressed shabbily, indulging at long inter-
> vals in a new coat, which was threadbare before he could supplement
> it with new trousers, which in turn were worn to shabbiness before
> another new coat was attainable … There was nothing striking about
> his features … One does not grow spirited on insufficient nutriment, or
> healthy by leaning over a desk all day in a close back office, and spend-
> ing one's leisure exclusively in the half basement and pinched attic of
> a shabby genteel house in the densest quarter of Camden Town.[82]

Together with his newspaper correspondence, Orchard's
research in Liverpool can be used to further supplement the de-
scriptive constructions of popular fiction with examples of
household budgets provided by correspondents at various stages
on the career ladder. These computations complement, but also
complicate, the literary evocations. While their selection was more
likely to represent an isolation of content which underpinned the
author's own thesis, rather than an accurate sample of general
practice, they provide both some sense of spending priorities across

a range of possibilities, and an indication of the importance paid to the issue of public image by an otherwise reticent historical constituency. Correspondent A wrote:

> How a fellow with £150 and the habits and tastes (I don't say of a swell or of a spendthrift, but) of an ordinary well reared man can venture to set up his household standard, and invite a nice woman of similar rearing to share with him, is beyond my comprehension. It can't be done … For proof of which, read the following figures:

House with bathroom in Bootle	22	0	0
Tax	4	10	0
Water & gas	2	0	0
Coal	5	0	0
Home board, 2 & servant	91	0	0
My dinners & teas in town	19	10	0
My clothes, boots, cigars, gloves, papers & c.	15	0	0
Wife's clothes, boots, gloves	15	0	0
Servant's wages	10	0	0
Summer holiday & theatre	10	0	0
Church pew, collection & c.	6	0	0
Life insurance	6	0	0
Fire insurance	0	5	0
Furniture wear & tear	10	0	0
Total	216	5	0

By contrast, on less than half the income, correspondent D remained within credit on a salary of £80 and projected a tone that was markedly more positive, stating:

> We are both healthy, and from the outset, resolved to live on plain food without unnecessary stimulants. Doing this, we have escaped sickness, have been comfortable, yet never felt poor. My wife makes her own bonnets and dresses and my shirts. She also cooks nicely. Whatever others, who have not studied as an art household economy may say, the result is that, including 7s 3d a week for rent, taxes and water, my wife has:

Kept house on £1 a week	52	0	0
My lunches were 2s a week	5	4	0
Her and my clothes	12	0	0
Life insurance	1	2	0
Sub to clerk's provident assoc.	1	4	0
Chapel expenses	2	10	0
Coal & Gas	4	0	0
Total	78	0	0

Respectability, it would seem, did not reside wholly in the contents of a clerk's wage packet and could carry a variety of connotations according to the political, religious and societal asso-

ciations of particular earners. The budgets do not suggest that a lower-middle-class outlook or the spending priorities of office earners were in any sense uniform, and the emphasis on chapel, union and thrift suggested by correspondent D positively shames the cigars, gloves, holidays and town teas of A. It is interesting though that in both examples it is possible to discern the characteristics that underpinned the popular and contradictory stereotype of petit bourgeois culture, where meanness and aspirational snobbery were often placed in juxtaposition without apparent irony.[83] What it is difficult to discern from the single-line entries of household account books is the precise nature of clothing expenditure or any sense of a coherent 'petit bourgeois style'. The philosophies underpinning the acquisition of garments may well have differed, but in form or quantity did the shirts and boots of correspondents A and D bear any similarities?

Published autobiographies provide a further perspective on the material 'stuff' of middle- and lower-middle-class male fashionable taste. Frederick Willis and W. MacQueen Pope both published in 1948 accounts of their lives in London at the turn of the century. The anecdotal tone of their texts, and the clear subjective positions which the authors took in a bid to compare the gentle rhythms of the past with a post-war modernity that they may have found

18] Cabinet photographs, c. 1890. Three City businessmen, photographed on two occasions in a Cheapside studio, display the well-cut suits and heavy watch chains of professional respectability.

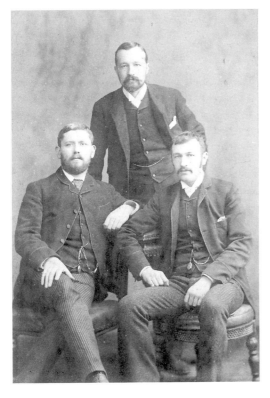
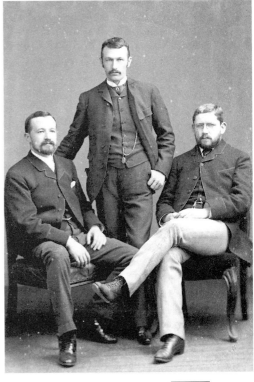

alienating, position such narratives on the very peripheries of 'objective' historical method. Yet to dismiss their recollections as unreliable overlooks the value to be gained from descriptions of the ephemeral nature of social life that carry a heavy personal and emotional commitment lacking in more quantified forms of documentary evidence. More than any other source (in the absence of an oral history record for the period), these texts constitute the language and prejudices that built up middle- and lower-middle-class lifestyles and consequently offer a privileged view of their physical manifestations. Willis was a silk hatter in the West End with a heightened memory for the idiosyncrasies of dress, as well as the reassurance to be gained from its function as a social marker. 'It was an age when everyone made the best of his appearance. No proper clerk would dare to appear at the office without the official black coat and vest and pin stripe trousers. Bank and similar clerks wore silk hats. People were expected to dress in clothes suitable to their calling.'[84] Any attempt to disguise, or get beyond, that calling sartorially was remembered by Willis with contempt. The marker of a 'respectable' wardrobe for him was the time lavished on its maintenance, its strict adherence to an ordered neatness and the uncomfortable weight of a necessary formality:

> Stiff white shirts and collars ... were indispensable. On Saturday afternoons and evenings children could be seen in every street carrying home the weekly white shirt and collars from the laundry ... He who could not afford the dignity of a white shirt, carefully built up the illusion of one by covering his chest with a dicky and pinning stiff white cuffs to the wrist bands of his plebeian Oxford shirt. Further economy was effected by those who were a nick or two higher in the social scale. They had a white shirt but the cuffs and front were removable so that the shirt, which had to last a week, could be renewed and refreshed in the middle of this period with clean cuffs and front ... Some people were so lost in moral darkness that they wore ready made clothes and rubber collars ... an abomination of the period with a rubber foundation and a white shining surface like the tiles in a public lavatory ... At the best, a rubber collar looked like a dead collar that had been embalmed for centuries, and I only resurrect it as being a curious faux-pas in an otherwise immaculate period.[85]

MacQueen Pope made a more direct association between the restrained and heavy appearance of middle-class, middle-aged respectability and the pecuniary comfort enjoyed by that stratum. Good cloth and the morally assertive display of gold accessories went beyond symbolism to constitute the very substance of bourgeois confidence: 'The watch chain, the watch and the sovereign purse were the outward and visible signs of solvency. You pulled out your purse, flicked it open, slipped out your sovereign,

and there you were. You could not carry many sovereigns that way, but there was no need, so great was its purchasing power.'[86] Here is the essence of the middle-class stereotype. Aristocratic forms of dressing directed all economic energy into the fine distinction that a Savile Row tailor could bestow, pursuing shifting templates of fashionable taste that dictated a spectacularly fugitive approximation of modish gentlemanliness. In the centred dependability of the watch chain and the sovereign purse, or the static functionalism of the business suit, the successful bourgeois found an image that fixed an otherwise precarious existence with remarkable symbolic clout. This had nothing to do with an evangelical rejection of luxury, but was intimately bound up with the optimism of a newly discovered authority.

On the edge of the abyss: clothing and deprivation

> The working classes of England are far behind those of France in the matter of dress. In Normandy you meet with the neat, white, well starched cap; in Lancashire, with a tawdry shawl; in the midland and southern counties, with a dusty, ill shapen bonnet. The men are worse. They never seem to change their working clothes when the day's work is over. Those who go to chapel and church have a black or dark suit for Sunday wear, generally creased and often ill fitting, but on other days it is seldom that you meet with a nicely dressed working man or working woman. I have seen political meetings attended by men who had taken no trouble to wash off the dirt of the day either from their faces or their clothes. A brush up before meals is a part of civilised life, and it is to be hoped that it will spread more extensively among the working classes.[87]

If aristocratic and middle-class stereotypes provided some positive models for the pursuit of modes of sartorial behaviour, descriptions of the clothing of the working classes and the poor between c. 1870 and 1914 are unremittingly negative. Following the same patterns as literature describing the material qualities of respectability, the pessimistic treatment of poverty was also a function of the genres in which such descriptions were couched, a reflection of the economics of publication and the intended circulation of texts whose aim was ultimately moralistic. There is no real sense of the self-definition which drove the choices and personal presentations of the rich or the comfortable, though later chapters in this book will aim to question the assumption that male proletarian dress was driven only by function and necessity. Similarly, reports of the limited scope and lack of pride apparently endemic in working-class attitudes to clothing seem engineered purely as an admonitory device which throws the proprietorial fetishes of the middle classes or the conspicuous consumption of the

aristocracy into higher relief. The rags of the 'unwashed' merited scant attention in their own right, other than as evidence of the supposed fecklessness and wasted lives of their wearers. This represents a significant change from descriptions of working-class consumption habits and appearance earlier in the century, when a robust and evidently proletarian John Bull provided a stereotype of nationalistic popular sentiment. Draped in ready-made clothing and fed on a diet of roast beef, here was a vision which put semi-naked and emaciated representations of the European peasantry to shame.[88]

In this light Samuel Pearson's unfavourable reversed comparison of English and continental working-class dress codes, published in 1882, is entirely to be expected. As a didactic moral guide to the problems of contemporary urban living, written for educated young people about to enter metropolitan employment, it naturally encouraged a celebration of the rational restraint of lower-middle-class dress, and used the disorder of proletarian garb as a metaphor for an unhygienic spiritual life, evidence of the indiscipline of the working man's cultural milieu. By the final quarter of the nineteenth century the deprivations of the indust-rial city, combined with a growing expectation of social and political emancipation for the disadvantaged, set up the figure of the working man and his ghost, the unemployed loafer, as a threatening, disruptive spectre rather than a patriotic totem. His shambolic frame incorporated many of the problems that over-whelmed political and moral debate at the time, from imperial decline to sexual incontinency, which makes any description of its visual characteristics doubly difficult to read as anything other than the prejudices of compromised and apprehensive novelists and journalists. Aristocrats and clerks at least left some auto-biographical traces with which to temper the more outrageous fictional stereotypes, but such a voice was largely denied the poorest inhabitants of factory floors and slum dwellings. As social historian Carl Chinn has recently shown, middle-class descriptions of the urban poor most often jettisoned familiarity for a more conscious emphasis on difference

> The urban poor looked different to outsiders. Many were not tall, well built, blond haired and blue eyed. They were short, slight, dark haired and sallow skinned. Their actions were not reserved. They swirled along the streets, noisy and raucous ... In the frantic imagination of many ... the urban poor seemed to be a peculiar tribe who lived in a foreign place.[89]

In the final part of this chapter, then, it will be useful to reappraise the manner in which working-class consumers both appeared to

engage with, and were used to define, a mainstream rhetoric of masculine fashionability. The stereotype may be a negative one, but its features offer a perspective on men and dress which complements and underpins those representations interrogated so far.

Pearson's isolation of dirt and dishevelment as indicators of low social status and personal esteem was a common strategy, employed both as a means of differentiating white-collar workers from the physical, filthy labour that marked the appearance of manual workers and as a more contained device for setting the 'residuum' into a hierarchy that placed spiritual and material cleanliness at opposite poles from immorality and a perceived lack of respect for a basic sanitary code. The social reformer Charles Russell made use of this approach in *Young Gaol Birds* of 1910. Here he traced a graduation from sartorial negligence to a respectable smartness, paralleled by a turning away from crime towards legal employment. The possibility of reading street garb as anything other than a personal shortcoming was remote in Russell's terms, as his description of Joe, 'a Borstal case', made obvious:

> Joe's regeneration had been largely assisted by his possession of a characteristic quite exceptional amongst his class. He was always scrupulously neat and clean. No matter how poor his clothes, how grimy his occupation while at work, he was invariably careful to appear as smart as possible in his leisure hours, and this respect for his personal appearance rendered it far easier for him than for the great majority of regular young visitants of prison cells to take his place in the ranks of respectable artisans when once he had put from him all thought of continuing the career of a housebreaker. It is doubtful whether anyone to whom soap and water and more or less tidy clothes are a matter of course, can rightly estimate the extent to which this question of clothes and cleanliness bear upon the criminality of youth. Dirty, ragged garments, greasy caps and headscarves worn day after day without the possibility of a change, are, I believe, responsible for much. Certain it is that the lad who is content with but one set of raiment invariably belongs to a very low stratum of society, and the absence of a desire for a Sunday suit and the unabashed wearing of the week day suit on the Sunday is very frequently indeed the mark of one largely impervious to outside influences.[90]

Other commentators went much further, in equating the shabbiness of working men's clothing not simply with a lack of understanding for middle-class mores but as a more positive statement of anti-social intent. The journalist James Greenwood turned this 'lack' which typified proletarian stereotypes on its head to offer a more subversive reading of working-class dress as a nonconforming political stance. His description of an encounter with a working-class radical on Hampstead Heath during a Whitsun holiday of 1882, though dwelling on the picturesque, and in many

ways safely traditional, aspects of the labourer's wardrobe, also suggested the development of a clearly defined proletarian type that stood in opposition to middle-class constructions of respectability, while surreptitiously borrowing from its material trappings. The quotation is a problematic one, less perhaps a description of a bona fide meeting than a journalistic fantasy of romanticised proletarian posturing in which middle-class values, especially a contempt for the ready-made, are internalised to symbolise revolutionary inversion. A rejection of 'Sunday best' on a Whitsun holiday when new clothing was generally paraded in public would have made a bizarre gesture:

> He was a broad shouldered individual, attired in a mole-skin suit such as is commonly worn by men engaged in the iron making line of business, and to judge from his general aspect he might that morning have walked straight from the workshop to the spot where I discovered him. There was a slovenliness about his dress that suggested a studied contempt for appearances, rather than a constitutional disregard for tidiness. His boots were unlaced, his waistcoat buttoned awry, and his black neckerchief a mere whisp tied with a knot, was under his ear ... 'You might think, seeing me as I am in my working clothes, that I haven't got any others to wear. You'd think wrong. I've got as good a suit of clothes as a working man could wish to put on his back - not slop things, but made to measure. You won't catch me encouraging the ready made merchant tailors as they've got the impudence to call themselves, who grind the flesh off the bones of the sons and daughters of toil, so that they may go rollicking about in scarlet and fine linen, and gorging on the fat of the land. I've got a good West of England coat and westkit, and I've got a pair of tweeds that would stand alone almost on the score of quality; but I'd scorn to wear 'em on a Bank holiday. Likewise I've got a watch that I'd back to go against anyone in England of its size, and a silver chain, hall marked ... but no thanky. When I come out on a Bank holiday I leave 'em at home. If I want to know what time it is, the church clock is good enough for me ... I haven't cleaned my boots this morning, says you. I know I haven't. I wouldn't degrade an honest black and shiner in doing it ... I'm dead against the whole thing, from the sole of my foot to the crown of my head, and if I wore a tall hat, instead of a cap, blessed if I wouldn't brush it the wrong way.'[91]

Any real sense of choice was severely circumscribed for many of those on limited budgets. Working-class consumers were commonly restricted in their acquisition of clothing by more practical considerations of inherent value, questioning for example, whether the garments purchased would produce much-needed credit. Flexibility in wear was a further issue, as divisions between work and leisure clothing were necessarily more fluidly defined than middle-class equivalents. A suburban plumber quoted in the 1896 collection of working-class family budgets, commissioned by the Economic Club of London under the chairmanship of Charles

Booth, prioritised warmth and decency as the major considerations in his narrow selection of garments:

> Out of doors the man wears an overcoat, which is warm and conceals a deficiency of other clothing. Indoors, or at work, the overcoat is removed, and reveals him in shirt sleeves ... He is sensitive to the feeling that, in any public building, he or his children might be looked down upon as having 'no right to be there' because they are not decently dressed.[92]

Arthur Morrison in a working-class budget published in the *Cornhill Magazine* in 1901 computed the outgoings of a fictional and composite East End worker earning thirty shillings a week, and found it difficult to generalise on an area of consumption in which circumstances dictated a flexibility towards the acquisition and maintenance of clothing lacking in the more rigid provisions of the lower-middle-class wardrobe:

> In the matter of clothes, I am brought to a stand. Particular clothes are needed in particular trades, and some trades are more destructive of clothes than others. Some workmen buy cheaper clothes than other workmen, and while some are careful of their garments others are not. Some children's clothes are bought at the slop shop, but more are made at home from father's and mother's cast offs ... A practice is sometimes followed of setting aside a sum of about 2s a week for clothes, boots and repairs. The 2s alone would, perhaps, scarcely do it, but the thrifty housewife has ways of saving ...[93]

Aside from the romantic references to hard-wearing fustian and moleskin already noted in descriptions of working-class dress, style was an element rarely discussed while commentators remained convinced that scarce resources dictated rather more basic criteria. Stereotypical reporting prioritised a haphazard combination of second-hand, ill-fitting, roughly altered garments that constituted an unintentional 'look' of their own, reflective simply of smoke-filled surroundings and stunted imaginations. Among younger working men however, fashionable and oppositional dress codes produced alternative stereotypes. Charles Russell in his sociological study of *Manchester Boys* differentiated the homeless 'street arab' and the unemployed 'loafer' who 'rarely possesses any clothes except those he stands up in'[94] from the more fashion-conscious members of street gangs, the 'scuttlers' and the 'Ikes': 'The ike is the successor of the scuttler who has now almost disappeared from our midst ... You knew him by his dress. A loose white scarf would adorn his throat; his hair was well plastered down upon his forehead; he wore a peaked cap over one eye; his trousers were of fustian, and cut like a sailor's with bell bottoms.'[95] This adoption of a distinctive and threatening appearance was aided by the

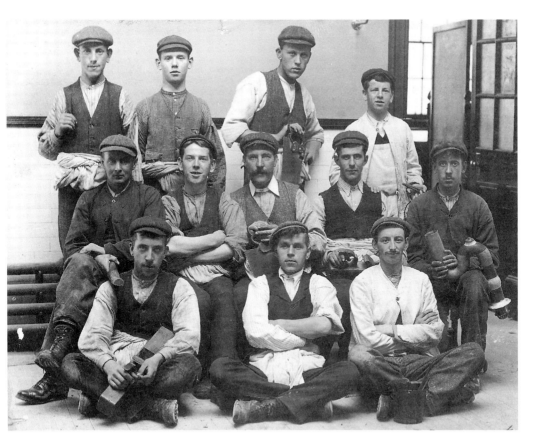

19] Postcard, a group of trade apprentices, 1905. By kind permission of Simon Fraser. A group of young working-class men displaying the tools of their respective trades also show the various ways in which the staples of working dress could be combined to suggest individual taste and character.

increased disposable income available to youths who were still living at home without the responsibilities of rent and family falling directly on their heads. At the age of nineteen Russell estimated that the average Manchester worker was

earning twenty shillings a week. His contributions to the house do not increase correspondingly ... there are few youths who pay more than twelve shillings to their parents. The balance – eight shillings a week – is now very largely spent on clothes of a more fashionable cut and quality. It is quite common for lads of this age, living at home, to spend comparatively large sums on their week end or non working clothes.[96]

Beyond the reckless priorities of adolescence, working-class consumers could also look to the wide range of ready-made items available from local clothiers. The London retailer Edward Grove of Lower Marsh, Lambeth, and Edgware Road, Paddington (railway districts associated with labouring communities), advertised a broad selection of styles in 'mechanics superior clothing' during the summer of 1874 which must have appealed for price and choice to young and old alike:[97]

Double Twill Cord Trousers, rule pocket	8	6
White cord or mole - best in London	8	6
Drab Mole, light & dark shade	8	6
Our noted worsted Cloths	14	6
Heavy Pilot Jackets lined with rug	14	6
All Wool Pilot Jackets lined Tweed	16	6
ditto. warranted fast colours	21	0
Stout cord jackets lined with mole	11	6
Long mole stable jackets	9	0
Duck jackets for engineers	2	4
Stout Cord or Mole Vest	4	6
Blue Serge jackets & trousers	5	6
Stout Holland or Dowlais blouses	3	0
White Drill & Dowlais Jackets	4	6

Rare autobiographical accounts further contradict the assumption that appearances invariably took on a low priority in poorer areas. Robert Roberts, in his recollections of Salford slum life at the turn of the century, suggested a concern with sartorial respectability and the recognition of social hierarchies and appropriate models of manly behaviour that puts in doubt claims that the lower middle classes retained sole custody over clothing etiquette. Indeed, proof of competitive clothing practices in working-class areas heightens the sense that clerks and lower-status white-collar workers literally embraced aspirational stereotypes as a means of distancing their fashion choices from the models established by neighbouring artisanal communities:

On weekdays among us our few artisans wore rough, hard wearing jackets and pants, and worked at lathe or bench, the sleeves of their union shirts rolled, in white aprons, overalls as yet being hardly known. 'Turpin's 10/6 Trousers Astonish the World!' advertised the local store. Unamazed we bought them - heavy, rebarbative garments that would stand erect even without a tenant ... Low quarter shoes were of course derided by all proper males, but for weekend wear the artisan would go as far as a pair of 'light business boots', price 10s 6d, and make a dignified if squeaky way to the pub ... No artisan, except in jobs which demanded them, would have been seen in clogs. At weekends boys smeared sharp odoured blacking from a paper bag onto leather vamps and polished all the footwear. One wore shining boots ... as a blazon of family respectability ... For men with any claims at all to standing the bowler hat or 'billy pot' was compulsory wear. Only the lower types wore caps. Even the most indigent tried to get head covering of some sort (more than half a century earlier Engels had noted the same need. 'Hats' he wrote 'are the universal head covering in England, even for working men, hats of the most diverse forms, round, high, broad brimmed, narrow brimmed, or without brim - only the younger men in factory towns wearing caps ...) Those brave spirits who in the years before World War I dared to stroll bare headed in the open gave rise to a jeering urchin cry that swept the land: 'No 'at brigade'.[98]

To arrive at a coherent reading of the working-class wardrobe, or a single working-class stereotype in the last quarter of the nineteenth century is then a complex endeavour. While middle-class accounts of working men's dress stressed that pecuniary disadvantage and restricted parameters led to an undifferentiated and mean appearance, other sources prioritised the potential of social and work relations for producing a clearly defined, almost subcultural series of working-class 'looks'. The social historian Michael Childs, in his recent examination of working-class youth cultures in the period, alludes to the problem of establishing fixed class identities when he states that

> class is not only or even primarily the sum total of the objective differences that separate one group of people from another, but is also the result of the assumptions and actions taken by people who find themselves in a certain social situation distinct from others in the community. Class is thus as much a product of conscious human thought and action as it is of impersonal economic or social factors, and for many, the recognition of class comes by an identification with a group through common experiences, events and symbols.[99]

Richard Whiteing's opening description of those male groupings that gathered in front of the Bank of England in 1888 attempted to delineate the material differences resulting from widely varying cultural, social and economic experiences through a mobilisation of recognisable visual and sartorial stereotypes. It has been the intention of this chapter to unpack those stereotypes a little further, not simply in order to test their veracity, or compare their features with actual practice, but to reveal the strength of their currency in dictating the ways in which fashion for men was conceived, worn and discussed. Like fashion plates and style reports, stereotypical descriptions and displays of dress provided rather pure templates whose function and status deserve closer attention from the fashion historian. When their generalisations are decoded it becomes possible to trace the complex negotiation of a wide variety of fashionable masculine models in the spaces and streets of the nineteenth-century city. The language and imagery chosen to identify social class and pecuniary means through clothing was highly subjective and deeply prejudiced, whether describing the dress of a duke, a bank clerk or a hooligan, but it sprang from a common recognition that, in Samuel Pearson's words:

> Man is a clothes wearing animal, and this being the case, it is as well that he should pay some little attention to his outermost cuticle. Dress is a passport through society. It is the first thing that makes an impression on outsiders; and the procuring of it cannot be therefore

relegated to the easy method of writing an order on a half penny postcard.[100]

Notes

1 R. Whiteing, *The Island: Or an Adventure of a Person of Quality* (London, Longman, 1888), p. 1.

2 D. Roche, *The Culture of Clothing: Dress and Fashion in the Ancien Regime* (Cambridge: Cambridge University Press, 1996), pp. 18-19.

3 L. Hapgood, 'Regaining a Focus – New Perspectives on the Novels of Richard Whiteing' in N. Le Manos and M. J. Rochelson (eds), *Transforming Genres: New Approaches to British Fiction of the 1890s* (London: Macmillan, 1994,), pp. 178-84.

4 *The Tailor and Cutter*, 19 April 1888, p. 215.

5 J. S. Bratton, *Acts of Supremacy: The British Empire and the Stage 1790-1930* (Manchester: Manchester University Press, 1991), pp. 7-9.

6 A. J. Reid, *Social Classes and Social Relations in Britain 1850-1914* (London: Macmillan, 1992), pp. 60-1.

7 F. Chenoune, *A History of Men's Fashion* (Paris, Flammarion, 1993); D. De Marly, *Fashion for Men* (London: Batsford, 1985); P. Byrde, *The Male Image: Men's Fashion in Britain 1300-1970* (London: Batsford, 1979).

8 A. Miles and D. Vincent, *Building European Society: Occupational Change and Social Mobility in Europe, 1840-1940* (Manchester: Manchester University Press, 1993), p. 3.

9 P. Mason, *The English Gentleman, The Rise and Fall of an Ideal* (London: Deutsch, 1982); M. Girouard, *The Return to Camelot: Chivalry and the English Gentleman* (New Haven: Yale University Press, 1981).

10 G. Crossick and H. G. Haupt, *The Petit Bourgeoisie in Europe 1780-1914* (London: Routledge, 1995), p. 191.

11 P. J. Cain and A. G. Hopkins, *British Imperialism: Innovation and Expansion 1688-1914* (London: Longman, 1993), p. 131; W. D. Rubinstein, *Men of Property: The Very Wealthy in Britain since the Industrial Revolution* (London: Croom Helm, 1981); W. D. Rubinstein, *Elites and the Wealthy in Modern British History* (Brighton: Harvester, 1987).

12 M. Wiener, *English Culture and the Decline of the Industrial Spirit 1850-1980* (Harmondsworth: Penguin, 1981).

13 S. Gunn, 'The Failure of the Victorian Middle Class: A Critique' in J. Wolff and J. Seed (eds) *The Culture of Capital: Art, Power and the Nineteenth Century Middle Class* (Manchester: Manchester University Press, 1988), pp. 17-39.

14 Cain and Hopkins, *British Imperialism*, p. 116.

15 D. Cannadine, *The Decline and Fall of the British Aristocracy* (New Haven: Yale University Press, 1990), p. 342.

16 J. Camplin, *The Rise of the Plutocrats: Wealth and Power in Edwardian England* (London: Constable, 1978), p. 90.

17 *Ibid.*, p. 89.

18 Lady Agnew, 'Ten Thousand a Year', *Cornhill Magazine*, August 1901, quoted in E. Royston Pike, *Human Documents of the Age of the Forsythes* (London: Allen & Unwin, 1969), p. 175.

19 *The Tailor and Cutter*, 6 November 1890, p. 367.

20 R. Whiteing, *No 5 John Street* (London: Grant Richards, 1899), pp. 172-4.

21 J. Vincent, *His Royal Highness Duke of Clarence and Avondale: A Memoir* (London: J. Murray, 1893), pp. 1-2.

22 T. Aronson, *Prince Eddy and the Homosexual Underworld* (London: J. Murray, 1994), p. 3.

23 *Ibid.*, p. 82.

24 Reid, *Social Classes*, pp. 12-13.

25 D. Thompson, *Queen Victoria: Gender and Power* (London: Virago, 1990); A. Munich, *Queen Victoria's Secrets* (New York: Columbia University Press, 1996).

26 V. Cumming, *Royal Dress* (London: Batsford, 1989), p. 129.

27 Cannadine, *Decline and Fall*, p. 342.

28 Cumming, *Royal Dress*, p. 135.

29 *The Tailor and Cutter*, 23 July 1896, p. 310.

30 *Ibid.*, 11 July 1895, p. 278.

31 The Ceylon Observer, *The Grand Tour of the British Princes* (Colombo: Ceylon Observer Press, 1882), p. 4.

32 C. Steedman, *Childhood, Culture and Class in Britain 1860-1931* (London: Virago, 1990).

33 M. Ginsburg, *An Introduction to Fashion Illustration* (London: Pitman, 1980), p. 37.

34 Vincent, *His Royal Highness*, p. 19.

35 L. Colley, *Britons: Forging the Nation 1707-1837* (New Haven: Yale University Press, 1992).

36 D. Jarrett, *British Naval Dress* (London: J. M. Dent, 1960), pp. 82-123.

37 *The Tailor and Cutter*, 21 December 1882, pp. 60-1.

38 Vincent, *His Royal Highness*, pp. 164-5.

39 W. Cairnes, *Social Life in the British Army by a British Officer* (London: J. Long, 1900), p. 35.

40 Vincent, *His Royal Highness*, p. 176.

41 R. W. Latham, *Cavalry Uniforms* (London: Blandford Press, 1969), pp. 181-2.

42 Cairnes, *Social Life*, p. 38.

43 Aronson, *Prince Eddy*, p. 82.

44 W. S. Gilbert, *The Savoy Operas* (London: Macmillan, 1932), p. 162.

45 K. Porter and J. Weeks (eds), *Between the Acts: Lives of Homosexual Men 1885-1967* (London: Routledge, 1991).

46 *Modern Society*, June 1889, private collection of Peter Farrer.

47 H. Cunningham, 'Leisure and Culture' in F. M. L. Thompson (ed.), *The Cambridge Social History of Britain 1750-1950. Vol. 2* (Cambridge: Cambridge University Press, 1990), p. 319.

48 T. Richards, *The Commodity Culture of Victorian England: Advertising and Spectacle 1851-1914* (London: Verso, 1991), p. 112.

49 Aronson, *Prince Eddy*, p. 162.

50 Cannadine, *Decline and Fall*, p. 348.

51 Aronson, *Prince Eddy*, p. 148.

52 Vincent, *His Royal Highness*, p. 270.

53 *Ibid.*, p. 271.

54 *The Tailor and Cutter*, 10 March 1892, p. 93.

55 T. Burke, *Nights in Town: A London Autobiography* (London: Allen & Unwin, 1915), p. 19.

56 W. MacQueen Pope, *Twenty Shillings in the Pound* (London: Hutchinson & Co., 1948), p. 9.

57 F. Bechofer and B. Elliott, *The Petit Bourgeoisie: Comparative Studies of the Uneasy Stratum* (London: Macmillan, 1981), p. 182.

58 *Ibid.*, p. 184.

59 T. R. Gourvish and A. O'Day, *The Rise of the Professions in Later Victorian Britain 1867-1900* (London: Macmillan, 1988), pp. 16-17.

60 T. H. S. Escott, *England: Its People, Polity, and Pursuits* (London: Chapman & Hall, 1885), p. 315.

61 *Ibid.*

62 *Ibid.*, pp. 332-3.

63 A. M. Carr Saunders and P. A. Wilson, *The Professions* (Oxford: Clarendon Press, 1933), p. 498.

64 G. and W. Grossmith, *The Diary of a Nobody* (Harmondsworth: Penguin, 1979).

65 R. Smith, *A Londoner's Log Book 1901-1902 - Reprinted from the Cornhill Magazine* (London: Smith, Elder & Co., 1902), pp. 54-8.

66 *Ibid.*, pp. 290-1.

67 Camplin, *Rise of the Plutocrats*, p. 149.

68 J. Harris, *Private Lives, Public Spirit 1870-1914* (Harmondsworth: Penguin, 1993).

69 H. Perkin, *The Rise of Professional Society: England since 1880* (London: Routledge, 1989), p. 95.

70 *Ibid.*

71 G. Colmore, 'Eight Hundred a Year', *Cornhill Magazine*, June 1901 quoted in E. Royston Pike, *Human Documents of the Age of the Forsythes* (London: Allen & Unwin, 1969), p. 165.

72 G. S. Layard, 'A Hundred and fifty a Year', *ibid.*, p. 161.

73 *Ibid.*, pp. 162-3.

74 J. A. Banks, *Prosperity and Parenthood: A Study of Family Planning among the Victorian Middle Classes* (London: Routledge, Kegan & Paul, 1954), p. 48.

75 B. J. Orchard, *The Clerks of Liverpool* (Liverpool: J. Collinson, 1871), p. 44.

76 J. P. Blake, *The Money God: A Tale of City Life* (London: Heinemann. 1904), p. 22.

77 Orchard, *Clerks*, p. 63.

78 *Ibid.*

79 J. Carey, *The Intellectuals and the Masses: Pride and Prejudice among the Literary Intelligentsia 1880-1939* (London: Faber, 1992).

80 Crossick and Haupt, *Petit Bourgeoisie*, p. 1.

81 M. Hayes, 'Popular Fiction and Middle Brow Taste' in C. Bloom (ed.), *Literature and Culture in Modern Britain, Vol. 1. 1900-1929* (London: Longman, 1993), pp. 80-1.

82 A. St John Adcock, *In the Image of God - A Tale of Lower London* (London: Skeffington & Son. 1898), p. 125.

83 Banks, *Prosperity and Parenthood*, pp. 199-200.

84 F. Willis, *101 Jubilee Road: A Book of London Yesterdays* (London: Phoenix House, 1948), p. 20.

85 *Ibid.*, p. 70. and p. 127.

86 MacQueen Pope, *Twenty Shillings*, p. 19.

87 S. Pearson, *Week Day Living: A Book for Young Men and Women* (London: Kegan Paul, Trench. 1882), p. 139.

88 B. Lemire, *Fashion's Favourite: The Cotton Trade and the Consumer in Britain 1660-1800* (Oxford: Oxford University Press, 1991), pp. 96-7.

89 C. Chinn, *Poverty Amidst Prosperity: The Urban Poor in England, 1834-1914* (Manchester: Manchester University Press, 1995), p. 126.

90 C. E. Russell, *Young Gaol Birds* (London: Macmillan, 1910), p. 171.

91 J. Greenwood, *Odd People in Odd Places, or The Great Residuum* (London: F. Warne, 1883), pp. 82-3.

92 Economic Club of London, 'Family Budgets; being the Income and Expenses of 28 British Households 1891-94' quoted in Royston Pike, *Human Documents*, p. 150.

93 *Ibid.*, p. 159.

94 C. E. Russell, *Manchester Boys: Sketches of Manchester Lads at Work and Play* (Manchester: Manchester University Press, 1905), p. 46.

95 *Ibid.*, p. 51.

96 *Ibid.*, p. 17.

97 London handbills and advertisements 1860-1880. Guildhall Library. GR 1.4.6.

98 R. Roberts, *The Classic Slum: Salford Life in the First Quarter of the Century* (Manchester: Manchester University Press, 1971), pp. 22-3.

99 M. J. Childs, *Labour's Apprentices - Working Class Lads in Late Victorian and Edwardian England* (London: Hambledon Press, 1992), p. xvi.

100 Pearson, *Week Day Living*, p. 138.

The spectacle of the shop: provision for the male consumer

4

What inexhaustible food for speculation do the streets of London afford! ... we have not the slightest commiseration for the man who can take up his hat and stick and walk from Covent Garden to St Paul's Churchyard, and back into the bargain, without deriving some amusement - we had almost said instruction - from his perambulation. And yet there are such beings: we meet them every day. Large black stocks and white waistcoats, jet canes and disconnected countenances, are the characteristics of the race ... You will meet them on a fine day in any of the leading thoroughfares: peep through the window of a West-End cigar shop in the evening, if you can manage to get a glimpse between the blue curtains which intercept the vulgar gaze, and you see them in their only enjoyment of existence. There they are, lounging about on round tubs and pipe boxes, in all the dignity of whiskers and gilt watch-guards; whispering soft nothings to the young lady in amber, with the large earrings, who, as she sits behind the counter in a blaze of adoration and gas-light, is the admiration of all the female servants in the neighbourhood, and the envy of every milliner's apprentice within two miles round.[1]

The Tailor and Cutter, in appropriating the journalism of Charles Dickens for its occasional pages of instructive entertainment, presented to the apprentice cutter or suburban tailor subscriber an evocative picture of the metropolitan shop browser which portrays many of those characteristics that have more recently come to be associated with the nineteenth-century female consumer.[2] Readings of the position of men within the market place for fashionable goods have more usually tended to equate the leisured directing of the male gaze with the minimal actions of the flâneur rather than the more frenetic and engaged activity of shopping itself. They draw on descriptions of a splenetic resignation to the distractions of city life, suggested in the poetry and critical writings of Charles Baudelaire and later expanded into a broader critique of the workings of consumer culture by Walter Benjamin.[3] Certainly Dickens's sketch of cosmopolitan browsing appears to illustrate a London version of the phenomena. True to the genre, it isolates a dandified presumption of irresponsible loafing, and

suggests a vague promise of sexual gratification. Equally, however these men seem to share that sense of a more passive abandonment to the pleasures of commerce, identified as a feminised prerequisite for 'modern' forms of consumer behaviour by historians of feminine culture including Elaine Abelson and Mica Nava.[4] The listlessness of their passage counterbalances the hysteria associated with female kleptomaniacs and shopping addicts alike, while blue velvet, gas light, tobacco and the physical attractions of the 'ambered' counter assistant hold them in sway like wasps to tree sap. There is little here to differentiate the scene from the white linen displays and the eroticised blandishments of male shop-walkers which captivated women consumers in Emile Zola's much-cited novel of department store life, *Au Bonheur des Dames*.[5]

Men could then be positioned as supplicants at the altar of retail in nineteenth-century texts, placing in doubt the firm assertions of historians such as Lori Anne Loeb that 'acquiring the goods for consumption ... was socially perceived as a feminine task'.[6] I would suggest, in contradiction to those claims and in response to its particularised representations, that the meanings attached to the 'task' of consuming relied very much on the nature and type of consumption taking place rather than an over-arching conception of sexual and social control. Of direct relevance to this chapter is the arising need to approach the material structure of nineteenth-century consumption, its spaces, personnel and depictions, not as a unified and necessarily feminised whole but as a more open forum in which social, sexual and cultural identities were formed and sometimes contested. As recent social and economic histories of retailing and consumption have indicated, this necessitates the breaking down of spheres of consumption into their constituent parts and an interrogation of their structural and communicative features.[7] The examination of the developing male wardrobe carried out in the previous chapters revealed that the adoption of various types of clothing entailed a negotiation with a variety of cultural stereotypes and moral positions, many of them implicated in the circulation of particular constructions of class. The acquisition of that clothing, while still reflecting the divisions of social status, also carried with it the deeper resonances of gender formations and sometimes even appropriated the characteristics of a sexual transaction. For it was on the point of purchase, in the environment of the retail business, that fashionable masculine identities often found their earliest concrete influences.

Furthermore, the range of outlets for constructing a male sartorial image was much wider than the tight focus on the department store associated with recent examinations of consumption has implied. In short, there were as many different shops supplying

items of male clothing as there were elements in the male wardrobe, all serving a market stratified by class and location, with many of them boasting an established history that preceded any notion of a mid-century 'retailing revolution' by several decades.[8] Their profusion suggests that the formation of identities through shopping was a complex and open-ended transaction, allowing room for the free play of all of these considerations. Charles Booth presented the parameters of that choice through the examination of a product that lies at the heart of those distinctions which marked the men's clothing retail sector in the period. His enquiry offers a useful introductory link between the look of a garment, its production and its procurement, and conveys the futility of dismissing a 'masculinised' field of consumption as peripheral or unproblematic, simply because its physical manifestations now 'appear' uniform and undifferentiated:

> Take a morning coat made by an English journeyman tailor for a first class West End Firm (say Messrs Poole and Son) and the same article turned out by a Jewish contractor for the wholesale trade in slop garments. Lay them side by side. There may be no difference in the material; that is settled by the taste of the customer. There may be no difference in the cut, for cutters trained at good places command high salaries from all classes of merchant tailors and wholesale clothiers. But look at each garment closely and examine the workmanship. At a glance you will perceive that one is hand-sewn and the other machine made. Examine further into the work of the English journeyman tailor: you will note that in those parts of the coat that need lining the latter will be fitted to the material and felled over ... attached by a slight tack to one or other of the seams of the material ... There are fewer stitches, yards less thread or silk, and yet in all places material and lining lie compactly together. Now turn to the coat of a Jewish contractor. Take the material in one hand, the lining in the other. Pull them apart. Why it is not a coat at all – it is a balloon ... it is 'bagged together', material and lining seamed up separately, laid back to back, run round the edges by the heavy treading machine ... The coat made by the individual Englishman will wear three times as long as that made by the staff of the Jewish contractor. Still more it is a question of fit ... Walk behind the wearer of a sweater's coat; if the material be light it will sway to and fro with a senseless motion; if heavy, it bulges out first here, then there ... Clearly then, the order of the gentleman who knows how to clothe himself, and is able to pay for it, cannot be executed by a Jewish contractor. In the making of hand sewn garments the English journeyman tailor has no rival.[9]

Booth's account of the values inherent in bespoke and ready-made goods was overly reductive, concerned largely with a racist discourse which positioned the blame for underemployment and poverty amongst the London working classes squarely at the door of the immigrant community in the East End. It was convenient

to attach notions of inferior workmanship solely to Jewish goods for 'patriotic' motives, and little attention is paid to the broad range of finishes possible within the bespoke line of trade alone. From the craftsmanship inherent in a Henry Poole Savile Row suit it was a long way down to the shoddier materials, swift construction and bargain prices of a Westminster Bridge cash tailor. To pitch a comparison between the former and a Whitechapel sweat-shop garment took the contrast even further, stretching its fairness and representative clout. Nevertheless, competition between 'traditional' English tailoring and 'foreign' unskilled 'sweating' was commonly perceived, even at the point of consumption, as the defining binary feature of the clothing industry. This was thrown into sharper relief in the menswear business by the closer correlation between producer and retailer in that field, seen as a traditional characteristic of skilled 'West End' tailoring. Booth lamented that an erosion of this state of affairs was

> not only a question of the quality and the price of the labour, it is, to a great extent, the result of that transformation of a large section of the tailoring trade from a retail to a wholesale business which has taken place within the last thirty years. We may say ... that this transformation was itself effected by the introduction of the sewing machine and sub-divided labour – by the demand for machine made goods of the balloon type by a middle and working-class public and in the colonial markets.[10]

Whatever his prejudices, Booth's presentation of the struggle between bespoke and ready-made goods offers a valuable source for understanding the range of associations attached to male clothing and its acquisition at a pivotal moment in their development. Within his description of the construction of the items it is possible to read the defining features of the sector and its broadest boundaries. Yet between the understated detail and functional 'good manners' of the Poole morning coat and the 'breezier' surfaces and quick financial returns of the wholesaler's equivalent lay an even greater range of commercial considerations and contexts that demand a fuller investigation. My aim is to test the parameters of that commercial sphere in order to shed light on the dynamics of masculine consumption in the period. Beyond Booth's coats, how was the competition between classes of goods and types of consumer manifested in the environment of the shop, the quality of its goods and the action of shopping? In arriving at some conclusions it will be necessary to outline the various outlets for male garments between 1870 and 1914, their remit in terms of stock and the material characteristics of their architecture. More generally, this chapter defines those structural formations pertaining to the

exchange of fashionable goods, and the promotional rhetorics employed in their sale, which together place purveyors of men's clothing in the same discursive sphere as the department-store proprietors and advertising pioneers more commonly associated with new forms of 'feminised' urban modernity.

'Our friend the tailor'

> In the matter of dress, tailors have always been considered the best off among working men, and certainly the younger members of the trade keep up their reputation in that respect. Many of the supposed West end mashers are nothing more or less than our friend the tailor.[11]

As Booth's comments suggest, tailoring in its traditional form occupied the pinnacle of the sartorial trades, both in the perceived quality of its output and in the status accorded its best workers, whose own dandified clothing choices reflected the exalted opportunities of their calling (though the seasonal nature of the work, even in prestigious firms, entailed a constant threat of unemployment). Beyond the rhetoric however, the tailoring trade encompassed a variety of levels. These were simply broken down. The high-class or 'West End' trade served an elite 'account' market and was based largely on hand-crafted production by skilled artisans which took place within the confines of the establishment. A middling or 'provincial' trade relied more heavily on a factory system in which the cutting and construction of garments drew on a combination of machinery and manpower, and where bespoke tailoring might be mixed with the retailing of part- or ready-made garments produced largely outside of the premises by contracted hands. And the cash tailor traded largely on ready-made garments sourced from warehouses and wholesale clothing companies and produced by the sweating system in which standardised garments were manufactured by hand or machine through a system of divided labour, utilising immigrant or female workers on low pay. The columnist of a popular men's journal of the 1910s deftly defined the differences according to methods of payment in an article titled 'When Buying a Cheap Suit: How to make it look like the Bond Street Product'. He advised readers to

> bear in mind that the cheap tailor - the man who makes you a suit for 25s or 35s is invariably a cash tailor … The man who makes you a suit, and receives his money before you take it away, is naturally much less concerned to make it a good fit than the man who supplies you with a suit on credit; for the reason that in the latter case you can, if not satisfied, refuse to pay for the suit, or, at any rate, to pay the full price for it.[12]

In all three cases the emphasis of the trade lay in the fitting up of the customer with a suit of clothing and in winter an outer layer from a stock of suitable textiles, which in terms of the 'logistics' of the tailor's shop dictated space for measuring up, and shelving for the display of various cloths. For those elite establishments who produced all of their own garments, the space devoted to customer transactions was likely to be dwarfed by the provision of room for workshops, while firms specialising in ready–made goods or contracting commissions out to home-workers, relied more heavily on display space. Encompassing all levels was a functional emphasis on providing the minimum of necessary comfort within a workmanlike atmosphere that lent the tailoring trades their reputation for conservatism in broader spatial and aesthetic considerations. As late as 1911, when other descriptions of retail environments were prioritising rampant expansion and the adoption of progressive decorative schemes, the *Harmsworth Encyclopaedia of Retail Trading* summarised the fittings of a tailor's shop in the most spartan of terms:

> The fixtures may be of the simplest nature, just plain shelves with turned bars to act as divisions. The shelves should be about 18 to 20 inches apart. A counter not less than 30 inches high and about the same width should be arranged of convenient length. A private room should be provided for trying on, and in this there should be mirrors arranged so that both back and front views of the figure can be obtained ... The fittings of this room may be amplified to taste. There must, of course, be one or two chairs, but there may also be blocks for saddles &c., which are especially useful in the case of riding garments; a selection of framed fashion plates are also very useful here. A cutting table must be provided, and this should be of a substantial character, as it will be subjected to a good deal of hard wear ... The light should be sufficient for all practical purposes, but there is no need for that big blaze of light which characterises the premises of the clothier and draper, and which involves a heavy expense.[13]

That all resources seemed to be directed towards the commodity, with little more than bare boards provided to frame the ritual measuring up for, and trying on of, the suit, was further evidenced through the importance placed on fitting out the workrooms, a space generally removed from public view but integral to the quality of the finished merchandise:

> there should be a broad bench provided ... for the men to sit on, a sewing machine with wide table, a stove for heating the irons ... a selection of irons from 10 to 20 lb, sleeve boards, duplex press boards, iron stands, bowl and other sundries ... The best workshops in London are provided with electric light. There must be rails and coat hangers, stools or chairs for the machinist and any female workers, and a few other sundries which will suggest themselves.[14]

Similarly, a high proportion of capital was reserved for the pur-
chase of stock, divided between a constant reserve of popular
'perennial' textiles and some changing examples of fashionable
styles. Laid out in bales across shelving at the back of the fitting
room, or available to order from swatch books, with samples
draped under fashion plates in the window or along the walls, the
raw cloth often provided the only tangible evidence of a firm's
function.[15]

Further evidence of the expectations placed on a finished gar-
ment which existed in fairly abstract terms for most of the time
that a customer transacted business with the shop, lay in the tend-
ency of tailoring promotions to emphasise qualitative, rather than
material attractions, final product rather than architectural am-
bience and display. Frequently located on the upper floors of
buildings with only a brass name plate to denote occupancy at
ground level, many firms would have viewed display consider-
ations as an optional luxury anyway. Thus 'in advertising a
tailoring business it is necessary to emphasise the fact that every
effort will be made to carry out the customer's wishes; that the
talent employed in the cutting and fitting rooms will produce
goods of fit and style; that the materials sold are reliable in both
dye and quality, and that the workmanship is such as will give
good style'.[16] An established reputation however, together with the
requisite financial reserves, allowed for some indulgence in the
sphere of interior decoration and customer comfort. Henry Poole
& Co. of Savile Row occupied a place at the head of the profession,
and descriptions of its buildings and working practices often filled
the pages of *The Tailor and Cutter* during the 1890s, serving as a
template for ambitious readers. The public face of Poole's in the
late 1820s had constituted 'simply a private door' on Old Burling-
ton Street, but by 1870, following an increase in foreign custom
resulting from the International Exhibitions of 1851 and 1862, the
premises had expanded into three interconnected adjacent houses
on Savile Row fronted by a colonnaded Greek revival façade sur-
mounted by the Prince of Wales's feathered crest.[17] Incorporating
visual features reminiscent of the factory, the studio, the office, the
palace and the gentleman's club, Poole's represented the closest
that a tailor's shop might come to impinging on the magnificence
of the department store. Consumer-oriented spaces included the
show room with its:

> huge forests of cloth, arranged so that each piece could be seen by the
> customer. One large mahogany table of magnificent build, and which
> we were told cost £300 to make, was heaped up with black cloths, on
> another was placed blues, on a third greys, on another fancies, the next
> containing half mourning goods; while away … on one side was a

magnificent show case, which had been prepared and fitted up by the firm with specimens of English tailoring ... for the Vienna exhibition ... Here and there were placed mirrors, and in front of these some magnificent bronze ornaments. These we were informed were relics of the Great Exhibition of 1851 ... The floor of this room was richly carpeted, and the walls and ceilings tastefully decorated, the effect being heightened by the subdued light which came through the frosted glass in the ceiling.[18]

The privacy of the fitting rooms offered a surprisingly indulgent neo-rococo atmosphere of the sort commonly described in women's magazine descriptions of couturier's salons in the 1880s.[19] They recalled the over-decorated intimacy of the boudoir rather than the ascetic functionalism of the changing room:

They were miniature palaces; the pile of the carpet reminded one of rich meadow land; the decorations of the walls were one harmony of gold and satin and mirrors; the seats were cushioned in the most luxurious fashion, and the fittings of the most costly character. Moveable mirrors, adjustable electric lights, and swinging side glasses, all lent their aid, while the top lights from the ceiling were of the softest character, all adding to the palatial character of the apartments. Secrecy and comfort, ornamentation and utility, had all been studied; and the only drawback that could be suggested was one that was expressed by our guide, viz., that a gentleman with a scarcity of hair, such as himself, might not appreciate the reproduction of the 'bright and shining place where no parting was' on every side, a joke which was heartily appreciated by the visitors. There were some five or six of these fitting rooms, each decorated in its own style; and we feel our own inadequacy to describe the beauty of their satin upholstered walls, their painted panels and ceilings in relief. One room would be white and gold, another green and gold ... the treasures of art being ransacked to add beauty ... The express purpose ... was the fitting on of clothes, and that, too, for gentlemen; for though we saw the horse dummy &c. for Riding habits, yet we were informed they did not cater for the ladies' trade, preferring to confine their attention to gentlemen's attire. One could hardly enter these rooms without experiencing an inspiration of style and beauty; and we can readily understand customers feeling that those who could show such taste in the fitting up of their premises, had certainly mastered the laws of beauty and proportion, and were consequently equal to the task of clothing them in a befitting manner.[20]

Other areas in which customers were directly attended accorded more closely with received notions of the commercial masculine interior. The counting house for example was 'arranged on the same principle as a bank. On desks facing the walls were some thirty ledgers of 1,000 pages each, arranged in alphabetical order. In the front was the pay counter where customers desirous of paying their accounts might do so, and where every weekend the workmen come to receive their wages.'[21] In all other respects,

Poole's appears to have been a well-appointed exception, an early example of a concern with the architectural ambience of consumption that did not fully affect other tailors until the end of the period.

The novelist St John Adcock produced a more commonplace, though fictional, evocation of suburban tailoring in his description of a north London business set up to clothe the children of the Kentish Town lower middle and working classes. What is significant in his passage, produced, like the description of Poole's, in the late 1890s, is its stress on the specificity of location, in which trades concerned with the retail and care of clothing appear to be grouped together in the same stretch of street, serving the local community. This configuration is not so far removed from the more splendid concentration of sartorial merchants in Savile Row, with their Mayfair custom:

> Northampton Street, Kentish Town, was neither altogether given over to business nor exclusively reserved for private residents ... Several of the shops and portions of some of the private houses were devoted to clear starching and general laundry work, as the elaborate legends on their windows sufficiently indicated; one shop was occupied by a boot-maker in a large way of business: boots choked the interior of his premises, they hung in strings after the manner of onions down his doorposts, they stood in serried ranks on the flags outside, and an amazing banner fluttering above the shop front announced to mankind in general all year round that 'our penny boot club is now commenced.' At three other shops cheap bootmenders might be seen working all day in their windows ... a pawn shop hung out its golden symbol at a convenient corner; and at each end of the street a fried fish shop assailed the ears of passers by with unctuous frizzlings and scattered greasy odours on every wind that blew. Near the centre of the street, on its dingiest side, rose a small, double fronted shop that was divided in two by a wooden partition ... A linen draper was boxed in one half of the shop ... the other half contained a morose tobacconist who sold newspapers, and fastened up in a lower corner of his window, against a background of sensationally illustrated journals, a neat card announced in stiff round hand: 'Mrs Loroff. Tailoress. Second Floor. Please Ring Middle Bell', and a deformed finger pointed to the adjacent door post.[22]

There, however, the comparison ends. The interior of the north London premises collapsed domestic squalor with the bare tools for the disorganised earning of a supplementary wage, with little attention yet paid either to the sensibilities of the customer or the potential of decoration to increase efficiency or income:

> Floor and table were littered with snippings of various cloths; a miscel-lany of brown paper patterns lay on a chair, and two suits of much worn clothing hung over the back; obsolete fashion plates were pinned on

the walls; a large smooth ironing board leaned in a corner with a gigantic pair of brass handled scissors fallen against it; a treadle sewing machine stood in the window with a drift of cotton ends, stray pins and scraps and savings of cloth and paper all about its feet. A crazy Dutch clock clucked noisily above the grate ... and in place of ornaments, to left and right of it were several reels of thread, a long necked tin utensil for oiling the machine, a few cards of buttons, two enormous flat irons, and a bottle of medicine. Carpet and curtain were ragged and full of dust; an air of cold discomfort and disorder brooded over everything.[23]

'Every novelty for the season in stock': the modernity of the hosier and outfitter

Hosiers' and outfitters' shops occupied a more prestigious location on suburban high streets and centrally positioned promenades than the half-hidden garrets belonging to tailors. Directly reflecting Booth's worries concerning the detrimental effects of the rise of wholesaling on the nature of men's clothing provision, these emporia of ready-made articles pushed masculine attire out from the obscurity of second-floor cutters' workrooms or the back cabinets of draper's shops and into the plate glass glare of late nineteenth-century public culture. If the interiors and practices of tailors' shops stubbornly clung to eighteenth-century habits, the fitting out of an outfitter's promised a direct encounter with modern retail methods. The hosier represented a more focused area of trade, isolated in 1878 by the author of *The Draper and Haberdasher - A Guide to the General Drapery Trade* as a genuine departure from established forms of fashion retailing, marked both by its specific service to men and by an espousal of current practice in design and stock control:

> It is a remarkable fact that of late years this department has more than ever drifted from general drapers; hosier's shops abound, and the public, particularly males, patronise them for this class of goods in preference to drapers. No doubt one reason is because men have a disinclination to enter draper's shops, and as the system of door dressing, or blocking the entrance with drapery has extended, it has also increased the aversion. The employment of female assistants does not tend to draw male customers; men like to be supplied with articles they require with readiness and despatch; females cannot handle hosiery parcels like males, hence gentlemen prefer going to hosier's shops. Moreover, draper's assistants themselves are to blame - few of them being good hosiers.[24]

The clear rhetoric of segregation employed here reflected the intimate nature of a hosier's stock as much as anything. Though aside from 'all kinds of men's underwear', a hosiery department might also be expected to hold 'men's ties, scarfs, handkerchiefs, belts, braces, night caps, shirts, collars, towels, portmanteaus, travelling

rugs, bags, straps, studs and links'.[25] The general identification of
drapers' stores as a feminine sphere of influence was however sig-
nificant, the habit of hanging bulky items of female underwear
(such as crinolines and bustles) over the doorway, like so many
chicken coops, providing a physical and moral impediment
against the entrance of male consumers.[26] Once inside a general
draper's, confusion between male and female provision promised
further potential for social embarrassment. Fred Burgess, offering
advice to shopkeepers in 1912, cautioned that

> some articles for men, such as hosiery and gloves, are almost invariably
> kept along with women's, and the same salesman or saleswoman
> handles them. In a general draper's shop there is a great deal of overlap-
> ping. This is not altogether inducive to good business, and it will be
> found that the business of an outfitter will increase when men's outfit-
> ting is kept quite separate, especially when men are not required to pass
> through women's departments to reach the men's department.[27]

The annexing of male concerns into separate branches allowed
for the development of a distinctively innovative and exclusively
masculine form of shopping environment. By 1911, the *Encyclo-
paedia of Retail Trading* was advising in favour of a stock that
embraced the most modern articles in the male wardrobe:

> gloves for driving, hunting, motoring and walking, in real cape, buck-
> skin and reindeer, retailing at from 3s 6d to 7s 6d a pair, and varieties in
> wash leather, kid, suede, and chevrette, to sell at 2s 6d to 3s 6d … and
> dress gloves in … lisle thread and silk, in Paris kid and llama, both white
> and lavender, at from 1s per pair … The word hosiery embraces all var-
> ieties of knitted articles … jerseys, sweaters … waistcoats, and cardigan
> jackets for golfing, cycling and boating, also undervests, pants, socks,
> nightshirts and combinations in unshrinkable natural wool, fancy col-
> oured cashmere, spun silk, merino, cotton, lambswool, Indian gauze and
> silk and wool.[28]

A heavy reliance on the branding of such goods encouraged loyal-
ties and specialisms in hosiery branches which further tied their
reputations to a particularly forward-looking sector of the clothing
industry.[29] The British Xylonite Company of Homerton and Hollo-
way, for example, supplied hosiers across the globe with their
celluloid and linen collars and cuffs, which they claimed released
consumers from excessive laundry bills: 'A person who wears a
clean xylonite collar … and … cuffs … daily, will simply have to
wash them occasionally with soap and water and dry them on a
towel in much the same way as he would wash his hands.'
Together with their special soap, studs and soutaires, and a range
of collars answering to the exotic titles of 'Wolseley, Tourist,
Phyllis, Guards, Ambulance, Geneva, Magenta, Seymour, Lancer,

Hussar, Goodwood, Ascot, Duke, Brighton, Achille, Ajax and Montreal',[30] the company, like many others, was well placed to make a significant intervention in the stocking practices of small independent retailers. For their part, hosiers, with a fairly rapid turnover, retained a freedom to circulate goods and anticipate trends which were denied to more traditional establishments, fettered with predictable and conservative account customers. The hosier could be thankful that his 'trade will be almost exclusively cash, and maybe entirely so. Hence little time and expense are required in book-keeping and bad debts will be trifling.[31]

An emphasis on the surface appearance of modernity extended beyond the stock to considerations of staffing and interior decoration. The personal nature of a hosiery store and its products encouraged a modish embracing of the rhetoric of hygiene together with a tendency towards an affected, almost antiseptic dandyism amongst counter assistants. J. W. Hayes advised that 'smoking above all things should be avoided ... or, if indulged in at all, should be deferred until after the hours of business are over ... Better by far to be redolent of lavender water or eau de cologne than tobacco smoke, even though the risk be run of incurring a charge of effeminacy from one's companions.'[32] A more conventional masculine demeanour, though hardly of the muscular variety, was demanded of employees through requests that 'a polished manner, a neat and pleasing exterior, and great patience and self restraint, are requisite in all who adopt this trade as a vocation ... and what is it to possess these qualifications, but to have all the marks of good breeding and education that form the credentials of a gentleman?'[33] (A paradoxical demand since no 'gentleman', by any strict definition, could be seen to be employed as a shop assistant.)

The retailing of commodities ranging from the latest line in rational underwear to a novelty tie pin called for a specialised mode of address and the flattering of a customer's fashionable sensibilities that found further corroboration in the neat, clean, almost 'bijou' aspect of the shop's decoration, a contrast to the deal and brass utilitarianism of the typical tailor's. The *Encyclopaedia of Retail Trading* noted

> a marked tendency towards light colours – cream for instance – for both
> outside and inside decoration, but black, especially for the outside,
> shows a more artistic taste and harmonises better with the stock ... All
> woodwork inside the shop ought to be painted black; the ceiling may
> be cream coloured, and the walls washed with a grey distemper
> paint.[34]

This concentration on detail, reflecting the minutiae of masculine

sartorial practice, clearly situated the hosier within a particular market, oriented towards respectable consumers, who took some pains over their choice of largely superfluous, if essentially 'distinctive', additions to the wardrobe:

> as an independent venture, and not merely as a department in a general drapery or outfitting business, a glover or hosier's shop should be opened up in a city or large town, and in a shopping thoroughfare frequented to some extent by fashion. A working-class population may buy hose, but gloves are luxuries of which their purchases are sparing, and glove selling is more profitable than any other department of the business.[35]

The comprehensive nature of the stock of an outfitter's store encouraged a more catholic social profile than that achieved by the hosier. The *Encyclopaedia of Retail Trading* acknowledged that the concerns of an outfitter overlapped with the business of several more specialised clothing retailers including bag and trunk dealers, clothiers, drapers, glovers and hosiers, hatters, hairdressers and umbrella merchants, though at the core of the trade lay the production and selling of shirts: 'The backbone of a gentleman's outfitting business is a properly fitting shirt, and the retailer should shape his course accordingly. He should learn to measure from shirts and to cut out from measures.'[36] In this sense the remit of the outfitter incorporated features associated both with the traditional and demotic provisions of the tailor (suffering occasionally from similar seasonal depressions) and the 'fancy' offerings of the hosier. Stock might consist of 'ready made and bespoke suits, overcoats, mackintoshes, hats and caps, hosiery, boots, shirts, collars, ties, gloves and underwear of every description'.[37] An emphasis on ready-made suits pointed the proprietor more clearly in the direction of the clothier's line, while an orientation around the shirt retained more specialised and 'up-market' connotations. In the case of the latter, like the hosier, select city centre locations promised the patronage of passing custom, but usually dictated smaller premises. Robertson suggested that 'the interior of the shop need not be large [but] the site chosen should be near offices or works, where men pass frequently. Men do not usually "go shopping" as women do, preferring to make their purchases in the route of their promenade to and from work. The rent of a shop will probably be about £150 in a city or half to two thirds of that sum in a large town.'[38]

Ownership of a City business dictated a concentration on the replacement or refitting of business shirts. The trade guides advised that

> White shirts with long cloth body and starched cuffs and fronts must be stocked to retail at 2s. 6d. and 4s. 6d. each, or at slightly lower prices

in half dozen lots ... particular attention must be paid to the cut of the shirt sleeves so that cuffs may never cause discomfort when writing. A tape loop at the back of the neck to take the necktie, and a tab at the bottom of the front are details which, in a shirt, often commend its acceptance. The refitting of white shirts is profitable; collar bands, cuffs and fronts for refitting should be stocked.[39]

On top of this, in taking account of leisure pursuits and holidays, the astute outfitter could also provide a range of finishes aside from white cotton or linen, varied enough to satisfy the most fussy of customers, and including French and Manchester prints and cambrics, zephyrs, Ceylon flannels, pure wool flannels, Oxfords, unshrinkables, Viyellas, silks, tropical flannels and shirtings, all made up in soft fronted tunic shirts, tennis, rowing, cricketing and golfing shirts. Collars and ties presented greater opportunity for misguided buyers to over-order, being highly susceptible to frequent changes in fashion: 'In both colour and shape of neckties the public are particular, and to become loaded with stock that does not meet popular approval is a serious business.'[40] However the remainder of a city centre outfitter's stock fell more safely under the category of 'sundries', occasional items useful for display purposes and guaranteed to sell as presents. From handkerchiefs of various colours, through to nightshirts, pyjamas, fancy waistcoats, dressing gowns and smoking jackets, oufitters offered a dapper and decorative template to potential consumers. More expensive 'hard' commodities ranging from jewellery to trouser stretchers, umbrellas, walking sticks and leather goods 'always go well with the class of customer to whom the outfitter appeals'[41] and could be acquired from manufacturers on a sale or return basis.

The discreet façade of the hosier was an inappropriate showcase for the serried ranks of shirts, collars, handkerchiefs and canes that marked out the typical outfitter's window. A good glass frontage was a primary consideration for those whose stock was largely seasonal and who relied on frequent sales to whittle down the previous season's mistakes:

> The exterior of the shop should be painted white or stone colour, and a good glass fascia and stall boards should be fitted. If space permits, money should be spent on one or two small outside wall cases, which should always be neatly dressed with the latest novelties marked in plain figures. Such cases, if properly attended to, will be very remunerative ... A good variety of window fittings ought to be bought - brass rods with moveable brackets, shirt stands, telescopic stands and a glass shelf along the front of the window.[42]

Inside the model outfitter's, a studied sense of efficiently arranged profusion might be maintained through the strategic use

of glass-fronted cabinets and an arrangement of ordered stock boxes to line the walls:

> The ceiling should be plain white, the walls neatly distempered, and the floor covered with plain linoleum. These details with two or three good rugs and half a dozen bentwood chairs, will make a bill of about £10. A similar sum will purchase a 6ft counter, with glass case top, ends and sides. For the rest, the wall shelving should be of plain deal, of height and depth to suit the stock boxes, there should be a plain strong table to use for cutting out, and sundry rods and brackets where convenient for hanging goods on for display. It is well to have proper stock boxes of uniform colour. Two or three dozen wood or mill board boxes, covered with green union will suffice.[43]

If bespoke shirts accounted for the backbone of the operation, trying-on rooms and an adjacent workshop similar to those encountered in the tailor's were necessary. Properties with more space and in central locations might also have found that, with a captive market cognisant of the need to maintain appearances but desirous of swift lunch-break service, 'a haircutting and shaving department is usually remunerative apart from the direct profits, especially if to reach the hairdressing saloon customers have to walk through the outfitting shop'.[44]

Space does not seem to have been at a premium for G. J. Wood's, merchant tailor and clothing manufacturer of Highbury and Hackney in north-east London. Established in 1864, the fittings of Wood's emporium illustrated the manner in which the remit and spatial pretensions of the outfitter expanded as one moved out into the prosperous suburbs. Depicted during the 1890s on the covers of the promotional leaflets and stock catalogues that were essential aids in securing a local family market, the Islington branch at 228 Upper Street occupied a single-bay building with curved, full-length glass windows flanking a mosaiced and monogrammed porch.[45] Above the sign-board a huge and elaborate wrought-iron sign obliterated the upper-storey windows. The Dalston branch at 536 Kingsland Road filled two bays under a decorative wrought-iron portico. Six large glass lamps lit the way past decorously dressed windows into a spacious interior. Within, the commercial illustrator recorded a broad retail floor lit by a decorative skylight and two rows of shaded gas lamps suspended from a coffered ceiling. A double cashier's booth with frosted and engraved windows and a large clock was placed centrally on bare wooden boards. To the right a free-standing glass display case offered collars, ties and shirt fronts, while, above, braces and fancy shirtings hung like heraldic banners. A long counter edged with bentwood chairs backed on to stock cupboards faced with decoratively arched dividers lining one half of the room; groups of

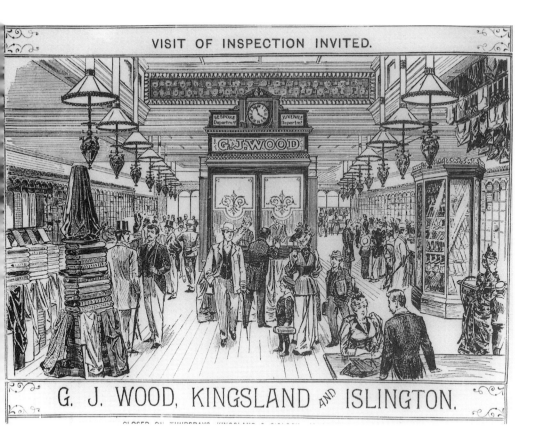

VISIT OF INSPECTION INVITED.

G. J. WOOD

G. J. WOOD, KINGSLAND AND ISLINGTON.

20] G. J. Wood's, trading brochure, c. 1890. By kind permission of London Borough of Hackney, Archives Department. The well appointed interior of G. J. Wood's Hackney branch.

women and boys with the occasional gentleman suggest that hosiery and juvenile items were kept here. The left hand side of the shop was devoted to tailoring, bales of suiting textiles decoratively arranged around a three-tiered table and balanced and draped across the counter. Male customers in top hats and frock coats or lounge suits and bowlers enquired here of shopwalkers in morning coats and measuring tapes, unmolested by the sailor-suited children and bustled women across the way. The whole scene seems to have been orchestrated to suggest a comfortably appointed, rationally organised synthesis of respectable suburban fashionability; closer in pattern perhaps to representations of American men's clothing outlets than to the luxurious confusion of Oxford Street department stores.[46]

Wood's advertised itself as a purveyor of 'specially selected styles in gentlemen's, youth's and boy's clothing', and its catalogues illustrated a broad selection of goods. Numbered fashion plates recorded the whole range of day and evening wear, from morning coats to evening dress, each with its appropriate hat and accessories and all available for a range of prices. A dress suit for example, 'made specially to order in corkscrews, supers, elastics, worsteds

& c., by first class workmen' could be had for between 50s and 90s, while lounge suits in harris tweeds and serges ranged from 21s to 42s ready made and 35s to 60s to order. Departments were listed as 'gentlemen's and boy's hosiery, hats caps & c., outfitting of every kind, sea outfits, boy's school outfits, servant's liveries, contracts: military, naval, civil, school, hospitals and charities (special price), ladies' riding habits, jackets & c., and girls' costumes, reefers & c.'. The services of the shop, in common with many of its kind, stretched beyond the front door, with an international postal shopping service and home visits by 'efficient assistants who will submit patterns, take measurements, or fit on ready made cloth-ing'. Gentlemen's mourning could be bought for immediate use, or to order for collection in ten hours. Distinctions between ready-made and bespoke items might then be blurred under the auspices of an establishment which traded simultaneously on its respect-able reputation and eye for value. G.J. Wood's saw no contra-diction in promoting itself variously as the 'oldest established clothier and manufacturer in the north of London', providing 'every novelty for the season in stock', a 'marvel of value' with 'perfection in style and fit guaranteed'. Its local standing, and a shift in attitude towards ready-made goods, left it an enviable niche within the menswear market, concurring with the view of *The Practical Retail Draper* that:

> The clothing trade has changed much during recent years, and much of the one time prejudice against ready-made garments has vanished, or has been lessened by the improvement effected by wholesale clothiers. Manufacturers and the proprietors of clothing factories know perfectly well that the public are more familiar with the correct styles than they ever were, and consequently ready-made clothing must no longer be a season behind the present fashion. The inexpensive ready-made suit, cut and made up in a well ordered clothing factory, are very much more to the taste of the buyer than inefficiently cut suits made to measure. There is another reason, too, why the buyer of cheap clothing prefers the ready-made. It is that when the garment is offered him ... he has an opportunity of judging its finish, the lining and other trifling matters which go towards making up a satisfactory garment. Unless a customer has absolute confidence in his tailor he is often a little uncertain as to the result of buying a cheap suit made to measure.[47]

The modern outfitter was in a position to provide assurances of quality through the evidence of its ready-made stock while en-couraging the more remunerative patronisation of its tailoring branch based on those same assurances. Ready-made and made to measure didn't necessarily represent polar opposites: when grouped together under the same roof, alongside all other sundries necessary for the male wardrobe, the outfitter's stock and presen-

tation represented all the 'advantages of universal shopping'[48] and shone out as a beacon of fashionable modernity.

'Bundles of hosiery with labels on them - stuck outside the door': the common clothier and warehouseman

The social stability of an outfitter's shop was not, however, guaranteed: much depended on location and the nature of local custom. As Charles Dickens noted, the slip from 'flash' hosier to 'sordid' clothier was not a long one, and ready-made clothing could quickly assume all the older, more reductive connotations of 'shoddy'. In his study of the changing face of a shopping street 'on the Surrey side of the water - a little beyond the Marsh gate', which was reprinted by *The Tailor and Cutter* in 1897, he isolated:

> a handsome shop, fast approaching to a state of completion ... on the shutters were large bills, informing the public that it would shortly be opened with 'an extensive stock of outfitting and hosiery.' It opened in due course; there was the name of the proprietor 'and Co's', in gilt letters, almost too dazzling to look at. Such hats and ties! and two such elegant young men behind the counter, each in a clean collar and a white neck cloth, like a lover in a farce. As to the proprietor, he did nothing but walk up and down the shop, and hand seats to customers, and hold important conversations with the handsomest of the young men who was shrewdly suspected by the neighbours to be the 'Co'. We saw all this with sorrow; we felt a fatal presentiment that the shop was doomed, and so it was. Its decay was slow but sure. Tickets gradually appeared in the windows; then bundles of hosiery with labels on them, were stuck outside the door, then a bill was pasted on the street door, intimating that the first floor was to let, unfurnished, then one of the young men disappeared altogether, and the other took to a black neckerchief, and the proprietor took to drinking. The shop became dirty, broken panes of glass remained unmended, and the stock disappeared piecemeal. At last the company's man came to cut off the water, and then the outfitter cut off himself, leaving the landlord his compliments and the key.[49]

This was of course a process of decay speeded up for the purposes of dramatic literature. To view the clothier's trade simply as a lowlier version of outfitting would be to deny the financial weight and innovative interventions of a significant player in the industry. The overloaded shelves and pavements of the clothier's store offered direct evidence of the propensity of broad swathes of the working class and others to purchase new, reasonably fashionable, ready-made garments at bargain prices. Within that definition the scope of a clothier might easily overlap with the supposedly more respectable remit of the outfitter. The author of *The Practical Retail Draper* was careful not to over-generalise differences in quality between the two, preferring to mark the division through noting

the varied emphases that credit and cash retailers might adopt to
secure sales. His guidance stated that 'the cash drapery stores may
or may not maintain quality as the prominent factor in their
trading. Some try very hard to induce the public to believe that
their goods, while cheap and sold at low prices for cash, are equal
in quality to what they buy for credit ... at increased prices ...
others, however, seem to build up their reputations by inducing
customers to regard them as cheap.'[50] More pertinently, the fast
turnover and low prices of the cash clothier facilitated the pro-
vision of overtly 'fashionable', perhaps 'faddish', styles that
appealed to particular tastes and pockets. 'There are people who
must have plenty of change in clothing, and prefer to buy some-
thing "cheap and showy" rather than something which will cost
them a little more and yet last longer ... The taste of some is loud,
and goods which are low priced are more easily fashioned and
made attractive to suit markets where such tastes prevail – it is in
working class neighbourhoods where such cash trade is done.'[51]
Cash trading was then in many respects a very different field to
the more conservative field of 'respectable' outfitting, for here
'solidity should mark the strictly credit draper; and quality and
good value, as well as the lasting properties of everything sold,
should be primarily in evidence.'[52] However, the two were com-
plementary in their provision of modern clothing to a wide
market.

Elias Moses had set a precedent for the supply of ready-made
items to clerks and businessmen in the City of London during the
1850s, and by 1865 the British Clothing Company of 14-15 Poultry
was emulating his success at bulk selling in the same district. Build-
ing on the twenty-year history of an established merchant tailor's
and outfitting store, the shareholders' prospectus of the company
promised to expand its colonial, foreign and shipping business
serving over 'four thousand first class customers'. Contracts to
supply clothing to 'above two thousand persons in departments
of the government service' were also being negotiated and the
directors forecasted that

> the formation of the British Clothing Company Limited is an applica-
> tion of the co-operative system in the most favourable form of
> development. Each shareholder has it in his power to forward his own
> interest by bringing business to the company, whereas the ordinary
> customer, already supplied at economical rates, can, by becoming a
> shareholder, secure a material increase of discount on his purchases in
> the shape of large dividends on the amount he may invest.[53]

By the 1890s similar concerns were common in the West End of
London and the suburbs. The Globe Clothing Trust, employing a

40/- Gentlemen's Business Suits, for 13/3

SEE SAMPLES. SEE SAMPLES.

We have procured a large supply of these strong, durable Cloths, and, as an advertisement offer, we will supply a Gentleman's Suit, consisting of Jacket, Waistcoat, and Trousers, at the ridiculous price of **13/3**, Carriage Free.

This Suit is named the "Ludgate."

Square-cut Fronts to Jackets, 1/- extra.

Lined Trousers, 9d. extra.

(Any size up to 44-inch Chest.)

From Photograph.
The "LUDGATE"

Please send your Measures on the back of this card. See Samples below.

21] Globe Clothing Trust, order form, *c.* 1895. Bodleian Library, University of Oxford: John Johnson Collection. Men's Clothes 2. The 'Ludgate' business suit, offering the latest style at ready-made prices.

similarly universal and imperial title, advertised 40s. gentlemen's business suits for 13s 3d (Figure 21), noting on its 'self measurement' and 'sample' cards that 'we have procured a large supply of these strong, durable cloths, and, as an advertisement offer, we will supply a gentleman's suit … at the ridiculous price of 13/3 carriage free. This suit is named the "Ludgate".'[54] The made-to-measure rhetoric promised a bespoke quality directly contradicted by the knock-down tone of the promotion, and the location of the Trust, which advertised itself as a 'wholesale tailors' at 18 and 20 Oxford Street 'next door to Oxford Music Hall' clearly targeted a 'variety'-attending clientele, who would quickly recognise the clerkly associations of a suit named after a leading financial district in the City. The language of a promotional flyer produced by the Trust at the turn of the century underlined the jingoism of music hall taste with its promise of 'English Firm! English Labour! English Capital!' and provided 'unsolicited testimonials' to the value of their system, patronised for example by a Highgate policeman who on the receipt of his black serge suit claimed that

> I fail to find words to express my gratification, as it is beyond all expect-
> ations, and fits most beautifully. I can honestly say it is far better finished

off than suits I have paid £2 10s for ... And as I am doing plain clothes duty, shall feel proud to be a walking advertisement for you. I showed it to a gentleman today who was in the Park, and he said 'I am sure the Prince of Wales would not be ashamed to wear it,' and I am of the same opinion.[55]

Further out from the centre at 376–80 Holloway Road, close to G.J. Wood's, the Capital & Labour Clothing Stores, established in 1877, advertised itself as a 'merchant tailors, outfitters and juvenile clothing specialist', illustrating its flyer with a plump cherub, pulling on a pair of Capital & Labour ready-made breeches. *The Tailor and Cutter* acknowledged the value of such outlets in providing employment for distressed tailors through co-operative schemes that might challenge Jewish competition, and in an article of 1874 summarised the opportunities available in an expanding market:

> I have great faith in co-operation as a panacea for the distressed condition of many tailors, but not for a 'bespoke' or order business; for no amount of artistic or financial talent in the management can extend it so as to make the demand equal to the supply; but it is vastly different with regard to the 'Ready-Made' and 'Stock' department. There is an almost universal demand for some 'ready made' article, and this demand may be further stimulated by a judicious and choice profusion of supply. In nearly every town are two, three or more shops stocked with 'ready mades', the proprietors are seldom themselves tailors, but perhaps drapers with a little capital, and the advantage of experience in window dressing and management of business so as to ensure profit, and they combine the selling of slops which they euphoniously call 'our ready-mades' with the sale of hosiery, and they 'push' jackets and overcoats the same as they do shirts and scarves. Their supply is from the wholesale concern which offers the best terms, and they have but little risk ... The demand for these ready-mades is continuous, from the improved conditions of the labouring classes generally, and the mechanics in particular; and an advantage to the slop seller is that the purchaser is always impatient and cannot brook the necessary delay and frequent disappointment occurring with orders; but the greatest advantage he has is the ready cash payment ... We know that the slops are mostly made by the 'residuum' of society and the workmanship a mixture of good, bad and indifferent sewing, but according to a wise scheme, those garments may be made up by the best of workmen in their slack time, of which they have too much.[56]

However, despite the vigorous success of high-street and city-centre 'merchant tailors', 'clothing trusts' and 'co-operatives', the common perception of the clothier's remained more lowly. The *Encyclopaedia of Retail Trading* wasted few lines in suggesting that the priority for a clothier was simply to identify the class of goods most demanded by the district in which he was situated, whittling his buying practice down to a representative selection of the most

common sizes.[57] The position of a shop was also important, many of the smaller suburban examples straddling the intersections of streets and gaining double fronts. With little money to spare for advertising or elaborate window schemes, a basic expanse of glazed space was required to display a wide range of stock 'on a few planks and boxes'.[58] 'Tickets are, of course, an essential,' advised the *Encyclopaedia*, 'but their style must be in harmony with the class of trade catered for, and should always be refined rather than gaudy, as the former invariably suggests a better quality of goods than the latter.'[59] Inside, the attention to fittings was equally minimal: 'plain shelving of sufficient width and depth to take the stock will suffice, and the shelves should not be carried too high. One or two mirrors … can often be arranged very effectively at certain angles, so that while they serve the purpose of letting customers judge the suitability of the articles tried on, they also add to the size of the shop.'[60] Beyond those basics a clothier provided little more than his name suggested, the straightforward provision of cheap clothes. Anything further could 'always be met by the aid of a pattern book supplied by one of the wholesale bespoke houses who cater for the clothiers in this department'.[61]

Underpinning all of these forms of men's clothing retail, from tailor through to clothier, were such wholesale houses, also known as merchants or warehousemen, and while to the average consumer they remained rather mysterious though architecturally imposing repositories, their importance in moulding the content and direction of menswear shops from the 1860s onwards was considerable. The *Practical Retail Draper* described them as 'an indispensable factor of commerce in the drapery trade, for although some goods are purchased direct from the manufacturer, and the large storekeeper has open accounts with many mills and works, the draper in country and town regularly visits the drapery and haberdashery warehouses in Wood Street, and their counterparts in Manchester.'[62] Consulted for new lines during 'special autumn and spring shows … the warehouseman is in a position to lead the retailer, and if allowed the opportunity will often prevent him from making losses'.[63] Wholesale houses dealing in menswear items were situated largely to the north and west of Cheapside in the City of London, with some overspill out towards Shoreditch. Hosiery and outfitting provision was dominated by Jeremiah Rotherham and Welch Margetson & Co.; the latter occupying a three-floor palace in Moor Lane whose business was based on the manufacturing of collars but whose showrooms and catalogues provided coats, jackets, trousers, waistcoats, portmanteaux, umbrellas, flannels, silk and knitted scarves, cardigans, vests, handkerchiefs, ties and cravats, belts and braces, hats, socks,

shirtings and jewellery.[64] James Platt & Co., of St Martin's Lane and
Great Newport Street in Charing Cross, offered a similarly wide
range of coatings, suitings and trouserings, waterproofs and tweeds
to the West End tailor.[65] The size of Platt's operation promised
competitive prices that often undercut the mills from which the
warehouseman received his stock. Renewed every season, the com-
pany's comprehensive holdings 'reveal[ed] in a striking manner the
true nature of the enormous business so quietly and decorously
carried on within Mr Platt's establishment'.[66] Nestling against these
leviathans of modern cloth exchange, however, was a form of mass
retail that owed little to either measured display or sartorial mag-
nificence, its provision aimed at a class of consumer for whom the
decorous atmosphere, polished boards and cash booths of the retail
clothing store were largely an irrelevance.

'Gutter vendors of pinchbeck trifles': street selling and the second-hand trade

> The busy street throbbed and hummed with strenuous life. Unhappy
> penury in insufficient rags jostled unhappier penury in faded broadcloth
> and rusty bombazine on the narrow way. Gutter vendors of pinchbeck
> trifles, that never could be of use to mortal man, chaffered seductively
> with such poor wives and mothers as could be brought to tear them-
> selves between vases or a chromolithograph for the parlour and boots
> for their small yeared offspring. Hapless women these! Most of them
> hard put to it to stretch a scanty store of toil worn home money over
> a multitude of too pressing needs, yet retaining still, in the deeps of their
> nature, a sediment, a few poor grains, of puny feminine aestheticism.
> Bull throated costermongers, hoarse tradesmen, feebly emulative, but
> with an inflated dignity to uphold, rent the dank hot air with blatant
> bellowings ... senseless howls and hoots and shrieks from youth for
> whom the sweets of youth were not; addled utterances of drunken
> manhood, staggering from ale house doors ... There was a thin rattle of
> traffic too, the clack, splash, clack of horses hoofs, scattering the crowd,
> threatening the unwieldy barrows ranged in either kerb. Over all was
> diffused the heavy red glare of flaming naphtha lamps, eclipsing the
> thinner brilliance of the hissing gas.[67]

The atmosphere of the street market provided potent inspiration
for commentators on the city scene. Edwin Pugh in his description
of East End poverty that opened his novel on social inequality *The
Man of Straw* of 1896, offered a typical rendering of costermonger
deprivation and depravity that prioritised the overbearing colours,
smells and noise of a Friday night among the stalls. Little attention
was given to the place of market trading in a network of domestic
provision amongst the urban poor, Pugh's central intent being to
convey the senselessness and waste that he assumed pervaded the

eastern reaches of metropolitan life. Gaudy products and raucous exchanges provided a neat parallel to the psychotic bargain-hunting of the West End department store and consumption is presented as fertile ground for a distinctive 'feminine' display of weakness. Yet, behind this apparent disorder, the flow of dress goods through the market system represented a source of male clothing as distinctive as the interlinked offerings of tailors, hosiers, outfitters and clothiers. There are, unsurprisingly, no retailers' guides or trade publications to help reconstruct the appearance, stock and profile of selling practices that lay at the peripheries of legal and social acceptability. But the descriptions of novelists and journalists, though coloured by dramatic licence, convey some sense of a significant contribution to the menswear retail industry otherwise marked by its transience. The Sunday morning Rag Fair at Petticoat Lane, represented for many commentators the epitome of a retail concern that bordered on the sublime in its accumulation of secondhand items, each with its own biography, 'in every gaudily fashioned waistcoat ... a tale perhaps of sorrow and sadness and want'.[68] Daniel Kirwan, an American journalist, remarked on its location in Houndsditch between the more salubrious fruit shops, jewellers, mercers and clothiers of the Jewish community, protected from the elements by a wooden roof, before giving himself over to a romantic reading of its morbid contents:

> It was a very queer place in more senses than one. To get an idea of it take a section of Washington Market, New York, with its stalls and blocks, and buyers and sellers; and on the walls where the pork, mutton and beef are hung ... and instead of the flesh of the cow, pig and peaceful sheep, hang hundreds upon hundreds of pairs of trousers - trousers that have been worn by young men of fashion, trousers without a wrinkle or just newly scoured, trousers taken from the reeking hot limbs of navies and pot boys, trousers from lumbering men of war's men, from spruce young shop boys, trousers that have been worn by criminals hung at Newgate, by patients in fever hospitals; waistcoats that were the pride of fast young brokers in the city, waistcoats flashy enough to have been worn by the Marquis of Hastings at a racecourse, or the Count D'Orsay at a literary assemblage; take thousands of spencers, highlows, fustian jackets, some greasy, some unsoiled, shooting coats, short coats and cutaways; coats for the jockey and the dog fighter, for the peer and the pugilist, pilot jackets and sou-westers, drawers and stockings, the latter washed and hung up in all their appealing innocence, there being thousands of these garments that I have enumerated, and thousands of others that none but a master cutter could think of without a softening of the brain; take two hundred men, women and children, mostly of the Jewish race, with here and there a burly Irishman sitting placidly smoking a pipe amid the infernal din; and shake all these ingredients up well, and you have a faint idea of what I saw in Rag Fair.[69]

James Greenwood, writing twenty years later, noted the survival of a second-hand clothing market in the same location. That sense of claustrophobic containment was now dispelled in a description of dealers with their scattered piles of cast-offs on stalls, in the middle of streets and in the gutter, all under open skies and interspersed with food sellers retailing cake, sliced pineapple, whelks, cucumber and hot peas amidst the 'frowsiness and fustiness' of old boots, shirts, sheets, blankets, caps, gowns and petticoats. By the 1890s the primary function of the second-hand market in providing a comprehensive selection of garments to wear had apparently succumbed to the twin assaults of an organised rag-recycling industry and the increasing provision of cheaper, more fashionable, ready-made clothing. Greenwood's emphasis lay in presenting the market as spectacle, providing a space for leisure, social interaction and the less focused enjoyment of browsing for bargains. The intention to buy took a lower priority in later accounts, though prices still remained very low: 'I have heard it seriously asserted', Greenwood claimed, 'that a full and complete suit of clothes may be bought at the fair for the low figure of four and sixpence, including cap, boots and necker-chief.'[70] Beyond its picturesque or diversionary qualities, however, the Fair continued to offer possibilities for sartorial transformation amongst its dwindling customers. The practice of 'moulting the mouldys' illustrated the way in which men's clothing at this level of transaction was implicated in a complex cycle of use and re-use that lay far beyond the remit of 'respectable' retailers:

> When I was at the Fair I had noticed some curious instances of economy on the part of purchasers. A person requiring a cap or hat, his own being in the last stages of decay, would make a swap with the hatter (who in some cases carried his stock dangling from the edges of an expanded umbrella held above his head as though it was raining) and give him two pence or three pence and the old one for another that was just a few shades better looking … 'Moulting the mouldys' is a business trans-action that cannot be negotiated by a vendor of 'clobber' whose show of wearing apparel is in the open street. It necessitates possession of a shop with a convenient back parlour behind, or at least a partitioned space contrived with a hanging canvas. As was so frequently instanced among my Sunday morning Rag Fair riders, the patched and threadbare habiliments on their backs were so far gone that it appeared a marvel how they contrived to get into or out of them without rending them piecemeal. But they are not utterly valueless in the hands of the Rag Fair tailor. There are pieces of the material here and there that may be torn out and utilised in making up articles of clothes … for small boys. When therefore, the tattered one is haggling for a change of raiment, and a mere few pence is the only obstacle to the completion of a deal, the 'clobber' man will suggest that if the customer will moult his mouldys … he will let his goods go.[71]

For Greenwood the testimony of a coster offered as much pictur-
esque potential as the chaos of the fair, and the resulting
description of the 'moulting the mouldys' ritual, though very poss-
ibly over-elaborated in this account, shows the lengths to which
a punter might go in attempting to acquire a suitable wardrobe
for impressing his women friends:

> I had no other togs but them as I was wearing, and they were so wore
> out I was ashamed to be seen in 'em. So ... I said to myself, 'Blest if I don't
> go over to the Fair ... and moult the mouldys, and buy a tidy suit to
> wear, and then in the ar'ter noon I'll bowl over to St Lukes and rayther
> astonish Eliza ... by lettin' her see what a swell I am ...' I had made up
> my mind to do the thing to rights while I was about it, and while I had
> the money in my pocket. I moulted to my very shirt and socks. I gave
> seven and six for a light suit, and half a dollar for a pot hat, and eighteen
> pence for a sky blue neckerchief, and likewise bought a shirt with an
> ironed front to it, and afore I came away I put 'em all on. Then I went
> to a barber's and had my hair cut ... and here I was, all a toff, up'ards
> and down'ards.[72]

A further collapsing of categories between the retailing of cheap
ready-made and second-hand clothing, which confuses distinc-
tions between classes of goods and the manner of their selling, can
be discerned in debates surrounding the intrinsic value attached
to fashionable male dress at its various levels. Beyond the weekly
market a variety of outlets other than the clothier sold, bought or
exchanged sartorial items of all kinds in working-class districts.
Social historian Melanie Tebbutt, for example, has provided an
illuminating account of the role of the pawnbroker in the manage-
ment of working-class household economies and appearances. The
action of pawning both affirmed gendered distinctions in
working-class consumption patterns so that 'a woman's manage-
ment of the family budget was a world entirely separate from that
of her husband, necessity forcing it to encompass a thriving sub-
culture of credit activities'[73] and ironically prioritised male
garments over female as creditworthy items. Tebutt intriguingly
suggests that the poorer quality and transient nature of ready-
made female clothing forced women, often surreptitiously, to look
to the Sunday suits of their menfolk for higher-value pledge ma-
terial.[74] This must have had the strange effect of transforming a
retail environment associated with the secret activities of women
into a space marked by its weekly accommodation of countless
ready-made men's suits.

Besides the pawnbroker, wardrobe and misfit dealers offered
further outlets for the acquisition of men's clothing, and an easy
route for the disposal of goods fallen beyond their usefulness or
illegally come by. Arthur Harding has revealed as much in his

autobiography, edited by Raphael Samuel to convey the life and times of an East End small-time criminal born to a family of wardrobe dealers whose Shoreditch businesses operated as efficient covers for the receipt of stolen goods.[75] In support of the rag-man's place amongst more respectable high street concerns, a rare 1905 image of a wardrobe dealer in Stoke Newington depicts a decidedly down-at-heel shop, sandwiched next to a dyer and dry cleaner's, a property belonging to a 'C. S. Harrison – Perfect Fitting Tailor' and a public house. The sign in its window states, 'Left Off Clothing Bought to Any Amount', while a top hat, a billycock and a boater stand on piles of clothing stacked behind the panes (Figure 22). A row of rifles appears to have been propped ominously in the doorway.[76] The misfit dealer, according to an admonitory article in *The Tailor and Cutter*, though marginally more reputable, offered an equally suspect array of goods whose provenance was shady at best:

> We have known 'salvage sales' last for years; 'clearance sales' … run on forever, while the stock in the window of a regular 'misfit dealer' is, like the birth of a noted Thackerian character 'wrop in a mystery'. How is it, one wonders, that in a window full of misfits, almost every garment bears evidence of the same source of origin. The same make of buttons exactly, even when differing in shade in harmony with the colour of material; the same class of stitching; the same style of cut; indeed the whole stock consisting of some half dozen kinds of cloth, duplicated again and again in different garments. How is it too, that these misfits

22] Wardrobe dealer, Stoke Newington Church Street, North East London, *c.* 1905. By kind permission of London Borough of Hackney, Archives Department. At the bottom end of the clothing system, the wardrobe dealer dealt in cast-off goods, ends of lines, and items with a disreputable provenance.

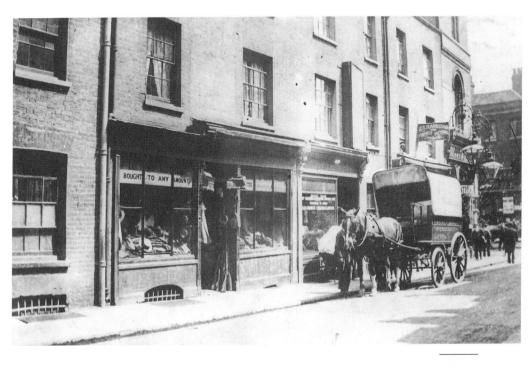

are always made up to proportionate measures? How is it such incongruous tickets as 'Misfit, best West end make, only 30/-; perfect fit guaranteed' can be used? [77]

As the description suggested, misfit dealers bought up a range of seconds, customer rejects, good-quality cast-offs and ready-made end of lines, selling them at high profit under the banner of the bargain sale. *The Tailor and Cutter* went further in claiming that such retailers were in the game of deliberate deception:

> 'Taking old clothes as old clothes' said the misfit dealer 'they're not of much value; but as misfits there's a respectable income in the business. A second-hand overcoat at 10s 6d might stay on your hands for months; call it a misfit and it'll sell for 15s like winking ... My line is converting cheap new clothes into second hand goods ... half an hour's dragging through a good muddy thoroughfare will make second hand clothes of the newest suit in the world ... For this job I pay a man £1 a week, his time in the evening being filled by visiting different working men's clubs and institutions ... for the purpose of puffing my goods ... By carrying pawn tickets, showing how he has made a few shillings out of my misfits, a good man at this game will bring in a lot of custom, as working men are pretty keen on "making a bit"... 'Style' continued this cunning clothier, as he flicked a speck of dust from a faded frock coat, which bore the inscription 'Bond Street' in large type ... 'is the thing to fetch the customers ... a West end tailor's name in this case means money ... a certain Jew in Whitechapel can supply me with any maker's name tab at a low figure ... you only require a few stitches to turn a 5s. 11d. pair of trousers into a misfit by a swagger West end outfitter ... A leading feature in the business is a good window show. Plenty of swords and pistols, a swell uniform or two, a cocked hat and the rest of the window filled with ordinary clothing. A pair of trousers in the centre marked ... "Smith's latest" takes well; if it's extra neat add "Regent Street".' [78]

Between the West End tailor and the East End misfit dealer, the workings of the men's clothing industry moved full circle, linking bespoke and ready-made, new and old, aristocratic and working-class. Such connections can be viewed both as a series of real elisions in which the passing of an item down the fashion chain cemented its various parts in a shared process, and an illusion of linkage, encouraged for purposes of deceit in the case of the misfit dealer, or (more promisingly) representing a profound endorsement of sartorial unity that celebrated the 'well-turned-out' man as a common goal. This inclusiveness strengthens a reading of masculine shopping practice predicated on gendered as well as class lines, opening up a previously hidden arena in which imaginative choices and challenging exchanges were played out, inscribing the further circulation of particular male identities. The fascias, interior fittings and stocking practices of shops selling

men's clothing products conformed to an aesthetic and ideological rationale that prioritised a range of masculine attributes varied according to specific markets. The overriding pursuit of order and a self-imposed reticence with regard to surface embellishments can be read in the details of retail spaces from the plain deal of the tailor to the sharp black and gold of the hosier; and these are also characteristics which can be applied to the description and development of male clothing itself during the period. Excess marked only the outer boundaries of the social scale, appearing in the luxurious provisions of the West End bespoke tailor and the sublime disorder of the East End market, and here commentators couched their observations in the context of more general critiques of aristocratic and plebeian indolence. In the light of such prescriptive tendencies it is necessary to move beyond these more structured descriptions of idealised retail practices, to consider the extension and ultimate contestation of these characteristics in the broader sphere of promotion and display.

From street façade to store interior: shop display and masculine aesthetics

> To some shopping is a pastime and pleasure; they look upon such an excursion as a treat – a holiday occasion. Such customers are very delightful to serve ... there seems to be no reason why shopping should be a tiresome duty and buying goods sordid drudgery. Commerce has been lifted to such very great heights now, owing to the great commercial palaces which have been built, that shopping can be carried on under exceptionally pleasing conditions ... That such conditions benefit the trader none can doubt, for the shopper and the salesman carry out their several duties and occupations with greater ease and under more pleasant surroundings. These are conducive to more business, and in many cases lead to the purchase of more articles or more expensive goods. Nearly everything in the drapery trade has been improved by artistic rendering, and by a greater appreciation of colour and form, all tending to better trade.[79]

In their different ways it has been shown how retailers responded to local demand in terms of their stocking practices, while instituting forms of selling that shaped various conceptions of modern, fashionable masculinity. *The Practical Retail Draper* in its summary of recent trade accomplishments in 1912 indicated these broader patterns of progress with respect to architectural design, commercial display, advertising and customer service which further positioned the shopkeeper at the forefront of innovative retailing practice. New selling tactics undoubtedly impacted on the general 'modernisation' of urban life, and this process was reflected through shifting attitudes towards consumption. This is an area

that has received much attention from cultural historians in the past decade, though, once again, it is largely the sphere of the department store and the identity and reactions of the female shopper that have benefited from their scrutiny.[80] The fittings and commercial transactions of the menswear shop, though less overtly expressive, offer a history of expansion and progress as valid as the more familiar terrain, and equally loaded with cultural significance.

The store window offered the male consumer the first indication of a private interior space given over to considerations of luxury, economy and the promotion of style that spoke directly to his desires. Evidence of a long-standing interest among tailors, outfitters and clothiers in the commercial possibilities which lay in the shop front can be gained from handbills circulated at the time of the Great Exhibition in 1851. Here a didactic intention to display the industry and dexterity of the craftsman or manufacturer, mirrored a timely public interest in the democratic and spectacular potential of the trade display.[81] N. Benjamin, proprietor of 'the cheapest tailoring & outfitting establishment in the world' at 78 Westminster Bridge Road, produced a flyer for winter

23] Advertising flyer, N. Benjamin, c. 1850, detail. Bodleian Library, University of Oxford: John Johnson Collection. Men's Clothes 1. This representation of a mid-century tailor's window shows the traditional workman sat in the midst of a forward looking display.

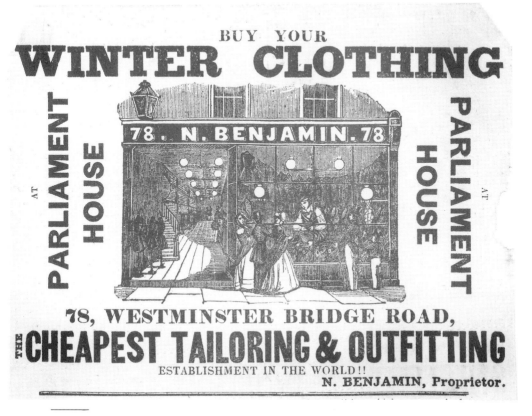

clothing which, within the rather old-fashioned graphic remit of
the trade card and press announcement, depicted a group of gen-
teel consumers gathered around the window of his premises
observing the figure of a tailor sat cross-legged on the window
bottom (Figure 23).[82] Amidst the piles of textiles and surrounded
by a recessed curve of finished items hung on mannequins, this
figure led the spectator's gaze further into a space lit by several gas
chandeliers. It boasted an extravagant spiral staircase and some
display dummies artfully arranged in groups about the entrance.
Benjamin's façade provides a bridge between older attitudes to-
wards the tailor's shop as a site for the simple production of
clothing, personified in the iconic figure of the working tailor at
his bench, and a renewed interest in exterior and interior retail
space as an aid to marketing, the encouragement of consumption
and the spectacular forging of modern urban identities.

This is not to suggest that earlier shopkeepers made no invest-
ment in the luxurious fitting out of their interiors. Important work
has been carried out on the displays chosen by eighteenth-century
retailers, but the emphasis here has tended to isolate the luxury
and fancy trades as sites of progress.[83] Tailoring retained stronger
associations with traditional forms of provision for much longer.
The linking of manufacture and display, in the exhibition culture
of the 1850s and 1860s therefore found a particular resonance in
the field of menswear retailing. Here the problems of reconciling
the 'feminised' and 'profligate' visual sphere of the modern shop
with the 'rational' behaviour of a conservative male market or the
cautious investment of the shopkeeper could produce such surpris-
ing juxtapositions as that glimpsed in Benjamin's promotion. Half
a century later *The Practical Retail Draper* still supported the place
of such strategies in the promotional armoury of men's clothing
shop proprietors:

> There is a great fascination in living and moving figures, especially in
> realistic displays carried out so as to give customers an opportunity of
> judging the value of the goods they buy. This is possible in woollen
> garments where a practical demonstration of their manufacture …
> shows the whole process of production from the raw material to the
> finished garment … A Harris tweed exhibit was effected by showing
> sheep, representative of the raw material, a loom in operation, a few
> lengths of cloth already woven, samples of colourings and mixtures, and
> model figures shown wearing the completed costumes. Such exhibits
> are of great interest to those who are in search of tailor-made garments,
> as by them they can be convinced of the sterling qualities of hand made
> tweeds.[84]

Display was clearly unproblematic in the masculine retail
sphere, providing that it served some didactic purpose, aiding the

customer in a choice that was informed by accumulated knowl-
edge that reminded him of the labour and expertise involved in
the manufacture of his chosen item. Thus the image of the tailor
in the window established a precedent for the proper promotion
of commodities that Thomas Richards claims was endorsed by the
displays of The Great Exhibition: '[a] phenomenology of consump-
tion [that] can best be described as a set of purposive procedures
for producing consumption. The Crystal Palace did not isolate pro-
duction from consumption; to the contrary, it successfully
integrated the paraphernalia of production into the immediate
phenomenal space of consumption.'[85] As cutters and tailors grad-
ually disappeared from the interior space of the shop to a
workroom or factory hidden elsewhere, their presence remained
as a ghostly reminder of gainful productivity through the display
and promotion of their raw materials and tools: virgin bales of
textile awaiting the attention of the absent craftsman's shears and
fashion plate templates suggestive of suits to come. This was a
situation that found few parallels in the abandonment to enter-
tainment and escapism that commentators have claimed for the
lace-bedecked halls and windows of the department store.[86]

The other key strategy in menswear window arrangement and
marketing technique, which persisted through to the early twen-
tieth century but found its roots in older conventions and debates,
can be seen in the display promoted by Samuel Brothers, Merchant
Tailors, Outfitters & Woollen Drapers of 29 Ludgate Hill. In a man-
ner more direct than that employed by N. Benjamin, Samuel
Brothers pinned their reputation firmly on to the notoriety of the
Crystal Palace (a ploy also embraced by many of their competitors
across the retail sector).[87] Placing their text under the strap-line
'The Great Exhibition in London, High Art! High Success!! and High
Principle!!!', the establishment laid claim to the precise policies that
governed the promotion of goods in Hyde Park (Figure 24):

> Samuel Brothers ... having obtained a world wide fame, are determined
> to confirm their popularity to the Great Gathering of 1851, by not only
> equalling, but surpassing, all former efforts; and thus enabling Foreigners
> to witness a grandeur of Taste, an excellence of Material, a novelty in
> design, and a superb magnificence in every description of Clothing,
> that will ensure their patronage, and cause them to proclaim, on return-
> ing to their own Nation, that the gigantic and Wonderful Tailoring
> Establishment of SAMUEL BROTHERS ... is A GREAT FACT, An amalga-
> mation of great facts; their fit is a far-famed fact - their style a select fact
> - their variety a material fact - and their price a pre-eminent fact.[88]

In parodying the puffery associated with the theatre, and echoing
the Gradgrind-like assurances of unprejudiced quality that formed
the bedrock of progressive advertising technique, Samuel Brothers

moved beyond imitation to appropriate exhibition language and display for its own commercial ends. In its double-tiered windows the arrangement of ready-made clothing and accessories formed a less coherent pastiche of the Hyde Park style, though its

The Great Exhibition in London,
High Art! High Success!! and High Principle!!!

The following epitome will furnish a Catalogue of the extensive advantages to be derived at this Establishment.

THE READY-MADE DEPARTMENT
abounds with the Choicest and Best Stock of

SPRING AND SUMMER ATTIRE.

Superfine Cloth Dress Coats	21s 0d to	25s
Saxony Ditto	22s 0d	30s
Superior	33s 0d	42s
Frock Coats 3s. extra.		
Fancy Doeskin Trousers	9s 0d	14s
All the New Styles	12s	18s
Black Cassimere	10s 6d	21s
Samuel, Brothers' much admired French Style Trousers	15s 0d	22s

PALETOTS.

SAMUEL, BROTHERS have several quite New Designs in Over Coats, which can be seen on application.

Saxony Llama Cloth Paletot, sleeves, &c., lined with silk		24s
Saxony ditto	26s 0d to	34s
These Coats can be worn either as a Frock or Over Coat.		
Alpaca ditto	7s 0d	13s
Cachmere ditto	14s 0d	20s

OXONIAN, SHOOTING, FISHING, & LOUNGING COATS.

Fashionable Plaid	9s 6d to	25s
Super Green or Black Cloth	16s 6d	28s
Velveteens, any Colour		13s
The Oxonian or Business Coat	12s	18s
Saxony ditto	21s	30s

Boys' & Youths' Clothing.

Boys' Hussar Suits	22s
Boys' Tunic Suits	21s
Boys' Jackets	9s 6d
Boys' and Youths' Over Coats	8s 16s

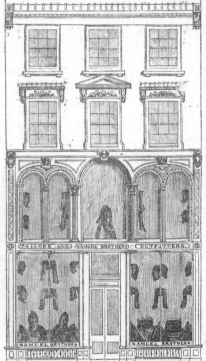

VESTS.

Shooting Vests	6s 6d to	10s 6d
Lustre Alpaca, quite new		4s 6d
Black Cloth	5s 0d	10s 0d
Satin	7s 0d	12s 0d
White		4s 6d

Our display of Vests is worthy of attention.

The Double Coat, which can be worn on either side, the greatest novelty ever produced, 45s. to 60s.

☞ Important to those frequenting the Opera and Evening Parties—SAMUEL, BROTHERS have just invented a **Frock Coat that will alter** to a **Dress Coat,** consequently being the most **economical** article of Dress ever submitted to the Public.

SUIT of MOURNING at FIVE MINUTES' NOTICE £2. 2s.

SUIT OF LIVERY £2. 10s.

☞ Patterns, List of Prices, with a Plate of Fashions, and Guide to Self-measurement (by means of which any Gentleman can forward his own orders), and Schedules for the information of those requiring Naval, Military, or Emigrant's Outfits, sent free to any part of the Kingdom.

Ladies' Riding Habits, Court Dresses, Naval and Military Uniforms, Liveries, &c., 40 per Cent. lower than usually charged for the same quality.

SAMUEL, BROTHERS,
MERCHANT TAILORS, OUTFITTERS, & WOOLLEN DRAPERS,

(One Door from the Old Bailey.) **29, LUDGATE HILL,** *(One Door from the Old Bailey.)*

Having obtained a world-wide fame, are determined to confirm their popularity **to the Great Gathering of 1851,** by not only equalling, but surpassing, all former efforts; and thus enabling Foreigners to witness a grandeur of Taste, an excellence of Material, a novelty in design, and a superb magnificence in every description of Clothing, that will ensure their patronage, and cause them to proclaim, on returning to their own Nation, that the gigantic and **Wonderful Tailoring Establishment of SAMUEL, BROTHERS, 29, Ludgate Hill, is A GREAT FACT.** An **amalgamation of great facts;** their fit is a **far-famed fact**—their style a **select fact**—their variety a **material fact**—and their price a **pre-eminent fact.** SAMUEL, BROTHERS respectfully ask a **trial,** to prove the fact, satisfied that if they do have a trial, no **good judge** can conscientiously condemn them, except perhaps, for taking too little profit, and then the sentence will be—"*Go on and Prosper.*"

Most Establishments are anxious to preserve the secrets of their trade; SAMUEL, BROTHERS are not: for this simple reason, that *their System* have no secrets, their success being the result of varied beauties of their fabrics, a fashionable cut, a correct fit, and a price to suit every pocket.

SAMUEL, BROTHERS' *original system* of charging *separately* for the *material* and *making,* which has given such unqualified satisfaction, will be continued as heretofore. Gentlemen must bear in mind that *every material* is marked in *plain figures* at the price per yard.

THE FOLLOWING IS AN EXEMPLIFICATION OF THE SYSTEM:—

For a Coat	1½	Superfine Cloth....12s 0d per yard	Material Costs £1 1 0	Making and Trimmings 20s 0d	Cost Complete £2 1 0		
For a Vest	¾	Ditto Cassimere 5s 6d ditto	Ditto 0 4 1½	Ditto 6s 6d	Vest do.	0 10 7¼	
For a Pair of Trousers	2¾	Ditto Ditto.. 5s 0d ditto	Ditto 0 13 1	Ditto 6s 6d	Trousers do.	0 19 7	
		SUIT COMPLETE £3. 11s. 2¼d.					

Remember the address!—SAMUEL, BROTHERS, 29, Ludgate Hill, one Door from the Old Bailey.

organisation was clearly attuned to the spectacular potential of the exhibited commodities found there. Isolated items of the wardrobe hung suspended on a regular grid in a fairly literal representation of the 'factual' excess trumpeted through the body of the advertisement. Reflecting the serried ranks of products that flanked the aisles of the Crystal Palace in confirmation of national tastes and design principles, the arcaded panes of Samuel's window offered the clearest evidence of finish, variety and price simply through the ordered exposure of its stock. Trousers, jackets, collars and ties had become so many 'exhibits', their material and visual properties attesting to the standards of the proprietor and inviting the expert scrutiny of the purchaser.

The retail historian Bill Lancaster has advised caution in lending too much credence to the transformative powers of the 1851 exhibition, and it is undoubtedly important to view the development of modern retail display methods and their relationship to consumer activity in a longer continuum, subject to a broader range of economic and social pressures than the effects of one isolated phenomenon. However, he does acknowledge the long-term effects of an exhibition which 'did draw a mass audience and did heighten the popular awareness of the achievements of British power and the industrial revolution' and which in combination with the exhibition culture of Paris after 1855 marked 'the beginning of a process that was to take two decades to bring about noticeable change to retailing'.[89] In this sense both Benjamin and Samuel Brothers represent significant examples of the fixing of a mode of address in menswear promotion. They were linked to concurrent considerations surrounding the values of commodity culture explored at the Crystal Palace, but also provided precedents for succeeding tailors' and outfitters' windows. An 1890 flyer for the West End Clothiers Company at 80 and 81 The Strand reproduced, in a highly schematic form, a representation of the resulting distillation of display that marked the uniform appearance of menswear outlets at the end of the century (Figure 25). It showed regularised display boards ranged in regimental fashion across an otherwise featureless, though neatly finished, glass expanse. On the basis of this example, it is little wonder that the trade press should have lamented the lack of scope or ambition which betrayed so many windows by this time, contrasting the dismissive attitude of some shopkeepers with a continuing obsessive regard for controlled arrangements by others:

> Tailors' windows are not always a source of attraction. We have seen them in both town and country, dirty, dusty, and untidy, with nothing more than a few faded remnants hung over boxes, and some ancient specimens of fashion plates, upon which the flies have left their mark

24, *facing*] Advertising flyer, Samuel Brothers, 1851. Bodleian Library, University of Oxford: John Johnson Collection. Men's Clothes 3. The text of this flyer draws on the spectacular promotional rhetoric of the Great Exhibition, whilst the arrangement of clothing in airy arched windows recalls its displays.

————

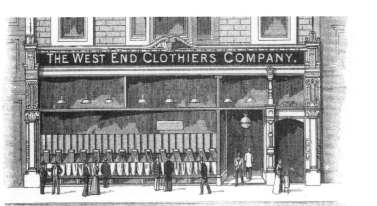

GREAT EXTENSION OF PREMISES.
ALTERATIONS NOW COMPLETED.
80 & 81. STRAND. W.C.

25] Advertising flyer, West End Clothing Company, *c.* 1890. Bodleian Library, University of Oxford: John Johnson Collection. Men's Clothes 3. By the 1890s, the standards of display established at mid-century had fossilised into the abstract formula of repeated motifs illustrated here.

in the years which are past. Of all tradesmen, the tailor should keep his establishment spic and span, his windows well dressed, and his premises so arranged as to give the impression that he is a man who attends to the details of his trade and who is thoroughly abreast of the times.[90]

Now that we have traced the development of its narrow parameters, what potential did the tailor or outfitter's window offer the inspired dresser at the peak of the trade's modernisation? Some evidence remains of a renewed interest in the effectiveness of the window through a series of articles which appeared in *The Tailor and Cutter* through the 1890s. During the previous two decades of publication attention to such issues was largely absent, and significantly the author of the later series prefaced his remarks with a veiled apology to more conservative subscribers for their inclusion. He stated that

> I will admit that the best class of tailoring firms make no display in their windows, and just from reasons opposite to those who adopt this plan of advertising their goods. In the one instance, a display would repel the customers, in the other it attracts them: and while many of the old established family trades still preserve their privacy, the younger school of merchant tailors have no aversion to this method of ... increasing their business.[91]

The advice offered in earlier issues, assuming the peripheral standing of the subject amongst reader's interests, restricted itself to the discussion of basic desiderata: the acquisition of a plain level-bottomed window with gently angled sides and floor painted 'white or some very light tint of green or blue', the introduction

of mirrors to increase light and space, though 'these may be looked upon more as ornaments than necessaries to window dressing', and the selection of a range of movable 'rods, racks or dummies' in brass if expense presented no problem, or otherwise constructed from 'disused cloth boards'. Materials intended for display were discussed in similarly restrained tones, their possibilities so limited for the tailor that the author suggested supplementing the 'tweeds, wests, worsteds, pilots, vestings plain and fancy … and trouserings' with 'hosiery, hats, scarves, shirts and other items necessary for gentlemen. The latter goods are not always found in tailoring establishments, yet … a good display of small articles such as these may occasionally be the means of introducing larger orders' and 'a little colour, such as the smaller articles are possessed of, give some lightness and tone to the darker and heavier materials'.[92] This resistance to any serious discussion of window display in *The Tailor and Cutter* reflected a deeper mistrust of the competition offered by more innovative clothiers and outfitters to the tailor's presumed supremacy. Yet the demands from readers for further guidance in succeeding issues suggest a genuine desire to capitalise on prevalent commercial trends. One correspondent caught the popular mood when he voiced a desire that 'he should like to see more of the front shop and office and less of the cutting room in this journal'.[93]

In tandem with the interests of the drapery trade, whose journals and leading businesses had also exhibited a tendency to dismiss the seriousness with which American, French and German organisations took issues of design and display in the early 1890s, the menswear sector appears to have reassessed its position in relation to the window question by the turn of the century.[94] Evidence of a widespread embracing of the tactics which transformed West End department store windows from the 'crammed, cluttered jumble' that characterised the heavily ticketed and densely packed displays of Whiteley's and Harrods to the spacious, themed tableaux that Selfridges presented as a challenge to the older style in 1909 is, however, lacking.[95] Tailors and outfitters, while achieving a new sense of cohesion and purpose in their displays, retained the standard grids and threw their energies into the details, producing in effect a polished and streamlined reflection of the new urbane masculine aesthetic with little visual disruption to the established canon. A self-consciously conservative tone pervades most of the discussion of window dressing in the menswear journals, and, while consideration of scarlet flannel backing cloth, colour co-ordination and the inclusion of price tickets 'uniform in size, striking in design and artistic in colour' betray a new receptiveness to innovatory technique, an underlying insistence that display somehow under-

mined rational masculine values always remained.[96] Its repression rather ironically constituted a defining, almost protective feature of tailoring publicity style:

> Some merchant tailors have an objection to a large display of goods, because of the amount of waste and deterioration incurred in showing the goods. Dust finds its way into the window, the sunshine may fade the colours, the heat and smoke of the gas soils the lighter shades, and sometimes places one in a dilemma. Every means should be taken to prevent any waste from arising from this cause. If the window is not altogether enclosed and has no folding or sliding glass doors, the best thing to keep out dust is a piece of plain muslin … The close texture of the muslin prevents the dust from entering the window, and is also sufficiently thin to allow the light to pass through.[97]

The evidence of shop windows themselves, while still conforming to arrangements that displayed the minimum of 'fuss', offered some scope for comparisons and the assessment of experimentation. *The Tailor and Cutter* employed the informative practice of sending a reporter and later a photographer to record examples of outstanding achievement in shop-front management, and its articles often exposed interesting instances of city-centre and suburban ingenuity. Ludgate Hill presented an obvious focus for the journalist in May 1896, where

> with one or two exceptions … the windows of the outfitters along the route are not so large as many of their suburban competitors, and one might naturally expect to find the cream of taste and design in the smallest possible compass. Many of these outfitters never advertise, yet they succeed in doing a large business, extend their premises, and acquire fortunes rapidly; and attractive window dressing plays a large part in drawing customers to their shops.[98]

Fittings including black varnished rods and bright brass supports helped to establish the dapper rhetoric of the area whose metropolitan style was further evidenced through the use of linen cuffs and collars piled and suspended across the window space as abstract foils for ties, bows and jewellery. Most of the arrangements were constructed to draw the consumer in, with gloves placed at eye level and umbrellas fanned out so that their variously crafted handles almost touched the inside of the glass panes. The author of *Publicity: A Practical Guide for the Retail Clothier and Outfitter* of 1910, the nearest publication to American advertising manuals available to the British menswear retailer at the time, approved of this grouping together of goods, stating that

> everything must be in keeping with what you are showing … have care as to what departments are shown together … in quite smart looking hosiers I have seen neckwear and underwear not only shown in the

High Street, Lewisham.

26] Illustration, *The Tailor and Cutter*, May 1906. Formalism and creative ingenuity went hand in hand in the virtuoso displays of hosier's windows.

27] Illustration, *The Tailor and Cutter*, June 1907. Sale seasons were an important means of controlling stock and transformed the shop window into an abstract pattern of reduced ticket prices.

same window, but mixed together. This is bad taste. If you must represent two departments or more in one window then underwear, half hose and pyjamas, or gloves and ties, or shirts and collars, but see that one thing helps another.[99]

This was all in stark contrast to the habits of provincial outfitters who, according to the laments of cosmopolitan journals, used window space indiscriminately to show their entire ranges or for extra storage, rather than as a strategic promotional tool. Drawing attention to such differences, *The Tailor and Cutter* columnist noted that 'we may say, for the benefit of our country readers, that very few [London] outfitters show their ties or scarves in a box with a glass lid; they are displayed singly or in rows at a price. The tickets are also small and tastefully executed, and an extra inducement is held out to purchase more than one tie at a time.'[100] The abstracted effect of the Ludgate Hill style was endorsed in a later illustrated article of May 1906 (Figure 26) in which shirt fronts, ties and handkerchiefs were shown cleanly suspended on brass stands

> the ties ... made up and shown as in actual wear, while the cuffs have been turned out to show there is no deception ... the bases of the stands have each been carefully (yet apparently carelessly) concealed by a fancy silk handkerchief; the eye therefore, rests on nothing but which conveys a suggestion to the possible buyers who inspect the content of the window.[101]

Beyond any avant-garde stylistic pretensions to Art Nouveau in
the window design, honesty in the revealing of forms and values,
discipline in their tight arrangement and pricing, and a didactic
desire to educate the inspecting gaze of the consumer, still under-
pinned the dresser's intentions. The maintaining of a relationship
with the potential buyer remained central to such design
strategies, cognisant of the advice from manuals that:

> If you open in the midst of lawyer's offices and where Stock Exchange
> and banking clerks 'most do congregate' the most alluring window of
> 6½d ties and 3½d collars will not speak loud enough to be heard a foot
> from your window, or rather will utter their message in such harsh and
> disagreeable tones that passers by will avoid them. On the other hand
> if you are surrounded by ship building yards, bicycle and motor works,
> high class fancy goods would beckon your passers by in vain ... You
> must suit your goods to your public.[102]

Seasonable window dressing, or schemes engineered for special
occasions witnessed a breaking out from the restraints of the local
and the everyday, and even the conservative *Tailor and Cutter*
allowed itself a moment of escapism in its ambitious description
of possible Easter scenes such as a hat window containing 'an
arch ... trimmed with smilax, and studded with lights. In the centre
an egg ... upon a revolving disk, also lighted, and from the broken
sides a crop of Easter hats ... protruding as if just hatched out'.[103]
Despite their technological sophistication and conceptual origin-
ality which competed well with the extravaganzas accomplished
in department-store displays, visual evidence of their take-up
beyond the world of trade journalism, by real tailors and outfitters,
is more difficult to locate. The adoption of a humorous tone, how-
ever, is highly suggestive of the commercial uses to which a
homosocial sharing of jokes and puzzles might be put, and dis-
tances such descriptions from the more lyrical or romantic
treatments deemed suitable for the draper, milliner and haber-
dasher:

> Some amusing windows have been those containing a flock of little
> chickens dyed in brilliant colours. This operation does not hurt them,
> and can be done by making a bath of various hues with the aniline dyes
> which now come ready to be dissolved in water ... the chicken may be
> quickly dipped therein, while its eyes and mouth are held closed. A
> background of mirrors may be placed to form a maze, and the reflected
> images will be endless. The mirrors should be placed so the ground plan
> is somewhat like a Greek cross ... to make a baffling effect; a prize
> might be offered to the person correctly guessing the number of
> chickens actually in the window. The window may also be filled with
> chickens dressed in paper suits. Their antics when so attired will be
> highly diverting.[104]

Sale times offered more realisable opportunities for the rearrangement of displays, even though *The Practical Retail Draper* claimed that 'men, unlike women, are seldom attracted by sales or great reductions, and it is only the few who are economical and take any special interest in the outfitter's window during the sale season',[105] and this despite a later assertion that 'the reduction of unseasonable stock, and the rightful adjustment of the balance of stock, is effected largely through the use of the window. It is the safety valve of the shop-keeper.'[106] Two views of shop fronts in south London selected by *The Tailor and Cutter* in June 1907 suggest that retailers made full use of the facility regardless of received wisdom (Figure 27). Both windows show the same careful arrangement of large bright sale tickets placed in symmetrical patterns to accentuate a familiar method of display that would otherwise hold the year through. Cooper of Lewisham, Camberwell and Walworth offered a façade marginally better appointed than its pair, with its inscribed brass base or stall plate, ornamental fascia and fancy wooden tracery. Gardiner & Co. of Deptford compensated with a more overt recourse to brash temporary posters, obscuring the first storey of the building with a banner proclaiming 'one half usual prices'.[107]

The combination of restrained gentility and rapacious commercialisation that the two examples represent found a more coherent focus in the windows of West End retailers, whose position and custom allowed for more experimental extremes. Harry Hall of Oxford Street was an astute publicist whose displays and promotions often merited an inclusion in *The Tailor and Cutter*. During the season of 1907 it featured a photograph of his window celebrating the equestrian events that formed the focus of the gentleman's calendar through the summer months. 'It will be observed', noted the editorial, 'that he makes a special feature of riding outfits generally. Leggings, breeches, vests, riding lounges, sporting coats and overcoats are all shown; while a variety of tweeds intersperse the specimen garments.' This anticipated the practice suggested in *Publicity* of allocating thematic displays to calendar red-letter days, thus:

> Jan 6 (Twelfth Day) 'Back from the Party' Outdoor snow scene: figures in overcoats and mufflers ... A warm looking outfit can be labelled 'better than doctor's bills'; March 1 (St David's Day) Welsh National Display - Ticket: 'Welsh Flannels for Satisfaction'; Sept 29 (Michaelmas) The dinner jacket and dress shirt: 'Tuck the goose behind one of these waistcoats.'[108]

The broader context of the window accentuated the reserve of elite connections and the modernity of current retail design with

gilt letters across the front which, according to *The Tailor and Cutter* announced:

> 'Harry Hall, American and Colonial Outfits' and [included] a City of London coat of arms; while the stall plate states in the fewest words the name of the proprietor, and the specialities of his business. The window is lighted by a row of electric lamps from the top. The frame in the centre ... is devoted to the praise of his 21s special breeches, while the side frames contain fashion plates.

All of the components contributed to a window vista marked by its depth and variety (Figure 28). Furthermore the offer on the breeches was considered audacious enough to 'spread consternation in many West End Houses'.[109] The wider significance of Hall's window, however, lay in his ability to suggest the reserved visual rhetoric of traditional tailoring practice alongside an embracing of promotional chutzpah and fast turnover; a clear endorsement of the new methods summarised by the author of *Publicity* in his gentle mocking of 'the retailer in a rut':

> His window fittings have lost their freshness, but he is too short sighted to scrap them, or even send them to a shopfitter to be renovated at a trifling cost. He clings to his old brass standards, fixed in the same position year after year, rather than buy for a few shillings the modern spring top adjustments which would enable him to change the position of his fittings for every display. He despises the glass window shelves of his competitor, and would rather loose business than admit he followed

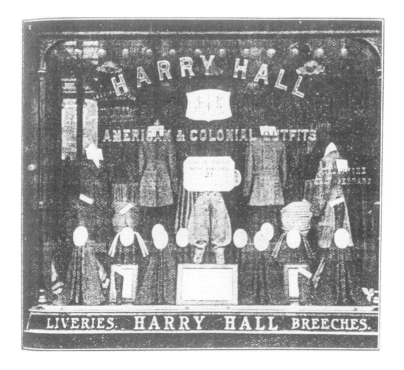

28] Illustration, *The Tailor and Cutter*, June 1907. Thematic displays were often connected to events in the social calendar. Here, the equestrian events of the social season dictate the choice of stock in Harry Hall's West end window.

his neighbour's example with such an innovation. He sticks to his dirty old paper or even faded sateen for the bottom of his window. He cannot afford to put in a parquet window floor and he is not smart enough to substitute the excellent imitation in linoleum which can scarcely be detected from wood when polished ... He is a good fellow in himself and will assure you that his trade is 'a personal connection'. He 'serves most of the customers' himself even if the shop and stock are in a hopeless state in consequence. If you suggest that a smart window dresser and salesman would attract new customers, the 'retailer in a rut' protests that he would certainly lose money, and probably his valuable 'personal connection'.[110]

The costs of fitting out a window in the modern style were not inconsiderable and go some way towards explaining the reluctance of some small businesses to update their premises. M. S. Gotlob, Tailor and Haberdasher of 32A Charing Cross, evidently undertook a major refurbishment of his property in the winter and spring of 1911-12, and his ledgers record significant outgoings for fixtures and fittings:[111]

Oct	2	To Balance	101	160	6	5
	3	" Browning & Holtum	1	24	7	"
	"	" Owen & Co. - carpet	"	1	14	"
Nov	7	" Whiteley W. Ltd - curtains	2	2	11	3
	16	" Potter & Co. - tickets	"	8	7	4
Dec	7	" Cunningham R.N & Co. - lamps	3	1	2	"
Feb	12	" Rubenstein J. - wages	5	2	"	"
Mar	20	do	6	2	"	"
	"	" Maple & Co.	"	48	"	"
May	21	" Browning & Holtum	7	1	7	"
Mar	2	" Safe	pc41	2	5	"
Sept	30	To Balance	6/a	237	10	"

Beyond the payments to Owens, Whiteleys and Maples for carpet, curtains and furniture, Gotlob made use of William Potter & Sons, shopfitter of 160 Aldersgate Street in the City. Potter's trade catalogue of the early 1890s provides the most detailed evidence of the range of ephemera and equipment available to the aspirant shopkeeper (Figure 29). This is detail otherwise lost in the gloom of store photographs or the inevitable transience of retail interiors, caused by constant refits over the course of the intervening century. In a cramped representation of a tailor's window the company's dummies are laid out, the accompanying text advising that

for proper display of coats, suits, trousers & c., busts of approved and modern shapes should be used. These should vary in height from floor level up to 3 or 4 feet high, according to depth of window. Woollen and piece goods are best shown on upright tin or wood dummies. By a simple arrangement these can be sloped at any angle or laid flat. Piece goods

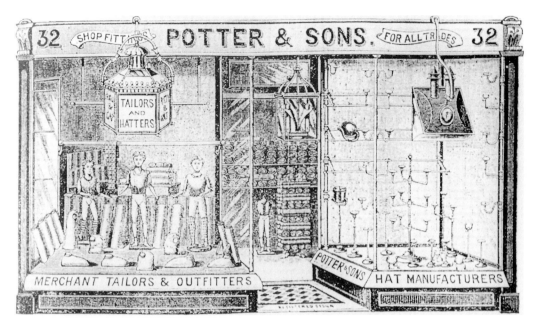

29] Catalogue illustration, Wm Potter & Sons, *c.* 1895. The complex architecture of the window display dictated the need for a variety of supports, shelves and stands.

dummies are useful for many purposes, particularly for shelves and fixtures ... The brass rail at back is intended for a trouser or cloth rail. For showing piece cloth or ready mades something of the kind must be used ... It is hardly necessary to point out that here as in other windows, plate glass mirrors are not only desirable, but absolutely necessary.[112]

Closer inspection of the dummies revealed a wide range of figures with jointed arms, shoulders and hands on velvet pedestals with papier-mâché or wax heads and realistic head and facial hair. Also available were position figures 'for cricketing, football, tennis & c.', and clown, pantaloon and 'black boy's' heads. Prices ranged from 5s. 6d. for a boy's headless figure to £5 5s for the most superior wax models.[113] The existence of such props casts into doubt the assertion of retail historian William Leach that male mannequins were not 'used much at all, except as foils for other displays or to illustrate male dress in the most non-animated way'.[114] Other items, including functional japanned iron cloth stands for supporting cloth bales, carved mahogany mantle stands, telescopic glass shelving and intricate brackets and sockets for the display of umbrellas, competed with a full selection of display boards and price labels with illuminated letters and gold stamped figures on 'marone, cream or olive green card'.[115] Their intricate brilliance further undermines the assumption that 'the display of men's wear was low keyed, unassuming, connected with drab colours, always simple, muted and undecorative in the "masculine" manner'.[116]

Through this grouping of bizarre objects, unrelated by any linking stylistic or decorative characteristics, but all representative of

the spectacular possibilities inherent in late nineteenth-century technology and manufacture, one is reminded again of the ambience of exhibition culture and the visual confusion of modernity, isolated as key features in the development of Victorian commodity culture. Thomas Richards states that the design of the Crystal Palace

> produced a kinetic environment for inert objects. Like a prototypical department store, it placed them in a climate controlled landscape, it flooded them with light, it isolated them in departments, it channelled people through them, and it turned them into the focal points of aesthetic and linguistic contemplation. Its peculiar ambience charged things with special significance and made it difficult to perceive them as static … producing a space that drove consumers to distraction.[117]

The elements of the outfitter's window at the turn of the century performed a similar function, transforming and enlivening the morbid traces of the male wardrobe. To suggest that they drove the consumer to distraction is more hypothetical. Promoters of modernisation in the menswear retail trade would surely have disagreed, claiming such transformations as evidence of a progressive rationalisation of haphazard older habits that were guaranteed to increase revenue. Richards is right, however, to identify the visual impact of display, when he claims that 'the Crystal Palace both extended the sway of sight over all commodities and signalled the rise of a new imagistic mode for representing them.'[118] The modern shop window did precisely that, leading the consumer from a framed representation or reflection of fashionable urban masculinity into an interior where the concerns of surfaces reformed to focus on the fitting out of his own body.

The artful ambience of the shop interior

> After passing scores of shops, suddenly the pedestrian stops, and after a casual glance is led to study a certain window. His hand goes gently to his pocket, and after a casual look into a handful of money he walks in and leaves some of it in exchange for some article of gentleman's attire. Why? He passed other shops and felt no need. They were showing things similar to what he bought and maybe cheaper, but nothing made any loud appeal; but by some witchery or other, which the one shop exercised, he had started in his mind the train of thought which ended in his exchanging his 1s 6d for a scarf or other useful article.[119]

Finally then, leaving the window display behind, the consumer entered into a direct negotiation with clothing as commodity. The appropriate decoration and differing environments found within the menswear store have already been discussed, at least in relation

to the various outlets that characterised the sector in the period. But in the conclusion to this chapter there remains an opportunity to chart more directly the connections that arose between these new forms of retail design and the emergence of the 'modern' male consumer. In 1910 the author of *Publicity*, quoted above, positioned a rhetorical question concerning the succesful transacting of a sale. The answer to his 'Why?' lay in the clever application of modern retail methods, chiefly through the manipulation of window space, but also through the provision of an interior setting which calmed and flattered the customer into making a purchase. In broad terms this entailed the rejection of the old 'vogue for heavy and carved ornamental work'[120] and an acknowledgement of new trends in commercial interior design which stressed individualis-ation and fostered a heightened sensitivity to issues of style amongst clients:

> It is of no use for the shop interior to be just the same as any other shop interior; trade can nowadays only be successfully attracted and held by unique methods, and the shop with the individual and distinctive char-acter is the shop that gets business. The art of design is being wonderfully developed in this way by our leading shopfitting firms. The shop inter-ior as we used to know it will, within a very few years now, have been transformed into the resemblance of the reception rooms of a public building, strikingly typifying the evolution of the retail outfitting trade from its former status to its recognised position in the public service. The entire business of the clothing of the nation is taking on a new phase with every step of social, commercial and industrial progress; and the environment of the shop service must reflect that advance.[121]

While that shift was couched with the aid of reassuringly mascu-line metaphors for advancement, the material changes that affected menswear shop interiors were as aestheticised and decora-tive as those affecting the feminine commercial sphere. As the author of *Publicity* continued: 'while clothing is a necessity it is also an art ... our 'clothes galleries' should be no less ornamental and artistic than our picture galleries'.[122] Thus, within their reuphol-stered walls, the tensions between received notions of manliness and the visual demands of a redefined consumer sphere were par-ticularly acute. The spatial considerations of the ideal new interior certainly favoured a lightness and delicacy far removed from those expectations of dark wood and green baize that identified mas-culine space in other spheres of life: the domestic study, the office boardroom or the club dining room. *The Practical Retail Draper* referred to the transforming effects of glass in lightening the look of menswear shops by the turn of the century, noting that

> in the very well fitted menswear showrooms in the premises of several London outfitters and drapers the glass topped counters ... are a

conspicuous feature, their circular ends giving a very beautifully fin-
ished appearance ... there must be mirrors in all ladies departments and
in the menswear shops too, for they are appreciated by both sexes ...
Glass is strongly in evidence in a well appointed shop. It is found in the
windows, in fixtures, on counter tops, mirrors in the showroom and in
use as shelves on which to display goods.[123]

The theme of light was continued in other elements of decoration
which 'will of course follow in line with the fixtures to be used. It
is said that in the decoration of their rooms, the leading drapers in
the colonies prefer quieter shades of green, greys and pale
blues.'[124] *Publicity* concurred with the adoption of pale tones,
advising 'neutral tints and designs rather than ... decoration of an
elaborated or ornate character'.[125] As far as wood was concerned,
plain light oak was pushed as the sensible choice.

These were the templates offered by retail writers and journal-
ists. The concrete spaces of existing shops provide clear evidence
that advice in many cases was heeded. For the most part, though,
proprietors retained some semblance that the menswear store was
a space still reserved for the exchange and circulation of masculine
goods, and by extension a stage for the performance and formation
of more traditional masculine identities. This was particularly the
case with respect to menswear departments which found them-
selves part of larger organisations whose public image projected
the feminine nature of their provision. When *The Practical Retail
Draper* held up the premises of the south London department store
Arding & Hobbs for approval it observed that

> the interior of the building ... is divided up into compartments by more
> or less permanent structural divisions - a very desirable feature in map-
> ping out a large space ... on the ground floor under review it will be
> noticed that the main entrances are at the corners, giving immediate
> access to those departments in which the chief staple trade of a draper
> lies. Side entrances also give access to the same departments, and to those
> portions of the building where the side-lines of drapery are stored. Men's
> boots and shoes and gentleman's outfitting are arranged prominently
> on the ground floor.[126]

Implicit in such a description was an understanding of the desir-
able separation of men's concerns. This was a desire reiterated in
an advertisement for Marshall & Snellgrove, aimed at a predomin-
antly male readership, which appeared in *Punch* in August 1913. It
announced that: 'You are invited to visit our newly appointed and
re-arranged department on the ground floor for all that is worth-
while in gentlemen's outfitting. The entrance of this section is at
the corner of Vere Street and Marylebone Lane, so that it is not
necessary to walk through any other department.'[127] Contrary to
the interpretation of those historians who view the desires of men

as being extraneous to the spatial conception of department stores, or demoted to their farthest extremities almost on sufferance, one might read the discreet, though central, placing of menswear provision more positively, as an attempt to retain the integrity of a specific masculine mode of consumption within the broader sphere of a consumer activity more usually defined as feminine.

It is significant that the Marshall & Snellgrove advertisement should have been carefully pasted into the press book of Austin Reed, a modernising men's outfitter which expanded rapidly during the period following its founder's apprenticeship in the department stores of Chicago and New York.[128] While his own business dealt exclusively with items for the male wardrobe, Reed clearly felt the need to remain abreast of developments in the wider retailing world; and if the interiors and strategies of Oxford Street posed any competition to his own City-located empire, then the department stores must have been infringing on the same market. Indeed the potential value of that market encouraged the company to open a branch in Regent Street in 1910. Reed had no need to worry over this. His own premises presented a coherent and confident setting for masculine consumption, deftly combining old and new approaches to meet current demands. In a brochure of 1911 the company collated a series of interior photographs of its stores in Fenchurch and Regent Street which lay out the Reed aesthetic (Figure 30).[129] They show a rational organisation of stock in neatly labelled boxes, carpeted rooms lined with glass display cases and informally positioned display dummies. The

30] Catalogue illustration, Austin Reed, 1911. Austin Reed combined the efficiency of American systems of retailing with an attention to creating traditional club-like interiors.

opaque glass lamps, plaster ceiling mouldings and broad polished staircases impart a country-house atmosphere, the combined effect of which provided a model followed by retailers across the country. The author of *Publicity* isolated the similar interiors of Messrs Gieve, Matthews & Seagrove of Portsea, designed by Birmingham shopfitters Harris & Sheldon, for a special mention:

> They made all the fixtures, such as wall fixtures, glass counters, show tables, and fittings such as fixture boxes, and every description of display stands for showing gloves, ties, socks, caps and umbrellas. The scheme was carried out in fumed oak, wax polished, the fixture boxes being covered with an art shade of green cloth, and the bottom of the counters lined with art green felt. The whole looks exceedingly handsome, the colour scheme being very restful to the eyes ... It gets away from the usual type of shop interior, in as much as the counters are in short lengths, and the articles for sale are displayed about the shop in a man-ner that enables prospective customers to inspect them at their pleasure.[130]

A final example, from the Midlands, illustrates how far an accept-ance of modern methods and a linking of consumption with wider questions on the nature of twentieth-century masculinity had penetrated the English retailing psyche. Besides embracing the contemporary use of mirrors, this interior also incorporated the notion of a dialogue into its decorative scheme, a dialogue point-edly located within the romantic and theatrical milieu of the Elizabethan sixteenth century. One might justifiably read retail space in the late nineteenth- and early twentieth-century city as a theatre in which modern forms of masculinity were acted out. The evidence gathered here to reconstruct its scenery has not directly uncovered the intentions or behaviour of any actors, though it does offer some sense of their environment and its importance in shaping sartorial attitudes. In this last interior we are provided with a rudimentary script, leading on to a discussion in the final chapters of the book of the ways in which men's clothing itself constituted a language for the performance of modern mascu-linities beyond the confines of the shop:

> The interior of the new hat and tailoring department of Mr Sydney W. Knight of Knight's under the Grand Hotel Leicester, is contrived by the aid of mirrors to produce an endless corridor effect. The long vista adds quite an attractive feature to the establishment, and in an instance, of the ingenuity of modern methods of shop arrangement ... One of the most striking features of the decoration of the new department is the aptly chosen series of quotations from the works of Shakespeare adorn-ing the cornices: 'Costly thy habit as thy purse can buy: for the apparel oft proclaims the man.' Hamlet I iii.[131]

Notes

1 C. Dickens, 'Shops and their Tenants' (adapted) in *The Tailor and Cutter*, 30 September 1897, p. 496.

2 L. Walker, 'Vistas of Pleasure: Women Consumers of Urban Space in the West End of London 1850-1900' in C. Cambell Orr (ed.), *Women in the Victorian Art World* (Manchester: Manchester University Press, 1995), pp. 70-88.

3 W. Benjamin, *Charles Baudelaire: A Lyric Poet in the Era of High Capitalism* (London: Verso, 1989).

4 E. Abelson, *When Ladies go A-Thieving: middle-class Shoplifters in the Victorian Department Store* (Oxford and New York: Oxford University Press, 1989). M. Nava and A. O'Shea (eds), *Modern Times: Reflections on a Century of English Modernity* (London: Routledge, 1996).

5 E. Zola, trans. F. Belmont, *The Ladies Paradise* (London: Tinsley Brothers, 1883).

6 L. Loeb, *Consuming Angels: Advertising and Victorian Women* (Oxford: Oxford University Press, 1994), p. 11.

7 J. Benson, *The Rise of Consumer Society in Britain 1880-1980* (London: Longman, 1994), pp. 59-81; J. Benson and G. Shaw (eds), *The Evolution of Retail Systems c. 1800-1914* (Leicester: Leicester University Press, 1992).

8 D. Alexander, *Retailing in England during the Industrial Revolution* (London: Athlone Press, 1970), pp. 128-46.

9 C. Booth, *Life and Labour of the People of London*, revised ed. 1902, Vol IV. *The Trades of East London Connected with Poverty* (New York: Augustus Kelley, 1969), pp. 38-40.

10 *Ibid.*, p. 40.

11 *Ibid.*, p. 143.

12 *The Modern Man*, 8 January 1910, p. 15.

13 W. B. Robertson (ed.), *Encyclopaedia of Retail Trading*: Harmsworth Business Library vol. VII (London: Educational Book Company, 1911), pp. 264-5.

14 *Ibid.*, p. 265.

15 *Ibid.*, p. 266.

16 *Ibid.*, p. 267.

17 'A Famous Firm of Tailors', *The Tailor and Cutter*, 15 July 1897, p. 357.

18 'Academy Students at Poole's', *The Tailor and Cutter*, 22 July 1897, p. 369.

19 *The Queen*, 15 October, 1881.

20 'Academy Students at Poole's', *The Tailor and Cutter*, 29 July 1897, p. 381.

21 *The Tailor and Cutter*, 22 July 1897, p. 369.

22 A. St John Adcock, *In the Image of God: A Tale of Lower London* (London: Skeffington & Son. 1898), p. 30.

23 *Ibid.*, pp. 32-3.

24 J. W. Hayes, *The Draper and Haberdasher: A Guide to the General Drapery Trade* (London: Houlston's Industrial Library, 1878), p. 90.

25 *Ibid.*, p. 92.

26 H. Mayhew, *The Shops and Companies of London and the Trades and Manufactories of Great Britain* (London, 1865).

27 F. W. Burgess, *The Practical Retail Draper: A Complete Guide to the Drapery and Allied Trades*, (London: Virtue & Co. 1912), vol. IV, p. 22.

28 Robertson, *Retail Trading*, vol VII, pp. 12-13.

29 *Ibid.*, p. 12.

30 Price list of xylonite linen 1901, Walthamstow Libraries, W24.5XYL/8-3649.

31 Robertson, *Retail Trading*, vol. VII, p.14.

32 Hayes, *Draper*, p.13.

33 *Ibid.*, p.20.

34 Robertson, *Retail Trading*, vol. VII, pp.10-11.

35 *Ibid.*, p.10.

36 *Ibid.*, p.3.

37 Burgess, *Practical Retail*, vol. IV, p.23.

38 Robertson, *Retail Trading*, vol. VII, p.4.

39 *Ibid.*, p.5.

40 *Ibid.*, p.6.

41 *Ibid.*, p.8.

42 *Ibid.*, p.4.

43 *Ibid.*

44 *Ibid.*

45 G.J. Wood's, Kingsland & Islington, trading brochures, *c.* 1890, London Borough of Hackney Local History Archive 332.14P. Y6865.

46 Ira Perego & Co., New York, Trading brochure, *c.* 1890, National Art Library, Victoria & Albert Museum.

47 Burgess, *Practical Retail*, vol. IV, pp.23-4.

48 *Ibid.*, p.27.

49 C. Dickens, 'Shops and their Tenants' p.496.

50 Burgess, *Practical Retail*, vol. II, p.211.

51 *Ibid.*

52 *Ibid.*

53 Share Prospectus of British Clothing Company Limited, 1865, Guildhall Library 31.41.

54 John Johnson Collection of Printed Ephemera, Bodleian Library, Men's Clothing.

55 *Ibid.*

56 *The Tailor and Cutter*, 5 June 1874, pp.428-9.

57 Robertson, *Retail Trading*, vol. VI, pp.253-4.

58 *Ibid.*, p.252.

59 *Ibid.*, p.253.

60 *Ibid.*, p.252.

61 *Ibid.*, p.254.

62 Burgess, *Practical Retail*, vol. I. p.25.

63 *Ibid.*, p.27.

64 Welch Margetson & Co., trade catalogue, 1913, National Art Library, Victoria & Albert Museum.

65 James Platt & Co., advertisement, *The Tailor and Cutter*, 18 January 1883.

66 *Modern London: The World's Metropolis* (London: Historical Publishing Company, 1888), p.117.

67 E. Pugh, *The Man of Straw* (London: Heinemann, 1896), p.3.

68 D. Kirwan, *Palace and Hovel, or Phases of London Life* (Hartford, Conn.: Belknap & Bliss, 1871), p.140.

69 *Ibid.*

70 J. Greenwood, *Behind a Bus: Curious Tales of Insides and Outs* (London: Diprose & Bateman, 1895), p. 87.

71 *Ibid.*, pp. 88-9.

72 *Ibid.*, p. 91.

73 M. Tebbutt, *Making Ends Meet: Pawnbroking and Working Class Credit* (Leicester: Leicester University Press, 1983), p. 38.

74 *Ibid.*, p. 49.

75 R. Samuel (ed.), *East End Underworld: chapters in the life of Arthur Harding* (London: Routledge & Kegan Paul, 1981).

76 London Borough of Hackney Local History Archive P10783.

77 *The Tailor and Cutter*, 16 September 1897, p. 470.

78 *Ibid.*

79 Burgess, *Practical Retail*, vol. II, p. 169.

80 R. H. Williams, *Dream Worlds: Mass Consumption in Late Nineteenth Century France* (Berkeley: University of California Press, 1982); S. Porter Benson, *Counter Cultures: Saleswomen, Managers and Customers in American Department Stores 1890-1940* (Chicago: University of Illinois Press, 1986); B. Lancaster, *The Department Store: A Social History* (Leicester: Leicester University Press, 1995); R. Bowlby, *Just Looking: Consumer Culture in Dreisser, Gissing and Zola* (London: Methuen, 1985); Abelson, *Ladies Go A-Thieving.*

81 T. Richards, *The Commodity Culture of Victorian England: Advertising and Spectacle 1851-1914* (London: Verso, 1991).

82 John Johnson Collection of Printed Ephemera, Bodleian Library, Men's Clothing.

83 C. Walsh, 'Shop Design and the Display of Goods in Eighteenth Century London', *Journal of Design History*, vol. 8, no. 5, (1995), pp. 157-77.

84 Burgess, *Practical Retail*, vol. II, p. 89.

85 Richards, *Commodity Culture*, p. 30.

86 M. Nava, 'Modernity's Disavowal: Women, the City and the Department Store' in Nava and O'Shea, *Modern Times*, pp. 46-56.

87 Richards, *Commodity Culture*, p. 52.

88 John Johnson Collection of Printed Ephemera, Bodleian Library, Men's Clothing.

89 Lancaster, *Department Store*, p. 16.

90 *The Tailor and Cutter*, 16 May 1907, p. 334.

91 *The Tailor and Cutter*, 28 April 1892, p. 159.

92 *Ibid.*

93 *The Tailor and Cutter*, 12 May 1892, p. 176.

94 Lancaster, *Department Store*, pp. 55-6.

95 *Ibid.*, pp. 75-9.

96 *The Tailor and Cutter*, 12 May 1892, p. 176.

97 *Ibid.*

98 *The Tailor and Cutter*, 7 May 1896, p. 200.

99 *Publicity: A Practical Guide for the Retail Clothier and Outfitter to all the latest methods of successful advertising* (London: The Outfitter, 1910), p. 34.

100 *Ibid.*

101 *The Tailor and Cutter*, 17 May 1906, p. 394.

102 *Publicity*, p. 3.

103 *The Tailor and Cutter*, 26 March 1896, p. 141.

104 *Ibid.*

105 Burgess, *Practical Retail*, vol. IV, p. 30.

106 *Ibid.*, p. 31.

107 *The Tailor and Cutter*, 6 June 1907, p. 382.

108 *Publicity*, p. 38.

109 *The Tailor and Cutter*, 20 June 1907, p. 411.

110 *Publicity*, p. 1.

111 M. S. Gotlob, private ledgers 1910–1916, Westminster Local History Archive 405/1.

112 Wm Potter & Sons, price list, *c.* 1895, National Art Library, Victoria & Albert Museum, p. 41.

113 *Ibid.*, p. 55.

114 W. Leach, *Land of Desire: Merchants, Power and the Rise of a New American Culture* (New York: Pantheon Books, 1993), p. 67.

115 Potter, p. 11.

116 Leach, *Land of Desire*, p. 66.

117 Richards, *Commodity Culture*, pp. 30-1.

118 *Ibid.*, p. 32.

119 *Publicity*, p. 3.

120 *Ibid.*, p. 24.

121 *Ibid.*, p. 27.

122 *Ibid.*

123 Burgess, *Practical Retail*, vol. I, pp. 117-25.

124 *Ibid.*, p. 123.

125 *Publicity*, p. 25.

126 Burgess, *Practical Retail*, vol. I, p. 67.

127 Austin Reed, advertising pulls 1913-1914, Austin Reed Archive.

128 B. Ritchie, *A Touch of Class: The Story of Austin Reed* (London: James & James, 1990), p. 11.

129 Untitled pamphlet, 1911, Austin Reed Archive.

130 *Publicity*, p. 29.

131 *Ibid.*, p. 30.

'In London's maze': the pleasures of fashionable consumption

5

> For Quain knew the monstrous city from north and south to east and west. He was at times a dilettante of London as a town: if he had been in better circumstances he could have studied it with scientific ardour. But poverty dipped him in alien toils: he was dyed with the juice of this urban fungus: he could keep no clear mind or aloofness: he had gyrated with the other moths about the central glow, and with burnt wings, which might have borne him far, he crawled near horrible attractions that at the best could satisfy nothing.[1]

City life at the turn of the nineteenth century was often represented in popular literature as a sensual trap for the unwary. Imagined as a nocturnal place by those who took this line, its illicit pleasures taxed the wealthy and consumed the poor alike. Morley Roberts was well aware of this conceit when, in his melodramatic novel *Maurice Quain*, he represented his anti-hero as a slumming moth, drawn by the glaring lights of West End casinos and East End fleshpots to moral bankruptcy and economic ruin. While for women very real dangers were seen to lie in the 'city of dreadful delight',[2] the threat to masculinity was conceived of in more metaphorical terms, as the leaching away of manly fibre, an enervating pull that robbed men of vitality and individuality. In many ways this was also an argument much utilised to undermine the viability of fashion in the masculine sphere, itself a symptom of the corrupt urban condition. This congruence of the threat represented by the ever expanding and fragmenting city with the growing importance of leisured fashionability as a social marker in an increasingly commercial culture, resulted in several debates centring on the physical and aesthetic experience of self and others in the new urban context. The questions they raised extend directly into the remit of this chapter. Essentially, how were the acts of buying and wearing fashionable clothing validated as a pleasurable and 'modern' experience for men whose cumulative social education appeared to dismiss the process as unmanly, dangerous and peripheral?

As Richard Stein has commented in his work on urban identities: 'populated cities populate our consciousness, and our self consciousness. The very habit of generalising urban experience ... is one of the ways "we" define identity in a culture preoccupied by the erosion of the self in mass society.'[3] That process of definition, which hangs so closely on the appearance of clothed bodies, was an issue that first found a voice through the literary construct of the flâneur, the leisured connoisseur and critic of contemporary life, in mid-nineteenth-century Paris. His delineation offers one model for considering the status of fashionable masculine consumption in the nineteenth-century city. Charles Baudelaire's text 'The Painter of Modern Life', first published in *Le Figaro* in 1863, presented the flâneur as the quintessential Parisian voyeur, though his symbolic importance has since been utilised by literary theorists and art historians as a more general, less spatially specific commentary on the experience of urban modernity that finds resonances in New York, Berlin and London at various moments since the 1860s. Eli Blanchard, for example, in her exploration of decadence, has framed the flâneur as a spectator and recorder of the shifting, elusive richness of a generic city life:

> The city has become a stage, a spectacle, and while the timing of appearance is unpredictable, the subject can attune himself to these happenings by preparing himself for everything. He is the flâneur. Walking desultorily through the city and paying attention to the way the city begins and ends before his very eyes ... Those appearing are types. Never does the flâneur know them personally. He recreates a picture of the encounter he has had with them ... They linger on in his memory while he reconstitutes for us and for himself the story of their life.[4]

The usefulness of her framing lies in the importance it places on understanding the flâneur as a partial, literary architect of imaginative past moments. This is of direct relevance to the approach adopted in this chapter, which attempts to consider the ways that the pleasurable adoption and circulation of fashionable forms of clothing lent meaning to the ever shifting construction of varying types of masculinity in *fin de siècle* London, basing its conclusions on the far from impartial reminiscences of men who would have considered themselves as 'connoisseurs' of the city scene. Previous chapters have relied to a greater extent on the evidence of more formal sources for their interpretation of the scope, provision and display of garments. Trade journals and catalogues, alongside topographical recordings and didactic manuals, have offered readings of distinctive forms and outlets relatively free from the interpretative problems of representation and subjectivity (though they are arguably just as strongly determined by the conventions of genre

and the requirements of use). The questions of pleasure and identity raised here, necessitate consideration of a wider and more problematic range of evidence not normally associated with the empirical endeavours of the social, economic or design historian, though more freely linked with the debates on representation and modernity that have concerned literary, cultural and art historians over recent years.[5]

The imaginative meanderings of the flâneur and the subsequent re-interpretations of his message emerge as a critical precedent for reading and understanding the unstable status of the street argot, advertising scraps, popular journalism, sentimental novels and music hall lyrics within which a language of fashionable urban masculinity was couched. While we should acknowledge the impossibility of recapturing intact the impulses and motives of the nineteenth-century consumer, an assessment of the ephemera, the visual and aural 'urban noise' that may have informed his choices seems essential. The most fastidious of historians might count those sources as peripheral at best, and unlikely to yield reliable data, but, like the actions and reminiscences of the flâneur, they offer intriguingly suggestive insights into the nature and experience of modernity and should not be too lightly dismissed for their lack of provenance or resistance to closure.

Social historians in their recent concentration on leisure have understandably been reticent to take such 'romantic' obsessions on board. As Peter Bailey's introduction to his classic study of leisure and class in the nineteenth century shows, the dominant debates here have concerned the extent to which forms of (working-class) leisure betray a range of exterior structuring practices, economic, political, social and cultural. Leisure is a phenomenon that

> has been variously represented as massified and manipulated under a new corporate consumer-oriented capitalism; as less than totally manipulated but at the same time more complicit with the hegemonic 'national-popular' culture of an imperialist state; as newly 'traditional' and custom bound; as predominantly consolatory; as vigorously populist and self-determining; as typically associational and individualist; as independently class-based; as class convergent.[6]

Aside from a suspicion of the cultural studies pre-occupation with the instability of historical texts, and that search for meaning in their surface signs which has characterised much treatment of flâneur literature, the social history of leisure (reflecting its roots in a Marxist adherence to history 'from below') has been more concerned with its official, public manifestations, rather than the personal, private reactions embodied in literary and other representational responses to its forms.[7]

In approaching the masculine pursuit of fashion (a field of leisure that has received scant attention from any academic quarter, from gender studies through to dress history), it makes sense to capitalise on the stimulating leads that both cultural and social historians have opened up for its further exploration. Moving from the practical acquisition to the cultural meaning and diffusion of men's clothing, the behaviour and image of the consumer, this chapter takes as its starting point those city spaces in which both the scholar of 'flâneurie' *and* the social historian might feel comfortable. Remaining at first in the shop interior, the chapter uncovers the forms of language used to sell clothing as an artefact implicated in wider constructions of a leisured urban life. Focusing on the formations such a life might have taken, it proceeds to examine the role played by fashion in demarcating the boundaries of a bachelor existence, a key phenomenon of the turn-of-the-century city scene that permitted the notion of a pleasurable consumption consistent with the ideals of the gentleman. Together this discourse of fashionability and its iconic imagery set a loaded template of modish masculinity that influenced subsequent considerations of the difficult and unstable relationship between manliness and clothing.

'SAUCY CUT TOGS': the language of sartorial pleasure

Shopping for clothing and the subsequent discussion of valued purchases constitute one of the prime pleasures of metropolitan life, but also one of the most fleeting. Any attempt to reconstitute the experience historically is hindered by the ephemeral nature of the moment of consumption. Retail historians are able to reconstruct the appearance of shops, the details of stock and display, but the transactions that took place behind the window are more difficult to fix. The spoken word plays a key role in determining those choices that dictate the nature of a purchase, but its forms are rarely recorded. Young men with a predisposition to fashion at the end of the nineteenth century were blessed with a range of vibrant terminologies that described their clothes and established connections with other leisure pursuits. The roots of that language originated at the point of purchase and go some way towards establishing the nature of masculine consumption habits and the 'lost' relationship between the market place and the client that offered particular pleasures to its participants. Any survival of its forms elicits a shock through the directness of their communication and the light this sheds on the obscured 'practice' of consumer behaviour:

Pay a visit to C. Greenburg, the noted working men's tailor, well known

by everybody to be the only genuine clothing manufacturer in Chelsea for flash toggery. The above champion builder begs to thank his customers for their liberal support, and wishes to put them awake to the fact that he has dabbed his fins on a nobby swag of stuff for his ready brass, consisting of cords, moleskins, doeskin plushes, velveteens, box cloths, pilots, tweeds & c., which he will make up in the best of styles to suit all comers at the following low prices: A pair of ikey cords, cut slap up with the artful dodge and fakement down the sides, from 10 bob. Proper cut togs, lick all comers, for pleasure or business wear, turned out up to the knocker, from a quid. A pair of kerseymere or fancy doeskin or any other skin kicksies, any colour, cut peg top, half tights, or to drop down over the trotters, from 10 and a tanner to 25 bob, fit to toe it with any swell. Lavenders, built spanky, with a double fakement down the sides, and artful buttons at the bottom, any price you name, straight. Fancy sleeve vest, cut very saucy, tight cut round the scrag or made to flash the dicky, from 9 bob. A discount made to prize fighters, shop lifters, quill drivers, counter jumpers, bruisers, snobs, scavengers, sparrow starvers, and lardy dardy blades on the high fly. Kids' clothing built very saucy. Caution. – C. Greenburg has no connection with any roughs, calling themselves working men's tailors, as he is the only true and genuine one in the world. 5 White Lion Street, Lower Sloane Street, in a direct line with Chelsea Barracks.[8]

In a printed broadside, roughly datable to the 1880s from the conflation of its various slang terms, the pricing and style of the merchandise and the proprietor's known period of trading, the tailor C. Greenburg of Chelsea subscribed to a form of address associated with the advertising of men's clothing since at least the 1830s.[9] Many of the phrases he adopted to describe the appearance of his products had an earlier origin dating to the late eighteenth century, while others made reference to contemporary prejudices and issues.[10] The use of the term 'kicksies' to describe trousers and the descriptive epithets 'saucy', 'spanky' and 'slap-up' for example, have their roots in the vulgar language of aristocratic debauchery associated with that earlier period of dandyism, popularised in Pierce Egan's tales of metropolitan life during the first quarter of the nineteenth century.[11] 'Ikey' and 'quill driver' reflected more recent terms of abuse, respectively coined for a flashy young Jewish man (a usage made more familiar by the inclusion of the character Ikey Mo in the working-class comic strip 'Ally Sloper' from the 1860s through to the end of the century)[12] and a dockside shipping clerk. Individual etymological roots aside, the advert conveyed a lively blending of back-slang, coster, Yiddish, theatrical, criminal and nautical argot that has barely survived into the late twentieth century, surfacing occasionally in the 'polari' of gay subcultures and the verbal clichés of cockney rhyming slang. Its significance in the late nineteenth century points to the existence of a widely recognisable set of verbal references that place the

selling and promotion of men's clothing within a social frame-
work and general mode of performance that was remarkably
inclusive, addressing as it did consumers as diverse as the lounging
Piccadilly swell and the music-hall-loving monkey parader. Its
alliterative text in turn described certain forms of fashionable
masculinity that correspond closely with those moments of
almost subcultural excess in men's clothing habits which marked
the chronology set out in Chapter 2, from the heavy swells of the
1860s and 1870s to the mashers and knuts of the 1880s and 1890s.
In other words, the joyous vulgarity of the language offers a useful
context for thinking about the mechanisms employed by shop-
keepers and their customers to aid and give meaning to the
acquisition of those loud checks and experimental cuts that signi-
fied a subversive form of fashionable dressing for men of the
moment. Tailoring slang provided an unofficial urban lexicon for
the communication of fashionable masculinities.

Greenburg's own constituency probably drew in consumers as-
sociated with the nearby military barracks. Guardsmen retained a
reputation throughout the period for their loud and finely tuned
appreciation of fashionable taste that often verged on the porno-
graphic in its attention to tightness and fit, and whose social and
occupational relationships were predicated on the exchange and
promotion of slang terminologies. More generally however, the use
of a 'disreputable' vocabulary to encourage custom can be seen
across the retailing outlets of London, taking various forms and
encouraging a reading which uncovers dialogues previously hid-
den from retail historians. In establishing the fleeting relationships
forged between tailors, outfitters and their clients through such
strategies, it becomes possible to suggest that the exchange of
money for clothing entailed much more than the simple provision
of goods. Transactions within the menswear shop instead repre-
sented the first stages in the formation of masculine identities that
have otherwise been obscured by the insistence that men some-
how resisted the blandishments of consumer culture through an
adherence to rational decision-making processes. This refutes the
suggestion that those exchanges marked by any enthusiasm for or
fetishising of the product are peculiar to the feminine environ-
ment of the department store.

As Greenburg's promotion reveals, advertising also offers an
indication of the codes adopted by sellers to convince potential
customers that the business methods or stock of a company con-
formed to pre-existing expectations or would furnish the desired
fashionable image. Pre-existing expectations were themselves re-
liant on established commercial or vernacular rhetorics that might
then be honed by the retailer to isolate the more idiosyncratic

tastes of the local audience. Thus Harris's, clothing manufacturers of 145 High Street, Whitechapel, embraced a stock vocabulary almost identical to the military patois of Greenburg, but tweaked and expanded to reflect the proximity of Petticoat Lane Market with its language of deals and bargains, and directly competing with its rivals in the use of the most colourful adjectives. In its brazenly aggressive claims, the advertisement encapsulated the illicit rough attraction of the East End, capitalising on the tone of promotions for prize fighters and blood-thirsty melodramas which plastered city walls. It betrayed more everyday concerns only in the announcement of its location 'direct opposite the tramway terminus':

> To His Rile Highness The Prince of Nails and His Imperial Majesty The Emperor & his Wench. Harris, well known to everybody to be the only genuine clothing manufacturer in Whitechapel, and acknowledged by the natives to be the cheapest and best house in the neighbourhood for cord and cloth clothing of every description. The Champion of England, slap-up tog and out-and-out kicksies builder, nabs the chance of putting his customers awake that he has just made his escape from Canada, not forgetting to clap his mawleys on a rare dose of stuff, but on his return home was stunned to tumble against one of the tip-top manufacturers of Manchester, who had stuck to the gilt, cut his lucky from his drum, and about namousing off to the Swan Stream, leaving behind him a valuable stock of moleskins, cords ... and having the ready in his kick grabbed the chance, stepped home with the swag, and is now safely landed at his crib; he can turn out toggery very slap-up, to lick all the slop shops in the neighbourhood, at the following prices: ready gilt-tick being no go. Upper Benjamins, built on a downy plan, a monarch to half-a-finnuf. Proper cut togs, for business or pleasure, turned out slap, 1 pound; sneaking or lounging togs at any price you name ... black or fancy vests made to flash the dickey or tight up around the scrag, from six and a tanner ... Double milled drab or Plum box, built in the Melton Mowbray style (by men) at four and twenty bob ... Pair of out and out cords, built very serious from six bob and a kick, upwards ... Young ladies' habits attended to by a practical shickster ... A decent allowance made to seedy swells, tea kettle purgers, quill drivers, mushroom fakers, counter jumpers, organ grinders, bruisers, head robbers, and flunkeys out of collar. Shallow coves, see sailors, or fellows on the high fly, rigged out on the shortest notice ... Gentlemen finding their own broady can be accommodated. Make no mistake! It's HARRIS'S, The most celebrated clothing manufacturer in the world. 145 High Street, Whitechapel.[13]

By the time that Greenburg and Harris were capitalising on the commercial benefits of engaging their customers in the exchange of clothing slang, other clusters of menswear retailers had already established a reputation through their promotion of value and service, couched in a banter engineered to appeal to a broad, specifically male audience, whose shopping priorities did not fit the

usual parameters set up by respectable high-street and department-store methods. Charles Lyons, one of several clothiers situated in the Westminster Bridge Road, sustained an advertising campaign during the 1860s that incorporated the modes of doggerel, political satire and straightforward bargain-hunting to attract the attention of consumers whom Lyons labelled 'working men'. In December 1862 he circulated a poem, 'What & Where', which, while stopping short of the jargon utilised by those purveyors of 'saucy cut togs', nevertheless managed to make 'chatty' reference to contemporary style and popular obsessions without jettisoning the usual advertiser's requirements to provide proof of price and competitiveness:

First on the list comes the 'Indispensable'
A coat which for price is most reasonable
One guinea! Indeed, it's really too cheap
For any material and fashionable shape.

Then follows in suit the 'Beaver Diamond'
Which keeps one dry as a duck in a pond
25s to 45s and very superior
Why go elsewhere for what is inferior?

The elegant Witney, both light and dark
For riding or strolling about in the park
Smart men about town will be sure to buy
And also the 'Young man from the country'

Then comes the 'Dundreary' – a Guinea's the price
Which makes a young man look so very nice
It is the cheapest coat in all the Town
Beating every other clothier brown.

The wool dyed black suit, at two pounds and ten.
Is a fact only seen every now and then.
But at C. Lyons, near the railway
It may be seen any hour of the day.[14]

The theatrical names and stock melodramatic images betrayed the shops' location in an area of south London associated with the administration of the burgeoning music hall industry. The offices of stage managers, actor's agents and theatrical entrepreneurs sprang up along the small streets surrounding the Canterbury Music Hall and the Old Vic Theatre in the 1860s, cementing the district's mythic reputation as a destination for the bohemian and fashionably dissolute. On a more respectable note Lyons was also able to refer to activities across the river at Westminster when in 1868 he reminded 'Borough of Lambeth working men! Before registering your votes for the Liberal candidates, select a one guinea overcoat at C. Lyons, The Liberal Clothier, Westminster Bridge Road.'[15] Both approaches, the romantic and the pragmatic,

however disparate and mercenary the underlying motives, clearly hint at the interest within the clothing profession in establishing tangible relationships with customers based on shared priorities and preoccupations, a common sartorial language. The deliberate promotion of dress by rather risqué means flattered the purchaser that his transaction signified an engagement with the wider sphere of urban fashionability in all its variety, conferring a literal 'worldliness' on his choices.

The performance of masculine consumption: clothing transactions and the romance of the purchase

The 'official' organs of the menswear trade were equally cognisant of the need to respond to consumer desires for more than the simple supply of goods. Towards the end of the century, journal editorials and business guides turned their attention towards issues of customer service and the fostering of correct relationships between server and served in the outfitter's shop. In the tailor's shop such relationships attained an intimacy that was physical as well as psychological, the fitting up of a customer's body taking on a directness lacking in the business of the outfitter or hosier where discussion of fit and style was more likely to be at one remove. Once the customer had been lured in by the promises of a window or an advertisement, the process of being fitted up for new clothing moved beyond even the familiarity of a shared vocabulary and interest towards the negotiation of an intimate social terrain in which the potential breaching of corporeal, sexual and class taboos became dangerously real.

The Tailor and Cutter was certainly aware of the strict protocol involved in the act of measuring up when its aptly named correspondent T. H. Holding reminded readers to

> remember always that your hands are going about a sensitive, intelli-
> gent, animate man, and not a horseblock. First rule - Never stand while
> taking any measures in front of your man, but on his right side. To do
> so is to commit a gross piece of familiarity, rather offensive in all cases ...
> your customer will think none the worse of you for showing a little
> 'breeding' or deference.

The delicate manoeuvres required for the taking of leg measure-
ments received particular mention as

> the leg measure is one of the chief, if not the very chief measure in a
> pair of trousers, and is often taken very faultily. With great quickness
> place end of your measure close up into crutch, then pass down your
> left behind his thigh to knee joint ... take thigh measure close if you use
> them, I don't, nor do a good many others, except under exceptional

circumstances as a guide for the dress. If a man's dress is right, well two measures thus 24, 22, will at once indicate on which side that has to be cut out.[16]

In an article of 1897 it was suggested that the measuring process be carefully hidden in a well-practised sequence of ritualistic transactions, from a courteous introduction, through a general discussion of fabric and style, to an agreement upon detail and finish. It is little wonder that tailors received particular opprobrium from the caricaturist and songster as purveyors of a pompous, dehumanising and highly formulaic masculine shopping experience, in which inappropriate suggestiveness and a servile attention to the customer's physical needs constituted a long-standing component of the stock humorous exchange, one that survives in the contemporary clichés of situation comedy:

> Some cutters will poke here and feel there, pinch up the cloth in one place and smooth it away in another, acting generally as if they were horse dealers or cattle buyers. Such a manner is, in the highest degree, objectionable, for, though a good idea of the customer's body may thus be obtained, yet it is done in such a clumsy brutal way, that it is altogether lacking in grace or style, such as a cutter should possess. This same man who handles his customer in this way would very likely shout aloud to the clerk 'head forward', 'round back', 'prominent blades', 'hollow waist', 'flat seat', 'narrow chest' and generally detail such a list of disproportions that the customer might be excused for considering himself a candidate for a museum of living curiosities.[17]

Beyond a close familiarity with the body of the consumer, the retailer was increasingly expected to foster an assessment of his type and taste that also verged on the unseemly when considered outside of the context of the shop interior. While a pandering to psychological traits was a commonplace in advertising by the 1870s, the suggested translation of such methods to the selling transaction was rare in the trade literature until the influence of American publications after the turn of the century. Before this time advice tended to err on the side of restrained caution, stating in a typical remonstration that 'there is a fussiness which bothers people, and, as a general rule, men leave the minor details to the cutter, believing him to be one whose experience has taught him how to fit these things in a practical manner, which will be better than he can tell him'.[18] Later approaches jettisoned the value of tacit knowledge, which had appeared to underpin a silent trust between fitter and fitted, echoing the reticent characteristics accorded to definitions of traditional 'English' tailoring. New advice opted for a more intrusive manipulation of unspoken desires that might be profitably coaxed out with the aid of American 'therapeutic' retail strategies. Stanley LeFevre Krebs, author of the

chapter 'Finding, Pleasing and Serving Customers' in the guide to
retail salesmanship published by the New York Institute of
Mercantile Art in 1911, confidently asserted that:

> Each one of us shows his taste and ability in his dress, yet taste and
> ability are quite invisible in themselves … As a salesman you can get a
> number of helpful 'leaders' in forming your plan of treatment of a
> customer by a hasty glance at his clothes when he approaches the
> counter … A scientific salesman was standing behind the counter in a
> large store, in the men's furnishing section. A young man walked up to
> the counter and in a flash the observant clerk noticed that the young
> man was wearing a $5.00 shirt and a $10.00 suit of clothes. This customer
> was a young man who evidently prided himself on the quality of his
> haberdashery. He doubtless spoke of the quality which he wore to his
> companions. It was his fad. The clerk saw this at once, and therefore
> when he asked about shirts that salesman did not commence by show-
> ing him dollar shirts or the cheapest in stock. Oh no! He went to the
> best he had. This flattered his customer and reached him along the line
> of least resistance, viz., his tastes and desires. He bought a fine shirt.[19]

In a sense the arrangement of stock in the retailer's window and
behind the counter, necessitated such exchanges, regardless of the
opportunities they suggested for 'scientific' consumer manipu-
lation. The customer fully expected to engage with an assistant
over the selection of goods, which generally had to be physically
'revealed' from shelves and compartments for the client's perusal.
An enjoyable consideration of colour, texture and style with an
informed employee thus formed a reasonable desideratum for the
male consumer throughout the period. He would have been sur-
prised to be faced with anything less, since there were few
opportunities for independent rummaging through stock, except
at the lower end of the market. In this light the advice of *The Tailor
and Cutter* to 'take stock of your customer' betrayed a careful
balancing between retail knowledge and consumer desire:

> is he a quiet style of gent? then shew him goods of that class and as soon
> as you see he has a fancy in a certain direction endeavour to lead him
> to a decision, enlarging on the advantages of these goods and generally
> recommending them to him. Of course you will use discretion as to their
> suitability … though you ought not to shew your customer anything
> that will make him appear absurd.[20]

Without doubt the finely drawn parameters of that relationship
were prone to constant disruption, and the 'drama' of the tailor
and outfitter's business supplied frequent inspiration for social
commentators. The awkward customer was a type constantly
derided in those readers' reminiscences that found their way on to
the pages of the trade journals. In 1874 *The Tailor and Cutter*

published the memoir of a pseudonymous society tailor, Tom Jones, who recalled that he

> waited this morning on General Correy, a retired East Indian officer; I was not quite punctual to the time specified by the General, and he told me with some appearance of anger, that I was too late - that he never saw any one on those matters out of his dressing room, that his hair dresser was punctual, and his boot maker, and he would teach his tailor to be also. From this I learnt that military time must be kept with military men.

Further humiliations gathered at the end of the same week when

> Mr *** the popular Member of Parliament, whose coats we have long made, ordered some trousers. 'Make them', said he, 'perfectly easy, but not loose like those things so commonly worn now, that resemble nothing but the unmentionables of the women in the Turk's harem'. He required one pair made first very quickly, that he might determine whether or not he approved our cut; accordingly I put a pair in hand ... I have cut them close and await with some little trepidation.[21]

An 1895 reconstruction of 'A Day in the Season' was similarly despairing of the vagaries of customers' tastes and the potential therein for conflict when it noted that

> Mr J. says 'Hang fashion ... I want my things as I like, and I will have them. Cut my coats square in front and give me inches of room and plenty of pockets, so that I shall not be obliged to ram everything in one.' Then Mr R. is just the opposite. He says 'Make my things fit me tight and I will not have an outside breast pocket as it spoils the coat. I like to feel my things all over' ... Unless you note all these things on the pattern and from thence to the workman's ticket, you will always be in grief.[22]

The bandying about of technical terminology and a competitive struggle over the eventual look of a garment epitomised transactions at the upper end of the market. The relationship between client and tailor was often represented in the context of an erudite sparring match. Richard Whiteing in the 1899 novel *No 5 John Street* contrived a 'set piece' tailoring scene between the aristocratic dandy Seton Ridler and his Savile Row 'snip', Settles, that further coloured this conception of masculine consumer behaviour as aggressively combative:

> Seton has so much the use and habit of the place that he passes at once to his favourite private room. A lay figure, moulded exactly to his shape ... stands in a corner, clad in his latest suit. The lugubrious effigy is a model for clothing only, so its representative functions stop short of the head which is but a block, and of the feet, which are but pedestals of iron. The rest is Seton to a hair, in shoulders, waist and hip.
> 'I want you to see that trouser again sir, as a match for the frock coat.

In my idea you'll never like it, it's a couple of shades too light.'

'Split the difference to one shade Settles, and I'm of your opinion. If I don't call tomorrow, send the pattern round ... But what's wrong with the skye?'

The melancholy shape has developed a crease in its dorsal region, and Seton points to it with accusing finger. Settles touches a bell.

'Who dressed this model?' 'Blundell, sir.'

'Send him to me presently – A clumsy valet, Mr Ridler, that's all'; and with two deftly nervous pulls from the master builder, the crease disappears.

'It isn't merely knowing how to make clothes sir, it's knowing how to put 'em on ... You and Captain Bransome are the only two gentlemen that can take a coat through a drawing room crush as if it was on the model's back.'

'Not always Settles ... I wasn't very well pleased with the behaviour of that grey cashmere at the garden party.'

'Perhaps you stretched yourself in it first go off sir. It's as well to break 'em in a bit gently to the harder work.'

'Perhaps so, perhaps so', says the youth absently, as his effigy is spun round once more, 'til it stops with its breast to the light. 'I don't like the fall of that black angola Settles. We're still at sea ...'

Then there ensues a most amazing discussion of experts, in which the dandy holds his own in fair give and take of technicalities with the snip ... Such Mesopotamian terms as 'forepart', 'sidebody', 'middle shoulder', and again, the triply mysterious 'skye' are freely bandied about ... From time to time, Seton seizes the chalk and makes drawings on the garment, or makes the figure spin like a prayer wheel. In vain is the cutter summoned to reinforce the head of the firm. On the question whether a back seam should be convex or straight, our young blood takes the pair of them without yielding an inch, while the staff gather about the door as though to catch glimpses of a well stricken field.[23]

Such exchanges could be interpreted as part of the pleasurable round that marked daily life for the leisured gentleman in London, rather than the focus for any meaningful disagreement. Even for those unable to patronise the emporia of the West End, the menswear shop constituted a form of entertainment as much as it provided clothing. Central to this notion of performance stood the figure of the shop assistant, placed simultaneously as stooge and knowledgeable connoisseur. The contradictory expectations of subservience and expertise placed on his actions by employer and customer produced some lively fictional explorations of his character, epitomised most famously by H. G. Wells in the novels *Kipps* and *Mr Polly* and Arnold Bennet in the opening chapters of *The Old Wives Tale*.[24] Beyond literary caricature other popular texts also recognised the standing of the shop assistant as a key urban type. In a series 'Behind the Counter – Sketches by a Shop Assistant' of 1886, *The Cardiff Times* delineated the stereotypical appearance

and interests of young men working in the retail trade, noting of a type classed as 'stage struck' that

> our friend wears a Newmarket coat. In his hand he carries a ponderous walking stick; and when he meets a friend he brings it down with considerable force in close proximity to that individual's toes, while he salutes him with a sentence from the latest melodrama ... He transforms his bedroom into a miniature theatre, the walls of which are profusely decorated with the illustrated advertisements of dramatic companies ... On the whole he is a jolly associate and extremely popular with customers. [25]

Though the clothing and retail trades may inadvertently have encouraged an inclination towards 'inappropriate' emulation among staff assigned to serve a carriage trade that must have symbolised the limit in gracious living, work-place behaviour could hardly have been less theatrical when managers also insisted on the importance of maintaining surface appearances behind the counter. *The Tailor and Cutter* in its 'Hints to Salesmen' of 1896 warned that

> you cannot afford to appear otherwise than respectable. A shabby appearance may arouse some people's pity, but will not inspire confidence in you or the firm which you represent. To be respectably attired excites curiosity, but a seedy appearance provokes contempt. A soiled collar, a worn out necktie, a threadbare suit, a common pair of shoes – all or any of the above will not serve to attract, but repel the class of people whose patronage you can least afford to lose ... If you cannot pay cash for an outfit, get one on credit, and I feel certain that you will soon come to the conclusion that it was a good investment. If you are poor, do not advertise the fact, but strain every nerve to convey the opposite impression. [26]

That stereotypical combination of over-accommodating patter, a tendency towards the verbal joust and the too-obvious veneer of polished respectability, contributed much to the formation of a dubious reputation for male shopworkers, mirroring those long-standing accusations of easy virtue directed at female counter assistants and fashion workers, contaminated as they were seen to be by the dangerous attractions of commodity culture.[27] The implications for masculinity in that context, however, were to encourage a rather more triumphal stereotype, outweighing the negative connotations. The male shopworker could claim a relative superiority over his fellows in more mundane employment, pacing the retail floor in all the trappings of fashionable gentility and consequently exerting considerable sexual and social power. The novelist St John Adcock, echoing existing retail hierarchies in his narrative, created an exemplar of the suburban

department store in 'Messrs Fall and Mungo's colossal drapery es-
tablishment in the Chalk Farm Road' where his heroine

> found even the conventional flatteries and anaemic facetiousness of the
> elegant young men employed about the place fresh and amusing ... All
> Messrs Fall and Mungo's young men were elegant, but Mr Pridd was
> particularly so. He was one of the shopwalkers, a tall, shapely young
> man, who paraded along the lines of the counters, tugging at an auburn
> military moustache, and a bristle of pins in the lapel of his frock coat.
> Half the girls in the shop cherished a sneaking sentiment of regard for
> this splendid creature; he was suave mannered and condescending to
> them all.'[28]

It is little wonder that male consumers not blessed with the self-
assurance and sartorial knowledge of the metropolitan dandy
crumbled in the face of such intimidatory tactics. Osmond
Ormsby, the fictional hero of the 1896 *Story of a London Clerk*,
associated the figure of the counter assistant and his persuasive
banter with his own troubled experiences as a naive new arrival
in the City:

> How London brought out his weaknesses! In spite of all his conceit of
> cleverness, he was very backward, very shy, and easily deceived. Wher-
> ever he went, he thought he was singled out as being new to London,
> so self conscious was he ... Once he ventured into a large hosier's to buy
> a necktie. A ... man danced before him on the other side of the counter
> in a halo of smiles. 'Yes sir, yes sir; these are what you want sir' producing
> a box, the first to hand - of the identical articles Osmond did not require.
> Osmond meekly enquired whether there was any other kind. 'These are
> the best sir - the latest shape - the very best we have in stock. They were
> made to be sold at half a crown, but we are selling them at eighteen
> pence'. The 'latest' shape had a suspicious resemblance to something
> Osmond had seen a few years before, and it was one he disliked, but
> how could he oppose this courteous and genial ... gentleman? It was
> preposterous to think of it. So he decided in its favour.[29]

In many ways the tailor or outfitter's counter assistant, with his
knowledge and control of sartorial goods, his brash epitomisation
of popular taste, policed any further access to the hallucinatory
and pleasurable world of London's fashionable milieu. His choices
dictated the choices of others. It would be short-sighted to over-
look just what a pivotal role he played in the system of clothing
provision.

Promotional pleasures: the rhetoric of advertising

Besides the relationships set up between retail employees and con-
sumers within the shop, the circulation of printed material
representing the acquisition of clothing as a social performance

also played a significant part in the formation of urban masculine identities by the turn of the century, further conditioning the ways that male consumers interacted with clothing as part of the city scene. If the shop assistant presented a challenge to the integrity and taste of the customer, directly impinging on the construction of self-image, the growing importance of the catalogue or advertisement provided an emollient, offering through innovative text and illustration the assurance of a safely removed, imaginative encounter with the world of 'bon ton', alongside more established promises of uncompromised service. Official attitudes towards graphic forms of promotion in the earlier part of the period were wary of experimentation, with fashion plates and catalogues showing little development from standards developed at least fifty years earlier. *The Tailor and Cutter* acknowledged the usefulness of its own plates, which it stated 'can be folded in map or book form … a very convenient companion, when visiting customers at their homes', or 'placed upon a piece of material suitable for the garments it represents' as an aid to window dressing or interior displays.[30] However their formal characteristics differed little in their schematic representations of cut and texture from the crude woodcuts that had advertised tailors' wears since the beginning of the century. Only the introduction of improved printing techniques and the evolved nature of the clothing represented hinted at an engagement with modernity.

The Practical Retail Draper was much clearer about the effectiveness of directing advertising and visual material directly towards male readers, exploiting their potential as an active agent of fashionability, and hinting at particular modes that might be adopted to promote the wider discussion of men's fashion. It stated that

> the men's outfitting department … gives the advertisement manager the cue for drawing up many powerful circulars. This department, although distinct, is made much of by general drapers in their autumn and spring lists and catalogues, and in their special sale advertisements. It gives them opportunity of very distinct announcements, and by forceful illustration arrests the attention of a different class of buyer. Men put on one side an ordinary drapery catalogue without a second glance, but should they perchance alight on a page in which are illustrations of the latest cut in men's tailoring, or note a stylish waterproof or overcoat, or catch a glance at the latest thing in hats, the chances are they will be just as much interested as the lady buyer who studies carefully the illustrations in a ladies outfitting circular.[31]

Austin Reed certainly seemed aware of the potential of the medium in its production of a booklet advertising its hat department in about 1910 titled *Types of men & the hat shapes that best suit them*

(Figure 31).[32] Echoing the advice of retail expert LeFevre Krebs that 'in so apparently an insignificant thing as the way a man wears a hat you may read something of his mental make up', Reed arranged its merchandise according to the social standing and expectations of potential consumers, rather than adhering to the stock responses of traditional promotional practice.[33] The finely tuned sensibilities of the customer were flattered by Reginald Cleaver's subtle line drawings illustrating 'The Major' whose 'unobtrusive style' make it thoroughly suitable for the man of 30 to 45', 'The General', which 'fuller in brim and crown … well suits a man of bigger build' and 'Mr Justice' … 'a type of man in business, the professions and private life'. Here in their bowler hats, overcoats and office suits, suavely urbane City patriarchs reflected and validated a confident engagement with the increasing gradations and choices involved in the ongoing narratives of contemporary city life. Their collection together in a carefully crafted promotional ploy invited an engagement with the imagination of the

31] Catalogue illustration, Austin Reed, c. 1910. Austin Reed appealed to the vanity of individual middle-class 'types' in his promotion of hat shapes.

32] Catalogue illustration, Dore, 1895. Bodleian Library, Univesity of Oxford: John Johnson Collection. Men's Clothes 1. The London tailor Dore subverted the traditional format of the seasonal brochure by inviting a modish cartoonist to replace the usual fashion plates with modern caricatures.

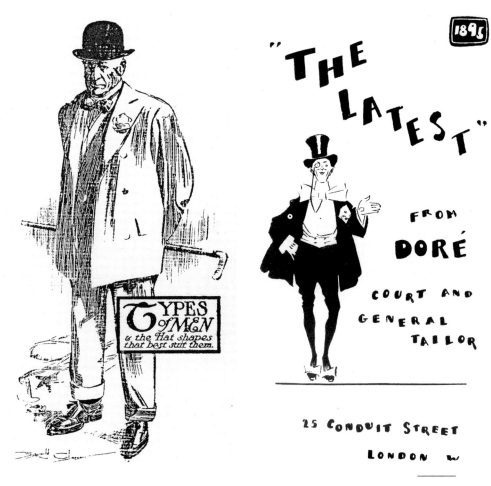

consumer in a manner that recalls the journalist Thomas Burke's rather whimsical comment on retail ephemera made in 1915:

> If ever I made a list of the hundred best books, number one would be an illustrated stores catalogue. What a wonderful bedside book it is! There is surely nothing so provocative to the sluggish imagination. Open it where you will, it fires an unending train of dreams. It is so full of thousands of things which you simply must have and for which you have no use at all, that you finally put it down and write a philosophic essay on the vanity of human wishes and thereby earn three guineas. Personally, I have found over a dozen short story plots in the pages of the civil service stores list.[34]

The West End tailor Dore pushed the communicative role of the seasonal catalogue even further in his annual price list for 1895, calling on the customer to adjudicate over the appropriateness of its illustrations, themselves representative of the vigorous new visual culture that now defined London as the centre for a distinctive brand of leisured, youthful masculinity (Figure 32).[35] The tailor presented his list, produced in the caricatured monochrome style of comic book artists such as Phil May, as a record of the correspondence between himself and the commercial artist hired for the job, carefully positioning himself, through the generous use of irony, as a retailer at the cutting edge of avant-garde practice. The brochure showed bow-legged and monocled bon viveurs in evening wear of ridiculous contrasts and proportions, with cigar-toting country squires in hunting costumes of an impossible jauntiness, standing assertively with hands in pockets as a direct affront to the discreet visual registers of the traditional fashion plate. 'I regret to say' bemoaned Dore, that

> they are widely different from those supplied me in previous years by other artists ... I trust you will excuse my doubting the advisability of publishing the sketches ... but there is such an air of levity about the figures, not at all in accordance with the staid productions of a business house – that I am seriously afraid the general public will resent this strange departure from the usual mode of representing prevailing fashions.

'Can you not see' ran the artist's reply 'that my drawings are infinitely truer to nature than the ridiculous monstrosity you so kindly send as a pattern? The costumes represented may perhaps be treated with a little artistic licence, but did you for a moment suppose that I was going to degrade my art by making the drawings like your clothes?'[36] While they challenged the conservative traditions of tailoring and boldly asserted their own individual quirkiness in a deliberately disruptive manner, Dore's progressive templates confirmed the spectator's ability to discern a new raffish

fashionability and stand as evidence of the prevailing tenor of turn-of-the-century masculine taste as disported in the retail sphere, a visual echo of the 'saucy cut togs' trumpeted by Greenburg and Harris. Vaudevillian, theatrically inspired and clearly oriented towards the pleasures of the modern city, they connote the very model of the new consumer, whose form beyond the world of the shop requires further unpacking.

The playground of city life: clothing and the conviviality of bachelordom

> Atkinson now comes in to put the finishing touches to his master for the morning promenade. He brings half a dozen cravats, and a whole trayful of scarf pins ... Seton is to choose ... puts a forefinger on a scarf of quiet grey; then again, laying it on a perfect pearl ... retires to his dressing room, followed by his man. When he reappears, it is as the finished product of civilisation. He is booted, hatted, gloved and generally carried out in all the details of a perfect scheme ... His valet regards him with the pride of the stableman who has just drawn the cloth from the loins of a flawless horse. 'Cigarettes, Atkinson, I think. Put the cigars in the bag!' The cigarettes are in a tiny case of enamelled gold, which bears an 'S' in inlaid diamond points on the lid ... 'Which cane sir?' 'Let me see!' and he turns to a suspended rack at the door. There are as many canes as scarf pins. He hesitates between a trifle in snakewood, with a handle of tortoiseshell, and a slender growth of some other exotic timber, capped with clouded amber almost as pale as the pearl ... Now we are out of doors, and skimming, in Seton's private hansom over the well watered roads ... until we reach the flower shop in Piccadilly for the morning button hole ... Our dandy looks at a whole parterre and points to one bloom, like the chess player who knows that he is pledged to the choice by touching the piece.[37]

Lynn Hapgood characterises *No 5 John Street* as 'a world of surfaces in a text full of sensuous detail that exposes the deceitful nature of what the physical eye sees ... the upper class in particular is portrayed as all surface since its concerns are with life as art, in a deliberate evasion of reality.'[38] Certainly the dressing rituals of Seton detailed above appear to conform to that commonly held notion of aristocratic dandyism as the denial of sordid realities through the deliberate manipulation of appearances, the construction of a protective and critical carapace of finely tuned sartorial exhibitionism. Yet beyond the caricaturing tendencies of the novel and the abstract definitions of dandyism, Seton's self-presentation can be seen also to link with real debates and concerns over the state of masculinity, the advances of consumerism and the problems of city life that informed an understanding of male behaviour and desire between c. 1880 and 1914. In the pages

of popular novels, tourist guides, journalistic accounts and adver-
tising promotions both real and imaginary men like Seton were
seen to epitomise a mood of assertive masculine acquisitiveness
whose challenging potency has since been overlooked or miscon-
strued by historians of consumption and gender alike.

Cultural historian Richard Dellamora, in finding connections
between these disruptive models and the sexual upheavals of the
1890s, conjectures the reasons for the dismissal of such characters
and their significance in broader histories when he states that

> heretofore, political historians, by which I mean male political histo-
> rians, have been blind to the significance of homosexual scandal in the
> 1890s ... a less defensive approach by historians would acknowledge the
> crisis of masculinity at the time. And a less pure history, which per-
> mitted itself to be contaminated by literary scandal and gossip, would
> recognise how anxiety about gender roles inflects a wide range of inter-
> actions.[39]

Along with Elaine Showalter, Regenia Gagnier and others, Della-
mora repositions the *fin de siècle* dandy at the centre of these
interactions, in a manner which, while it illuminates the rhetorical
intentions of a cosmopolitan minority, perhaps ignores the day-
to-day commercial significance of his type. His rise and downfall
is used portentiously to reflect 'a loss of balance between the dual
imperatives of leisure and work incumbent upon Victorian
gentlemen. The dandy is too relaxed, too visible, consumes to ex-
cess while producing little or nothing.'[40] In the spectacular and
very singular figure of Oscar Wilde, whose 1895 disgrace is gener-
ally quoted as precipitating the crisis over masculinity that
informed twentieth-century attitudes towards manliness, the two
models of dandy and gentleman are seen to have become danger-
ously confused.[41] As Gagnier states, between the demise of his
aesthetic mode in 1882 to the moment of his trial 'Wilde made the
respectable sartorial choice of non-working class men: to appear as
a gentleman ... in a manner which had been perfected by a
dandy'.[42] In his mannered appropriation of the evening suit and
other trappings of a leisured lifestyle, Wilde mocked the ideals of
gentlemanliness with ultimately disastrous results. But, beyond
that affront to notions of bourgeois respectability, the dandy is
held to signify very little else, perhaps because it is difficult to
extrapolate broad cultural meanings from the posturings of one
man, or because the close association of dandified forms of present-
ation and behaviour with the image projected by Wilde has
succeeded in limiting their application elsewhere.

While acknowledging the unsettling effects that figures like
Wilde had on the literary, legal and medical construction of

sexualities, and agreeing with the necessity for revisiting the period of the 1890s as a key moment in the development of their 'modern' forms, I would argue here for a clearer recognition of the less spect-acular circumstances which gave rise to an identifiable 'dandified' style as being rooted in a more popular, generalised celebration of leisured urban masculinity relatively untouched by high moral debate. The adoption of a visibly relaxed and 'non-productive' sartorial rhetoric was not in itself transgressive; only the context and manner in which it was mobilised made it so. In equating an embracing of idle display so closely with sexual dissonance, histor-ians are in danger of obscuring or distorting similar choices made by men who identified with the status quo. Furthermore, one might claim that the metropolitan dandy drew on a thriving, self-consciously virile culture of cosmopolitan masculine con-sumption which had been in evidence since the 1860s at least, and which colonised wider forms of popular culture at precisely the moment that Wilde's version was acquiring its problematic sexual reputation, sending the established version into partial eclipse. The two strands of leisured display, one associated with political, sexual and social resistance, the other with a commercial engagement with the urban market place, require careful unravelling if the defining features of the latter are not to be subsumed by the polemics of the former.

The fictional figure of Seton, with his carefully judged appear-ance and assiduous collecting of fashionable possessions, is thus as much a reflection of what London's shops and catalogues offered the ambitious young man at the turn of the century as he is evi-dence of decline and decadence. His literary scopophilia may look to the obsessions of Dorian Gray in one direction, but in the other it finds a brighter resonance in the pages of Dore's illustrated price list of tailored goods. That the mannered presentation of self could simply represent an unproblematic adherence to the rules of 'smart' society in an expanded arena of consumer choices is clearly communicated in guides such as *London and Londoners*, published in 1898, where the author provided tongue-in-cheek guidance to the ways of modern society:

> It is fashionable to be radical in theory and advocate women's privileges. To have an inner knowledge of all classes of society. To know the latest club scandals. To have some particular fad. To wear some particular garment different from anybody else … To telegraph always, but rarely write a letter, unless one has a secretary. To be up in the slang of the day … to know the points of a horse. To have an enormous dog in the drawing room … To know the latest music hall song … To go to Paris twice a year and at least once to Monte Carlo. Never to be in town after Goodwood or to return to it before November. To be abroad from

January to March ... To excel in one's special sport, fox hunting for preference, and be able to drive a tandem. To subscribe to every journal published. To belong to a club and have some of one's letters and telegrams sent there. Always to fill one's rooms with more men than women.[43]

While such a list evidently revelled in the paradoxical nonsense of trivia, its pointed social observations map the co-ordinates of an accumulated cosmopolitan knowledge that defined the exalted status of the fashionable bachelor. In its random citation of desirable adherences it is possible to discern the more serious juxtapositions of high and low culture, reactionary posturing and avant-garde enthusiasms, artistic affectation and hearty philistinism, that influenced a prevalent model of fashionable masculinity at the turn of the century. Here was a dandified position that comfortably accommodated sexual conformity, advanced tastes and commodity fetishism within its remit. Of particular significance are the references to music hall, slang, sport, new technology and travel. Beyond the expected mention of club life, gambling and hunting which would have denoted aristocratic excess in a list produced fifty years earlier, this engagement with the modernity of London, in company clearly defined as male, positioned the potential flâneur in the midst of a culture enthralled rather than repelled by the notion of masculine pleasures. More than this, the figure of the leisured London bachelor, targeted by the publishers of such guides, had himself come to symbolise a modern and fashionable position by the 1890s, as potent in commodity terms as the Gibson girl or the Dollar Princess. And, like his sisters, he was utilised by retailer and consumer as a prop upon which products and attitudes could be hung.

Aside from clothing, the elevation of certain forms of metropolitan recreations to the status of a bachelor 'specialism' had been a marked characteristic of popular writing from the mid nineteenth century. The 1860s were identified with the beginnings of a celebration of the romantic, irresponsible lifestyle associated with the cosmopolitan single man which reached its apex by 1900.[44] The twin poles of his existence, around which all other characteristics circulated and drew their influences, from political persuasion to visual appearance and interior decoration, were food and drink and the brash culture of the modern man's journal. Thus the apotheosis of the bon viveur was the man who spent his days either 'researching articles' for the popular press or reading them in the comfort of a West End restaurant or café, and his evenings at the theatre. One semi-fictional representative of his type complained in satirical tones that

people never seem able to understand what I do with myself in town. If a man doesn't follow a hall-marked profession such as soldiering, 'bridge' or driving a motor, they always imagine that he possesses a large income and a taste for dissipation ... I'm a hard working fellow. Why, this week I've done a column on 'How to Crease Trousers' for the fashion page of the Whirlwind; 'Delia in the Cowshed' for the Saturday Jujube; and 'Luncheon as a Fine Art' in the Pantheon, far more exhausting brainwork, mind you, than engrossing deeds in a solicitor's office.[45]

The playwright Clement Scott, remembered as the last man in London to wear scent, was eminently qualified for such a roll, despite more humble clerkly origins. For the novelist Pett Ridge his persona epitomised the contrived loucheness of the 1890s: 'His arrival in the stalls - Inverness cape with crimson lining - sent an aroma across the theatre which conquered all other perfumes; I fancy there must have been a whiff of patchouli about it.'[46] In his *Souvenir of the Trocadero: How They Dined Us in 1860 and How They Dine Us Now* published in 1900 to celebrate the anniversary of a fashionable Haymarket restaurant, Scott tracked the development of such masculine pleasures through the last four decades of the century, nostalgically viewing the 1860s as something of a burnished and formative moment:

> When did I become a student of London? You will ask me. Well, I will take the year 1860, for it was in that to me memorable year that on 23 May, the Derby Day, I accepted the responsibilities of manhood, received a latch key, became my own master, and entered the War Office, Pall Mall, as a happy and contented Government Office clerk ... In 1860 I did not come into London with the proverbial half crown, determined to make a fortune, I was born and bred a cockney under the sound of Bow bells ... but I was thankful enough to start life with a new hat, a new frock coat, a new umbrella ... and what was far more important a salary of £150 a year. In fact for that first year of my early manhood I was virtually a millionaire. A youth with no debts, no bills, no board or house rent to pay, and a quarterly cheque paid punctually by the government, is a millionaire in a small way.[47]

The possession of a disposable income at that point offered membership of a swiftly changing notion of society. Public life to some extent still mirrored the clubland rowdiness of the early 1800s, with provision across the board as yet untouched by the organised commercialism of late nineteenth-century catering, retail and leisure outlets. Thus Scott's descriptions of his earlier hunting grounds record the all-male environments and eighteenth-century decor and fare of the chop house. 'They were cosy, with boxes polished or plain, they prided themselves on their hospitable ways, their roaring fires.'[48] Across the board 'women were rarely seen at any restaurant whatsoever in a public room' as 'their presence there

would have been considered fast, if not disreputable'.[49] The intro-
duction of more relaxed social rules by the 1880s represented the
burgeoning of a new public culture, a modernisation of sexual
attitudes that bore profound consequences for the performance of
masculinity:

> It let the daylight into London life generally ... it may have substituted
> light wines, hock and claret, for heavy bowls of punch and tankards of
> beer; it may have hunted crusty old bachelors and holiday-making mar-
> ried men out of their clubs and chop houses ... But on the whole it killed
> the disgraceful old night houses ..and the new restaurant, by bringing
> men and women together to dine and sup without offence, made life
> in London far more decent than it ever was before. [50]

The youthfulness of masculine dress in the 1890s and the modern
nature of its retailing should be seen in the context of this general
commercial shift, which instituted those revolutionary social
dynamics identified by Scott as reflecting a broader feminisation
of the public sphere in which the bachelor played his part:

> We who took our so-called pleasures alone and moodily in the days
> before gaiety and electric light, and flower decorated tables, and stringed
> bands in gilded orchestras; we who were obstinately denied the priceless
> pleasure of women's society ... all that is refining and full of grace and
> charm and elegance; what should we have thought in 1860 of the
> marble halls, the frescoes, the soft carpeted staircases, the courteous
> liveried attendants, the scent of flowers and the air of hospitality and
> opulence that distinguishes such a distinctly new feature in London life?

Other commentators, though less ready to celebrate a feminising
influence, incorporated its features into a renewed examination of
the bachelor's status, with unsettling consequences for established
gender roles. A considerable number of publications in the 1890s
turned their satirical attentions to the social habits of single men,
revealing in passing the tortured and problematic relationships
engineered between masculinity, consumption and gendered ex-
pectations by the rarefied circumstances of a homosocial existence.
The figure of the bachelor was able to incorporate consumerist
tendencies that were permissible within his narrow context, but
disruptive of the sexual order in any broader consideration. In this
sense the promotion of bachelorhood made a great deal of com-
mercial sense, representing a profitable niche in the marketing of
goods including tobacco, alcohol, journals and clothing. Neverthe-
less his light-hearted characteristics required a cautious embrace.
His more sensual indulgences might be excused as the consequence
of his unmarried state. However, any extension of bachelor tend-
encies beyond their period of social acceptability in the life cycle,
transgressed accepted rules of behaviour and compromised the

usual moral balancing of male and female responsibilities after marriage. For this reason recollections of youthful habits often carried with them an elegiac air of regret, clearly mysoginistic in their implications, but also questioning of the social rules which assigned domestic considerations of display a feminine gloss. Seen in this light the stories of rabelaisian extravagance and the relentless pursuit of the high life which characterised late Victorian and Edwardian treatments of bachelor obsessions present a progressive reading of modernity that undermines older cultural strictures. Deshler Welch produced a typical example of the bachelor genre in his 1896 *The Bachelor and the Chafing Dish* which used as its pretext the provision of recipes for the new generations of young men who could no longer rely on servants, family or spouse for the preparation of food. The author also took the opportunity to weave a rose-tinted romance of the leisured bachelor lifestyle between the lists of ingredients, each item symbolic of a 'lost' state or a heightened 'manly' sensibility:

> Sometimes Jim would be hard up at an exceedingly unfortunate time – just when I was. On one of these occasions he said to me: 'We'll have to go it light old man – simply a snack of something or other.' Then we would have a bisque by the way of a soup with some toast and anchovy paste to start off on ... Then would come some calf tongue in brown sauce ... Then a salad – chicory with plain dressing – followed by Roquefort cheese that was solemnly declared to be genuine. Meanwhile we had completely destroyed a bottle of Chablis, and ended with black coffee and Benedictine, and a cigar that he knew how to recommend. There was not much variety to that, was there? Oh, but it was all very hearty and chummy, and we would wax warm in friendship over it. Does any woman know that? Does any woman realise the honest, pure feeling of affection that one man may have for another – that feeling that is never lost as long as life lasts? [51]

Duncan Schwann in his *Book of a Bachelor* of 1910, its cover aptly illustrated with a design of buttons and thread, ended his memoir of the unmarried state with a similarly mournful projection of the bachelor sensibility that utilised the description of a transient and emotive material culture which could only be associated with the 'unattached' young man around town. On the evening of his wedding, the hero destroys all physical evidence of this twilight existence:

> I would make a bonfire of the vanities rivalling Savonarola's in Florence, so gathering from my drawers and shelves the miscellaneous spoils of years, I heaped them in the fender and set them alight. There were at least three hundred dance programmes ... three locks of hair ... several signed photographs ... a ladies shoe, minus a heel, its white satin surface lost beneath a coating of dust; a fat packet tied up with a bootlace of a

correspondence ... and a vagrant mass of ribbons and bows, spangled hair ornaments and cotillion favours - in short the complete arsenal of a man of sentiment ... Jealously was that conflagration guarded until not a relic of my bachelor self remained. I was resolved to keep that memory untouched by matrimony. Audrey has neither part nor parcel of the man I have been. The future is hers, not the past. That belongs to me alone.[52]

As Schwann's bonfire implied, alongside the sentimentality of the shared bachelor life in which an appreciation of good food, fine wine and cigars, and indeed the cut of clothing, signified a release from later responsibility, a more robust engagement with the fashionable spaces and pastimes of the city offered opportunities for a louder celebration of masculine style, engineered to promote assignations with the opposite sex rather than to deny them. Again, the historical pedigree and cultural reference points for descriptions of turn-of-the-century nightlife found their roots in reminiscences of the 1860s when under cover of darkness sexual adventuring was perceived to be commonplace.[53] Clement Scott in his autobiographical recollections recalled that

To go on the spree was literally to make a night of it. The plan was this! First a dinner at a restaurant ... After dinner the play ... Then came a look in at the Argyll Rooms [in the Haymarket], where gentlemen never dreamed of dancing - the dancing was done by hired and very seedy professionals. The Argyll, for a man of fashion, was merely a lounge and a stroll, exactly the same kind of lounge and stroll that is seen to this hour in all the popular variety theatres ... At about midnight, the golden youth would leave the halls of dazzling light, and repair to one of the Haymarket nighthouses [brothels] ... After the nighthouses where roués, old and young, assembled, came a visit to Mott's [Langham Street] where gentlemen were all allowed to dance, and where the dance was generally supplemented by some awful row ... And then to bed, or to some pal's rooms, at five or six. This was called 'going round town' ... There was no romance about a night out in the year 1860. We pretended to enjoy ourselves, but didn't.[54]

In the intervening years Scott credited the commercial prowess of colonial entrepreneurs, alongside the increasing presence of respectable women, for transforming and sanitising the social scene, noting that 'London saw no greater change in its old conservative habits of eating and drinking than when Spiers and Pond arrived from Australia and set up in various parts of London their gilded saloons and drinking bars'.[55] Others attributed the metamorphosis of the claustrophobic and corrupted pleasures of the 1860s into the bright democratised leisure industry of the 1890s to an insidious 'Americanisation' of London culture, its effects evocatively conveyed by Thomas Burke, who remembered that 'it was a London that was going ahead. American ideas and ways of life

had been infecting it for some time, and where it had been rich and fruity it was becoming slick and snappy'.[56]

Duncan Schwann also saw the benefits of a newly regulated and respectable arena for the increased display of a bachelor's conversational, romantic and sartorial prowess in his readings of the renewed energy of the London season, when

> the air is charged with the electricity generated from the crowds of fashionable folk flowing in carriages and on foot from Hyde Park down Piccadilly and through the squares, filling the clubs and restaurants all day with well dressed idlers, occupying at night every stall and box at the theatres, and then filling up endless staircases amidst roses and similax to shake hands with be-diamonded hostesses.

Of direct relevance to 'the man about town' was the increased pressure to buy into the myth of the affluent bachelor, this being 'the time of year' when the aspirant gent

> discarding the garb of the shires or the links, puts on a tail coat and sits in the Park morning and evening; when his cab fares amount to a small fortune per diem; when his valet takes in a constant stream of parcels full of the latest things in suits and hosiery; when his letter box is crammed with dance cards from hostesses he has never heard of … when he raises his hat at intervals of half a minute … in greeting to his numerous acquaintances; when he eats his weight daily in salmon mayonnaise and gooseberry tart.[57]

Beyond Park Lane, MacQueen Pope recommended the Café de L'Europe in Leicester Square, which boasted 'an enormous room, with mural decorations of German Gnomes … filled with tobacco smoke' where 'waiters … all German … carried amazing quantities of beer mugs'; the Queen's Hotel favoured by jockeys 'because it was near the Turkish baths by the Alhambra and in Jermyn Street' and 'There was Romano's in the Strand, another gay place where money flowed with the champagne, where good food could be enjoyed, and where Gaiety girls went too. You would meet all Bohemia there at "the roman's" people like Phil May, who knew his London as well as he drew it.'[58]

Such frenetic consumption not only was represented through the highly subjective reminiscences of metropolitan raconteurs such as Schwann and MacQueen Pope, but also found its echoes in a new periodical literature aimed at a broader male market.[59] According to the guidance of the 1898 social primer *London and Londoners*, a selection of daily and weekly newspapers provided adequate coverage of issues likely to inform the pastimes and consuming habits of the bachelor type. *The Daily Graphic* and *The Daily Mail* established in 1890 and 1896 offered 'up-to-date' and 'popular' views, the *Mail* identified as being 'especially smart'. *The*

Daily Telegraph featured 'correspondence on current social topics', and The Globe 'smart articles under the headings "By the Way", "Men and Matters" and "Notes of the Day"'. Weekly newspapers of note included Black and White, for its satirical illustrations, The Sketch, with its portraits of actors and actresses, and The World, 'a popular society paper containing much news and gossip'.[60] The Strand and The Smart Set, 'very well produced with a picture of a perfectly dressed and modern Adonis in full evening dress (faultless of course) bowing to a wondrous fair and magnificently gowned lady on a pale grey cover',[61] offered further society insights. As the journalist J. B. Booth commented, newspapers reflected editorial personalities in a manner that borrowed directly from a sartorial rhetoric, further cementing their role as a prop for the bachelor identity: 'Labouchere, slim, waspish, a trifle wizened, looked the incarnation of the Truth of his time; Sala, rubicund, resplendent, ornate in dress, was the living embodiment of the "Telegraphese" of his day; Edmund Yates, burly, loud spoken, virile, was the embodiment of his World, and bluff old John Corlett, with his insatiable zest for life and sport ... was the ideal master for his beloved Sporting Times.'[62] More specialised journals capitalised on a public hunger for scandal, local colour and the details of the social whirl that London had become, while maintaining an allegiance to 'traditional' models of behaviour that lionised an imperialist vision of English masculinity. In this vein The Sporting Times, or Pink 'Un as it was affectionately termed, represented an 'extreme modernity and up-to-dateness' that 'went hand in hand with tradition in enthralling fashion'.[63] In Booth's words:

> It was more than a mere journal for the sportsman and the man about town; it had established itself as a social centre of a highly specialised nature, and its readers constituted a species of home and overseas club, whose bond of fellowship was good humour and good sportsmanship. There was more in the Pink 'Un than the 'good story' which made the round of the town. Behind the façade of the 'front page' there was a very solid structure indeed, based on the turf, social, political and theatrical influences, which were at the command of proprietor and staff. Amongst constant correspondents were a Prime Minister, an Irish Secretary, a Post Master General ... a Viceroy of India ... judges of the High Court, stewards of the Jockey Club. Admirals of the Fleet, subalterns, owners of race courses – from Dukes to commoners – pugilists, artists, actors ... music hall comedians, restaurateurs, chefs, barmaids – in an age when famous barmaids attained more than local celebrity – each and all with a story to tell, or information to give.[64]

Here a guiltless pursuit of pleasure received the endorsement of the establishment and the demi-monde in a celebration of urban modernity and its figurehead, the leisured bachelor. In this way

fashionability, or 'smartness' in the parlance of the Pink 'Un, was positioned at the centre of *fin de siècle* constructions of masculinity. MacQueen Pope remembered it as 'a weekly paper devoted to sport and the lighter forms of drama … very famous. On its front page it retailed all the spicy stories of the day. To be seen reading it labelled a man as a gay dog. It was the essence of naughtiness.' [65] In less elitist terms, but with an editorial focus similarly targeted on the sartorial and material concerns of unmarried male city dwellers, the publishers of *The Modern Man: A Weekly Journal of Masculine Interest*, which appeared during the first decade of the twentieth century, directed their gaze even more tightly on the bachelor as the standard bearer of modern manly taste. It was a compendium of informative advice regarding the maintenance of the wardrobe, rooming arrangements and decisions relating to interior decoration, leisure activities, physical development, shopping choices and the conducting of friendships. The magazine surmounted its masthead with the slogan 'for men only' and invited subscribers to join The Modern Man League, 'founded to encourage good fellowship and good sportsmanship wherever this paper is read - that is wherever the English language is spoken'.[66] Membership of the League entitled the reader to wear a tie pin, cap badge or watch chain pendant emblazoned with the artist Stanley Wood's image of a mounted frontier soldier, also available framed, 'a dashing sporting study that is exactly what you want for your den'.[67] This adherence to the prevailing tone of jingoistic machismo, evident in most popular publications, at the height of Britain's imperial ambitions is unsurprising.[68] What is significant in the promotion of the ideal bachelor type is the manner in which the editors linked a colonial rhetoric to what might otherwise have been condemned as a narcissistic and unmanly interest in appearances.

Through the figure of the bachelor the columns of *The Modern Man* presented further corroboration of a thriving interest amongst young men in fashion that was presented as being entirely consistent with the maintenance of the status quo in matters of gender and sexuality. Its writers were adept at presenting the pleasures of masculine consumption in language that suggested that the decorating of a room or the acquiring of a cuff-link offered opportunities for the display of manliness and national pride equal to an exercise regime using Sandow's dumb-bells or the honing of frontier scouting skills. Thus in a typical 1908 article titled 'Fitting up a Den' C. M. Wesson advised:

> Study, smoking room, snuggery or den: the terms are but variants for the same thing - a place where a man can take his friends for a smoke

or a chat. In such a room there can be a merry bachelor party, a function that loses its flavour when held in the dining room or parlour with the inevitable restraint of the presence of the lady members of the family. Here also there is privacy for a bout with the gloves; here there is peace for cramming if there are examinations to pass; here the best books yield their full enjoyment ... Somewhere you will find space for a hook to hang your hockey sticks upon. Slung up crosswise, they give the room just the necessary touch of the sporting element ... Any cups or prizes you may have won for athletics will find a place on top of the book-shelves; and if you are territorial your rifle or carbine will repose in a corner. Should you have any claim to colours, varsity or club, you may like to have a few cushions covered with the necessary stripes. Now we have the den pretty well licked into shape; there only remain the more trifling fitments. Beside the mantelpiece you will want a pipe-rack, a thing comparatively easy to cut out with a fretsaw or penknife ... Your finest picture goes above the fireplace, and beneath this ... you might have a long frame fitted to take a dozen cabinet photographs – portraits of the twelve best-looking girls you know.[69]

And in the matter of clothing, the weekly feature 'The Outer Man' by Captain L. H. Saunders made it clear that the 'spick and span' polish of the fashionable bachelor was nothing more than evidence of an adherence to the military principles of neatness and pride in one's appearance that connoted empire-building discipline, even if the constructing of such an appearance could also involve (in one week's edition) earnest discussion of correct carriage, the advantages of rubber heels, the tendency of brown boots to pick up traces of black polish from uncleaned trousers, the avoidance of baggy knees, the drying of wet shoes, the etiquette of fitting a new suit, the fashionability of puttee leggings, the advisability of turning out pockets nightly and the benefits of buttoned over stud-fastening gloves.[70] The polemics rarely compromised the pleasures.

However, while the assertive models of masculine consumption offered by popular journals proclaimed a bullish adherence to the clean and flourishing style of the bachelor dandy, less accommo-dating descriptions of his appearance and behaviour on the streets and in the bars of the metropolis give some indication of the tensions implicit in the ideal. Confined to the tailoring catalogue or the society column the leisured bachelor epitomised the essence of West End fashionable poise, and offered a refreshingly positive reading of the sartorial options open to the aspirant 'man about town'. Yet so ubiquitous did his figure become from the 1880s onwards, through its reproduction in yellowback novels, advertis-ing campaigns and stage productions, that more negative or less closed interpretations were inevitable. For every clean-cut English-man puffing the 'smart' attractions of the Arrow collar or

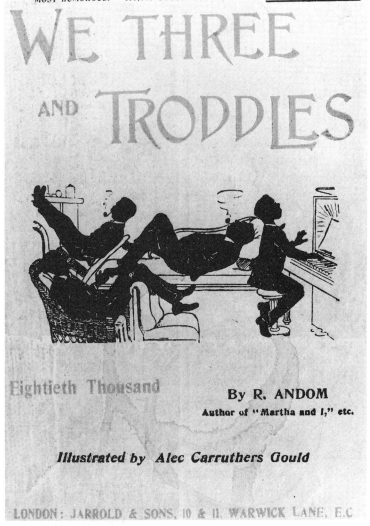

GILES'S TRIP TO LONDON. SIXPENCE.
"MOST HUMOROUS." 230,000 SOLD. 6d.

WE THREE

AND TRODDLES

Eightieth Thousand

By R. ANDOM
Author of "Martha and I," etc.

Illustrated by Alec Carruthers Gould

LONDON: JARROLD & SONS, 10 & 11. WARWICK LANE, E.C

33] We Three and
Troddles, 6d novel cover,
1902. The figure of the
bachelor presented a
problematic icon which
encapsulated modern
attitudes to
metropolitan life.

Wood-Milne shoeshine there was a more derogatory model espousing the 'wicked' attractions of the East End or the quick fortune to be made from venture capitalism. Beyond the fixing of the bachelor type as a model for an unproblematic, if occasionally risqué, consumerism, his mediation and wider diffusion through urban culture was revealing of a more profound crisis in the nature of an English middle-class and aristocratic masculinity not entirely secure with the tenure of its hegemony.

The tendency at the turn of the century to equate certain forms of dandified appearance with an entrepreneurial crassness and betrayal of the gentlemanly ideal clearly held anti-semitic implications. Those novels which celebrated the freedom and decency

of the bachelor existence were equally insistent on presenting a parody of the Jewish playboy to which the 'natural reserve' of an English sartorial style might be favourably compared. Duncan Schwann offered a formulaic caricature of the type when he recalled that his friend

> James Berners was wrapped in a fur coat, the impossible collar of which was formed of two seal skins, others giving each sleeve the appearance of muffs. On his head at an angle of forty five degrees was set a Tyrolese hat, with a cloakroom ticket stuck in the band ... He carried an ivory topped cane in his hand, a cauliflower, or was it a tomato? in his button hole, and a cigar, in an amber holder stuck out from the middle of his pale face ... he looked like a son of a Shylock and the Queen of Sheba, dressed as a combination of stage lobster and a millionaire from the far west, with his crimson waistcoat, check suit, and the precious stones he scattered over his tie and fingers.[71]

Similarly Montague Williams QC was unable to resist describing the wardrobes of 'Mr Herbert Maurice – Plutocrat and son of a Jewish trader and his son Gerald' in his reminiscences on life as a London judge. Of Herbert Maurice's riding habit he noted that 'though his get up in the saddle is of the most sporting description and similar to that of all the fashionable young men of the day, there is always something outré about it'. And true to form

> on arriving at man's estate Gerald became a member of one or two second rate clubs. He smokes an enormous number of cigarettes and passes a great portion of his time at the billiard table ... He wears collars that reach half way up his cheek ... and trousers that cling so closely to his thin legs as to suggest difficulties in the way of getting them off ... a remark he is very fond of making at the Rockingham Club is 'Hang it all, I think I ought to know a gentleman when I see one.[72]

Further inversions of fashionable masculinity might be found in the figure of the bohemian artist, whose lack of meaningful employment and laboured manipulation of appearances set him up as a potential rival to the bachelor in the role of London flâneur.[73] Schwann dismissed him as a 'blighter who never washed, ate with his fingers and let his hair grow as long as Samson's ... they slouch about Soho with seedy squash hats and seedier fur overcoats which they pinched from the last doss house they slept in, looking like a mixture of Svengali and a rag picker'. However, he also admitted that 'a contemporary of mine at Oxford got the reputation of being a bohemian because he usually sat in a dress gown, drank Benedictine after hall, read Verlaine and possessed an engraving of the Blessed Damozel'.[74] The contradictory tensions between the pull of a commercial culture and an adherence to

'artistic' originality embodied in the bohemian also concerned the West End hatter Fred Willis, who remembered that

> the genuine bohemian was an engaging fellow but his name was one that a West end tradesman did his best to keep out of his debt book. The type took great pains with the carelessness of their dress. At this time the Austrian velour hat was making a tentative appearance ... and the bohemian took to it with avidity ... Worn with a flowing bow tie and a corduroy coat it gave the wearer unquestioned right of entry into the Café Royal or Rule's.[75]

More threatening still to the mannered perfection of the bachelor model were not those who set his characteristics in sharper relief, or offered alternative, sexually or socially disruptive modes of dressing and behaviour, but the limits of his own make-up and milieu, and the possibilities inherent in a wider urban culture of transgressing the commercial boundaries set up to describe his own position as the commodified embodiment of West End soph-istication. Thomas Burke alluded to the risk-filled attractions of moving beyond the manufactured bonhomie and petty restric-tions of Piccadilly in the search for 'authentic' pleasures when he advised that:

> It is a good tip when tired of the West, and as the phrase goes, at a loose end, to go East, young man, go East. You will spot a winner every time, if it is entertainment you seek, by mounting the first East bound om-nibus that passes. For the East is eternally fresh, because it is alive. The West, like all things of fashion, is but a corpse electrified. They are so tired, these lily clad ladies and white fronted gentlemen, of their blood-less, wine whipped frivolities ... Night, in the particular spots of the East ... shows you life in the raw, stripped of its silken wrappings ... In the West, pleasure is a business; in the East it is recreation. In the East it may be a thinner, poorer body, but it is alive ... There when the lamps are lighted and bead the night with tears, and the sweet girls go by and throw their little laughter to the boys – there you have your true Bac-chanale.[76]

Despite the close association of the bachelor figure with the new energies of a fashionable consumer culture, and his symbolic role as a justification for the consumption practices of men, his relent-lessly cheerful and dapper persona still drew familiar moral accusations of inauthenticity, of hollow obsessions too closely tied to the feminised and enervating concerns of the West End and its emporia. Regardless of its status as a figment of the fevered imagin-ation of the hack writer, the mythical East End offered the promise of masculine pleasures in concentrated virile form, free from the taint of business or the shop, and an arena in which bachelor identities met more dangerous connotations and ultimate resist-ance or mediation. That is why the following chapter turns its

attention from the elite scripts for a pleasurable masculine consumption towards the nature of its representation and performance on the music hall stage and in the streets of the London hinterlands. The satirist E. J. Milliken produced a poem for *Punch* in 1883 in honour of those who frequented both worlds. It serves as a useful preliminary guide to the terrain:

> Lately in London's maze there dwelt a youth
> Who in that aimless labyrinth took delight
> He skimmed his World, he trifled with his Truth
> He watched Burlesque's belauded lamp at night.
> Ah me! He was in sooth a shallow wight.
> Much given to crackling chaff and hollow glee;
> Few earthly things found favour in his sight.
> Save ballet belles and bibulous company.
> And Turfdom's sordid thralls of high or low degree.
>
> The curtain's up, the spacious stage is cleared.
> Hundreds on hundreds piled are seated round;
> Long ere the fiddler's first faint squeak is heard.
> Small room for the belated guest is found.
> Here 'Arries, shop boys, blowsy dames abound.
> And nymphs of vivid tint and valiant eye.
> In gilded boxes raised above the ground
> The gilded youth, black garbed, of snowy tie.
> Cluster each to each, as 'pie to chattering 'pie.
>
> In hat of sheen and gaudy garb arrayed.
> Hear hoarse the loud bull throated 'Comique' roar!
> With jewelled hands exultantly displayed.
> Before the admiring herd, 'Hangcore! Hangcore!'
> The shop boys shout, and the coarse brassy bore
> Blares forth eulogium of the nightly deed
> Of some inebriate swaggering cad once more.
> While whistles shrill more piercing than Pan's reed.
> And Chappie claps gloved hands, and puffs the odorous weed.[77]

Notes

1 M. Roberts, *Maurice Quain: A Novel* (London: Hutchinson, 1897), p. 40.

2 J. Walcowitz, *City of Dreadful Delight: Narratives of Sexual Danger in Late Victorian London* (London: Virago, 1992); A. Ribeiro, *Dress and Morality* (London: Batsford, 1986).

3 R. Stein, 'Street Figures: Victorian Urban Iconography' in C. Christ and J. O'Jordan (eds), *Victorian Literature and the Victorian Visual Imagination* (Berkeley: University of California Press, 1995), p. 233.

4 M. E. Blanchard, *In Search of the City: Engels, Baudelaire, Rimbaud* (Saratoga, Anma Libri, Stanford University, 1985), pp. 76-7.

5 G. Pollock, *Vision and Difference: Femininity, Feminism and Histories of Art* (London: Thames & Hudson, 1988), pp. 67-70; K. Tester (ed.), *The Flâneur* (London:

Routledge, 1994); S. Buck Morss, *The Dialectics of Seeing: Walter Benjamin and the Arcades Project* (Cambridge Mass.: MIT Press, 1989); W. Benjamin, *Charles Baudelaire: A Lyric poet in the Era of High Capitalism* (London: Verso, 1989).

6 P. Bailey, *Leisure and Class in Victorian England: Rational Recreation and the Contest for Control 1830-1885* (London: Methuen, 1987), p. 16.

7 C. Waters, *British Socialists and the Politics of Popular Culture 1884-1914* (Manchester: Manchester University Press, 1990).

8 John Johnson Collection of Printed Ephemera, Bodleian Library, Men's Clothing.

9 E. Partridge, *A Dictionary of Slang and Unconventional English* (London: Routledge, 1984); B. Darwin, *The Dickens Advertiser* (London: Elkin Matthews & Marrot, 1930), pp. 156-76; T. R. Nevett, *Advertising in Britain* (London: Heinemann, 1985), pp. 31-40, 75-99.

10 N. McKendrick, 'George Packwood and the Commercialisation of Shaving' in N. McKendrick, J. Brewer and J. Plumb, *The Birth of a Consumer Society: The Commercialisation of Eighteenth Century England* (London: Europa, 1982), pp. 146-94.

11 P. Egan, *Life in London* (London: Sherwood, Neely & Jones, 1821).

12 P. Bailey, 'Ally Sloper's Half Holiday: Comic Art in the 1880s', *History Workshop Journal*, vol. 16 (autumn 1983), pp. 4-31.

13 John Johnson Collection, Bodleian Library, Men's Clothing.

14 London handbills and advertisements 1860-1880, Guildhall Library GR 1.4.6.

15 *Ibid.*

16 *The Tailor and Cutter*, 15 July 1880, p. 245.

17 *Ibid.*, 13 May 1897, p. 231.

18 *Ibid.*

19 S. LeFevre Krebs, *Retail Salesmanship*, vol. XI (New York, Institute of Mercantile Art, 1911), pp. 19-21.

20 *The Tailor and Cutter*, 15 July 1897, p. 347.

21 *Ibid.*, 9 October 1874, p. 20.

22 *Ibid.*, 22 August 1895, pp. 381-2.

23 R. Whiteing, *No 5 John Street* (London: Grant Richards, 1899), pp. 184-6.

24 H. G. Wells, *Kipps: The Story of a Simple Soul* (London: Macmillan, 1905); H. G. Wells, *The History of Mr Polly* (London: Thomas Nelson & Sons. 1910); A. Bennett, *The Old Wives Tale* (London: Chapman & Hall, 1908).

25 Cardiff Times, *Behind the Counter: Sketches by a Shop Assistant* (Aberdare: George Jones, 1886), p. 8.

26 *The Tailor and Cutter*, 23 July 1896, p. 318.

27 J. H. Kaplan and H. Stowell, *Theatre and Fashion: Oscar Wilde to the Suffragettes* (Cambridge: Cambridge University Press, 1994).

28 A. St John Adcock, *In the Image of God: A Story of Lower London* (London: Skeffington & Son, 1898), pp. 118-20.

29 Anon., *The Story of a London Clerk: A Faithful Narrative, Faithfully Told* (London: Leadenhall Press, 1896), p. 23.

30 *The Tailor and Cutter*, 8 May 1890, p. 154

31 F. W. Burgess, *The Practical Retail Draper: A Complete Guide for the Drapery and Allied Trades*, vol. IV (London, Virtue & Co., 1912), p. 23.

32 Austin Reed Archive.

33 LeFevre Krebs, *Retail*, p. 26.

34 T. Burke, *Nights in Town: A London Autobiography* (London: Allen & Unwin, 1915), p. 397.

35 D. Cuppleditch, *The London Sketch Club* (Stroud: Alan Sutton, 1994).

36 John Johnson Collection of Printed Ephemera, Bodleian Library, Men's Clothing.

37 Whiteing, *John Street*, pp. 182-3.

38 L. Hapgood, 'Regaining a Focus: New Perspectives on the Novels of Richard Whiteing' in N. Le Manos and M. J. Rochelson (eds), *Transforming Genres: New Approaches to British Fiction of the 1890s* (London, Macmillan and New York: Pantheon Books, 1994), p. 185.

39 R. Dellamora, 'Homosexual Scandal and Compulsory Heterosexuality in the 1890s' in L. Pyckett (ed.), *Reading Fin de Siècle Fictions* (London: Longman, 1996), p. 82.

40 *Ibid.*, p. 86.

41 A. Sinfield, *The Wilde Century: Effeminacy, Oscar Wilde and the Queer Moment* (London: Cassell. 1994); E. Cohen, *Talk on the Wilde Side* (London: Routledge, 1993); E. Showalter, *Sexual Anarchy: Gender and Culture at the Fin-de-Siecle* (London: Virago, 1992).

42 R. Gagnier, *Idylls of the Marketplace: Oscar Wilde and the Victorian Public* (Aldershot: Scolar Press, 1986), p. 67.

43 R. Pritchard (ed.), *London and Londoners: What to See; What to Do; Where to Shop and Practical Hints* (London: Scientific Press, 1898), pp. 323-4.

44 D. Shaw, *London in the Sixties by One of the Old Brigade* (London: Heinemann, 1910).

45 D. Schwann, *The Book of a Bachelor* (London: Heinemann, 1910), p. 37.

46 W. Pett Ridge, *A Story Teller: Forty Years in London* (London: Hodder & Stoughton, 1920), p. 236.

47 C. Scott, *Souvenir of the Trocadero: How they Dined Us in 1860 and How They Dine Us Now* (London: Trocadero, 1900), pp. 3-4.

48 *Ibid.*, pp. 7-8.

49 *Ibid.*, p. 8.

50 *Ibid.*, p. 12.

51 D. Welch, *The Bachelor and the Chafing Dish* (New York: F. Tennyson Neely, 1896), p. 15.

52 Schwann, *Bachelor*, p. 310.

53 K. Chesney, *The Victorian Underworld* (Harmondsworth: Penguin, 1972), pp. 363-432.

54 C. Scott, *The Wheel of Life: A Few Memories and Recollections* (London: Lawrence Greening, 1897), pp. 42-4.

55 *Ibid.*, p. 54.

56 T. Burke, *The Streets of London Through the Centuries* (London: Batsford, 1940), p. 145.

57 Schwann, *Bachelor*, p. 109

58 W. MacQueen Pope, *Twenty Shillings in the Pound* (London: Hutchinson, 1948), pp. 237-43.

59 R. Altick, *The English Common Reader: A Social History of the Mass Reading Public 1800-1900* (Chicago: University of Chicago Press, 1957), pp. 348-64.

60 Pritchard, *London*, p. 144.

61 MacQueen Pope, *Twenty Shillings*, p. 345.

62 J.B.Booth, *Sporting Times: The Pink 'Un World* (London: T. Werner Laurie, 1938), p.6.

63 *Ibid.*, p.13.

64 *Ibid.*, pp.6-7.

65 MacQueen Pope, *Twenty Shillings*, p.346.

66 *The Modern Man*, 5 February 1910, p.3.

67 *Ibid.*, 8 January 1910, p.22.

68 J.Bristow (ed.), *Empire Boys: Adventures in a Man's World* (London: Unwin Hyman, 1991).

69 *The Modern Man*, 7 November 1908, p.22.

70 *Ibid.*, p.24.

71 Schwann, *Bachelor*, pp.91-2.

72 M.Williams, *Round London* (London: Macmillan & Co., 1896), pp.118-19.

73 C.Cruise, 'Artists' Clothes: Some Observations on Male Artists and Their Clothes in the Nineteenth Century' in P.Kirkham (ed.), *The Gendered Object* (Manchester: Manchester University Press, 1996), pp.112-21.

74 Schwann, *Bachelor*, pp.31-4.

75 F.Willis, *101 Jubilee Road: A Book of London Yesterdays* (London: Phoenix House, 1948), p.33.

76 Burke, *Nights in Town*, pp.75-6.

77 E.J.Milliken, *Childe Chappie's Pilgrimage* (London: Bradbury, Agnew & Co., 1883).

6 'As I walked along the Bois de Boulogne': subversive performances

A feature of London street life that was peculiar to the nineteenth and early twentieth centuries was the oafish custom of crying purposeless catchphrases. The phrases had no special application and were seldom used in any apposite sense. They were parrot cries from one dull mind to another. One finds no record of them in earlier times; they seem to coincide with the coming of the music hall. One of the earliest, current in the 'forties was 'Wal-ker!' intended to convey incredulity. Others of later date were 'I'll have your hat' ... 'Fancy meeting you' ... 'Does your mother know you're out?' In the later years of the century they were chiefly used as an introduction between boys and girls at those now vanished institutions, Monkey's Parades. In a grosser, rather Silenian vein, but also of the 'eighties and 'nineties, were those parading groups of young men in Inverness capes and Gibus hats, who threw their sovereigns about, and were celebrated in such songs as ... 'The Rowdy Dowdy Boys' ... 'Hi-tiddley-hi-ti' ... They were the last phase of that spirit. Getting drunk, sitting on the roofs of hansoms and singing choruses, staying out all night ... The present century does not know the type ... it really died with Mafeking Night and Victoria.[1]

Thomas Burke, remembering the street life of his youth, provided an antidote to the polished veneer presented by the figure of the bachelor, that West End playboy, whose commercial application to sites and products in the thriving sphere of masculine consumption was examined in the previous chapter. In his description of urban street noise and its perpetrators, Burke recalled a 'vulgarisation' of the fashionable bachelor model by disruptive youths who parodied the significant characteristics of such metropolitan idols. The exchange of popular catchphrases, culled from the latest music hall hit, drew attention to the physical shortcomings or idiosyncratic dress code of their targets, here labelled as effeminate mother's boys or unworthy possessors of overly spectacular headgear. At the other extreme, the disposable income and smart attire of bachelor role models found a distorted reflection in the antisocial carousing of middle-class adolescents, followers of the very stage artistes whose songs lampooned their own misadventures and sartorial pretensions and provided ammunition for the less

genteel hecklers of the Monkey Parade. What Burke's memoir implies is that the bachelor model found a broader circulation beyond the confines of West End culture. Far from passively representing the possibilities inherent in the goods of city-centre sartorial entrepreneurs, the symbolic figure of the fashionable young man also pre-empted the contesting of masculine identities across the social and spatial gradations of the metropolis. Now that we have mapped out the fashionable ideal, this chapter aims to test its further reproduction in the broader social life of London. It will argue that suburban middle- and lower-middle-class men, alongside the gangs and 'clicks' of the industrial inner city, constituted a massive market for the fashionable commodity and its imagery, whether appropriating it into the rhythms of local fashion systems and assumptions regarding manly style or refuting its expensive connotations for more subversive ends. Both strategies found a platform in the culture of music hall, whose role as a mediator and archive for modern fashionable masculinities will be assessed in the conclusion to this section.

For and against respectability: suburban savvy

> When I arrived cabs and motors were forming a queue. Each cab 'vomited' some dainty arrangement in lace or black cloth. Everybody was 'dressed' (I think I said that it was Surbiton) … Everybody, you felt sure, could be trusted to do the decent thing … their features were clean and firm; they were well tended … Altogether a nice set, as insipid people mostly are: What are known in certain circles as Gentlemen. On one point I found myself in sympathy with them: they were a pleasure loving lot. They were indeed almost hedonists.[2]

The social rhythms of suburban life were often represented as a pale and anodyne reflection of inner-city energies by contemporary commentators. The suburbans themselves portrayed as a small mindedly respectable rebuke to the excessive follies of fashionable modernity. Accordingly, much recent scholarship has attempted to track an objective history of suburbia or account for the prejudices directed at its inhabitants in a manner that rejects contemporary sentiment or hyperbole as unreliable.[3] However, there is scope within the primary literature for illuminating both the material culture of those who found themselves labelled as conservative, old-fashioned or reactionary and the attitudes of those who condemned them.[4] I would argue that within the rhetoric which both attacked and sometimes validated a suburban existence lay valuable co-ordinates for the structuring of social identities. For at the precise moment when more and more of the population were choosing to identify themselves with an untested

life outside of the city centre, authors and publishers were expending a great deal of print and energy in ensuring the provision of a literature which set such lives under unprecedented scrutiny.

In ironic tones of mock concern, Thomas Burke portrayed a Surbiton whist drive as the place where the spontaneous wickedness of West End gambling was watered down to an over-structured opportunity for the testing of local rivalries, hosted under the weak pretence of a little organised decadence. In a more direct appraisal of the suburban condition, C. F. G. Masterman echoed the sentiment when he stated in 1909 that

> no one ... fears the suburbans, and perhaps for that reason no one respects them. They only appear articulate in comedy, to be made the butt of a more nimble witted company outside: like ... the queer people who dispute - in another recent London play - concerning the respective social advantages of Clapham and Herne Hill. Strong in numbers and in possession of a vigorous and even tyrannical convention of manners, they lack organisation, energy and ideas.[5]

Masterman overlooked the contradiction lurking in his assessment, for, far from lacking any coherent sense of social direction, suburban tastes and cultural inclinations, so far as they existed in the prejudiced opinions of professional observers, were underpinned and defined by a ferocious attention to propriety and good form, and by extension an attention to the nature of fashion itself. While this resulted in an undeniable conformity to rigid social rules concerning display and behaviour, it also placed the material culture of life on the peripheries of metropolitan experience in a direct relationship to that enjoyed by those at the centre. Its forms were as reliant on the inner city as a focus for both disapproval and emulation, as those sophisticates who defined the meaning of fashion at its supposed core were reliant on the 'dull' censure or adherence of suburbia to set off their 'brilliance' all the more brightly. These permeable boundaries and a sense of mutual existence underscored Masterman's more dismissive assumptions:

> They are the creations not of the industrial, but of the commercial and business activities of London. They form a homogenous civilization - detached, self centred, unostentatious - covering the hills along the northern and southern boundaries of the city ... It is a life of security; a life of sedentary occupation; a life of respectability ... Its male population is engaged in all its working hours in small, crowded offices, under artificial light, doing immense sums, adding up other men's accounts, writing other men's letters. It is sucked into the city at daybreak and scattered again as darkness falls. It finds itself towards evening in its own territory in the miles and miles of little red houses in little silent streets, in number defying imagination. Each boasts its pleasant drawing room ... its high sounding title - 'Acacia Villa' or 'Camperdown Lodge' -

attesting unconquered human aspiration. There are many interests be-
yond the working hours ... a greenhouse filled with chrysanthemums ...
a bicycle shed, a tennis lawn. The women, with their single domestic
servants ... find time hangs rather heavy on their hands. But there are
excursions to shopping centres in the West end, and pious sociabilities.[6]

Conformity and aspiration, it was claimed, informed a life that
otherwise found meaning through an adherence to the hollowness
of commodity culture. Leisure and gossip filled the void once
occupied, supposedly, by the moral energies of industrial produc-
tion. The implications for the forging of suburban masculine
identities, given the weight that such negative rhetoric carried,
were profound:

> Listen to the conversation in the second class carriages of a suburban
> railway train, or examine the literature and journalism specially con-
> structed for the suburban mind; you will often find endless chatter
> about the King, the Court, and the doings of a designated 'Society';
> personal paragraphs, descriptions of clothes ... a vision of life in which
> the trivial and heroic things are alike exhibited, but in which there is
> no adequate test or judgement ... This is the explanation of the so called
> snobbery of the suburbs. Here is curiosity, but curiosity about lesser
> occupations ... so ... a feud with a neighbour ... a bustling church ...
> entertainment, or a criticism of manners and fashion ... will be thrown
> force and determination which might have been directed to effort of
> permanent worth.[7]

Added to this, opportunities for the comparison of appearances
and attitudes were legion in a culture that devoted greater energy
and time to socially inclusive activities. For all the criticism of the
introverted nature of suburban living, the practicalities of travel-
ling to and from work every day and the intense engagement with
street life enforced by city-centre occupations that annexed a more
homogenous experience of home and work, actually encouraged
a tendency to observation, speculation and competition; a tend-
ency allied by some early sociologists to the degeneracy of crowd
behaviour and the feminising pull of metropolitan social activity.[8]
The Modern Man is littered with examples of the attention paid by
men to the appearance and behaviour of others in such situations.
In an article titled 'My Fellow Passengers', William Thomson noted
that

> The pawnbroker's assistant ... gets into my carriage every morning. His
> suit has obviously been dry cleaned, and the cut does not quite seem to
> have been suggested by the figure of the present wearer; but what he
> lacks in the matter of tailoring he makes up for in jewellery. Sleeve links,
> watch chain, tie pin are all crudely visible, and his diamond ring is the
> more noticeable because the finger which adorns it is not very clean,
> and is actually in mourning at the tip ... The callow youth is another

unbearable. I have several in mind, but one in particular … is appropriately addressed as 'Baby' … Fairly well dressed, he has every confidence in himself, and chatters inanely throughout the journey … his favourite subjects being allusions to going out to dinner, sly references to well known but perfectly respectable actresses, and complaints about the trouble it is to get into evening dress every night.[9]

A further column, 'Judging a Man by his Buttonhole', adapted the popular and sentimental language of flowers to an observational code that sorted the discredited 'green carnation brigade' from the passion-flower-wearing collier, the orchid-sporting 'young dog about town' and the rosebud-bedecked 'ladies' man'.[10] Light-hearted though such articles may have been, their joky pseudo-sociological tone endorsed a lively masculine attention to the social detail of everyday appearances and encouraged the circulation and discussion of fashionable stereotypes in suburban life. Contemporary critics like Masterman failed entirely, of course, to see the joke:

> No one can seriously diagnose the condition of the 'suburbans' today without seriously considering also the influences of [their] chosen literature. There is nothing obscene about it, and little that is morally reprehensible. But it is mean and tawdry and debased … The reader passes … from one frivolity to another. Now it is a woman adventurer on the music hall stage, now the principle characters in some 'sensational' divorce case, now a serial story in which the 'bounder' expands himself … At the end this newspaper world becomes – to its victim – an epitome and mirror of the whole world. Divorced from the ancient sanities of manual or skilful labour, of exercise in the open air, absorbed for the bulk of his day in crowded offices … each a unit in a crowd which has drifted away from the realities of life in a complex, artificial city civilization, he comes to see no other universe than this – the rejoicing over hired sportsmen … the ingenuities of sedentary guessing competitions, the huge frivolity and ignorance of the world of music hall and the yellow newspaper. Having attained so dolorous a consummation, perhaps the best that can be hoped for him is the advent of that friendly bullet which will terminate his inglorious life.[11]

While this celebration of the ephemerality and endless variety of the fashionable world earned suburban men a condemnation that labelled them as emasculated, the development of more internalised identities, which drew their influences from the enclosed domestic world of the suburban home rather than the bright lights and bachelor stereotypes of the public stage, further aided a characterisation of suburban masculinity and its appearances as effeminate. A renewed pleasure in the rhythms and material culture of domestic life has been identified by several recent histories as a defining trait of modern constructions of manliness from the turn of the century to the outbreak of the Second World War,

though a reaction to the horrors of trench warfare after 1914 is
more generally cited as the cause of the change. Margaret Marsh
urges a rereading of the cliché of the frustrated office worker that
allows more space for the consideration of the satisfaction derived
by men from marital and paternal relationships in the social con-
text of the suburb. Her focus and material are American, but the
thrust of her argument and the insights it provides for a recon-
sideration of chronologies and priorities are equally instructive for
the English situation. She states that:

> When historians think about ... men at the turn of the twentieth cen-
> tury, among the images they usually conjure up are that of a bored clerk
> or middle manager in some impersonal office ... counting the compa-
> ny's money, longing nostalgically for a time when a man could find
> adventure and get rich ... conquering new frontiers ... We owe the asso-
> ciation of the corporate drone with the flamboyant Rough Rider to an
> influential essay by John Higham who argued that one of the most
> significant American cultural constructs at the turn of the century was
> a growing cult of masculinity ... He cited the growing popularity of
> boxing and football, a disaffection from genteel fiction, and, not least,
> the rise in the level of national bellicosity, as important indicators of a
> new public mood ... Those anxieties ... undoubtedly existed, but in the
> course of my research on suburban families, I have discovered a different
> manner of middle class man. There is evidence to suggest that historians
> will need to supplement the image of the dissatisfied clerk with a picture
> of a contented suburban father, who enjoyed the security of a regular
> salary, a predictable rise through the company hierarchy, and greater
> leisure.[12]

Marsh's revisions find a resonance in the gentle tone of light do-
mestic novels published for a middle- and lower-middle-class
London market from the late 1880s onwards. Focusing on the rou-
tines of suburban life, they provided reassurance for their readers
that the markers of their lives - moving house, pursuing court-
ships, hiring servants, attending local functions, taking an annual
holiday and occasionally visiting the glowing lights of the West
End - carried emotional worth. Largely descriptive and lacking the
reforming drive that informed social realist novels of East End life,
their purpose was reflective, self-validating and entertaining. The
power of their humour relied on a close observation of, and sym-
pathy for, the rhythms of suburban life by the author, and a
recognition of the veracity of situations and character types by
the reader. In this sense their overlooked narratives provide a use-
ful source for the historian keen to uncover nuances lost in the
hostile characterisations of the suburban by polemicists such as
Masterman. The particular value of the novels for the design his-
torian lies in the emphasis they place on the role of clothing and

other commodities in establishing a sense of place, time and sub-urban order.

Foremost amongst the exponents of the genre was the novelist William Pett Ridge, whose obituary in *The Times* informed readers that

> in 1895 Pett Ridge published his first novel *A Clever Wife* but it was not until 1898 that he really found himself with *Mord Em'ly,* a vivid present-ation of a girl of the Walworth Road. Thereafter he produced some 30 novels and collections of short stories which established him securely in the affections of a large and faithful public ... His characters were nearly all people who have come down in the world or have bettered themselves, and his highly selective art was shown especially in little scenes of daily life depicted with a sureness of touch and a nice economy of words. He was also an admirable lecturer choosing subjects such as 'The London Boy', 'The Cockney in the Theatre' and 'The London Accent' on which he was an expert.[13]

Further supportive elaborations on suburban mores were penned by the author Keble Howard, who in his series on the Smith family of Surbiton included an open letter to his fictional heroes:

> You confided to me, when first you made your appearance, that you were pained because certain people insisted upon regarding you as satiri-cal figures, and the comedy in which you played as a sneer at the suburbs ... It is so conventional to scoff at the suburbs that the unimaginative take it for granted that any work with the name of 'Smith' or 'Surbiton' in the title must necessarily depend for success upon the old fashioned treatment. In the same class ... you must place those who protest that there is no scope for artistic work between Mayfair and Whitechapel. To write of the middle classes, in short, is a confession of mediocrity. They do not understand, you see, how much more difficult it is to get an effect without flying to extremes. They admit ... that the middle classes are the mainstay of England, but ven-ture to write about them, save in the blessed spirit of satire, and artistically you are forthwith damned. But you and I, my friends, are not to be frightened off our little stage by such easy disparagement.[14]

The suburban novel also differed from the bachelor literature examined in the previous chapter, though both focused with differing degrees of sympathy on the significance of domestic de-tail and routine. Authors like Pett Ridge and Keble Howard were keen to stress the inclusive social nature of 'life outside the radius', coterminous with Marsh's claims that 'the suburb served as the spatial context for what its advocates hoped would be a new form of marriage. Husbands and wives would be companions, not rivals, and the spectre of individualist demands would retreat in the face of family togetherness.'[15] The bachelor novel was more likely to stress the benefits of independence from any broader family

economy, and the freedom this allowed for the more 'selfish' and 'fashionable' consumption of leisure, clothing or food that marked the 'individualist' gradations of metropolitan distinction. Occasionally, however, the two forms overlapped, with bachelor households portrayed as the happy though temporary twin of suburban matrimonial bliss. A short story by A.J.Lewis titled 'Our Treasures: A Story of Bachelor Housekeeping' of 1887, tracked the move away in authorial emphasis from a dissolute city-centre bachelor existence towards a more comfortable approximation of familial comfort, which anticipated the particular social style associated with the 'suburban man':

> Tidd and I are both ... confirmed bachelors. Tidd is an architect with a taste for music and dry sherry. I am a tea-broker, with an office in Mincing Lane. We had always lived in apartments; sometimes apart, but more often together. We had endured every possible variety of landlady, and every conceivable species of 'cat' from the feline who would use my Rowland's Macassar and my favourite hairbrush, to the 'tom' who borrowed my diamond shirt studs and smoked my best cigars. We had tried chambers ... but we found that Scylla the 'laundress' was, if possible, worse than Charybdis the landlady - the last straw in that case, I remember was finding Mrs Glooge ... wearing my dress boots ... We were [then] fortunate to secure a house ... which ... possessed a variety of exceptional attractions: a conservatory, a bath room, hot water laid on everywhere, and last but not least, a peculiarly admirable kitchen range ... known as the 'Treasure' ... Tidd and I rejoiced in anticipation over the recherché little dinners we should be able to give our bachelor friends - Toller of the Stock Exchange, and Tracy of the Probate Department.[16]

The dual identifying features of 'domestic' or suburban masculine style alluded to by Lewis found even bolder description in the context of the 'proper' familial suburban setting, where the appearance and social participation of men was contextualised rather than heightened. Here a man's occupation or role at work, together with his close involvement and enjoyment in the ceremonies and celebrations of a home life, marked the two sides of his sartorial self. When Pett Ridge conveyed the material presence of men in his suburban tales, they were either leaving for work en masse or returning to enjoy the freedom of evening or weekend. In both instances their characterisation stood in relationship to a description of the office suit or its alternatives; the fashionable trappings of leisure providing the truer indication of taste and personality. Thus in *Outside the Radius: Stories of a London Suburb* of 1899, he described how

> At about eight twenty every week day morning The Crescent despatches its grown up male inhabitants in search of gold. The adventurers

set out, each with a small brown bag and, excepting on rainy mornings, are silk hatted, because there are many ways of getting on in the City, but none apparently in which a silk hat is not indispensable ... Presently the detachment which went off in the morning to attack the City and to loot it, return, without perhaps any exuberant signs of triumph, but still preserving the small brown bags, and seemingly ready for the dinners whose perfumes stroll in the crescent. The younger men come out in startling change of costume, having put aside the silk hat and frock coat which constitute the armour they wear in attacking the City, and appear in white flannels and straw hats, which straw hats are lifted as white shoed young women trip also in the direction of the tennis ground.[17]

Beyond an adherence to the structured organisation of work and leisure, the suburban male wardrobe also played a part in marking weekly and seasonal evolutions, constituting a temporal fashion system as clearly differentiated as the pivotal commercial transitions from spring to summer, autumn to winter, that dictated change in women's fashionable dress. In *Sixty Nine Birnam Road*, Pett Ridge's 1908 tale of lower-middle-class life in a Clapham house, the link between clothing and the passing of time was made explicit, with the fading of older traditions adding a piquancy to his description of the development of a young male suburban style that celebrated the sporty, leisured atmosphere of summer weekends. On Sundays

> as the morning advanced there came peals from a distance, reminding City men, who sat out on the lawn and smoked a pipe, of youthful days ... when one had a suit kept for Sunday and one's hair was pomatumed and curled, and a handkerchief scented with lavender water ... A considerable detachment of Birnam Road went to church ... and this was made up principally of the aged and the young, who ... gave a glance that might mean reproof or envy at young men and young women who started off for Epsom Downs on cycles ... Smoke, at this hour, began to go straight up from chimney pots and in the roadway stood curls in the spring air ... from cigarettes belonging to young blades, who, always slightly in advance of the times, strolled up and down in white flannel suits, appropriate to Henley and a few months later.[18]

The ending of the working week on a Saturday lunchtime offered a less contentious space for the pursuit of pleasure for 'it was the afternoon of the week when Birnam Road welcomed the presence of its men. Young fellows raced home and went out immediately afterwards, taking kicks at an imaginary football; their fathers came with more deliberation, and changing silk hat for Panama, entered upon the precise task of clipping hedges.'[19]

The distinctive differences thrown up by a youthful adherence to informality, to light colours and textures, were influenced both by the ethics of sportsmanship that underpinned nineteenth-

century constructs of respectable manliness and more directly by the importance lent to team sports and activities in the workings of suburban society, as well as the proximity of suburban developments to the open parks and fields necessary for the tennis, cricket, football, cycling, walking and boating that Pett Ridge saw as superseding church attendance.[20] Their sartorial trappings marked young men out from the propriety of professional identities and the individualism of metropolitan dandyism. The resulting style, however, was no less commercial or mannered in its presentation. As summer turned to autumn in Birnam Road, Pett Ridge noted that Brown leaves began to carpet the road at the side of the common ('Dash 'em!' said City gentlemen as they slipped and slithered on the way to catch morning trains) … Cricket bats were oiled and put away, and white flannel suits sent to the wash ('They're never paid for' complained mothers. 'Continual source of expense. You boys will have to make up your minds to bear the cost of washing another year!')[21]

The holiday season witnessed the apotheosis of a finely honed

34] Cabinet photograph, c. 1890. The holiday season offered its own unique sartorial code and a release from the hierarchical rules usually associated with middle-class dressing.

suburban identity in which white flannels and straw hat became synonymous with a respectable release from the daily round, while instituting recognisable modes, language and demeanour which could signify a modern fashionability the whole year round. As Pett Ridge recalled, during the summer months

> four wheeled cabs drew up of a morning in Birnam Road, taking pale faces away and returning them a fortnight later as Red Indians, with habits and customs gained from far off places lasting for several days; babies going out in burlesque costumes, with wooden spade and tin shovel, to pretend that the Frying Pan on the Common was the boundless ocean; girls strolling without hats or gloves, young men in white flannels, a straw hat set at the back of the head ... and pianofortes in every house were badgered into efforts to recall the elusive airs learnt from Pierrots on the sands.[22]

Alongside the group photographs which recorded such *fin de siècle* excursions, autobiographer Fred Willis provided the corroborative evidence of young men adopting 'summer suitings ... most popular of all in blue diagonal tweed' cut in exaggerated double-breasted formations, nautically accented with shaped waist, glass or metal buttons and peg-topped trousers with a permanent turn up, soft shirt collars and prodigious use of white handkerchiefs.[23]

Whatever the combination of the constituent parts, the overriding aesthetic stressed relaxation and a conscious paring down of formalities, replacing the archaic introversion of office or church decorum with the over-familiar heartiness of the playing field or promenade. Willis further recalled that

> the young proletarian swells made certain concessions and modifications in their dress when they went on holiday - when for instance they took a trip by water to Margate or Ramsgate. The young man would discard his bowler for a ... boater. His waistcoat, the joy of his life, would be packed away among the mothballs and replaced with a cummerbund ... His patent leather boots would be replaced with brown shoes, and as a tribute to the nautical nature of his venture, his walking stick would be put out of commission.[24]

The extension of this irreverence for established sartorial etiquette beyond the beach could be felt in all those areas of suburban life where young men exerted their taste in the first decade of the twentieth century. MacQueen Pope credited the shift to the popularising effects of theatre and the rise to prominence of the matinée idol, though he was probably simply witnessing the symptoms of sartorial trends that could trace their antecedents back to the establishment of a recognisable suburban culture in the 1870s:

> Sir George Alexander ... was one of the leaders of male fashion, but he never went to extremes. He was always, of his time, the most perfectly

and correctly dressed of men. So when he made a tentative start with a soft collar in 'John Chilcote MP' there was a considerable flutter. And when he wore it again in 'His House in Order' the deed was done! Men who might have been chary of this informal innovation hesitated no longer. What was good enough for Alexander was good enough for them. The double fold soft collar swamped the shops of 1906 and sold like wildfire. It was flannel when it first came in and striped ... held together in front by the lower corners being linked by a gold safety pin ... it made no pretence to match the shirt. It was, however, never worn in town. It was for home or country only.[25]

Pope's last line was telling. While perhaps the new informality of a look indebted to a suburban taste for pleasure was impermissible in the work environment, such indictments did nothing to curb

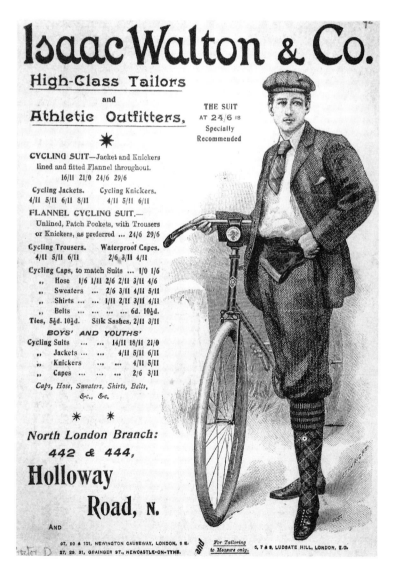

35] Promotional flyer, Isaac Walton & Co., c. 1900. Bodleian Library, University of Oxford: John Johnson Collection. Men's Clothes 3. Cycling and other leisure pursuits allowed for the adoption of more relaxed modes of dressing all through the year.

its popularity. Suburban outfitters directed much of their energy to the promotion of soft collars and sportswear during the period, basing their advertisements on the style's suitability for leisure pursuits, allying their fashionability to the modernity of rowing, cycling and flying. What was significant about the figure of the suburban masher was not the obvious affront his image offered to the desk-bound paterfamilias, but the roots of his wardrobe in a masculine celebration of the domestic sphere, its alliance with the sentimental and romantic features of the heterosexual suburban imagination and its concordance with the 'wholesome', sporting atmosphere of an idealised suburban life. It was indeed a choice 'for home ... only', but 'home' didn't necessarily imply a negation of modernity or fashionability, rather the opposite. In the end though, behind the negligent laid-back surface, the final point of reference for the fashionable young suburban still remained in the mocking guise of his cosmopolitan counter point. Keble Howard represented the two models with a savage wit. At the Surbiton Rowing Club Ball, where the hero, Jack, was attempting to impress his future wife, the example of the bachelor dandy and the suburban swell clashed with devastating results:

> As for the rival suitors ... there was a disparity in their attire that made poor Jack feel sick at heart. For Harry, that cunning one, had taken every possible advantage of his superior means. His dress suit was new enough to be in the very latest fashion, yet not so new as to look uncomfortable. His pumps were of the shiniest, his socks in the most exquisite taste, his shirt and collar of the finest, his gloves of superb quality and his tie so cleverly tied that the inexperienced might be readily pardoned for mistaking it for a made up one. And Jack? He was wearing a suit that his father had discarded and which had been altered, more or less skilfully, by a local tailor. His pumps were deadly dull in comparison with Harry's, his socks were of the ordinary woollen variety, his shirt was a wee bit frayed, his collar a size too small, his gloves had done duty more than once before, and his tie, alas! was obviously a made-up one.[26]

'Arryism and the repudiation of respectability

As suburban fashionability was mocked from above for its homely ties to domesticity and pathetic attempts at modishness, the strata positioned directly below were also singled out for their lack of taste and presumptuous claims on style. Young working men had found their 'selfish' spending habits the butt of social reformers' criticisms since the 1830s at least. The expansion of retailing outlets selling mass-produced clothing in working-class areas had increased the potential for wayward consumption:

> It requires but a showy tailor's window, with offers of cheap ready made

suits, to tickle a young man's fancy into wild extravagance. A boy earning twelve or fifteen shillings a week is always saving with an eye for a new suit for Sunday. He buys, not one, but two or more in the course of a year, for their smartness is short lived. They are too cheap to wear for very long. They are not kept with sufficient care at home; they are worn at the wrong times. Those tight green trousers, the waistcoat with fancy buttons, the coat which fits like a glove, are not to be wasted on only local eyes. They are taken for a day in the country and returned soaked and shapeless, with seams awry and far more than the fashionable number of creases ... One good suit at nearly double their price, wisely worn and neatly folded would last a year or more, while for the weekday evening an old coat and grey flannel trousers, with a well tied scarf, would serve every purpose. On these points public opinion requires education, but with boys the process is comparatively easy, for they are of a highly imitative disposition.[27]

The rising profligacy of working-class consumption habits was condemned by Alexander Paterson in his 1911 social report on the social life of south-east London. Young men as much as young women were targeted for their inappropriate spending patterns, and the drive for fashionability discouraged in favour of encouraging a more concerted effort towards thrift. As Paterson continued,

> it is more and more the custom of the working boy or man to spend a penny on being shaved, to spend a half penny on a tram ... another half penny on an evening paper, another penny for having his boots blacked. All these little conveniences of civilization are pardonable as occasional extravagances, but as regular expenses they belong to a more prosperous type of life, where the struggle for daily bread is less acute.[28]

For all his insightful visual observations, however, the author failed to appreciate the wider returns on a new suit of clothing, its role as a symbol of belonging, of sharing tastes, and understanding the vagaries of style as a sociable practice. He read sartorial acquisition as a wasteful example of emulation without considering the meaning of fashionability in a personal context.

Paterson's descriptions of items bought do betray something of the vibrant idiosyncrasies of a popular working-class look at the turn of the century, but he dismissed their implications, preferring to support the adoption of the unthreatening overcoat and muffler which signified a more traditional proletarian compliance with the 'proper' order of things. Tight green trousers, fancy buttoned waistcoats and a cut that fitted like a glove were features far removed from the loose flannels and easy masculinity of middle-class hearties, suggesting a sharper edge more akin to the tailored dandyism of the Piccadilly bachelor. But denuded of the social conventions and fitness for purpose accorded aristocratic or metropolitan models, Paterson merely viewed them as shoddy cash-tailor copies,

ruined by overwear and presumptuous in their pretence at modish-
ness. Set in the context of the development of a recognisable
working-class style that Paterson presumably neither knew nor
cared for, the characteristics of the Bermondsey wardrobe actually
announced a distinctiveness separate from both suburban sporti-
ness and metropolitan flash models, and as well established. Indeed
the subversive rhetoric of tight, bright clothing found its origins
in popular representations of the London cockney seventy years
before Paterson's comments, and offered its own attractions to
retailers and consumers both from the East End and of more 're-
spectable' provenance by the end of the 1870s at least.

In his study of the representation of working-class life in Victor-
ian fiction, P. J. Keating isolates the figure of the cockney as a key
symbol of London proletarian style, finding his most eloquent
representatives in the characters of Sam Weller from Dickens's
Pickwick Papers of 1837 and 'Arry from the satirist E. J. Milliken's
popular *'Arry Ballads* of 1877. These two 'gave their names to certain
types of speech and attitude; both names were used as synonyms
for cockney mannerisms; both inspired a host of imitators; and the
personality projected was in each case a crystallisation of cockney
characteristics current in popular literature of the time'.[29] Weller,
as the prototype of urban 'flash', is presented as the descendant of
the devoted valet, a constant in eighteenth-century satirical litera-
ture. His wit and courage are reflected in the jauntiness of his
carriage, his stylish clothing seeming to mock the vanity and prigg-
ishness of his superiors, all the while containing a man confident
of his position as a servant of beneficent middle-class paternalism.
As Keating points out, Weller epitomised a version of the urban
picaresque that in the turbulent social context of the 1830s and
1840s provided comfortable imagery for a nervous bourgeois
readership. 'Arry, by contrast, represented a later erosion of the
boundaries that demarcated class stereotypes. He was not specifi-
cally working-class, but symbolised a pervasive celebration of
caddishness and vulgarity that were assumed to have lowly social
origins. While his speech and dress trace a direct line back to the
Weller type, his contemporary relevance reached out to all classes.
As Milliken himself suggested: 'My real subject indeed, is 'Arryism
rather than 'Arry. And 'Arryism is not confined to the streets. Its
spirit pervades only too plentifully the race course, the betting
ring, the sporting club, the music hall, many spheres of fashion,
and some sections of the press.'[30]

Both Weller and 'Arry offered versions of working-class and thus
inner-city masculinity to an audience safely removed from the
source of such descriptions, and as such their relationship to the
actual sartorial practices or attitudes of young 'cockney' men is as

problematic as that suggested by Paterson's subjective reports. All three, however, offer evidence of the circulation of knowledge about a satirical type whose influence infiltrated beyond its original target. The tailor's promotions discussed in the previous chapter, alongside the descriptions of elite bachelor carousing, all drew on its attractive power. Closer to home, the working-class or adventurously déclassé consumer found further cause for identification with a mode of dressing and behaviour that intensified the veracity of the literary stereotype. Peter Bailey's examination of the cartoon character Ally Sloper reveals an abandonment to pleasure anchored in working-class culture which found its clearest reflection in popular practice yet. Sloper, whose finest hour spanned his appearance in the weekly penny comic book *Ally Sloper's Half Holiday* between 1884 and 1888, when his mature image was fixed by the illustrator W. G. Baxter, had generally been depicted since his first appearance in the paper *Judy* in 1867 as a slovenly, inebriated lounger in battered top hat, tatty tailcoat, stiff collar and tight trousers. Baxter's version, which remained the model after his death in 1888 until the demise of the *Half Holiday* in 1923, elaborated on the prototype, introducing the hero to many of the features which isolated Paterson's later Bermondsey boys as proletarian dandies. Loud checks, straw boaters, coster costume and evening dress all found their way into Sloper's extravagant repertoire, hinting at the socially inclusive nature of his characterisation, while still maintaining a sense of cultural specificity (Figure 36).[31] Bailey draws attention to the multiple readings that his sartorial image gave rise to:

> Sloper's dress may have been intended and read by some as a parody of the ineffable bad taste of the bookmaker, the publican and the stage army of vulgar swells, but there is nothing in his demeanour that suggests the conscious copyist or slave of fashion. What impresses is Sloper's unabashed sartorial confidence. His splendidly eclectic wardrobe serves him admirably in whatever role he plays and he proves himself a master of the accessories - monocle, watchchain, hat and gloves, cigar and, most notably, the umbrella. For Sloper it is the umbrella, the symbolic insignia of the city clerk, that gives him additional powers, serving variously as a truncheon, cane, slap-stick, wand, hold-all and auxiliary phallus. In the manner of modern subcultures that make their own selection and combination from the dominant culture, Sloper creates his own style and conventions, and encourages others to do likewise.[32]

An encouragement to emulate was aided by the ubiquity of the Ally Sloper figure beyond the pages of the comic. The urban lounger could hardly miss his distinctive silhouette in his journeys round the city. Besides his reproduction on commodities ranging from buttons and socks through to pickle jars and firework displays, the consumption and replication of Sloper's adventures by

36] Price list, Wm Potter & Sons, *c.* 1895. The distinctive features of comic book hero Ally Sloper were reproduced across a range of men's commodities.

a working-class audience, and their translation into behaviour and attitude on the street, was viewed with some concern by more 'discerning' contemporary commentators.[33] Richard Whiteing, never slow to incorporate local colour and topical debate into his novels of London life, referred directly to the genre's appeal and its allegedly demoralising effect in his discussion of working-class reading habits in *No 5 John Street*, crediting a thinly disguised *Half Holiday* with an insidious influence, as profound as that wielded in the suburbs by the romantic yellowback:

> These weekly comics, as they are called, are nearly all illustrations. They have hundreds of cuts to the issue, and but a thin black line of legend to each. There is no vice in them in the sense of conscious depravation;

it is but the bestiality of bad taste ... Covey's ... selection has failed to
please him. 'Swipey Loafer ain't up to much this week' he murmurs, as
he lays it aside with a sigh of disappointment. In this elegant trifle, a
typical family, and especially the typical head of it, lives before the
public on a nutriment of winkles and gin. It gives us the humours of
the beanfeast and of Margate sands, varied by glimpses into the back-
yards of Somers Town ... All the men are drunk, and most of the women
are in short skirts. It is 'Arry in 'Eaven, a heaven of plenty to eat and
drink, plenty to wear, and a celestial choir for ever on the spree. Words
cannot tell its vulgarity, its spiritual debasement. Better vice itself, if
redeemed by a touch of mind. The police sheets detain him longer - the
sheets in which the same scheme of social observation is more or less
associated with crime. 'That'll do to begin with' he says, laying aside one
in which sprightly young women kick off the hats of maudlin young
men in evening dress. As gin and shell fish are the principal ingredients
of the first dish, so leg and chemisette are indispensable to the last. These
in their innumerable varieties form the mirror of life for the slums. They
should be carefully stored in our literary archives, for they will be price-
less to the future student of manners ... They represent the visible world
as the incarnation, under an innumerable variety of forms, of the univer-
sal cad ... The creative spirit moves upon the slime and we have
organisms and institutions. In the first it is the cad as swell, as plutocrat,
as strumpet, or as thief. In the other, it is the environment of the gin
shop, the race course, the prize ring, and the police cell.[34]

The translation of Sloper's misadventures on to the streets of
London was not straightforward, but many of the features dis-
cussed by the critics, especially the love of display and the
promotion of consumption for its own sake, did find their parallels
in leisure activities associated with inner suburban and working-
class districts. It is in descriptions of institutions such as the weekly
monkey parade that the features of 'Arry's 'living' style can be
discerned. In the Hackney monkey parade, a Saturday and Sunday
night promenade down Mare Street in which gang rivalries, friend-
ships and courtships were subsumed into an excuse to parade in
one's best clothing, young women attained an unusual promin-
ence, and George Sims's description of the scene in *The Strand
Magazine* during 1904 provides a useful context for considering the
relationship of a masculine sartorial image to broader gender
relationships. According to Sims, young women in Hackney set the
tone for the evening and clearly led innovation in terms of adopt-
ing distinctive 'coster' clothing styles. The emulative habits of the
minority of young men, though equally theatrical in their own
way, remained a foil to the brilliance of the street sellers and
factory girls who made up the majority of the crowd:

We have heard so much of the famous Monkey's Parade that we expect
to see a bustling crowd directly we enter the thoroughfare. There are
plenty of people on the pavement and in the roadway. Here and there

are groups of typical London lads, cane, cap and cigarette, and we exclaim simultaneously 'The Monkeys!' ... And yet the scene was remarkable, and in one sense I should think unique. There were considerably more young women than young men ... They were dressed in pairs like sisters, yet in many instances there was not the slightest family resemblance ... The costumes were as gay and gorgeous as the costumes that grace the Heath of Hampstead on a Whit Monday. The favourite colours were petunia, violet, green and sky blue. Two young ladies, one dark and one fair, had adorned themselves in light green blouses, red hats and blue skirts, and waistbands of bright yellow ... When the scene was at its busiest Mare Street was absolutely prismatic ... Occasionally a weird effect was added ... by a looping up of the skirt with the old fashioned dress suspender which fastens round the waist ... As soon as the novelty of seeing a crowd of young women in pairs similarly attired had worn off, the feature of the crowd that leapt to the eyes was the complete absence of gloves and umbrellas.[35]

There is much here suggestive of the desire to both acknowledge and reject mainstream fashionable dictates and foster a 'louder' appearance based on local networks of friendship, exchange, supply and competition. A willingness and ability to consume underlies the extravagant clothing of the promenaders, and the author indicated that young women in the district had greater access to disposable income than men of the same age, stating that

there are a large number of industries in Hackney employing only women; there are a few in which men only are employed ... the net result of this condition of affairs is that unmarried women are constantly attracted to Hackney and unmarried men are constantly compelled to leave it. This accounts for the magnificent display of finery in Mare Street on Sunday evenings, and for the fact that the Jills promenade together. Most of the Jacks are considerably their juniors - mere lads who have not yet come to the age when they must flit in search of work and the making of a home of their own.[36]

Attempting to read subcultural activity from the evidence of a monkey parade dominated by young women presents interpretative problems which are ultimately highly revealing, the field of writing on fashion and working-class youth culture having been dominated largely by discussion of the practices of young men, often directly contrasting with treatments of middle-class and aristocratic fashionable practices.[37] Indeed, in the most recent texts on masculinity and consumption, post war male subcultures are usually credited with opening the gates to a wider masculine engagement with fashionable consumption in the final decades of the twentieth century.[38] Conversely, in broader debates on the nature of modernity and mass culture, critics and historians have tended to link issues surrounding consumerism and femininity without recourse to considerations of class or masculinity, so the

acknowledgement of a public engagement with various levels of
fashionability by working-class girls is perhaps less surprising in
this context.[39] Sally Alexander and Angela McRobbie have both
provided more nuanced evidence of young working-class women's
ability to read and reinterpret the messages of middle-class cloth-
ing retailers and advertisers, questioning the assumptions of
explanations of consumption and gender that prioritise coercion,
though much of this work has not been reflected in mainstream
narratives of teenage style or the evolution of popular fashion.[40]

In fact it is precisely the supposedly unprecedented emergence
of young proletarian men as avid followers and decoders of fashion
in the 1960s that historians of subcultures have isolated as an illust-
ration of the uniqueness and revolutionary quality of the postwar
experience.[41] However, by prioritising new male consumers and
male-oriented boutiques and subcultural groupings in the later
period and accepting an over-arching discourse of feminised con-
sumption for earlier periods, such histories have missed a great deal.
In the figure of 'Arry or the Mare Street girl promenader it is
possible to discern the precursor of the former and an amendment
to the latter propositions, which rather dilutes their significance.
The unpacking of historical subcultural style thus presents a para-
digm case of the manner in which constructions of gender and
class, like notions of fashionability and modernity, are contingent
on more immediate contexts and concerns.[42] The aggressive model
of the sharply attired cockney needs to be read as part of the
commercial, sexual and social flux suggested by the forging of
identities in Mare Street and all those other turn-of-the-century
monkey parades, not as a bit-player in some abstract subcultural
grand narrative. Edwin Pugh, in his collection of journalistic
vignettes *The Cockney at Home* of 1914, presented just such a male
promenader, as sharp and self aware as any Colin MacInnes char-
acter from fifty years later, though the subversive coding of his
clothing and attitude have remained invisible to those who locate
the emergence of such behaviour after 1945:

> Said the cynical youth in the amazing collar: 'There's a kind of young
> man who is merely background. I mean that without his clothes he
> wouldn't be noticed ... There was Bertie Amplett for instance ... I re-
> member him as a perambulator ... This Bertie you know ... was a deuce
> of a fellow. He didn't 'work in the City somewhere', he drew, I believe,
> a quid a week, but I vow he never earned it. His wages went on clothes
> mostly, and Woodbines. His mother was a charwoman ... Bertie was king
> of the local monkey parade. And if you don't know what a monkey
> parade is ask Anderson here. He's straight off one ... It's a place where
> the elite of the beau monde of suburbia meet nightly for purposes of
> flirtation ... the fellahs and the girls wink and smirk as they pass, and

break hearts at two yards with deadly precision ... The Kentish Town Road was his preserve, and he paraded it nightly, like a revolving sky sign. There wasn't any escaping him. You see he was a tall chap, and that isn't usual. He was good looking too, in the style of the novelette hero. And he really knew how to wear clothes. In fact it was in his blood, his father having been a shopwalker.[43]

Pugh's perambulator displayed all of the tensions that absolved his parading of the cosmopolitan image from becoming a straight emulation of more metropolitan or suburban modes. Aside from the question of his upbringing and occupation, his singleminded embracing of a 'flash' façade for its own sake marked him out from the underplayed sentimentality of suburban masculine display or the nonchalant luxuriousness of the bachelor dandy. In all other respects his deceptive, parodic public persona mirrored the familiar respectable role models, though the ostentatious mention of a cigarette carried its own complex symbolism. MacQueen Pope nostalgically recalled that 'a man could get gold-tipped cigarettes ... if he wanted to be ostentatious. Some men even had their cigarettes specially made ... with their name printed on the paper ... there were cork tipped cigarettes then too, one brand known as 'the belted earl' having the cork surrounded by two little belts of silver paint'.[44] In a similar vein Alexander Paterson referred to the practice whereby

> one commonly lights his fag, draws in the smoke twice, inhaling deeply, breathes it out, spits, says something, and then holding his cigarette in his right hand, extinguishes it with the thumb and first finger of his left, and replaces it in the bottom right pocket of his waistcoat. Ten minutes later the process will be repeated and by this means, though the boy will always seem to be smoking, he will only consume a penny packet a day.[45]

Thus clothing and gesture together produced a rakish mirage, subtly critical of the status quo and engineered to impress cronies or attract the opposite sex.

Echoing this strategy, the wearing of West End styles by female participants in the Mare Street parade was not in itself subversive. On the contrary, fashionable display and a concern with appearances were skills expected of young, respectable unmarried women in the 1890s. It was the deliberate choosing and mixing of colours and styles, and their massed display by promenaders more usually associated with the factory floor or the street market, that constituted a challenge to accepted models. At their most extreme such practices blurred into criminality, as a report in *The Times* of July 1914, quoted by Stephen Humphries in his oral history of working-class childhood, attested:

> At Marylebone yesterday Nellie Sheenan, 17, pattern matcher, was
> charged on remand for stealing a pair of shoes. She belonged to a gang
> of about twenty girls who went about the West end … taking advantage
> of the first opportunity to steal anything they could get hold of. One
> feature of the gang was that they dressed alike in check skirts and blue
> coats and all came from the neighbourhood of Harrow Road.[46]

Similarly Montague Williams noted of the clothing of match fac-
tory girls that 'dress is a very important consideration with these
young women. They have fashions of their own, they delight in
a quantity of colour, and they can no more live without their large
hats and huge feathers than 'Arry can live without his bell bot-
tomed trousers.'[47] What is striking here is the complementarity
between male and female modes of presentation. As suburban
masculine style can be read as evidence of a domestic fashion-
ability, a conscious distancing from the homosocial separatism of
the metropolitan office or club, so working-class subcultural style
could be said to have engineered a celebration of romantic friend-
ship in the public sphere of the street. However, this was a
celebration that often developed into a more disruptive lampoon-
ing of the rituals of courtship. Local historian W. J. Fishman places
more emphasis on the violence inherent in the sexually provoca-
tive display of local fashionable taste, rather than the surface
romance of its variegated image:

> The devil found work for idle hands along the Bow Road on Sundays.
> This was the infamous monkey parade when gangs of young lads, aged
> between 15 and 20 marched up and down the main highway between
> Grove Road and Bow Church molesting passers by, especially young
> women on their way to Sunday service. Early spring brought the lads
> out in force and their pranks were enumerated in court; such as 'pushing
> respectable people off the pavement.' Some of them had lamp black on
> their hands which they placed on young girls faces, while others whit-
> ened their hands and clapped girls on their backs.[48]

This ambivalence went hand in hand with those constructions
of aggressive heterosexuality that upheld notions of a female
sphere concerned with conspicuous display, while simultaneously
devaluing its worth by rejecting overt interest in sartorial matters
as effeminate or anti-social, so that *any* major deviation from the
standard conservative working wardrobe, 'Arry's bell bottoms ex-
cepted, signified a rebellious or even pathological act. Robert
Roberts in *The Classic Slum* recalled the dangerous associations of
particular modes of working-class dandyism in turn of the century
Salford when

> the proletariat knew and marked what they considered to be the sure
> signs of homosexuality, though the term was unknown. Any evidence
> of dandyism in the young was frowned upon. One 'motherbound'

youth among us strolled out on Sunday wearing of all things gloves, low quarters and carrying an umbrella! The virile damned him at once – an incipient nancy beyond all doubt.[49]

The subtleties of coding and detail that consequently surrounded 'street dress' functioned subconsciously or associatively to produce forms of subcultural identification almost hidden to the gaze of the uninitiated contemporary observer, or else suggestive of a heightened violence that simply magnified masculine expectations. In his novel *To London Town* of 1899, Arthur Morrison alluded to the encoding of a bowler hat with connotations of workshop etiquette, and the observation of a hierarchical order that was easily fractured by inappropriate display, stating that 'it was the etiquette of the shop among apprentices that any bowler hat brought in on the head of a new lad must be pinned to the wall with the tangs of many files; since a bowler hat, ere a lad had four years of service, was a pretension, a vainglory and an outrage'.[50] This fine division between the proprieties of work and leisure clothing, and the contradictory codes pertaining to each, had a long-standing tradition and gave rise to frequent misinterpretation. Thomas Wright, writing under the pseudonym of 'a journeyman engineer' in 1867, produced a very rich description of working-class habits that identified the various codings of weekday, Saturday, Sunday and holiday clothing among skilled labourers. The author acknowledged that 'in all phases of life there is I fancy a sort of inner life … that is known only to the initiated … there are traditions, customs and images interwoven with, and indeed in a great measure constituting the inner and social life of workshops, a knowledge of which is … essential to the comfort of those whose lot is cast among them'.[51] According to Wright the consequences of such intricate coding were a tight adherence to specific looks, policed by a merciless lampooning of the unfortunate who attempted to 'rise above'. He noted that 'the general body make one of their number unhappy by glancing meaningfully at a new coat that he has got on and telling him that "it fits him too much" that it is "like a ready made shirt, fits where it touches" and much more to the same disheartening effect'.[52]

Saturday nights and Sundays, for Wright, presented the one opportunity for the display of more individual tastes without risk of censure, though his own preferences appeared to lie with the functional grace of work dress. The contrast between the two modes was significant:

When the workmen, with newly washed hands and their shop jackets or slops rolled up under their arms, stand in groups waiting for the ringing of the bell, it is a sight well worth seeing, and one in which the

working man is, all things considered, perhaps seen at his best. He is in good humour with himself ... in his working clothes, in which he feels and moves at ease, and not infrequently looks a nobler fellow than when 'cleaned' ... Some of the higher paid mechanics present a very different appearance when cleaned up ... working class swelldom breaks out for the short time in which it is permitted to do so in all the butterfly brilliance of 'fashionably' made clothes, with splendid accessories in collars, scarves and cheap jewellery. But neither the will or the means to 'come the swell' are given to all men, and a favourite Saturday evening costume consists of the clean moleskin or cord trousers that are to be worn at work during the ensuing week, black coat and waistcoat, a cap of somewhat sporting character, and a muffler more or less gaudy.[53]

For Paterson, writing after the turn of the century, the ritual transformation from work to pleasure retained its drama when he observed that

the programme of spare hours begins almost invariably with tea in the kitchen, a wash at the tap in the yard, and the putting on of a collar and another coat. The exact order of the preparation varies, but it is quite clear that the washing and dressing is not in honour of the tea ... but a tribute to the publicity of the street ... Percy's working clothes are old and worn, bespattered with mud and oil; hence the efflorescence of bright ties and new suits.[54]

Surviving images of working-class groups, assembled for a Whitsun outing, or even posing unawares on street corners, sporting bowlers and tight suits with a jaunty pride, gain a further resonance from their juxtaposition with documentary and literary evidence, which provide nuances that graphic or photographic representations themselves can no longer convey. From simple visual comparisons of middle-class and working-class clothing, the mechanic's 'Sunday best' suggests only a clumsy emulation of bourgeois conservative respectability. Contemporary attitudes reveal a more studied and critical negotiation of gendered and occupational positions behind the frozen poses, producing a series of looks differentiated enough to earn subcultural labels. Both Geoffery Pearson and Stephen Humphries in their investigations into late Victorian youth and criminality provide useful examples of hooligans adapting the usual coster uniform of flat cap, collarless shirt, reefer jacket and flared trousers to communicate aggressive intentions and gang membership, creating a mannered appearance that avoided accusations of unmanly display by sending into higher relief the dandyism of monkey parade celebrants. Pearson quotes *The Daily Graphic* of November 1900 which stated that

the boys affect a kind of uniform. No hat, collar or tie is to be seen. All of them have a peculiar muffler twisted around the neck, a cap set

rakishly forward ... and trousers set very tight at the knee and very loose at the foot. The most characteristic part of their uniform is the substantial leather belt heavily mounted with metal. It is not ornamental, but then it is not intended for ornament.[55]

Similarly, Humphries notes that the Napoo, a turn-of-the-century Manchester gang 'were recognised by the distinctive pink neckerchief they wore and the razor blades that they displayed in waistcoat pockets or in slits in their cloth caps'.[56]

Raphael Samuel's *East End Underworld*, an oral history of street life in the slum district of the Nichol, which straddled Whitechapel, Shoreditch and South Hackney, and based on interviews with Arthur Harding, a 'retired' petty criminal active from the years preceding the First World War, is richly suggestive of those spatial and visual networks which informed and supplied local gangs with their influences and raw materials. Here was a smoky blend of public houses, shop windows and music hall that underpinned the wider circulation of the street rough as glamorous anti-fashion stereotype. Harding remembered that

> the high heaven of everything in the Nichol was Church Street where all the shops were. The whole place was crooked, even those who kept shops ... The White Horse Pub stands on one corner and on the other corner was a big men's and boy's tailor shop known as Lynn's. Turk Street was at the top of Brick Lane ... there was an old clothes market on Sundays. The old girl, she had a shop in Turk Street, selling old clothes, next to the Duke of York ... On the corner of the next street, Camlet Street, was a wardrobe dealer's shop which sold second hand clothing of all kinds ... You could say that Shoreditch High Street was our Champs Elysees. It was a prosperous market place with stalls and shops ... and pubs and also the London Music Hall which had performances six days a week.[57]

Descriptions of the varied dress codes adopted by East End youths prove the importance of those retail options suggested by Harding. The second-hand markets of Brick Lane offered the widest range of styles to those whose image was bricolaged together from the remnants of more respectable wardrobes. For the more solvent, the proliferation of tailors' shops in the district provided the sharper suits of gangs such as the Titanic Mob whom Harding describes as 'well dressed fellows' who concentrated on robbing men at race meetings, in theatres and at boxing matches. Their 'heroic' sartorial image must partly have been derived as a means to blend in with crowds composed of men whom Thomas Wright described thirty years before, though its threatening precision also positioned its adherents at the head of a local criminal hierarchy:

> They are great in slang, always speaking of the features of the human face in the technical phraseology of the day - according to which the

nose is the beak or conk, the eyes ogles or peepers, the teeth ivories, and
the mouth the kisser or tater-trap ... Meantime they have their hair cut
short, and when off work wear fancy caps and mufflers and suits of the
latest sporting cut; in which they assume the swaggering walk of the
minor sporting celebrities whom they are occasionally permitted to
associate with and treat.[58]

George Ingram provided corroborative detail of the mob in his
romantic recollection *Cockney Cavalcade* when he stated that 'most
of them were dressed in the fashions of the day, with caps, jackets
and waistcoats of lurid colourings and fantastic cut. The jacket was
acutely waisted, had perpendicular pockets with buttons topping
slits at the back, and well pressed pleats ... waistcoats had weird
styles of their own, unknown outside the select circles and tailors
who catered for them.'[59] Such distinctive garb would also have
distinguished them from, and competed with, the local Satini boys,
an Italian rival gang who 'were flashily dressed in expensive suits,
light colours predominating. No waistcoats seemed to be the rule,
but touches of brilliant colouring were supplied by an expanse of
silk handkerchief ... Not a few possessed heavy gold ... watch
chains that flopped loosely from the button hole.'[60]

Paterson's Bermondsey monkey paraders, the boys cited at the
head of this section, who found it difficult to resist the 'showy
tailor's windows with offers of cheap ready made suits', were aim-
ing for a similar loudness in their dress, though theirs was a choice
much more reliant on the provisions of the local market. It was
also closer to the blandishments of a consumer culture that en-
couraged young men to compare their image with that of sporting
stars and vaudeville acts. The frisson of criminality merely added
surface glitter to the finished effect. The main purpose of dressing
up probably conformed more closely to Paterson's own opinion,
however caricatured or sentimentalised its tone, and further
undermines any literal notion of sartorial 'renunciation'. The
opportunity to promenade provided a source of shared pleasure
for its participants, affording space and time for the imaginative
performance of the range of 'modern' masculine identities, or at
least their closest possible approximation. The social historian
Michael Childs equates the freedom to explore such identities with
the economic circumstances of Edwardian affluence and of
'rapidly expanding cultural horizons' when 'youths in general
were ... able to symbolise their outlook and their hopes by a
selective and conscious use of distinctive clothes and practices'.[61]
Whether this positions 'Arry and his kind as 'the original teddy
boy'[62] is perhaps incidental to the fact that young men at the
turn of the century from all social complexions were blessed with
an unprecedented repertoire of fashionable models and choices,

whose variety echoed the complex range of masculine subject positions opened up by the effects of a growing consumer culture. As Paterson suggested:

> The pleasure to be derived from this haunting of the streets is the joy of wearing something a little brighter than working clothes. The variation may merely be a new tie of green and red and gold, or a straw hat with a brown ribbon, or a scarf pin, or a white silk scarf peeping from underneath the waistcoat like a nineteenth century 'slip'. On Saturday evening and all through Sunday the change will probably be very thorough, and may include gloves, stick, bright waistcoat. These varieties add lustre to ten shillings a week, and make the Sunday promenade an active pleasure and no mere formality. Bill the conqueror has an athletic reputation and feels it incumbent on him to appear in something rather striking at these times, while Percy, with his good looks and wavy hair, never presents the same complete picture on two successive Sundays. Bert and Alf are mere hangers on, and feebly echo the taste of their leaders. Buster is rather reckless with his money and can only rise to a butterfly bow, and Fatty does his best by wearing clothes that are far too tight for him.[63]

The mirror of masculinity: music hall as fashionable space

> My Life is like a music hall.
> Where in the impotence of rage.
> Chained by enchantment to my stall.
> I see myself upon the stage
> Dance to amuse a music hall.
>
> 'Tis I that smoke this cigarette
> Lounge here and laugh for vacancy.
> And watch the dancers turn; and yet
> It is my very self I see
> Across the cloudy cigarette.[64]

Arthur Symons, poet of the twilit London world of the 1890s, editor of its journal *The Savoy* and influential essayist on 'The Decadent Movement in Literature', displayed an obsession common amongst the *fin de siècle* literati for the tawdry sexual glamour of music hall life. The verses quoted above from the prologue to his poem 'London Nights' reflect on the hold that popular stage spectacle wielded over men of 'bohemian' sensibilities, who reveled in the lowness of the form, finding in the tobacco haze and yellow limelight an authentication of their own mannered identities. A contemporary critic singled out Symons's adeptness at capturing the commonplace vulgarities of London life, which distinguished his work from the more profound resonances of Parisian symbolism. He claimed that

Baudelaire and Verlaine generally ring true, and their horrors and squalors and miseries and audacities have the value and virtue of touching the reader to something of compassion or meditation. Symons no more does that than a teapot. 'This girl met me in the Haymarket with a straw hat and a brown paper parcel, and the rest was a delirious delight: that girl I met outside a music hall, we had champagne and the rest was an ecstasy of shame!' that is Symons. And this sort of thing in cadences of remarkable cleverness and delicacy ... A London fog, the blurred tawny lamplights, the red omnibus, the dreary rain, the depressing mud, the glaring gin shop, the slatternly shivering woman: three dextrous stanzas telling you that and nothing more.[65]

In his predilection for the licensed immorality of modern London, Symons succeeded in fixing its material features in a totemic and enduring manner. He also offered a reading of its culture which explored the formation of sexual identities through such fixings, and promoted the notion of a 'glamorous' lifestyle that might be lived as much as performed, encouraging the blurring of boundaries between spectacle and self.

Peter Bailey has identified the notion of glamour as fulfilling an important role in controlling the performance and mediation of gender stereotypes from the mid nineteenth century onwards. Through a study of the Victorian barmaid he has suggested that 'the sexualisation of everyday life' sits at the centre of debates regarding the gendering of modern power relations and the experience of material culture. He claims that 'glamour and its stimulus to the sexual pleasure in looking that is scopophilia plainly gave a new emphasis to the visual element in the changing sexual economy'.[66] The phenomenon of glamour, defined by Bailey as a visual property utilised in the management of arousal, positioned its subjects in an illusory realm, physically or emotionally distanced from the material world of the consumer, but its forms were engineered to encourage his engagement with the very real practice of consumption: 'a dramatically enhanced yet distanced style of sexual representation, display or address, primarily visual in appeal'.[67] The most familiar application of the device lay half a century in the future with the elevation of Hollywood screen actresses to the role of goddesses. But its effects can also be seen in the earlier alluring organisation of shop windows, the sensual displays of the public bar which form Bailey's focus, and the paraphernalia of the popular theatre which concerns us here. Glamour is read also as the visual code of a broader sexual ideology which Bailey identifies as 'parasexuality'. This he defines as 'an inoculation in which a little sexuality is encouraged as an antidote to its subversive properties'[68] – in other words, a strategy for managing the everyday circulation of sexualised codes and practices that constituted the

exchanges of urban custom, which otherwise viewed sexuality as a dissonant force. This was a practice that was particularly pertinent in the 'expanding apparatus of the service industries, and a commercialised popular culture' that typified the late nineteenth-century urban scene. As Bailey continues:

> The barmaid and the pub were thus part of a larger nexus of people and institutions that stood athwart the public/private line and provided the social space within which a more democratised, heterosocial world of sex and sociability was being constituted, a world that is still inadequately mapped by historians. It is on this distinctive terrain that the less august branches of capitalism converted sexuality from anathema to resource, from resource to commodity, in the development of a modern sexualised consumerism. Parasexuality, with its safely sensational pattern of stimulation and containment, was a significant mode of cultural management in the construction of this new regime ... It is plain from its operation ... that it worked primarily to valorise male pleasures. Yet the making of this world was undertaken not just by a cadre of male managers - but by the members of this cultural complex at large, in a self conscious and mutual working out of new modes of relationship between men and women.[69]

Taking into consideration the powerful 'sexual' attraction of stereotypes including the bachelor dandy, the suburban hearty and the working-class masher discussed so far, I would argue for an application of the notion of parasexuality to the management of masculine sartorial figures. Where the glamorous fantasy of the barmaid smoothed the 'determination of the informal rules and boundaries of sexual encounter ... now pursued in a more fragmented and inchmeal manner, in the individual transactions of a continuously recomposing leisure crowd',[70] so the popular communication of sartorial formulae attached to the varieties of urban masculinities present in the modern crowd allowed young men to assess themselves visually and physically against other men in an increasingly competitive sexual market place. This led to a heightened awareness of their own sense of glamorous fashionability as well as placing them under the critical gaze of potential female suitors. Furthermore, the figure of the fashionable young gent, like that of the barmaid positioned in the public sphere of pleasure by 'the mechanistic formula of parasexuality ... dissolved in practice into a more popular discourse, the elasticity of whose rules was scrutinised in a vernacular knowingness that informs music hall song and other popular idioms'.[71] Arthur Symons's conception of himself as a reflection on the music hall stage was then particularly apt, for it was in the new sphere of variety performance that the drama of a glamorous masculine commodification was largely played out.

A large-scale elaboration of the plebeian singing salons of the 1840s and 1850s, themselves a formalisation of the ad-hoc amateur singing contests that had punctuated public house activities since the late eighteenth century, the 'classic' music halls of the *fin de siècle* incorporated the respectable comforts of middle-class supper rooms together with the democratised spectacle of the public entertainment familiar from pleasure gardens, circuses and exhibitions. At the height of their popularity, from the 1880s to the 1910s, a night within their plush and gilt interiors promised a succession of 'celebrity' turns who would make their performances carry over the general din of drinking and shouting through utilising the inherited skills of street balladeers and minstrel troupes, while all the time suggesting the surface polish and drama of established opera and theatre. This amalgamation of 'high' and 'low' cultural forms, its masterful manipulation under the promotional leadership of music hall caterers, and gradual appeal to a wider audience that no longer represented the original constituency for such forms of entertainment, has been variously interpreted by social historians as a betrayal of 'authentic' working-class taste and creativity by the wiles of capitalism, a prime example of the late Victorian democratisation and commodification of leisure, and a reflection or incorporation of shifting forms of popular identity. In the words of one historian the story of the music hall is the story of a shift 'from class consciousness through emulative hedonism to domestication; or if you will, from a class culture to a mass culture'.[72]

More recent analyses of the role played by music hall culture in wider public debates, marked by their deconstructions of the content of its performances and their attendant critiques, have emphasised the role played by the medium in a presumed crisis of morality, representation and indeed masculinity that defined the cultural complexion of the 1890s.[73] As literary historian John Stokes has claimed, 'in the 'nineties, the music hall was a disorientating place. You could see society changing before your very eyes; but the longer you looked the less certain you became about where you were looking from. It was a vertiginous atmosphere that was to make the life of the halls an irresistible theme for artists and writers.'[74] Thus artists including Joseph Pennel and later Walter Sickert, together with commentators from Max Beerbohm through to Arthur Symons, bequeathed an interpretation of music hall life that emphasised its immoral hollowness while celebrating its 'entrancing iridescent surfaces'.[75] The long-standing existence of a trade in female and (less famously) male bodies on the promenades of the more prestigious halls also underpinned the notion that what was being presented on the stage was of a nature not

compatible with common standards of decency, and culminated in a vigorous moral debate that found its way into the pages of the broadsheets. In 1892 the renewal of the music and dancing licence of the Empire, Leicester Square, was opposed by Mrs Ormiston Chant and a committee of philanthropic society women on the grounds that the premises were given over to the pursuit of vice. *The Daily Telegraph* ran a celebrated series of articles under the title 'Prudes on the Prowl', calling for deregulation of the theatre, while Ormiston Chant secured a compromise finding by the theatres and Music Halls Committee of the London County Council that the promenade bar should be concealed from public view. The erection of a screen caused a near riot at a subsequent performance where 'well dressed men', reported *The Evening Standard*, 'some of them almost middle-aged, kicked at it from within, bursting the canvas ... then went out into the street brandishing fragments ... in all it was calculated that the crowd was swelled to the number of about twenty thousand'.[76] While the argument carried with it the overblown features of farce, it was also indicative of the power played by music hall in fixing current attitudes and anxieties. Incorporating both the tendencies of decadent propaganda ('unique, individual, a little weird, often exotic, demanding the right to be') and the contrary appeal of the populist new journalism ('broad, general, the majority, the man in the street'), the culture of music hall exemplified 'the characteristic excitability and hunger for sensation' that typified both.[77] As such its forms were ideally positioned to mirror and construct the range of bewildering gender models on offer in the field.

The material culture of music hall was particularly well placed to effect an influence on the habits of an urban audience by the turn of the century. In 1898 *Little's London Pleasure Guide* listed fourteen venues within the central radius of London, each with its specialism and specific atmosphere, most of them advising that 'Ladies generally wear high dresses' in a pitch at respectability; others, including the Empire and the Palace, Shaftesbury Avenue, retaining their soignée reputation with the notice 'smoking permitted everywhere'. The guide, like many others, also provided information on Turkish baths, riding clubs, fancy dress balls, royal levées, restaurants and regattas, so that the halls appear to have gained a comfortable place within the fashionable social round without jettisoning a mass audience composed of all ranks. The pricing policy at most halls, with tickets ranging from £3 3s for a box to 6d in the gallery, further ensured that a broad swathe of the population could afford to attend.[78] A handbill for the Canterbury music hall in Westminster Bridge Road of 1884 promised potential consumers an evening that easily fulfilled all the criteria of

'variety' in its provision, and for all manner of tastes. The juxtaposition of comedians, singers, acrobats, melodramatic actors, classical pianists and art gallery defied easy categorisation, at least in class terms, and rather backs up John Stokes's supposition that 'the halls became too big a business not to carry a municipal significance and, like other kinds of popular diversion they could be seen as the cause as well as the product of social instability'.[79] The very instability of the presentations arguably aided the free circulation of fashionable stereotypes between performer and audience and back:

Canterbury Theatre of Varieties - Westminster Bridge Road
Proprietors - Messrs Crowder & Payne
The Sliding Roof opened when necessary, rendering this the coolest and
best ventilated theatre in London.
Monday May 26 1884 - Important Engagement for Six Nights Only.
Mr Frank Hall's Variety Company in his musical sketch entitled Robin
Hood.
supported by Mrs George Fredericks (specially engaged) Mr George
English, Mr Frank Hall and other artistes in addition to a numerous
corps of auxiliaries.
Medley - A. G. Vance (The Inimitable) Sisters Cassatti, Will Poluski and
the Black Eel.
The World Renowned Paul Marinetti and Troupe in the successful
eccentricity entitled
'A Duel in the Snow' suggested by the celebrated picture of Jerome ...
New Scenery - Original Music - Limelight Effects & c.
Charles Carlton & Maude Wentworth - Versatile Sketch Artistes.
Frank Travis & Little Don - In Sketch 'Out of the Ranks'
Lottie Collins
The Craggs - Unrivalled Acrobats
Jenny Hill - The Vital Spark
Pianoforte Recitals in the Grand Lounge every evening by Mr
J. W. Speaight LAM (Pupil of Sir Julius Benedict) At intervals from 8 till
11.45. Upright Iron Grand Piano by John Brinsmead & Sons.
Canterbury Aquarium. A Fine Seal. Direct from the Arctic Regions is on
view in one of the tanks and is fed nightly at 8.00 and 11.30; also a
Russian Water Rat - The largest specimen ever caught. Fed at 8.00 and
11.30 every evening.
The Grand Billiard Saloon now open daily from 11am till 12 midnight.
Also the Grand Lounge and Refreshment Bar, with valuable collection of
pictures by Eminent Artists, open all day.[80]

In reminiscences of evenings spent at the halls it is the latter attractions announced by the Canterbury, the existence of comfortable lounges, promenades, bars and billiard saloons, that impressed the most upon the memory of variety habitués. The content of the performances paled a little besides the opportunities the halls offered for browsing, socialising and enjoying the varied

company of a diverse audience. It was as though music hall offered two sites for performance, the stage being subservient to the action of the auditorium. J. B. Booth remembered of the Alhambra in Leicester Square that

> the stalls, the most comfortable in London, rarely filled until after nine o'clock, in time for the principle ballet, while the promenade and the bars were in the nature of a club – a rendezvous for guardsmen, members of the House of Lords and of the Stock Exchange, barristers from the Temple, racing men and sportsmen of every description.

Its crowds offered the ideal backdrop for fashionable displays, and Booth recalled

> a youth who acquired the nickname of 'King of Diamonds' by reason of his unpleasant habit of wearing a dress tie, or rather a brooch in the shape of a dress tie, of these stones, his links and studs also being of huge diamonds; and a would-be sartorial reformer who affected black linen with his dress clothes, a funereal effect which obtained no followers.[81]

In contrast to the odd display of individuality, Percy Fitzgerald presented a rather cynical guide for 'correct' sartorial behaviour among the audience when he stated that

> in places where there is a promenade we constantly see 'gentlemen' moving in the crowd in pairs, who appear to have risen from some fashionable dinner table just to stroll into this scene of pleasure. There they are, imparting quite an air of refinement and high manners, as they lounge carelessly by, an Inverness cape lightly thrown over, but not concealing, the festive garments below: looking at the scenes about them with a blasé and haughty indifference, as though well accustomed to the West End … It is one of the social phenomena of the time to think of worthy shopmen and clerks taking all this trouble, night after night, 'making up' and dressing for the part; but there is no doubt an exquisite pleasure in the exhibition of the evening suit – transient dream though it be.[82]

The spatial context of the music hall further encouraged the practice of sartorial display by its male customers through significant strategies that have been isolated by Peter Bailey as central to contemporary perceptions of the culture of late nineteenth-century mass entertainment. With respect to the competitive posturing of the promenade crowd he suggests that 'it afforded proximity without promiscuity' and 'reduced the open social mix of the city street to some kind of territorial order while retaining mutual audibility and visibility amongst its different social elements'. Within the protected and carefully policed spaces of the theatre the social mix of the audience 'was sufficient to generate a lively drama of individual and collective acts of display … a perfect setting for the aspirant swell, the young clerk … decked out

in the apparatus of the toff, graduating from the protective cluster of his own kind at the side bar to the public glory of a seat at the singer's table'.[83] Gesture and dress, Bailey infers, were further heightened by the architectural setting itself, which in many halls employed the illusory effects of mirror glass. This clearly harked back to the fitting out of the gin palaces from which many halls had evolved, but, besides increasing the sense of palatial grandeur, mirrors also intensified an atmosphere of critical surveillance, both of others and of the self. 'All round the hall', remarked a review of the refurbished Middlesex in 1872, 'handsome mirrors reflect the glittering lights, and offer abundant opportunities for self-admiration.' As the lion comique paraded his fashionable self on stage, members of his audience could with a sidelong glance decide how their image matched up to that of their hero'.[84]

Music hall performance and conspicuous consumption

Bailey stresses the way that social distinctions were maintained, albeit in a very fluid manner, in the organisation and use of music hall space. Yet while it is true that pricing policies and the retaining of exclusive areas protected the elite from the touch, though not the gaze, of the hoi polloi, an overriding rhetoric of leisured display in the decor, dress codes and stage presentations, which often crossed social boundaries, also encouraged a more comprehensive mode of music hall fashionability that affected all classes of men. Dion Calthrop in his autobiographical *Music Hall Nights* attested that

> our music hall people love colour, gold and crimson and marble with its glittering reflections. They like the red curtain with its big tassels; they like plenty of light, a big chandelier, brass in the orchestra, looking glasses everywhere and attendants in livery. If a singer wears a diamond stud they like it big enough to be seen from the gallery. They are hearty in their tastes and quite right too. They use words which make the middle classes squirm, but are interesting to the cultured man because he uses them too.[85]

This promotion of an inclusive, indeed 'parasexual', masculine style associated with the glamorous escapism of the music hall promenade fed outwards in three directions: to the representations of masculine fashionability paraded on the stage, into the public world of commerce, and through to the life of the streets. As the department store and the woman's magazine provided a complete template for *fin de siècle* versions of fashionable femininity, so the music hall fed the consuming desires of men in a manner which

often prioritised their gender over their class in an open celebration of sybaritic pleasures. As Percy Fitzgerald noted:

> The quiet airy reserve and nonchalance of the stage gentleman would seem at the music hall to be unintelligible, or uninteresting. But the East ender has created his idea from a gentleman or 'gent' of which he has had glimpses at the 'bars' and finds it in perfection at his music hall. At the music hall everything is tinselled over, and we find a kind of racy, gin borne affection to be the mode; everyone being 'dear boy' or a 'pal'. There is a frank, cordial bearing, a familiarity which stands for candour and open heartedness ... a suggestion of perpetual dress suit, with deep side pockets, in which the hands are ever plunged ... and we must ever recollect to strut and stride rather than walk.[86]

In its most concentrated form, the words and gestures of the music hall artiste provided the most fitting summation of popular masculine consumerism, largely through the projection of recognisable stage types. The swell song enacted by the lion comique had the most distinguished lineage in the repertoire, providing the basis for later explorations of fashionable masculinity after the turn of the century. Promoted at first during the 1860s and 1870s by performers including George Leybourne known as 'Champagne Charlie', Arthur Lloyd, George MacDermott and Alfred Peck Stevens known as 'The Great Vance', the swell bore a direct relationship to straight theatrical comedy and particularly to the celebrated figure of Lord Dundreary, the aristocratic fop of the 1861 play *Our American Cousin*.[87] Generally presented as an upper-class dandy addicted to the pleasures of club life, horse racing and various forms of alcohol, the visual image of the swell conformed to established notions of how the upper ten dressed and behaved. Henry Chance Newton recalled how George Leybourne's 'lithe splendid figure, handsome semi-Jewish visage and majestic sweep of his hand play ... [made him] quite an Apollo among men, and able to "carry" the most distinguished apparel ... he flaunted the broad check suits, the puce jackets, widely striped trousers and lurid vests of his so-called swells', and this despite his own origins as 'a hammerman at Maudsley's, the marine engineers then in the Westminster Bridge Road' who was prone to display 'flashes of illiteracy quite amazing to those who saw or who spoke to him for the first time'.[88] Thus military bearing and a broad chest shown off through exquisite Savile Row tailoring, together with extravagant treatments in facial hair and an ostentatious use of the cane and top hat, arrived at a convincing approximation of Rotten Row style whose impact relied on the tension between illusory authenticity and the overblown talents of the performer. A late version of the type from the 1880s is illustrated in a song cover for T. W. Barrett's *He's Got 'Em On*[89] in which the protagonist stands

in tight morning coat with the requisite ivory-handled cane, monocle, cigar, striped shirt, button hole, love heart tie pin and gold fob chain (Figure 37). The American investigative journalist Daniel Kirwan writing at the height of the lion comique's popularity in 1871 transcribed the lines of a song he had heard performed at the Alhambra which relied for its humour on just such a combination of gesture, pronunciation and visual attire:

The Beau of Wotten Wow

Now evewy sumwah's day
I always pass my time away
Awm in awm with fwiends I go
And stwoll awound sweet Wotten Wow;
Fow that's the place none can deny

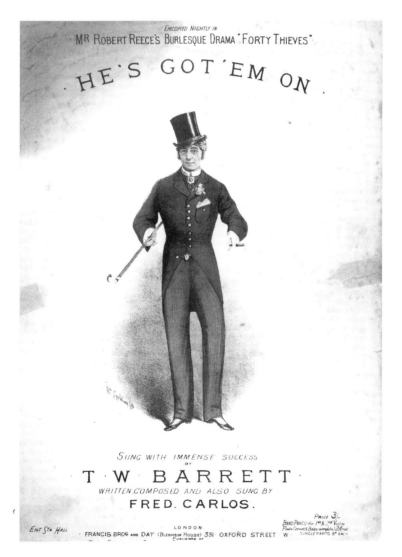

37] 'He's Got 'Em On'
music hall song sheet,
c. 1885. Bodleian Library,
University of Oxford: John
Johnson Collection.
Entertainers & Music Hall
Singers 1. The swell song
parodied the sartorial
pretentions and opulent
lifestyle of the
metropolitan dandy.

To see blooming faces and laughing eye;
And if youw heawts with love would glow.
Why patwonise sweet Wotten Wow.

So come young gents and don't be slow.
But stylish dwess and each day go.
And view the beauties to and fwo.
Who dwive and wide wound Wotten Wow.

Dressed, according to Kirwan, 'in the exaggerated costume of a Pall Mall lounger', the singer performed with 'a very affected voice and lisp, keeping his body bent in a painful position the while'. The audience responded to the cruel rendering of aristocratic idiosyncrasies 'and relished all the local hits of the speech and the dress of the ideal do-nothing'.[90] Later versions of the swell song shifted their focus away from social satire towards a direct celebration of the good life, and the benefits of prodigious consumption. This reflected the promotion of the singers themselves as 'stars' who could afford to flaunt the prizes of their profession and were expected to extend their stage personas to their actions on the street by contracts that specified travel in a barouche between performing venues and the ostentatious adoption of fur coats, diamonds and champagne bottles by the magnum.[91] The pointed promotion of champagne as a swell's beverage has been linked by Bailey with that particular commodity's entry into the drinking habits of the middle classes after a lowering of the tariff in 1861 and a broader myth of democratised consumption following the brief economic boom of the 1870s.[92] Its bubbling sparkle also provided a potent rhetoric for the unrestrained urge to consume in other areas of life, clothing included. James Greenwood, reporting on the performance of a lion comique in 1883, noted the recent concentration on issues of commodification, stating that

> a star comique of such renown that he drives no fewer than three ponies in his carriage, led off with one of his latest and best approved melodies ... It was quite in the new and highly relished style ... The song with which the star comique favoured the auditory was all about a hungry man, who, try what he might, could never lull his voracious appetite ... clutching the forepart of his trousers with his hands and planting his hat well on the back of his head, the delineator of modern comic song chanted – 'I've tried German sausages and sprats, boiled in ale, Linseed meal poultice and puppy dogs tail, Stewed gutta percha (which pained my old throttle), Sourkrout, ozokerit and soup brown and mottle.'[93]

It was the visual appeal of the singer, though, that engaged most directly with the aspirations of the audience. Chance Newton remarked that

so strongly, always, did Vance's and Leybourne's many coloured cos-
tumes for their 'dude' ditties impress me, even in my callow youth, that
whenever their respective names meet my eye ... I at once think first
of ... gaily assorted rainbow lined coats, vests and 'bags' and, especially
of their yellow topped glistening boots. Vance's fascinating footwear
indeed, filled me with awe.[94]

Albert Chevalier, one of the most celebrated of character turns
from the turn of the century, who specialised in more 'down to
earth' representations of East End humanity, nevertheless acknow-
ledged the powerful draw that the swell image held over those for
whom its glamour represented an unattainable dream:

> The 'Great' may be a trifle conspicuous in the matter of attire. He may
> develop a weakness for diamond rings, elaborate scarf pins designed as
> an advertisement, and massive cable watch chains, but he has seen too
> much of the seamy side not to know that these articles have a value,
> apart from emphasising the 'security' of his position as a popular fa-
> vourite. I once met, at the seaside, a prosperous comic singer 'got up
> regardless'. He wore a frock coat, white vest with gilt buttons, flannel
> trousers, patent leather boots, a red tie and a straw hat. Strange to say
> everybody looked round - and stranger still he did not seem to mind.
> He knew his business! Oh! I forgot to mention, that for a scarf pin, he
> had his initials worked in diamonds, and it was almost large enough to
> conceal his neck tie.[95]

For Chevalier, as for the audience, the recounting of swell mag-
nificence took on the currency of an urban mythology, full of
anecdote and supposition. However, in the language of such de-
scriptions, in the pleasure with which sartorial value and outrage
were considered and inevitably condoned, lay further oppor-
tunities for male spectators to evaluate their own position on
luxury and its relevance to their lives. Paste tie pins in the shape
of skulls, horseshoes and ballerinas, including some which sparkled
by the aid of a concealed battery, were for example available from
Gamages in tawdry emulation of music hall glamour. But Leyb-
ourne and Vance symbolised an attitude as much as they helped
to focus the aspirational desires of a commodity-hungry audience.
Furthermore, their delight in fashionable consumption offered im-
aginative compensations for the drudgery of men's lives. In 1891
the illusory pursuit of the good life reached a destination of sorts
with the popularity of Charles Coburn's song 'The Man who Broke
the Bank at Monte Carlo'. Here the promise of attaining the high
life on the results of very little physical or mental effort was in-
spired by a financial scandal avidly reported by the popular press
and induced by the activities of swindler Charles Wells

> a man who has gained considerable notoriety of late ... engineer and
> patent agent of London, he first came into note through his successful

speculation at the gambling tables of Monte Carlo. The newspapers reported his immense gains from day to day, and many a sanguine individual drew his balance from the bank and wended his way to the fascinating principality of Grimaldi in the hope that he would be equally fortunate.[96]

The real protagonist formed an unlikely focus for music hall celebration, described as 'a respectable looking man, of medium height, about forty five years of age, with a short black beard and a bald head ... nobody would suspect that he was the biggest swindler living'.[97] The translation of gambling notoriety on to the stage called for the ingenious use of stereotypical sartorial triggers that would identify character to the audience, and the song epitomised the late flowering of the swell genre. Coburn was adept at utilising the visual codes of popular culture to inform his acts, and with respect to his preparations for another role, which lampooned Gallic pretensions, he noted:

> I got my first idea for it actually from a match-box. It was one of those little boxes in which we used to buy wax vestas years ago. When I took it to my tailor and showed him the picture of the Frenchman on the cover, and asked him to make me a similar suit of clothes, he laughed at me: I must be joking of course ... 'You can do it' I replied ... 'All you've got to do is take your tape measure and see that you fit me. I want a collar just like that and the same comic trousers.' Well, he did what I asked, and when the suit came I only had to add a little tuft of hair under the chin, a loose flowing tie and a glossy silk hat to complete the costume. It was a success from the first evening I wore it.[98]

Coburn's rendition of 'Monte Carlo' was equally mannered, and in a surviving recording the final syllables of every line are drawn out in a mockery of upper-class diction while the pace of the song increases to suggest the frenzied pursuit of material success.[99] The circumstances which the lyrics celebrated were far removed from the experiences of the majority of the audience. As the author of *All about Monte Carlo* suggested, the city was 'not only the greatest gambling centre in the universe, it is also the most beautiful spot on earth. While we in London are having an old fashioned severe winter, there the palms, eucalyptus, lemon and orange trees, geraniums and aloes are growing luxuriantly.'[100] Indeed Coburn had his reservations about their general appeal recalling that

> Fred Gilbert wrote both the words and music shortly after ... Charles Wells brought out a book entitled 'How I broke the Bank at Monte Carlo' ... I liked the tune very much, especially the chorus, but I was rather afraid that some of the phrasing was rather too highbrow for an average music hall audience. Such words as 'Sunny Southern Shore', 'Grand Triumphal Arch', 'The Charms of Mad'moiselle', etc., seemed to me somewhat out of the reach of say Hoxton.[101]

The song's ensuing popularity attested strongly to the contrary, providing evidence of the capacity for men across the social spectrum to empathise with the appeal of conspicuous consumption. As the music hall historian Harold Scott affirmed:

> In Coburn one sees how nearly the two aspects of the music hall approached one another. His adoption of the 'swell' type in 'The Man Who Broke the Bank' was not made without some misgivings and its success, outstanding though it was, did not eclipse the vogue of 'Two Lovely Black Eyes' [a more proletarian 'coster' song by Coburn], by which he discovered a common denominator for the audiences of the Mile End Road and Piccadilly Circus ..[a] welding of flash life with the simple methods of the concert room.[102]

The distanced perfection of the swell was not the only model of fashionable style available to the music hall audience, though it was the most voluble. Dion Calthrop hinted at the competitive and envious tendencies which the swell's sartorial knowledge could engender when he recalled a companion's reaction to the polish of a swell performance: 'I'll bet that man's got a fur overcoat ... Look at him, he has been poured into his clothes and the only crease he has got is down his trousers; and look at his tie, it's tied just well enough to show it isn't ready made.'[103] If such extremes threatened to exclude participation by their preciousness, other character roles, including that of the shabby genteel and the masher, elicited a more sympathetic, less awe-struck response; for these were individuals whose attitude to the fashionable world mirrored more precisely the surface realities of a suburban or working-class engagement with *bon ton*, rather than their inner desires. The mode of shabby gentility addressed the nature of economic restraints which prevented the keeping up of fashionable appearances, and attributed a tragic pathos to those whose clothing betrayed a fall from material grace. In many ways the battered top hat and frayed frock coat of the genre represented an inverted version of the swell and referred to the ambivalence of clothing as a signifier of status and moral worth. Where the puffed up self-regard of the swell's attire often concealed an emptiness within, the rags of the shabby genteel failed to distort the essential 'breeding' of the wearer. Henry Chance Newton recalled Victor Liston 'in his threadbare frock coat and shockingly bad top hat, as he sang in broken tones that reached the heart "I'm too proud to beg, too honest to steal, I know what it is to be wanting a meal. My tatters and rags I try to conceal - I'm one of the shabby genteel."'[104] And Harry Clifton in a song of the same title (Figure 38) averred that 'We have heard it asserted a dozen times o'er, That a man may be happy in rags, That a prince is no more in his carriage and four,

Than a pauper who tramps on the flags.'[105] The image on the cover of the accompanying song sheet suggested just the opposite, with all the components of the wardrobe scrupulously correct though tragically creased and a decade out of date.

In order to ensure that the audience was able to converse with the social observations crucial to the construction of representations such as the shabby genteel, song writers and performers needed to ground their characters in a visual grammar that drew on what might be termed the tacit fashionable knowledge of the

38] 'Shabby Genteel' music hall song sheet, c. 1885. Bodleian Library, University of Oxford: John Johnson Collection. Entertainers & Music Hall Singers 1. Harry Clifton, in his crumpled out-dated clothing, drew attention to the precariousness of urban life and the struggle involved in keeping up appearances.

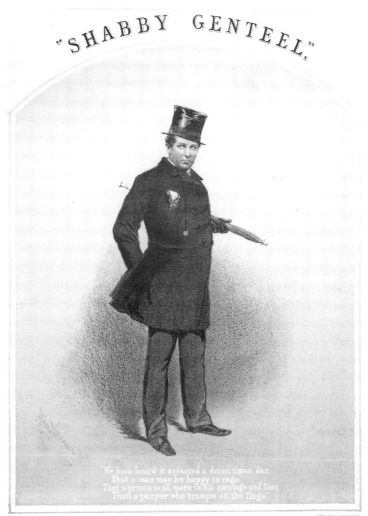

audience. The shabby genteel made sense only if the spectator realised that the pedigree of his frock coat belonged to 1870 rather than 1880, for it was in the detail that the affective depth of characterisation lay. Calthrop suggested that some of the most popular turns in music hall were the patter comedians, who drew on the mundane and sentimental characteristics of daily life that constituted the basis for such satire:

> right down to the footlights they come, one neatly dressed in white flannels and the other in a very short Eton jacket, wide trousers of terrific checks and a doll's straw hat upon his head ... this duet is a catalogue of low life ... It contains allusions to the Walworth Road, beer, Scotch and soda, tripe and onions, little bits of fluff, swivel eyed blokes, the police by the name of rozzers, persons who are up the pole and mothers in law.[106]

In their litany of commodities, types and locations, patter comedians came closest to affirming the priorities placed on things and images in the make-up of popular 'modern' masculine identities. In his song 'Second Hand Clothes' of the early 1890s, W. P. Dempsey was thereby able to incorporate allusions to the masher, the swindler, the pauper and the politician through the use of old clothing as stage prop:

> I'm a bloke who's had some trouble, lots of ups and downs I've seen.
> I could almost write a novel about the different things I've seen.
> Now I deals in left off garments, here who'll buy this old dress coat?
> Once a masher used to wear it, when he used to act the goat.
> Once he was the pride of ladies, and their waists he used to squeeze.
> Often to some rich young heiress he would go down on his knees.
>
> Chorus: For he was a masher, a regular toff.
> A la-di-da as you'll suppose.
> A regular mash, who hadn't much cash.
> And that's what I found in his second hand clothes. (produces a pawn ticket)
>
> Put that down then, nobody wants it, now then what do you say to this?
> There's a lovely garment for you, that's a racing coat that is.
> Once it mingled with the bookies at each popular resort.
> And the cove who used to wear it dearly loved a bit of sport.
> But my dear, once down at Epsom, someone overheard his name.
> And that someone, a detective, went and bowled his little game.
>
> For he was a welsher, a regular crook.
> A wrong'un as you'll suppose.
> The public he'd spoof, he'd collar their 'oof.
> And that's what I found in his second hand clothes. (produces 3 card trick)

(produces work house jacket with medals pinned on breast)
'Ere's a coat that's got a history, I shan't offer it for sale.
I shall keep it for inspection, so that I may tell the tale.
Who do you imagine wore it? Don't think I'm a telling lies.
Tis a fact my dear, tis really, though you'll hear it with surprise.
Once the man who used to wear it, fought hard by his colonel's side.
Tho' a Balaclava hero, in that pauper's coat he died.

For he was a veteran, a warrior bold.
A hero as you may suppose.
For his country he bled, yet he died wanting bread.
And that's what I found in his second hand clothes. (produces
 nothing)

Bet you know who this garment belongs to, him who buys this has a
 catch.
'Ere's a nobby garment for you, collar too as well, to match.
Once this frock coat ornamented one of England's greatest men.
Straight there isn't one to touch 'im, either with the tongue or pen.
Never mind how I came by it, at his house I often call.
And the gent who used to wear it, is well known to one and all.

For he is a statesman, a clever old man.
A grand old man as you'll suppose.
And in Ireland today, he'll have his own way.
And that's what I found in his second hand clothes. (produces home
 rule bill) [107]

Beyond the melodrama of the patter song, with its narrative that encapsulated the music hall standards of pathos and patriotism, other performances trading on the demotic currency of men's clothing and fashion presented a more bathetic interpretation of attempts by the 'cove' or 'bloke' to appropriate the language or looks of the swell. Here an emotional appeal to the charity of the audience was jettisoned for a gentle mocking of its pretensions. Thus in Harry Champion's *Any Old Iron* a dapper young man's boasts regarding his inheritance from 'Uncle Bill' are ridiculed when his gold watch and chain are found to be no better than base metal, fit only for the rag and bone collector: 'You look neat, talk about a treat, You look dapper from your napper to your feet, Dressed in style, brand new tile [hat], And your father's old green tie on, But I wouldn't give you tuppence for your old watch chain, Old Iron, Old Iron.' [108] Similarly Gus Elen's coster song *The Golden Dustman* drew its humour from the juxtaposition of everyday squalor and new-found wealth, in which malapropisms betrayed the aspirant dandy's social origins, and class allegiances threw the trappings of an idealised swell existence into sharper relief:

And now I'm going to be a reg'lar toff.
A-riding in me carriage and me pair.

A top hat on me head.
Fevvers in me bed
And call meself the Dook of Barnet Fair.
Asterrymakam round the bottom of me coat.
A Piccadilly window in me eye –
Fancy all the dustmen a-shouting in me ear.
'Leave us in your will afore you die!' [109]

The masher song traded less on the disruptive potential of fashionable emulation, presenting its heroes as standard bearers for the liberating effects of commodity culture. Distanced from the rousing pomposity of the lion comique, whose version of heightened masculine beauty had dictated the characteristics of swelldom with a rhetoric borrowed from the 1860s, the masher encapsulated the commercial energy of the men's retail trade from the 1890s, and the propensity of a broad swathe of young men to engage with its sartorial offerings. Occasionally the links between music hall representation and the market place converged completely, as in The Great Vance's late rendition of 'The Chickaleary Cove' which functioned as an advertising coup for the tailoring firm of Edward Grove of Lower Marsh and Shoreditch. His marketing ploys engineered a street slang similar to that utilised by C. Greenburg and Harris of Whitechapel, whose handbills were featured in the previous chapter:

> I'm a chickaleary bloke with my one-two-three
> Vitechapel was the willage I was born in;
> To catch me on the hop.
> Or on my tibby drop.
> You must vake up wery early in the mornin'.
> I've got a rorty gal, also a knowing pal.
> And merrily together we jog on.
> And I doesn't care a flatch.
> So long as I've a tach.
> Some pahnum in my chest – and a tog on!
>
> Chorus: I'm a chickaleary cove (repeat first four lines)
>
> Now kool my downy kicksies – they're the style for me.
> Built on a plan wery naughty;
> The stock around my squeeze is a guiver colour see.
> And the vestat with the bins so rorty!
> My tailor serves yer well.
> From a perjer to a swell.
> At Groves you're safe to make a sure pitch.
> For ready yenom down.
> There ain't a shop in town.
> Can lick Groves in the Cut as well as Shoreditch! [110]

Groves supplied Vance with 'a very shiny beaver topper, an extra-

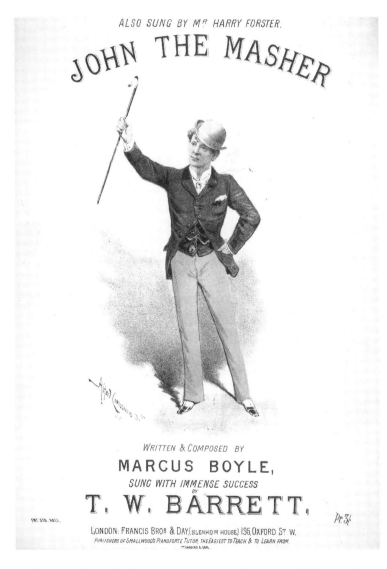

JOHN THE MASHER

WRITTEN & COMPOSED BY

MARCUS BOYLE,

SUNG WITH IMMENSE SUCCESS
BY

T. W. BARRETT,

ENT. STA. HALL.

LONDON: FRANCIS BROS & DAY,(BLENHEIM HOUSE) 195, OXFORD ST W.
PUBLISHERS OF SMALLWOOD'S PIANOFORTE TUTOR; THE EASIEST TO TEACH & TO LEARN FROM.

39] 'John the Masher' music hall song sheet, c. 1890. Bodleian Library, University of Oxford: John Johnson Collection. Entertainers & Music Hall Singers 1. In a close reflection of audience aspirations, the music hall masher celebrated the conspicuous style of the young man about town.

ordinary yellowish skirt coat, and a startling pair of light nankeen trousers'[111] for the performance of this favour. But beyond the theatricality of Vance's stage wardrobe it was the accessibility of the masher image which generally cemented its popularity. T. W. Barrett in the role of 'John the Masher' appeared in the bowler hat, horseshoe tie pin and lounge suit that would have struck a cord with any monkey parader, crowning his act with the catchphrase 'He's got 'em on' (Figure 39).[112] The appropriation of the role by female male impersonators at the turn of the century further cemented its association with a new youthful audience, distancing it from the hirsute heartiness of the Champagne Charlies and their kind. The modern masculine look celebrated on the stage now embraced a boyish agility with a bright, tightly cut wardrobe to

match, echoing the blandishments of the outfitter's window from Bow to the Burlington Arcade. In the newness of his clothing, its obvious espousal of novelty over lasting quality, the masher epitomised the brash modernity of turn of the century urban life. His song lyrics concentrated accordingly on the easy bargain, the collapsing of social distinction and the ephemerality of style. Nellie Power, one of the earliest male impersonators, joked in the early 1880s that 'He wears a penny flower in his coat, La di Da! And a penny paper collar round his throat, La di Da! In his hand a penny stick; in his tooth a penny pick, And a penny in his pocket, La di Da!' and Nellie Farren offered the question 'How do you like London, how d'you like the town? How d'you like the Strand, now Temple Bar's pulled down? How d'you like the La di Da, the toothpick and the crutch? How did you get those trousers on, and did they hurt you much?'[113]

Moving beyond satire, several commentators credited the impersonator Vesta Tilley with the ability to inspire as well as critique fashionable pretensions. As Booth noted,

> not only did she wear the clothes of the youth about town, but she set his fashions, and with an art above mere mimicry, lived in her costume, whether it was that of an 'Algy', a 'Midnight Son' or a 'Seaside Sultan'. The Tilley commentary on the types of male youth and fashions of the day was cameo-like, clear cut, finished to the tiniest detail, and the old lion comique ... faded before 'The Piccadilly Johnnie with the little glass eye'.[114]

Though Tilley claimed that her devoted following was made up largely of female admirers, and subsequent readings of her stage persona have stressed the actress's role in articulating *fin de siècle* worries concerning the public and professional role of women, the direct appeal her act made to the sartorial sensibilities of men in the audience is conveyed through Tilley's own reflections on the commercial impact of her dress and her art.[115] With respect to her American tour of the revue *Piccadilly Johnnie* she recalled that

> the dudes of Broadway were intrigued with my costume, a pearl grey frock coat suit and silk hat and a vest of delicately flowered silk - one of the dozens which I had bought at the sale of the effects of the late Marquis of Anglesey. Grey frock suits and fancy vests became very popular in New York; the dudes there loved to look English ... All my male costumes were absolutely the latest in fashionable men's attire, and were made for me during many years by the well known West end firm Samuelson, Son and Linney of Maddox Street, Bond Street, London.[116]

A combination of authenticity and fantasy, heightened by Tilley's patronage of Bond Street tailors and her appropriation of clothing and a stylistic manner borrowed from the controversial, effemi-

———

HETTIE CHATTELL

40] Theatrical postcard, *c.* 1900. The male impersonator incorporated the paradox at the heart of masculine fashionability. Her disguised femininity revealed the close association between effeminacy and fashionable consumption whilst her gutsy performance appeared to endorse the spectacular bravado of the urban dandy.

nate dandy the Marquis of Anglesey, lent her risqué characterisations a sense of controlled danger that was immediately marketable despite its perverse associations. So much so that when her dresser left her cufflinks out of one of her costumes she 'snatched a bit of black ribbon ... and hastily tied the cuffs together with a bow. Shortly afterwards a leading firm of gentlemen's hosiers ... were exhibiting cuff links in the form of a black ribbon bow.'[117] Similarly after the success of her holiday song 'The Sad Sea Waves', where she 'wore a straw boater hat, made in England of course, with a band of white binding around the brim', a firm of outfitters 'paid me a good sum to allow them to reproduce the hat under the name of the "Vesta Tilley Boater" and it had quite a vogue ... There were also a "Vesta Tilley Waistcoat", the "Vesta Tilley Cigars", the "Vesta Tilley Cigarettes".'[118]

The fact of Tilley's gender cast the paradoxes of contemporary masculinity into high relief, for here was a woman aping the gestures, phrases and appearance of a newly commodified and highly popular mode of public presentation for men, while appropriating the physical trappings of that mode in a manner that served to accentuate both its validity in the minds of the audience and the oppositional, invalidating power of her own femininity. It was an act that could have succeeded only at a moment of profound

transition in the practice and representation of gender roles grounded in an expansion of the market place, revealing as it did the manner in which masculinity was a case of directed consumption and performance, as much as it was an accident of nature. The correspondence between Tilley's biological body and the social body that she lampooned on stage threw into sharp relief the deep shift in attitudes and behaviour which some historians have claimed defined modern masculinity at the turn of the century, celebrating its more expressive surfaces while hinting at interior crisis.[119] That sense of crisis, embodied in the development of masculine appearances between 1860 and 1914, will form the focus of the final chapter.

Notes

1 T. Burke, *The Streets of London Through the Centuries* (London: Batsford, 1940), pp. 134-5.

2 T. Burke, *Nights in Town: A London Autobiography* (London: Allen & Unwin, 1915), pp. 183-4.

3 F. M. L. Thompson (ed.), *The Rise of Suburbia* (Leicester: Leicester University Press, 1982); J. Carey, *The Intellectuals and the Masses* (London: Faber, 1992); A. Jackson, *Semi-detached London* (Didcot: Wild Swan, 1991).

4 M. Marsh, *Suburban Lives* (New Brunswick: Rutgers University Press, 1990); A. Light, *Forever England: Femininity, Literature and Conservatism Between the Wars* (London: Virago, 1991); D. Ryan, *The Ideal Home Through the Twentieth Century* (London: Hazar, 1997).

5 C. F. G. Masterman, *The Condition of England* (London: Methuen, 1909), p. 68.

6 *Ibid.*, pp. 69-70.

7 *Ibid.*, p. 80.

8 G. le Bon, *Psychology of the Crowd*, 1895, quoted in M. Boscagli, *Eye on the Flesh: Fashions of Masculinity in the Early Twentieth Century* (Oxford: Westview Press, 1996), p. 70.

9 *The Modern Man*, 5 December 1908, p. 8.

10 *Ibid.*, 15 January 1910.

11 Masterman, *Condition of England*, pp. 93-4.

12 M. Marsh, 'Suburban Men and Masculine Domesticity 1870-1915' in M. C. Carnes and C. Griffen (eds), *Meanings for Manhood: Constructions of Masculinity in Victorian America* (Chicago: University of Chicago Press, 1990), pp. 111-12.

13 *The Times*, 30 September 1930.

14 K. Howard, *The Smiths of Valley View* (London: Cassell, 1909), Foreword.

15 Marsh, *Suburban Men*, p. 127.

16 A. J. Lewis, 'Our Treasures: A Story of Bachelor Housekeeping' in J. Strangewinter (ed.), *Wanted, a Wife: A Story of the 60th Dragoons etc.* (London, J. Hogg, 1887), pp. 104-6.

17 W. Pett Ridge, *Outside the Radius: Stories of a London Suburb* (London: Hodder & Stoughton, 1899), pp. 8-16.

18 W. Pett Ridge, *Sixty Nine Birnam Road* (London: Hodder & Stoughton, 1908), pp. 266-7.

19 *Ibid.*, p. 299.

20 D. Birley, *Land of Sport and Glory: Sport and British Society 1887-1910* (Manchester: Manchester University Press, 1995).

21 Pett Ridge, *Sixty Nine*, p. 119.

22 *Ibid.*, p. 77.

23 F. Willis, *101 Jubilee Road: A Book of London Yesterdays* (London: Phoenix House, 1948), p. 127.

24 *Ibid.*, p. 130.

25 W. MacQueen Pope, *Twenty Shillings in the Pound* (London: Hutchinson, 1948), pp. 182-3.

26 K. Howard, *The Smiths of Surbiton: A Comedy without a Plot* (London: Chapman & Hall, 1906), pp. 234-5.

27 A. Paterson, *Across the Bridges* (London: Edward Arnold, 1911), pp. 38-9.

28 *Ibid.*, p. 44.

29 P. J. Keating, *The Working Classes in Victorian Fiction* (London: Routledge, Kegan & Paul, 1979), p. 140.

30 *Ibid.*, p. 141.

31 P. Bailey, 'Ally Sloper's Half Holiday: Comic Art in the 1880s', *History Workshop Journal*, vol. 16 Autumn 1983, pp. 4-31.

32 *Ibid.*, p. 20.

33 *Ibid.*, p. 10.

34 R. Whiteing, *No 5 John Street* (London: Grant Richards, 1899), pp. 60-1.

35 G. W. Sims, 'Off the Track in London: Around Hackney Wick', *The Strand Magazine*, September 1904, p. 41.

36 *Ibid.*

37 A. Davies, *Leisure, Gender and Poverty: Working Class Culture in Salford & Manchester 1900-1939* (Buckingham: Open University Press, 1992).

38 J. Stratton, *The Desirable Body* (Manchester: Manchester University Press, 1996), pp. 179-80; F. Mort, *Cultures of Consumption* (London: Routledge, 1996); S. Nixon, *Hard Looks* (London: University College Press, 1997).

39 R. Felski, *The Gender of Modernity* (Cambridge, Mass.: Harvard University Press, 1995), pp. 61-90.

40 A. McRobbie, *Feminism and Youth Culture from Jackie to Just Seventeen* (Basingstoke: Macmillan, 1991); S. Alexander, 'Becoming a Woman in London in the 1920s and 30s' in D. Feldman and G. Steadman Jones (eds), *Metropolis London: Histories and Representations since 1800* (London: Routledge, 1989).

41 N. Cohn, *Today There Are No Gentlemen* (London: Weidenfeld & Nicolson, 1971); D. Hebdige, *Subculture: The Meaning of Style* (London: Methuen, 1979).

42 C. Evans, 'Street Style, Subculture and Subversion', *Costume*, vol. 31 (1997), p. 106.

43 E. Pugh, *The Cockney at Home: Stories and Studies of London Life and Character* (London: Chapman & Hall, 1914), pp. 115-16.

44 MacQueen Pope, *Twenty Shillings*, p. 227.

45 Paterson. *Across*, pp. 142-3.

46 S. Humphries, *Hooligans or Rebels: An Oral History of Working-class Childhood and Youth* (Oxford: Blackwell, 1981), p. 186.

47 M. Williams, *Round London* (London: Macmillan, 1892), p. 129.

48 W. J. Fishman, *East End 1888: A Year in a London Borough Among the Labouring Poor* (London: Duckworth, 1988), p. 195.

49 R. Roberts, *The Classic Slum: Salford Life in the First Quarter of the Century* (Manchester: Manchester University Press, 1971), p. 36.

50 A. Morrison, *To London Town* (London: Methuen, 1899), p. 129.

51 A Journeyman Engineer, *Some Habits and Customs of the Working Classes* (London: Tinsley Bros., 1867), pp. 83-4.

52 *Ibid.*, p. 233.

53 *Ibid.*, pp. 187-9.

54 Paterson, *Across*, p. 140.

55 G. Pearson, *Hooligan: A History of Respectable Fears* (London: Macmillan, 1983), p. 94.

56 Humphries, *Hooligans*, p. 191.

57 R. Samuel, *East End Underworld: Chapters in the Life of Arthur Harding* (London: Routledge, Kegan and Paul, 1981), pp. 8-10.

58 Journeyman Engineer, *Some Habits*, pp. 121-2.

59 G. Ingram, *Cockney Cavalcade* (London: Dennis Archer, 1935), p. 30.

60 *Ibid.*, p. 14.

61 M. Childs, *Labour's Apprentices: Working Class Lads in Late Victorian and Edwardian England* (London: Hambledon Press, 1992), pp. 115-17.

62 *Ibid.*, p. 116.

63 Paterson, *Across*, pp. 143-4.

64 A. Symons, *Silhouettes 1896 and London Nights 1897* (Oxford: Woodstock Books, 1993), p. 3.

65 L. Johnson, 'Notes on Symons Prepared for Katherine Tynan 1895' in *ibid.*, Introduction.

66 P. Bailey, 'Parasexuality and Glamour: The Victorian Barmaid as Cultural Prototype', *Gender and History*, vol. 2, no. 2 (summer 1990), p. 168.

67 *Ibid.*, p. 152.

68 *Ibid.*, p. 148.

69 *Ibid.*, p. 167.

70 *Ibid.*

71 *Ibid.*

72 P. Bailey, 'Custom, Capital and Culture in the Victorian Music Hall', in R. Storch (ed.), *Popular Custom and Culture in Nineteenth Century England* (London: Croom Helm, 1982), p. 198.

73 K. Beckson, *London in the 1890s: A Cultural History* (London: Norton, 1992).

74 J. Stokes, *In the Nineties* (London: Harvester Wheatsheaf. 1989), p. 56.

75 *Ibid.*, p. 63.

76 H. Scott, *The Early Doors: Origins of the Music Hall* (London: Nicholson & Watson, 1946), pp. 161-2.

77 Stokes, *Nineties*, p. 18.

78 C. Little, *Little's London Pleasure Guide* (London: Simpkin, Marshall, Hamilton, 1898).

79 Stokes, *Nineties*, p. 55.

80 London handbills and advertisements 1860-1880, Guildhall Library.

81 J. B. Booth, *A Pink 'Un Remembers* (London: T. Werner Laurie, 1937), p. 96.

82 P. Fitzgerald, *Music Hall Land: An Account of the Natives, Male and Female, Pastimes, Songs, Antics and General Oddities of that Strange Country* (London: Ward & Downey, 1890), p. 10-11.

83 Bailey, 'Custom, Capital', pp. 199-200.

84 P. Bailey, 'Champagne Charlie: Performance and Ideology in the Music Hall Swell Song' in J. S. Bratton (ed.), *Music Hall: Performance and Style* (Milton Keynes: Open University Press, 1986), p. 61.

85 D. Calthrop, *Music Hall Nights* (London: Bodley Head, 1925), p. 127.

86 Fitzgerald, *Music Hall Land*, p. 4.

87 Bailey, 'Champagne Charlie', p. 54.

88 H. Chance Newton, *Idols of the Halls: Being My Music Hall Memories* (London: Heath Cranton, 1928), pp. 58-9.

89 John Johnson Collection of Printed Ephemera, Bodleian Library, Music Hall.

90 D. Kirwan, *Palace and Hovel, or Phases of London Life* (Hartford, Conn.: Belknap & Bliss, 1871), pp. 469-70.

91 Bailey, 'Champagne Charlie', p. 50.

92 *Ibid.*, p. 58.

93 J. Greenwood, *In Strange Company: Being the Experiences of a Roving Correspondent* (London: Vizetelly & Co. 1883), pp. 232-3.

94 Chance Newton, *Idols*, p. 21.

95 A. Chevalier, *Before I Forget: The Autobiography of a Chevalier d'Industrie* (London: T. Fisher Unwin, 1901), pp. 227-8.

96 J. Peddie, *All about Monte Carlo: Extraordinary Career of Charles Wells, The Man Who Broke the Bank at Monte Carlo* (London: The Comet Publishing Company, 1893), p. 2.

97 *Ibid.*

98 C. Coburn, *The Man Who Broke the Bank: Memories of Stage and Music Hall* (London: Hutchinson & Co., 1928), p. 110.

99 *The Golden Years of Music Hall* (Wooton Under Edge: Saydisc, 1990).

100 Peddie, *Monte Carlo*, p. 2.

101 Coburn, *The Man Who*, p. 227.

102 Scott, *Early Doors*, p. 164.

103 Calthrop, *Music Hall*, p. 51.

104 Chance Newton, *Idols*, pp. 173-4.

105 John Johnson Collection, Bodleian Library, Music Hall.

106 Calthrop, *Music Hall*, p. 29.

107 *The Music Hall Songster 1891-1893* (London: W. S. Fortey, 1893).

108 C. MacInnes, *Sweet Saturday Night* (London: MacGibbon & Kee, 1967), pp. 55-6.

109 Booth, *A Pink 'Un Remembers*, p. 112.

110 Chance Newton, *Idols*, p. 25.

111 *Ibid.*, p. 24.

112 J. B. Booth, *Pink Parade* (London: Thornton Butterworth, 1933), p. 145.

113 *Ibid.*, pp. 144-5.

114 *Ibid.*, p. 146.

115 S. Maitland, *Vesta Tilley* (London: Virago, 1986).

116 V. De Frece, *Recollections of Vesta Tilley* (London: Hutchinson & Co., 1934), p. 125.

117 *Ibid.*, p. 126.

118 *Ibid.*, p. 195.

119 Boscagli, *Eye on the Flesh*, p. 1.

Manliness as masquerade: the disciplining of sartorial desire

<div style="text-align: right">7</div>

The Serio-Comic leaves the stage for a minute. He re-appears. Gone his diamond headed cane, his frivolous Newmarket overcoat, he wears a black Inverness cape now and has the demeanour of an Empire builder. He sings of 'Old England's Glory' of 'The gallant soldier lads in red, and the glorious boys in blue.' He turns himself into an Empire and rallies round himself. At impressive moments he removes his hat, overcome by patriotism. At the end of the song he throws back the wings of his Inverness and we perceive that they are lined with red, white and blue. At that moment a recruiting sergeant could enlist an entire regiment … Street betting, closing time, the wife left at home, are forgotten as the Union Jack, wrong way up, is lowered from the flies … The Serio-Comic goes off and on returning to take his call leads on a bulldog. It is the touch of a master. The only creature left unmoved is the dog.[1]

While the exuberant clothing of the masher clearly echoed the carefree pleasures of sartorial display encouraged by the music hall artist, Dion Calthrop's description of the bombastic patriotism which frequently ended the evening's entertainment at countless variety theatres in the 1890s introduces the idea that the promotion of masculine fashionability on the stage could also embody themes which disciplined the material desires of the audience. From witnessing a celebration of Piccadilly and champagne and enjoying a focus on the spectacular fitting up of the actor's dandified wardrobe, the consumer (faced with Calthrop's patriotic performer) was presented with an equally enduring interpretation of English masculinity as aggressively physical, triumphantly xenophobic and regimentedly martial in intention. These were qualities whose accomplishment entailed the suppression of those more sensual instincts that normally characterised the acquisition and display of fashionable dress. Indeed to end this consideration of masculine consumption practices without interrogating the contrary rhetorics which simultaneously positioned men as a part of and yet deeply critical towards the spectacle of the fashionable commodity would be akin to leaving the auditorium before the Serio-Comic had exchanged Newmarket overcoat for Inverness cape. Remaining initially with the representation of masculinity and fashion in the music hall, this concluding chapter moves towards an examination of the way that an economy of clothing

worked alongside a highly moral reading of manliness, which tempered the feminising dangers inherent in an engagement with the world of fashion. The evidence suggests that the ensuing sense of crisis concerning the status of the male body at the *fin de siècle* bequeathed a sartorial template that looked back towards mid-nineteenth-century interpretations of muscular manliness, while anticipating the core formal values that have since dictated twentieth-century models for masculine fashionable identities.

From Vesta Tilley to Eugene Sandow: masculinity as masquerade

Vesta Tilley was careful to present her audience with a broader selection of popular figures than her posthumous association with Burlington Bertie might imply. The diversification of her act ostensibly distracted attention away from a morbid concentration on leisure towards alternative models of male masquerade which made a virtue of imperialist sentiment - although even her impressions of soldiers and sailors carried with them the unsettling connotations of a feminised interest in fashionable surfaces. When, for example, in the tight-fitting costume of a midshipman she presented her naval song 'The Girls I Left Behind Me' at Portsmouth, Tilley could rely on the vocal support of the crowds of 'middies' who filled the auditorium to provide the requisite patriotic choruses, but she also had to contend with occasions when - as she recalled - 'a party of them came behind the scenes to tell me that the small white tab on my collar was not exactly the right shape'.[2] Percy Fitzgerald further underlined the male impersonator's disruptive physical attractions and confusing stance between the ebullient world of *bon ton* and the conservative domain of jingoism, when he described the type as 'a trim built, lively being who comes tripping out briskly, arrayed in a gentleman's complete evening suit, a crimson handkerchief stuck in her waistcoat. She brightens us up. Her two favourite topics are the forlorn condition of marriageable girls, and, above all, Tory patriotism.'[3] In her comic mirroring of masculine vanities, the faux swell, whatever the precise nature of her costume, utilised its attractive features in combination with the hidden promise of her own body to expose the ambiguity and essential decadence of the male consumer's gaze, while simultaneously shoring up its reactionary political and sexual prejudices. The perfection of the impression intensified the effects of a fear which cultural historian Rita Felski has identified as a key motif of critiques of the relationship between gender and consumption, where 'in attitudes toward modernity and mass culture … not only does woman remain the

archetypal consumer, but an overt anxiety comes to the fore that men are in turn being feminised by the castrating effects of an ever more pervasive commodification'.[4] In many respects the male impersonator incorporated such anxieties into the open secret of her disguise, representing a split in the masculine psyche between the pleasures of consumer culture and its disavowal.

One music hall characterisation promised some respite from an emasculating engagement with consumption in its espousal of a manliness that was literally laid bare, incontestably virile, laudably patriotic and unpampered. As Felski continues:

> the addressing of middle-class women as consumers led to a new prominence of icons of femininity in the public domain, and a concomitant emphasis on sensuousness, luxury, and emotional gratification as features of modern life. Such a feminisation … was clearly threatening to bourgeois men, whose psychic and social identity had been formed through an ethos of self-restraint and a repudiation of womanly feelings and whose professional status was based on an at best ambivalent relationship to the marketplace.[5]

The spectacle of a female performer transposing the sartorial imagery of masculinity and making clear its debt to the feminising power of commodification must have been as unsettling as it was amusing. The concurrent lionisation of acts whose effectiveness was based on a celebration of skill, power and the perfection of the male body *without* clothing (or the obvious taint of the market place that fashion implied), offered welcome compensation for those uneasy with the underlying cultural trends that the swell song, the masher and the male impersonator illuminated. Thus, while Vesta Tilley's parading of masculinity as fashionable masquerade corresponded directly to the hidden fact of her feminine sex, so the posturing of the body builder, epitomised in the massive figure of the celebrated performer Eugene Sandow, relied on the revealed truth of the male body for its impact and presumed honesty, leading the viewer back to a more reassuring interpretation of masculine role play and the promise of authenticity. At least that was the way it seemed, for the strong man incorporated as many paradoxes in his act as the most convincing male impersonator. As cultural historian Maurizia Boscagli states:

> Sandow as the 'perfect man' is an over-determined figure whose image splits and multiplies in a series of contradictory portraits according to the locale and the medium in which it is represented: vaudeville and music hall, theatre and photograph, advertisement images and text such as the autobiography. In each site his body stages a continual slippage between heroic and sentimental, high and low, erotic and ascetic, functional and ornamental, brute strength and black coated gentility. This

instability is what defines Sandow's body as a popular icon of masculine prowess.[6]

Sandow was a Prussian subject, born in 1867, who grew up alongside an emergent German health culture. Having studied sport and human anatomy at the Universities of Göttingen and Brussels, he enlisted the growing influence of the advertising, entertainment and publicity industries to promote tours of Europe and the United States in which he set his own body on display. His act combined the aesthetic and erotic pleasures of the *pose plastiques* troupes, who froze into three-dimensional tableaux of famous artworks in a bid to circumvent decency laws forbidding the exposure of moving naked flesh in public theatres, and the spectacular physical accomplishments of the acrobat or weight lifter. Sandow's particular contribution to the genre, however, lay in his use of the muscular body as an agent in a moralising crusade for the re-energising of young men which found a particular resonance in Britain at the turn of the century. His emergence into the public consciousness was marked by *The Daily Telegraph* in November 1889 when its correspondent noted that

> personally he is a short but perfectly built young man ... with a face of somewhat Ancient Greek type, but with the clear blue eyes and curling fair hair of the Teuton. When in evening dress there is nothing specially remarkable about this quiet mannered, good natured youth; but when he takes off his coat and prepares for action, the extraordinary development of the arms, shoulders and back muscles is marvellously striking ... the muscles stand out under a clear white skin in high relief, and suggest the gnarled roots of old trees.[7]

Following acclaimed runs at the London Aquarium, where he gained the title of 'Strongest Man on Earth' in front of an audience 'of men ... of position, shining lights from the Pelican Club, sporting men from the Stock Exchange ... the tobacco smoke, gradually rising like incense on high',[8] and at the more heterosocial Royal Music Hall, Holborn, his position as a celebrated icon of masculine perfection was assured. As Boscagli records:

> His character became the theme of public songs, his strength was displayed at work by Edison in a short film, and a plaster cast of his body was commissioned in 1901 by the British Museum. At the height of his fame his name figured in a commonplace phrase: 'As jolly as a Sandow' indicated the optimism and virtue attached to the perfect, healthy male body. At the outbreak of the First World War he became an advisor to the British Army, and even the pianist ... Paderewski asked for his help to develop a series of finger ... exercises. By 1905 the handbook 'Strength and How to Obtain It' had been reprinted three times, and in 1914 Sandow received a royal warrant as an instructor in physical culture, renewed annually until his death in 1925.[9]

What is particularly significant about the Sandow phenomena, other than its pervasiveness in the contemporary culture, is the way in which his image co-existed with that of other public ciphers for a modern masculinity, sometimes in the most unexpectedly close juxtapositions. Thus while the promotion of Sandow dumb-bells in *The Modern Man* was entirely to be expected, the fixing of his image by the society photographer Napoleon Sarony was much more piquant, as a decade previously the same Sarony had been responsible for capturing the self-promotional essence of Oscar Wilde in his high aesthetic mode. However while 'the polished exaggeration that popularised the aesthete's image had been achieved by dressing the subject up, in Sandow's photographs the bodybuilder is shown practically naked'.[10] In another strikingly apt coupling, his friend Vesta Tilley remembered him as

> a handsome, beautifully proportioned man, and a born showman. The ladies were particularly attracted by his performance, and he once showed me a good sized box containing all sorts of jewellery … which had been thrown on stage to him … He married the daughter of … a well known Manchester photographer, and when, shortly after his marriage, he retired from the stage, ran a big physical culture business in London.[11]

On the basis of such contradictory descriptions it is difficult to extricate Sandow's figure from the general celebration of the bizarre and the infamous that marked *fin de siècle* popular culture, an outlook that undermined stable readings of gender and contributed towards the defining features of decadence.[12] And this despite Sandow's self-determined reputation as a reforming character, purging all elements of physical or moral degeneration from the social body and leading an exemplary life of irreproachable decency. Yet, as John Stokes has claimed, seemingly irreconcilable cultural forms often formed a coherent whole in the logic of turn-of-the-century moral and artistic debate:

> the study of acrobats left a trail of aesthetic paradoxes. There was the realisation that the spasmodic sense of danger felt by the spectator depended upon the fine equilibrium of the performer … It followed that appreciation of acrobats benefited from a scientific approach, especially when their feats involved some distortion of the body that shifted the line between grace and deformity … requiring [the spectator] to demonstrate his sensitivity to the natural along with his openness to the abnormal, his wide eyed amazement with his cool headed analysis.[13]

In such a context Sandow's sinewed body was set up for the gaze of the bohemian aesthete as much as it was intended to mould the ambitions of the puny subaltern.

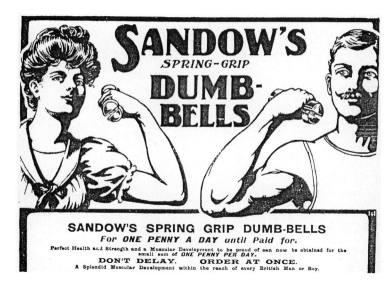

SANDOW'S SPRING GRIP DUMB-BELLS
For ONE PENNY A DAY until Paid for.
Perfect Health and Strength and a Muscular Development to be proud of can now be obtained for the
small sum of *ONE PENNY PER DAY.*
DON'T DELAY. ORDER AT ONCE.
A Splendid Muscular Development within the reach of every British Man or Boy.

41] Advertising ephemera, 1908. Despite its condemnation of the vanities of fashion, the physical fitness movement encouraged a narcissistic attention towards the beauty of the exercised body.

The disruptive 'strangeness' embodied in Oscar Wilde's dandyism and Vesta Tilley's roleplaying was therefore also imbricated in Sandow's assumption of an 'unproblematic' naked virility. In tandem with his more obviously contentious contemporaries, his performances threatened to blow open the complicated relationships forged between masculinity, pleasure and consumption. Stripped of clothing, the desire for fashionable forms of masculinity symbolised by the dandy didn't simply disperse, hastened by Wilde's arrest and indictment for homosexual offences in 1895 as some historians have suggested.[14] The musculature of the strong man and the monocle of the male impersonator continued to delineate the boundaries of a key public discourse on the nature of modern masculinities and consumption dating back to the era of dandy insurrection in the 1830s and 1840s. The supposed demise of the unashamed 'clothes-wearing' man, eclipsed by the rise of a 'feminised' consumer sphere and the criminalisation of homosexuality, has informed the assertions of some cultural historians that 'the eroticising male gaze was that of the fetishist seeking the phallus. Men could no longer display themselves for if they did they might find each other desirable spectacles.'[15] Sandow's undoubted success and huge appeal, together with Vesta Tilley's rise to the ranks of the plutocracy as Lady de Frece, wife of a Conservative MP, give the lie to such blanket assumptions that the fashionable, or indeed erotic male gaze was somehow taboo in its application to the popular imagery of masculinity. Their acts relied for their veracity and relevance on its power. The most sensible conclusion to be drawn from the high profile of such figures is that their presence provides rich evidence of a vigorous debate concerning the positioning of men within commodity cul-

ture at the turn of the century, even if the truths they revealed were uncomfortable and multi-layered.

The dandy and the gentleman – models for modern consumption

Much recent work on the ideological construction of modern masculinity positions the emergence of the homosexual as a recognisable type during the last quarter of the nineteenth century as a key event in the marshalling of normative male characteristics, which stressed an aversion to surface, to decoration and to looking. In short, the assumption of a masculine heterosexual subjectivity was seen to have required a renewed repudiation of the constituents of fashionability as the domain of 'inverts' and women, heightened by medical and sociological 'research' which for the first time associated the 'pathology of homosexuality' with defined 'feminine' traits.[16] My comments regarding the status of the dandy in Chapter 5 cautioned against crediting official discourses alone with too great an influence on the day-to-day consuming habits of 'ordinary' people, but it will be useful to rehearse the attitudes established through such debates on sexuality and gender roles, before testing their application in the public sphere. Kosofsky Sedgwick suggests a much loser prehistory to the association of conspicuous consumption with homosexuality, which finds its co-ordinates more closely tied to definitions of class than to sexual behaviour. She states that:

> Since most Victorians neither named nor recognised a syndrome of male homosexuality as our society thinks of it, the various classes probably grouped their range of sexual activities under various moral and psychological headings ... the working class may have grouped it with violence. In aristocrats – or, again, in aristocrats as perceived by the middle class it came under the heading of dissolution, at the very time when dissolution was itself becoming the (wishful?) bourgeois ideological name for aristocracy itself. Profligate young lords in Victorian novels almost all share the traits of Sporus-like aristocratic homosexual 'type' and it is impossible to predict from their feckless 'effeminate' behaviour whether their final ruin will be the work of male favourites, female favourites, the racecourse, or the bottle. Waste and wastage is the presiding category of scandal.[17]

In a similar vein Felski tempers the tendency of cultural critics to project contemporary constructions of sexuality back into a context in which their interpretation would have been markedly different. Like Kosofsky Sedgwick, she notes that 'an affinity with an aesthetics of performance and masquerade was itself significantly over-determined by class privilege in the late nineteenth

century; the composition of self through stylistic display and glamorous lifestyles was an option only available to a minority'.[18] As this book suggests, her claims of a monopolising of display by an effete aristocracy are challenged by the emergence of competing sartorial identities and a widening of choice across social categories from the 1860s onwards. But an insistence on considering the formation of fashionable identities through the class determinants that also shaped the pattern of sexual discordance is broadly helpful. It reveals the fact that 'the dandy's ironic exposure of the eroticism and the arbitrariness of the commodity was itself a function of spending power and a social status marked by the psychopathology of affluence',[19] an affluence that touched the construction of masculine identities at all social levels. Thus the new figure of the homosexual, while attracting opprobrium for his presumed association with material excess and its inappropriate display, also reflected previously established anxieties regarding the connections between gender, class and consumption. To prioritise sexuality in this triumvirate as a motor for cultural change has distorting effects, for, as Kosofsky Sedgwick boldly proclaims:

> there seems in the nineteenth century not to have been an association of a particular personal style with the genital activities now thought of as 'homosexual'. The class of men about which we know most – the educated middle classes, the men who produced the novels and journalism and are the subjects of the biographies – operated sexually in what seems to have been startlingly close to a cognitive vacuum.[20]

It is clear that the style Wilde epitomised acquired its sexual connotations only after the facts of his private life had been established as a defining symbol of decadence in court and by the popular press. During the 1870s and 1880s his serial adoption of aesthetic *Patience* garb, Neronian curls and bohemian velvet, and the urbane perfection of fashionable evening dress, escaped censure on the basis of sexual depravity because no single material template for homosexuality existed outside of the complex and secretive subcultural groupings that had constituted London's demi-monde since the late seventeenth century.[21] His contrived posturings certainly attracted controversy, but as Boscagli notes they 'were scorned and laughed at – and enjoyed – by the broad middle class because of what appeared as their parasitical and effeminate refinement. This very effeminacy could be used by Wilde to "pass" exactly because his contemporaries decoded it as a signifier of class rather than sexual dissidence'.[22] However, humorous though it might have seemed, the symbolism of affected clothing and effeminate mannerisms clearly threatened to breach the unspoken contents of that vacuum that constituted a material

discourse for sexual behaviour, so delicate were the boundaries that policed the formation of gender roles during this period. Once that knowledge entered the public domain, Wilde's effete image immediately gained a retrospective taint that was viciously lampooned for its duplicity, as evidenced in the street ballads and yellow press denouncements published at the time of his trials:

> Oh! Oscar, you're a daisy, you're a sunflower and a rose.
> You're a thick old dandelion from your pimple to your toes.
> You're the sweetest lump of boy's love.
> That's been picked for many a day.
> Oh! Oscar Wilde, we never thought that you was built that way!
>
> You've been 'An Ideal Husband' in your tin pot way no doubt.
> Though a 'Woman of no Importance' was your wife when you were
> out;
> At least that's what the papers say, of course they can't be wrong;
> They seemed to say that Oscar's fun was very very strong.
> He wouldn't treat a 'Lady' no not even Totty Fay.
> But with the pretty boys, he liked to pass his time away.
> Champagne and chicken suppers, and he'd also give them pelf.
> He was fond of manly beauty, he's so beautiful himself![23]

Taking the twin engines of class and sexuality together, their power heightened by a timely cultural focus on homosexuality though not exclusively driven by it, the potential of dandified behaviour for undermining masculine identities at the *fin de siècle* was therefore explosive and partially explains the proliferation of fashionable models that embodied more reactionary, energetic and youthful values after 1900. The liveliness of the masher stood at the opposite end of the sartorial scale from the ennui of Wildean decadence, his accoutrements chosen partly because of their valorisation of a 'sportiness' that bespoke a renewed version of defensive 'normal' manliness. Both fashionable forms, however, gained their communicative power from the same contentious relationship between consumer culture and the expectations of gender. In this sense the emergent homosexual aesthete and the homosocial consumer made perfect bedfellows. As Boscagli comments:

> the dandy's egotistic narcissism stood in open opposition to the chivalric virtues of self-sacrifice, courtesy, service, responsibility and work, which for the late Victorian middle classes characterised an ideal masculine national type ... During the last decade of the century, when England, despite its empire, struck many commentators as being in danger of losing its economic pre-eminence on the world scene, it was the dandy's ineffectuality, his effeminacy and narcissistic otium, more than any sign of homoeroticism that preoccupied and scandalised the middle class.[24]

The reckless pursuit of ready-made suits, music hall escapism

and monkey parade horseplay that characterised popular repre-
sentations of 'Arry, Lupin Pooter and the masher legions of the
clerk class, were as implicated in such furious scenarios of national
degeneration as any description of Mayfair languor.

The countering rhetoric of 'gentlemanliness' had been prevalent
in prescriptive forms of literature from etiquette guides to religious
tracts since the 1830s, and had found more concrete manifestations
in the regulatory practices of military, educational, government
and church organisations from the same period through to the
high summer of imperialism, which witnessed its subsequent dis-
integration after the turn of the century. At its highpoint in the
1860s the term embodied both the Christ like 'gentleness' inherent
in current Anglican doctrine and a stress on the more 'unforgiving',
assertive connotations of the word 'man' which had older evan-
gelical origins.[25] It thus formed the natural bedrock from which
critics of modernity and decadence aimed their attacks on the new
male consumer. Robin Gilmour has suggested that the cultural
profile of the gentleman rose at various historical moments in
response to attacks on bourgeois notions of propriety, with the
result that his constrained form always appeared to be shackled to
the looser outrages of the amoral dandy, the two of them standing
in a binary relationship that expressed official attitudes towards
masculinity and the fashionable life. It is then no surprise that the
concept of a controlled version of muscular manliness found a
renewed relevance at the *fin de siècle* when the excesses of dan-
dyism and consumer culture appeared to be infecting the virility
of the nation in tandem. In Gilmour's words, 'the gentleman
becomes an essentially reforming concept, a middle-class call to
seriousness which challenged the frivolity of fashionable life ...
gentlemanliness is on the side of decency, the values of family life,
social responsibility, the true respectability of innate worth as op-
posed to the sham respectability of fashionable clothes'.[26]

Gilmour and others are careful to show how the enduring con-
cept of the gentleman found its resonances altered by the
particular social and economic circumstances pertaining at the
moment of its mediation.[27] Thus, far from symbolising the time-
less, medieval qualities that its Victorian champions claimed for it,
the gentlemanly model underwent profound shifts in meaning
and effectiveness between its ascendancy in the 1850s 'when the
spirit of middle-class reform was making its challenge felt within
the aristocratic framework of English institutions'[28] to its appro-
priation by the lower middle classes from the 1890s as a similar
prop by which access to professional and social status might be
gained. By the turn of the century the championing qualities of a
modern chivalric code which had challenged access to institutions

formerly reserved for the patronage of the elite had been diluted. As Gilmour concludes:

> the idea undoubtedly lost some of its potency when it ceased to be problematic, and no longer had to carry the freight of the middle class challenge to the aristocracy ... Wilde's era asked instead, and with a new urgency, what it meant merely to be a man. Related to that development, and to the dilution through democratisation of the gentleman as a cultural type, is the growing suspicion that he may be, after all a rather conventional and colourless figure.[29]

Certainly when the body of the gentleman was invoked visually through representation, or polemically through admonishments by moralists to behave in a manner suitable to the chivalric calling, his figure usually espoused the dark inscrutable sheath so often claimed as a cloak for nineteenth-century masculinity in general.[30] This rejection of individualised surface interest, in preference for an outward display that celebrated the virtue within through a rhetoric of uniform denial that was almost monastic in nature, remained a constant feature of the gentlemanly mould from its origins in the re-orientation of public school curricula from the 1860s, which prioritised a cult of rough physicality and a celebration of the team over the nurturing of independent character. J. A. Mangan sees this reflected in the development of school uniform. Photographs of the Harrow School Eleven show the

42] Cabinet photograph, *c.* 1900. Images of sports teams from the end of the nineteenth century show in their poses and attire how a public school ethic of gentlemanly sportsmanship could be used to discipline the bodily desires of all men, regardless of class.

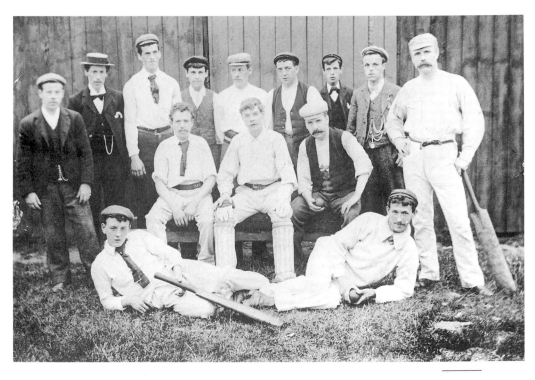

casual informality of the 1863 team gradually transformed into the 'immaculately and expensively attired ... bloods' of 1912, 'posed in the full glory of caps, scarves, blazers and spotless flannels, symbolising the high point of ante-bellum athleticism'.[31] However, the almost dandified aspect of the latter group showed the extent to which a narcissistic decoration of the manly body was permitted among those who epitomised the sensual appeal of the imperial hero. As Mangan continues:

> it was a sensuality in which physical contact was channelled into football mauls and emotional feelings into hero worship of the athletic blood ... Investigation of the literature of public school life will look in vain for the hero as intellectual, dilettante or cosmopolitan. The heroes of the time were, in Kipling's words 'gentlemen of England, cleanly bred'. Their pleasures were wonderfully stoical, their virtues grounded in the physical.[32]

This was a form of self-discipline that reverberated beyond the playing fields of Harrow. The historian Bruce Haley quotes anti-aristocratic examples of its diffusion through the pages of popular sporting journals:

> An 1864 article in the ... journal Bailey's, titled 'Mens Sana in Corpore Sano' argued that 'the sinews of a country like England cannot depend on its aristocracy. A good wholesomely cultivated mind and body, taught to endure, disciplined to obedience, self restraint and the sterner duties of chivalry, should be the distinguishing mark of our middle class youth'. The article objected not only to such modish sartorial affectations as the turndown collar and the Zouave breeches pocket, but to any sort of adopted style or manner. A man's bearing should be a natural expression of his own mind and body, and a programme designed to train both of these would impart 'a cheerful, active, confident tone, an upright carriage, and a graceful ease, instead of that lounging, semi-swaggering, confoundedly lackadaisical manner which they have adopted in compliment ... to the real swell and the man of fashion.' The true gentleman is recognised by his independent spirit, his unwillingness to be flattered or intimidated by the counterfeit gentleman ... If he remembers the principle of 'mens sana in corpore sano', his inner qualities will show through to the outer man.[33]

A mode of living based on the premise that 'authentic' masculine behaviour entailed a divestment of those characteristics associated with the material trappings of contemporary life for a clearer revelation of the soul, distanced its adherents from the corrupting field of fashion decades before the close association between fashion and depravity that defined the *fin-de-siècle* decadence. More than this, the gentlemanly rhetoric, as it developed away from the re-forming Anglo-Catholic medievalism which had marked its origins, embraced a spiritual cult of action that militated against

an engagement with the commodified trends of nineteenth-century urban culture. In this context any sartorial manifestation of its principles was deemed meaningless unless it entailed rejection. A lecture of 1877 on the subject of 'Manliness' given to the members of a church literary society in Derby provided clear guidance on the duty of young men to discipline their desires for surface in a manner that went much further than those contrived calls for 'renunciation' associated with Brummel and the fetishistic management of 'sober' dress in the earlier part of the century, and pre-empted the Wildean obsessions with fashionable imagery to come. Here was a middle-class philosophy of clothing and its negative relationship with identity that traced its lineage further back to the fundamentalist Protestantism of the seventeenth century, yet remained quite consistent with the contexts of empire-building, the missionary life, sporting prowess and the new professions. Together these under pinned a version of masculinity that was both 'puritanical' and sentimentally self-celebrating:

> The pleasure seeker is not manly. He is the very opposite. The manly character is not trained amid the scenes where pleasure wreathes her cup and sings her song and weaves her mystic dance. Pleasure enervates – pleasure emasculates ... Nor is the fashion worshipper manly. Manliness is not an affair of patent leather boots, or of fine clothes, or of tight fitting kid gloves, or of exquisite beard and moustache, or of faultless conformity to the rules of etiquette, or of acceptance of the prevailing creed of the time or place. Conventionalism is not manliness; foppery is not manliness; to put on airs, and talk large, and go where the great people go is not manliness ... Manly character is the grandest thing beneath the stars. And the day will dawn upon this sorely confused world of ours when the highest places will be filled by men, and the only nobility will be the nobility of manly character. For me the gilded palace, the glittering pageant, the pomps and shows of mere earthly greatness, have no interest. But the manly character, whatever its outward setting, no matter how poor and bare, and mean, commands my reverence ... it is the thing of greatest worth in God's sight. It is the temple in which he dwells.[34]

From a condemnation of the artificial trappings of fashionability it was a small step towards an admiration for physical strength, unfettered by clothing, that was seen to symbolise the honesty of manly character in countless didactic representations by the turn of the century. As Sandow and his physical culture followers understood, the triumphant male body presented a tabula rasa to disembodied groups of men who found themselves alienated both from the playground of consumer culture - a traditional position of power within the family unit - and from a meaningful role on the new treadmill of professional life. Furthermore it bequeathed a troubled reading of the relationship between

fashion, consumption and masculinity that has retained a credi-
bility unwarranted by its reflection in actual practice, but fully
representative of the tensions thrown up by its cultural and ideo-
logical implications in a longer historical picture. The aggressive
corporeality of the late gentlemanly ideal was not the only text
on offer, despite the convictions of its champions, and it would be
misconceived to map its influence alone on to the adoption of
particular modes of dressing and public presentation . As we have
seen, other rhetorics from the cult of suburban domesticity to the
conspicuous consumption of the masher offered models that chal-
lenged a renunciatory reading. Yet the uncompromised and ascetic
figure of the conservatively suited, sporting 'everyman' endured as
the normative representation of healthy, muscular English man-
hood. Its attractions made a special appeal to precisely that group
of middle- and lower-middle-class men who were simultaneously
being fitted up as a viable market in the expanding realm of com-
modity culture.[35] It was these men whose taste was to dictate the
restrained look of English masculinity on the street, in the office,
on the screen and on the page, until a later point of sartorial and
commercial challenge at the end of the 1950s.

'The mode of today': a conclusion

> In the writer's frank opinion, the twentieth century can so far boast of
> no other virtues than those of utility, comfort and convenience. To
> these cardinal points all else has been sacrificed. There is a dullness, a
> greyness, and a sternness in the European man's fashions which could
> be infinitely improved upon. There is that nervous touch both in colour
> and in style, that lack of individuality in all classes, which will render
> the mode of today characteristic only of the commercial mind ... Black
> and grey - words which have an ominous meaning in our language in
> addition to the colour they express - are still more worn than any other
> shade. Both are sombre and depressing, and though the present age is
> commercial, it is still artistic, so perhaps it may not be long before we
> evolve to a more spirited, a more cheerful, and a more attractive garb
> than the vogue of the moment compels us to wear.[36]

For H. Dennis Bradley, publicising the new season's collection in
1912 for the West End tailoring firm of Pope & Bradley, the re-
strained style of the professional man appeared to hold the
aesthetic progress of masculine fashionability in suffocating check.
His judgement might even be used to substantiate the veracity of
a Flugellian reading of masculine renunciation. At the same time
however, Bradley admitted that the dark and conservative cloth-
ing which were personified in the body of the ideal Englishman
offered an appropriate summation of all those characteristics
which have subsequently come to represent the triumph of demo-

cratising modernism over elitist distinction: 'utility, comfort and convenience'. The irony is a sweet one, for it was arguably those same rational elements that survived from the male wardrobe of the nineteenth century which would inform the relaxed and youthful, sports-derived look of the interwar years; a soft and un-obtrusive, but essentially 'popular' clothing style that was as appropriate for the publicity photographs of emerging Hollywood stars as it was for weekend wear on the terraces of football grounds and in the pavilions of cricket pitches. Hidden within Bradley's text lay the paradox which has defined the developing relation-ship between masculinity, fashion and consumption described over the course of this book, that in its apparent 'blankness' and tendency towards 'closure' Victorian and Edwardian male clothing provided a creative space for contestation and innovation. The effects of this have positioned consuming men at the forefront of the modernising process. As has been shown, the late nineteenth-century male wardrobe, with its broader context of retail and display, provided a motor for that transition rather than a brake.

Others have also noted the manner in which the conservative and aristocratic tenets of nineteenth-century dandyism, whose vis-ual formations did not differ so radically from the 'black and grey' of Bradley's 'everyman', evolved and transmuted to feed the atti-tudes and preoccupations of a publicity hungry and spectacle obsessed mass audience at the *fin de siècle*, bequeathing a particular configuration of style-led modernity to the development of twen-tieth-century fashion systems. Most recently Rhonda Garelick has illustrated how:

> As the end of the nineteenth century approached, dandyism could no longer maintain the self-enclosed, elite nature of its artistic and historical performances because powerful performances of quite a different kind began to dominate the cultural landscape. The explosion of mass culture in the 1880s and 1890s ... made possible a new, very public cult of personality that was distinctly at odds with the rules of dandyism. In the first place, mass culture showcased women especially, a fact at odds with dandyism's masculinist focus. The mass-cultural personality was, furthermore, necessarily an active part of a new social levelling, and therefore posed a contradictory model to dandyism's elitism ... More-over, images of the newly emergent star culture, in their endless replicability, dismantled the unreproducibility at the heart of the no-tion of the dandy.[37]

Underlying Garelick's argument, however, despite its helpful invocation of the importance of an emerging mass audience, is an insistence on a literal feminisation of the popular public sphere, in which the female 'star' supplanted the dandy as a representative of fashionable modernity, relegating his austere visual presence to

the private interior which had originally been her domain. In her view the consuming Edwardian woman or her stage counterpart became the new dandy while the material parameters of the separate spheres paradigm remained intact. Her assumption is that 'ordinary' men had no role to play in this articulation of fashionable identities:

> Decadent dandyism is paradoxical in that it turns sharply away from the external world while nonetheless being deeply aware of the new, changing and largely urban landscape ... the crowd becomes a key, menacing presence ... This development appears in the literature of decadent dandyism as the protagonists' attempts to define their lives against those of the masses, and the sequestering of much of the literary action within felted, ornate and remote interiors. And yet, the crowded world of the factory, the streets, and the music hall was compelling to the decadent dandy, and crept resolutely back into his work. The realm of mass culture was particularly alluring, in large part because the artists on stage so resembled dandies, offering spectacles of elaborately constructed, highly stylised selves.[38]

This is a provocative and in some ways a beguiling suggestion, but it is one that cannot be wholly supported by the findings of the research contained here, though certain parallels are clear. Garelick's interest lies largely in examining the connections that can be made between literary configurations of dandyism and selective forms of public performance, most notably those celebrity acts which relied upon the eroticising connotations of modernity (speed, light and movement), alongside a deliberate confusion of traditional sexual roleplay. It is certainly true that her dancers and singers fed a hunger for novelty and celebrity that was decadent and 'modern' in the extreme. But their popularity and innovative impact do not imply that male dandyism as a broader 'active' cultural category fell into a decline as a result. My examination of the material culture of male fashion, leisure and their attendant publicity will not sustain such a reading. The figures of the bachelor and the masher and their music hall milieu clearly refute its implications. Perhaps more exciting and useful for an understanding of the role that fashion played in the forming of modern identities is the suggestion that the projection of the self and an emphasis on auto-performance were phenomena that transcended older gendered or class-based stereotypes and owed much of their power to the new potential of the urban market place. It is in this sphere that shifts in the marketing and wearing of masculine clothing made their fullest contribution to new definitions of fashionable modernity, and their effect should not be marginalised. Indeed, it has been the primary motive of this book to

subject those shifts to a closer scrutiny, placing them within a material rather than a rhetorical and thus more tentative context.

As an illustration of the ways in which such themes have emerged, it will be instructive to return to Pope & Bradley's clothing empire. Launched at a moment when the notion of the 'Victorian' was beginning to attract negative connotations and the concept of the twentieth century could still evoke optimistic associations, their publicity incorporated many of the values which I have identified as being central to the reappraisal of the relationship between masculinity, fashion and urban modernity that took place between 1870 and 1914. Bradley's promotional rhetoric stands as a clear example both of the radical commercial developments which had marked the field over the previous half century and of a more enduring construction in which essentialising models of masculinity and the volatile idea of fashion were never entirely reconciled with each other. Beyond his condemnation of the 'unimaginative' fashioning of men's bodies in established tailoring concerns, Bradley clearly positioned his own business at the forefront of a modernising tendency in the trade. As I hope to have shown in relation to previous cases, this process is one that needs to be positioned spatially and socially, as part of a concurrent transformation in the nature of city life. With a branch at the hub of 'society' London and a monopoly on the most modern retailing site in the metropolis, the firm owed its success not to an unchanging ideal of the traditional and ubiquitous manly wardrobe but to an engagement with the demands of a clientele well educated in the vagaries of urban style and possessed of tastes highly specific to the immediate locale. As Bradley boasted:

> Known throughout the world as the centre of London's finest tailors, the value that the position of our house is fortunate enough to hold is unique. Situated within a few doors of Piccadilly, in order that we may study the convenience of the adjacent clubs, the building we occupy is an admirable example of the free Renaissance style ...
>
> With its splendid breadth of road, its wide pavements, and its avenue of trees, the magnificent new thoroughfare of Southampton Row and Kingsway is the only London street able to bear comparison with the boulevards of Paris. To adequately study the convenience of the many clients of a great business organisation such as ours would be quite impossible without both a central and a West end address, and with Southampton Row offering access for the professional and the business man and Bond Street for the man of leisure, our house is in an ideal position to cater for the needs of the class of men to whom our style appeals.[39]

Beyond stressing the importance of location in understanding the operation of masculine fashion systems in late nineteenth and

early twentieth-century London, this book has also shown how
the fitting out of the shop interior could reflect the problematic
connotations that 'clothes shopping' held for many male con-
sumers. Summarising a trend that had gathered momentum
throughout the period, Bradley reassured customers that 'with our
knowledge of the masculine temperament teaching us that men
as a rule hate shopping, our chief motive became to provide for
our clients salons for fitting and choosing where they would find
in all the appointments the luxury, comfort and good taste of their
club or home'.[40] Herein lay a further paradox whereby a social
pressure to renounce consumption conflicted with the attractions
of the latest in window promotions and interior furnishings, re-
sulting in a modern retail aesthetic that perfectly mirrored the
contradictions of display and disavowal inherent in men's clothing
itself. Within this contradiction lies a further endorsement of Ko-
sofsky Sedgwick's call, cited in the introduction, for questioning
whether 'it is men as a group, or capitalists as a class that chiefly
benefit from the modern sexual division of labour?' or for asking
'how close is the fit between the functions of the gendered family
and the needs of capitalism?'[41]

I have generally avoided explaining the organisation of male
fashion consumption through sole recourse to economic determi-
nants, but these questions and the evidence provided by
consumers and retailers come some way towards challenging a
simplifying 'separate spheres' perspective on the gendering of
fashionable consumption in the nineteenth century. If the idea of
the triumphant female shopper and the reluctant male consumer
incorporated all the baggage of a powerful social or moral dis-
course, that doesn't mean that its circulation stood in the way of
business and the free market, or that its effects consistently made
an active impact on consumer's experiences. The link between the
two was not perhaps as strong or clear as some historians have led
us to believe. In the move towards mass-marketing that increas-
ingly constituted early twentieth-century forms of fashion
production, the male clothing industry was as receptive to the
advances of profiteers and capitalists as its female counterpart.
Thus retailers could profitably draw on the rhetoric of segregation
in consumption and taste through their stock, fittings and promo-
tions, more finely honing the targets of their products, while
simultaneously encouraging an active participation in the shop-
ping experience by consumers who, theoretically, were assumed
to stand 'aloof' from its blandishments. In the final analysis this
leads one to consider the broader political and personal effects that
a reconstituting of clothing as an active participant in the con-
struction of gendered subject positions had on male consumers

themselves. This might best be illustrated by mapping the various
chronological and thematic developments in the formation of
modern fashionable masculinities that this book has traced. In
teasing out the significance of change, I would also like to cite the
recent work of James Eli Adams, whose investigation of masculine
'styles' in Victorian literature reveals several parallels with the lite-
ral process of self-fashioning that took place in the field of fashion
consumption.

First, I have shown how the appearance of men undoubtedly
underwent a process of transformation between 1870 and 1914
thanks both to the skill of the tailor and warehouseman, and rather
crucially to the exercising of taste by the consumer. This can be
seen simply as an illustration of fashion cycles in motion, speeded
up by the aforementioned shift towards a market driven by new
production techniques and advanced advertising strategies. But the
existence of change in a sphere more commonly noted for its
stagnation raises cultural concerns as well. The basic transition
from the brazen dandyism of the 1830s and 1840s, through the
stove-pipe severity of the 1850s and 1860s to the 'market choice'
of competing styles that marks the period after 1870 is revealing
of concurrent shifts and tensions in attitudes towards manhood
and in many ways went someway towards shaping them. As
Adams notes:

> Under the conjoint authority of Evangelical faith and romantic subjec-
> tivity, early and mid Victorian norms of manhood construct an ideal
> of essential selfhood that repudiates self-consciousness as a mark of thea-
> tricality. In attacks on the dandy or 'swell' for example, a theatricality
> readily accommodated in earlier constructions of aristocratic manhood
> is disavowed as the sign of a socially mediated identity, which betrays
> both religious integrity and the social autonomy fundamental to man-
> hood. But a manhood that ostensibly transcends self-interest and the
> gratification of social regard must nonetheless be proved in the theatre
> of the world ... the Victorian gentleman ... invariably depends on forms
> of recognition that he professes to disdain, and is thus implicated in the
> logic of the dandy.[42]

Thus the bright plaids, sumptuous velvets and form-hugging cut
of the wardrobes espoused by men like the young Disraeli, and
represented so fittingly in the delicate hand-coloured fashion
plates of the period, bore a more than passing relationship to a
romanticised notion of the self, encouraged through the dramatis-
ing and heroic prose of a novel by Scott or the sentimentalism of
early Dickens. Yet the dulled moleskin and broadcloth frock coats
of the mid-century decades, generally promoted in monochrome
steel plates on the backs of mature bearded models, were no less
self-conscious in their attention to form or ascetic gesture. They

celebrated a sparseness and monastic denial that chimed perfectly with the prose heroes of Kingsley and Arnold, who were equally dandified in their own way. A difficulty of interpretation arose when those ideal templates were subjected to the realities of the market place and the social necessity demanded of consumers to display their distinction. Adams offers a reading that acknowledges the productive gap that opened up in the 1850s between an emphasis on masculine self-sufficiency and removal from the world of fashion in didactic texts, and the exigencies of class in the real and rapidly transforming world beyond:

> In emphasising the economic utility of self-discipline ... historians have devoted less attention to the forms of symbolic capital it might afford ... The English, Samuel Johnson confidently asserted in 1755, were effectively governed by 'the fixed, invariable, external rules of distinction of rank.' A century later, those rules and the security they offered had largely disintegrated as 'rank' gave way to structures of class, yet social hierarchy was a more urgent preoccupation than before - largely as a result of its new flexibility. What had intervened, notoriously, was a momentous transformation of economic possibility that incited increasingly complicated and anxious efforts to claim new forms of status and to construct new hierarchies of authority ... In this context, the energetic self-discipline that distinguished manly 'character' offered not only economic utility but also a claim to new forms of status and privilege within an increasingly secular and industrialised society.[43]

It was also in this context that the notion of the stereotype, reliant on sartorial delineation, gained an increased currency as a vehicle by which consumers might make sense of an expanding arena of consumer goods and professional possibilities. What better way to display the symbolic capital of self-discipline than through the surfaces of a body that could now fit a variety of useful or wasteful roles and draw on a clothing repertoire that directly echoed the potential range, from the productive labourer, through Carlyle's 'captains of industry', to the idle aristocrat?

Two themes of change have emerged then. First the importance of a masculine fashion system based on economic and moral prerogatives in which style could be seen to progress, though not ostentatiously so; and second the increasing emphasis placed on social differentiation that grew from that development. Both of these readings could also be applied without great difficulty to an analysis of female clothing provision and self-fashioning in the same period. A third theme, however, positions shifts in attitudes towards the outward display of gender and the organisation of domesticity as a defining paradigm for the emergence of a 'modern' masculine fashion sensibility. This was the *fin de siècle* sensibility encapsulated in Pope & Bradley's call for modernisation.

A sensibility in which 'stove-pipe severity' was replaced by a more casual, democratised, sporting look, advertised in colour-printed lithographs that caught the variety of shades woven into a club tie or a striped shirt-front, as worn by the athletic 'boyish' figure of a morally confused but chippily confident H. G. Wells hero. Adams draws out the underlying importance of a clearly defined sense of sexual difference to the smooth functioning of nineteenth-century social relations which this model challenged, through quoting the poetic call to manly mastery of Tennyson's *In Memoriam* where 'life is not as idle ore, / But iron dug from central gloom, / And heated hot with burning fears, / And dipt with baths of hissing tears'. He concludes that:

> The fierce technology of masculine selfhood similarly informs that ne plus ultra of Victorian gendered binaries, Ruskin's 'Sesame and Lilies': 'You may chisel a boy into shape ... But you cannot hammer a girl into anything. She grows as a flower does.' The very familiarity of these passages may have dulled us to their potentially subversive implications ... they point to a self-fashioning not easily accommodated by domestic ideology. If masculinity defines a fundamentally ascetic regimen ... then the feminine balms of home may seem to enervate rather than support men ... Moreover, insofar as regimens of manhood embody an active self mastery rather than a mere capitulation to circumstance, they reproduce within masculinity a paradox ... virtuoso asceticism always incorporates an element of the mediated, performing selfhood against which it defines itself.[44]

Once again, this line of argument comes close to a renunciatory reading in which the apparent asceticism of male clothing in the late nineteenth century is invoked to signify the moral dominance of men over women. However, as we have seen, the mediation of that model provided conflicting constructions of fashionable masculinity, which while remaining true to an essential differentiation from the appearances associated with femininity (or, as Stefan Collini argues, with notions of the bestial or the immature),[45] could also carry traces of worldliness, domesticity or display derived from the very same sources. The clothing of the suburban father or the bachelor playboy revealed within their forms and associations a tension between private effeminacy and public rectitude which betrays a fundamental conflict between the confused but energising experience of urban life and an idealised template of correct behaviour. While other interpretations of masculine dress in the period have prioritised the latter, this book offers up the contradictory evidence of the former as a means of suggesting a more varied texture to the relationship between men and their outer selves in the context of consumer culture than has previously been considered. As images of

respectable femininity broke away from the constraints of the 'angel in the home' to take on the complexities of the 'new wo-man', so the certainties associated with the assured figure of the self-made paterfamilias also fractured under the pressures of a com-modified modernity. By the outbreak of war in 1914, the philosophical, social and commercial terrain of masculine fashion-ability had developed to such an extent that Dennis Bradley could suggest with some confidence that:

> It savours very much of cant and hypocrisy for any man to say that he does not study dress in one form or another. It is absolutely imperative for a man nowadays to study his appearance. As a business, a professional or a social asset it is a very potent factor, and it is the privilege only of the millionaire and the pauper to be able to dress badly.[46]

If this book has had one central aim it has been to show how that understanding of choice implied by Bradley, and the vicissi-tudes or occasional pleasures that it entailed, were articulated in those important debates, representations and actions surrounding the acquisition of men's clothing and the moulding of men's bodies at a moment of crucial flux in a longer history of 'fashion culture'. Such processes constituted an essential element in the complex formation of masculine identities between 1860 and 1914, as they continue to do today.

Notes

1 D. C. Calthrop, *Music Hall Nights* (London: Bodley Head, 1925), pp. 15-16.

2 De Frece, *Recollections of Vesta Tilley* (London: Hutchinson & Co., 1934), p. 130.

3 P. Fitzgerald, *Music Hall Land* (London: Ward & Downey, 1890), p. 18.

4 R. Felski, *The Gender of Modernity* (Cambridge, Mass.: Harvard University Press, 1995), p. 62.

5 *Ibid.*, p. 90.

6 M. Boscagli, *Eye on the Flesh: Fashions of Masculinity in the Early Twentieth Century* (Oxford: Westview Press, 1996), p. 107.

7 *Daily Telegraph*, 4 November 1889, quoted in G. Mercer Adams (ed.), *Sandow's System of Physical Training* (London: Gale & Polden, 1894), p. 44.

8 *Ibid.*, p. 56.

9 Boscagli, *Eye on the Flesh*, p. 106.

10 *Ibid.*,

11 De Frece, *Recollections*, p. 54.

12 S. West, *Fin de Siècle* (London: Bloomsbury, 1993).

13 J. Stokes, *In the Nineties* (London: Harvester Wheatsheaf, 1989), p. 86.

14 E. Cohen, *Talk on the Wilde Side. Towards a Genealogy of a Discourse on Male Sexualities* (London: Routledge, 1993); A. Sinfield, *The Wilde Century: Effeminacy, Oscar Wilde and the Queer Moment* (London: Cassell, 1994).

15 J. Stratton, *The Desirable Body* (Manchester: Manchester University Press, 1996), p. 138.

16 R. Trumbach, 'Gender and the Homosexual Role in Modern Western Culture' in D. Altman *et al.* (eds), *Which Homosexuality?* (London: Gay Men's Press, 1989), pp. 149-64.

17 E. Kosofsky Sedgwick, *Between Men: English Literature and Male Homosocial Desire* (New York: Columbia University Press, 1985), pp. 174-5.

18 Felski, *Gender of Modernity*, p. 105.

19 *Ibid.*

20 Kosofsky Sedgwick, *Between Men*, p. 173.

21 R. Norton, *Mother Clap's Molly House: The Gay Subculture in England 1700-1830* (London: Gay Men's Press, 1992).

22 Boscagli, *Eye on the Flesh*, p. 31.

23 Stokes, *Nineties*, p. 4.

24 Boscagli, *Eye on the Flesh*, pp. 32-3.

25 B. Hilton, *The Age of Atonement: The Influence of Evangelicalism on Social and Economic Thought 1785-1865* (Oxford: Clarendon Press, 1991), p. 333.

26 R. Gilmour, *The Idea of the Gentleman in the Victorian Novel* (London: Allen & Unwin, 1981), p. 11.

27 D. Hall (ed.) *Muscular Christianity: Embodying the Victorian Age* (Cambridge: Cambridge University Press, 1994).

28 Gilmour, *Idea of the Gentleman*, p. 92.

29 *Ibid.*, p. 183.

30 J. Harvey, *Men in Black* (London: Reaktion, 1995).

31 J. A. Mangan, *Athleticism in the Victorian and Edwardian Public School: The Emergence and Consolidation of an Educational Ideology* (Cambridge: Cambridge University Press, 1981), pp. 166-7.

32 *Ibid.*, pp. 187-8.

33 B. Haley, *The Healthy Body and Victorian Culture* (Cambridge, Mass.: Harvard University Press, 1978), p. 206.

34 W. Crosby, *Manliness: An Address Delivered to the Victoria Street Church Young Men's Literary Society, Derby* (London: Hodder and Stoughton, 1877), pp. 4-14.

35 Boscagli, *Eye on the Flesh*, pp. 56-7.

36 H. Dennis Bradley, *Vogue: A Clothing Catalogue for Pope and Bradley* (London, 1912), pp. 32-3.

37 R. K. Garelick, *Rising Star: Dandyism, Gender and Performance in the Fin de Siècle* (Princeton: Princeton University Press, 1998), p. 42.

38 *Ibid.*, p. 43.

39 Bradley, *Vogue*, pp. 7-9.

40 *Ibid.*, p. 11.

41 Kosofsky Sedgwick, *Between Men*, p. 136.

42 J. Eli Adams, *Dandies and Desert Saints: Styles of Victorian Manhood* (Ithaca: Cornell University Press, 1995), p. 10.

43 *Ibid.*, pp. 4-5.

44 *Ibid.*, pp. 9-10.

45 S. Collini, *Public Moralists: Political Thought and Intellectual Life in Britain 1850-1930* (Oxford: Clarendon Press, 1991), p. 186.

46 Bradley, *Vogue*, p. 55.

Select bibliography

NAL. = National Art Library, Victoria & Albert Museum.

Primary sources

Journals

The Tailor and Cutter. 1870-1914. NAL.

The London Tailor. 1890-1914. NAL.

The Illustrated London News. 1890-1900. NAL.

The Modern Man. 1900-1910. British Library.

The Strand Magazine. 1890-1914. Royal College of Art.

The Hackney and Kingsland Express. 1880-1900. London Borough of Hackney Local History Archive.

Trade catalogues, manuscripts and Ephemera

Austin Reed, Advertising pulls and promotional material. 1900-1914. Austin Reed Archive.

Bradley, Dennis H., *Vogue: A Clothing Catalogue for Pope and Bradley.* London. 1912. NAL.

British Clothing Company share prospectus. 1865. Corporation of the City of London, Guildhall Library. 31.41.

Field, A., Publicity leaflets. 1885. London Borough of Hackney Local History Archive.

Fox, G. P., *Fashion: The Power that Influences the World.* Sheldon & Co, New York & London. 1872.

G. J. Wood's department store. Trading brochures. London Borough of Hackney Local History Archive.

Ira Peregro & Co., New York. Trade catalogue. 1890. NAL.

Kelly's Hackney, Dalston, Old Ford & Bow Directory for 1890. London, Kelly & Co. 1890.

London handbills and advertisements. 1860-1880. Corporation of the City of London, Guildhall Library. GR 1.4.6.

M. S. Gotlob, private ledgers. 1910-1916. Westminster Local History Archive 405/1.

Official Guide to the Metropolitan Borough of Hackney. Hackney Borough Council. 1910.

Tailoring ephemera. John Johnson Collection of Printed Ephemera. Bodelian Library, Oxford University.

The British Xylonite Company. Business records. London Borough of Walthamstow Libraries.

Thresher & Glenny, promotional leaflets. Westminster City Archive.

Welch Margetson & Co., trade catalogue. 1913. NAL.

Wm Potter & Sons, price list. 1895. NAL.

Printed sources and novels:

Adcock, A. St J., *In the Image of God: A Tale of Lower London.* London, Skeffington & Son, 1898.

Anon., *Modern London: The World's Metropolis.* London, Historical Publishing Company, 1888.

Anon., *The Music Hall Songster 1891-1893.* London, W. S. Fortey, 1893.

Anon., *Publicity: A Practical Guide for the Retail Clothier and Outfitter to all the Latest Methods of Succesful Advertising.* London, The Outfitter, 1910.

Anon., *The Story of a London Clerk: A Faithful Narrative, Faithfully Told.* London, Leadenhall Press, 1896.

Beeton, S., *Beeton's Complete Etiquette for Gentlemen.* London, Ward, Lock & Tyler, 1876.

Bennett, A., *The Old Wives Tale.* London, Chapman & Hall, 1908.

Besant, W., *London North of the Thames.* London, A. & C. Black, 1911.

Blake, J. P., *The Money God: A Tale of City Life.* London, Heinemann, 1904.

Booth, C. (ed.) *Life and Labour of the People in London,* 1902 facsimile edition. New York, Augustus Kelley, 1969.

Booth, J. B., *Pink Parade.* London, Thornton Butterworth, 1933.

Booth, J. B., *A Pink 'Un Remembers.* London, T. Werner Laurie, 1937.

Booth, J. B., *Sporting Times: The Pink 'Un World.* London, T. Werner Laurie, 1938.

Bullock, S., *Robert Thorne: The Story of a London Clerk.* London, T. Werner Laurie, 1907.

Burgess, F. W., *The Practical Retail Draper: A Complete Guide for the Drapery and Allied Trades.* London, Virtue & Co. 1912.

Burke, T., *Nights in Town: A London Autobiography.* London, Allen & Unwin, 1915.

Burke, T., *The Streets of London Through the Centuries.* London, Batsford, 1940.

Cairnes, W., *Social Life in the British Army by a British Officer.* London, J. Long. 1900.

Calthrop, D., *Music Hall Nights.* London, Bodley Head, 1925.

Cardiff Times, *Behind the Counter: Sketches by a Shop Assistant.* Aberdare, George Jones, 1886.

Carr Saunders, A. M., and P. A. Wilson, *The Professions.* Oxford, Clarendon Press, 1933.

Ceylon Observer, *The Grand Tour of the British Princes.* Colombo, Ceylon Observer Press, 1882.

Chance Newton, H., *Idols of the Halls: Being My Music Hall Memories.* London, Heath Cranton, 1928.

Cheadle, E., *Manners of Modern Society.* London, Cassell, 1872.

Chevalier, A., *Before I Forget: The Autobiography of a Chevalier d'Industrie.* London, Fisher Unwin, 1901.

Clarke, B., *Glimpses of Ancient Hackney and Stoke Newington.* London, London Borough of Hackney, 1986.

Coburn, C., *The Man Who Broke the Bank: Memories of Stage and Music Hall.* London, Hutchinson & Co., 1928.

Crosby, W., *Manliness: An Address Delivered to the Victoria Street Church Young Men's Literary Society, Derby.* London, Hodder & Stoughton, 1877.

Cundall, J. W., *London: A Guide for the Visitor, Sportsman and Naturalist.* London, Greening & Co., 1902.

Darwin, B., *The Dickens Advertiser.* London, Elkin Matthews & Marrot, 1930.

De Freece, V., *Recollections of Vesta Tilley.* London, Hutchinson & Co., 1934.

Egan, P., *Life in London*. London Sherwood, Neely & Jones, 1821.

Escott, T. H., *England: Its People, Polity and Pursuits*. London, Chapman & Hall, 1885.

Fitzgerald, P., *Music Hall Land*. London, Ward & Downey, 1890.

Greenwood, J., *Odd People in Odd Places, or The Great Residuum*. London, F. Warne, 1883.

Greenwood, J., *In Strange Company: Being the Experiences of a Roving Correspondent*. London, Vizetelly & Co., 1883.

Greenwood, J., *Behind a Bus: Curious Tales of Insides and Outs*. London, Diprose & Bateman, 1895.

Grossmith, G. and W., *The Diary of a Nobody*. Harmondsworth, Penguin, 1979.

Haig Miller, W., *On the Bank's Threshold or The Young Banker: A Popular Outline of Banking*. London, S. Partridge, 1890.

Harding, A. (ed.) *Modern London: The World's Metropolis*. London, Historical Publishing Company, 1888.

Hayes, J. W., *The Draper and Haberdasher: A Guide to the General Drapery Trade*. London, Houlston's Industrial Library, 1878.

Howard, K., *The Smiths of Surbiton: A Comedy without a Plot*. London, Chapman & Hall, 1906.

Howard, K., *The Smiths of Valley View*. London, Cassell, 1909.

Ingram, G., *Cockney Cavalcade*. London, Dennis Archer, 1935.

Journeyman Engineer, A, *Some Habits and Customs of the Working Classes*. London, Tinsley Bros, 1867.

Kirwan, D., *Palace and Hovel, or Phases of London Life*. Hartford Conn., Belknap & Bliss, 1871.

Klingender, F., *The Condition of Clerical Labour in Britain*. London, M. Lawrence, 1935.

LeFevre Krebs, S., *Retail Salesmanship*. New York, Institute of Mercantile Art, 1911.

Little, C., *Little's London Pleasure Guide*. London, Simpkin, Marshall, Hamilton, 1898.

MacQueen Pope, W., *Twenty Shillings in the Pound*. London, Hutchinson, 1948.

Madox Hueffer, F., *The Soul of London: A Survey of a Modern City*. London, Alston Rivers, 1904.

Major, The, *Clothes and the Man: Hints on the Wearing and Caring of Clothes*. London, Grant Richards, 1900.

Masterman, C. F., *The Heart of Empire*. London, Methuen, 1901.

Masterman, C. F., *The Condition of England*. London, Methuen, 1909.

Mayhew, H., *The Shops and Companies of London and the Trades and Manufactories of Great Britain*. London, 1865.

Mayhew, H., *London Characters*. London, Chatto & Windus. 1881.

Mercer Adams, G. (ed.), *Sandow's System of Physical Training*. London, Gale & Polden, 1894.

Milliken, E. J., *Childe Chappie's Pilgrimage*. London, Bradbury, Agnew & Co., 1883.

Mitton, G., *The Fascination of London: Hackney & Stoke Newington*. London, A. & C. Black, 1908.

Morrison, A., *To London Town*. London, Methuen & Co., 1899.

Orchard, B. J., *The Clerks of Liverpool*. Liverpool, J. Collinson, 1871.

Paterson, A., *Across the Bridges*. London, Edward Arnold, 1911.

Pearson, S., *Week Day Living: A Book for Young Men and Women*. London, Kegan Paul, Trench, 1882.

Peddie, J., *All About Monte Carlo*. London, Comet Publishing Company, 1893.

Pett Ridge, W., *Outside the Radius: Stories of a London Suburb*. London, Hodder & Stoughton, 1899.

Pett Ridge, W., *Sixty Nine Burnam Road*. London, Hodder & Stoughton, 1908.

Pett Ridge, W., *A Story Teller: Forty Years in London*. London, Hodder & Stoughton, 1920.

Pett Ridge, W., *I Like to Remember*. London, Hodder & Stoughton, 1925.

Pritchard, R. (ed.), *London and Londoners: What to See; What to Do; Where to Shop and Practical Hints*. London, Scientific Press, 1898.

Pugh, E., *The Man of Straw*. London, Heinemann, 1896.

Pugh, E., *The City of the World: A Book about London and the Londoner*. London, Thomas Nelson, 1908.

Pugh, E., *The Cockney at Home: Stories and Studies of London Life and Character*. London, Chapman & Hall. 1914.

Roberts, M., *Maurice Quain: A Novel*. London, Hutchinson, 1897.

Robertson, W. B., *Encyclopaedia of Retail Trading*. Harmsworth Business Library vol. VII. London, Educational Book Company, 1911.

Russell, C. E., *Manchester Boys: Sketches of Manchester Lads at Work and Play*. Manchester, Manchester University Press, 1905.

Russell, C. E., *Young Gaol Birds*. London, Macmillan, 1910.

Schwann, D., *The Book of a Bachelor*, London, Heinemann. 1910.

Scott, C., *The Wheel of Life: A Few Memories and Recollections*. London, Lawrence Greening, 1897.

Scott, C., *Souvenir of the Trocadero: How they Dined Us in 1860 and How They Dine Us Now*. London, Trocadero, 1900.

Scott, H., *The Early Doors: Origins of the Music Hall*. London, Nicholson & Watson, 1946.

Shaw, S., *London in the Sixties by One of the Old Brigade*. London, Heinemann, 1910.

Sims, G. (ed.), *Living London*. London, Cassell, 1903.

Sims, G. W., 'Off the Track in London: Around Hackney wick', *The Strand Magazine*, September 1904.

Smith, R., *A Londoner's Log Book 1901-1902 – Reprinted from the Cornhill Magazine*. London, Smith, Elder & Co., 1902.

Strangewinter, J. (ed.), *Wanted, a Wife: A Story of the 60th Dragoons etc.* London, J. Hogg, 1887.

Symons, A., *Silhouettes 1896 and London Nights 1897*, facsimile edition. Oxford, Woodstock Books, 1993.

Veblen, T., *The Theory of the Leisure Class: An Economic Study in the Evolution of Institutions*. New York, Macmillan, 1899.

Vincent, J., *His Royal Highness Duke of Clarence and Avondale: A Memoir*. London, J. Murray, 1893.

Welch, D., *The Bachelor and the Chafing Dish*. New York, F. Tennyson Neely, 1896.

Wells, H. G., *Kipps: The Story of a Simple Soul*. London, Macmillan, 1905.

Wells, H. G., *The History of Mr Polly*. London, Thomas Nelson & Sons, 1910.

Wharton, E., *The Age of Innocence*. London, Wordsworth, 1994.

Whiteing, R., *No 5 John Street*. London, Grant Richards, 1899.

Whiteing, R., *The Island: Or an Adventure of a Person of Quality*. London, Longman, 1888.

Williams, M., *Round London: Down East and Up West*. London, Macmillan, 1892.

Willis, F., *101 Jubilee Road: A Book of London Yesterdays*. London, Phoenix House, 1948.

Zola, E. (trans. F. Belmont.) *The Ladies Paradise*. London, Tinsley Brothers, 1883.

Secondary sources

Abelson, E., *When Ladies Go A-Thieving: Middle-class Shoplifters in the Victorian Department Store*. Oxford and New York, Oxford University Press, 1989.

Adburgham, A., *Shops and Shopping 1800-1914*. London, Allen & Unwin, 1981.

Adams, J. E., 'The Banality of Transgression? Recent Works on Masculinity', *Victorian Studies*, vol. 36 no. 2, winter 1993.

Adams, J. E., *Dandies and Desert Saints: Styles of Victorian Manhood*. Ithaca, Cornell University Press, 1995.

Alexander, D., *Retailing in England during the Industrial Revolution*. London, Athlone Press, 1970.

Altman, D. et al., *Which Homosexuality?* London, Gay Men's Press, 1989.

Altic, R., *The English Common Reader: A Social History of the Mass Reading Public 1800-1900*. Chicago, University of Chicago Press, 1957.

Anderson, G., *Victorian Clerks*. Manchester, Manchester University Press, 1976.

Anderson, M., *Kafka's Clothes: Ornament and Aestheticism in the Hapsburg Fin de Siecle*. Oxford, Clarendon Press, 1992.

Aronson, T., *Prince Eddy and the Homosexual Underworld*. London, Murray, 1994.

Bailey, P., 'Ally Sloper's Half Holiday: Comic Art in the 1880s', *History Workshop Journal*, vol. 16, autumn 1983.

Bailey, P., *Leisure and Class in Victorian England: Rational Recreation and the Contest for Control*. London, Methuen, 1987.

Bailey, P., 'Parasexuality and Glamour: The Victorian Barmaid as Cultural Prototype'. *Gender and History*. vol. 2, no. 2, summer 1990.

Banks, J. A., *Prosperity and Parenthood: A Study of Family Planning among the Victorian Middle Classes*. London, Routledge, Kegan & Paul, 1954.

Barraclough Paoletti, J., 'Ridicule and Role Models as Factors in American Men's Fashion Change 1880-1910', *Costume*, vol. 19, 1985.

Barthes, R., *Mythologies*. Harmondsworth, Penguin, 1972.

Bechofer, F. and B. Elliott, *The Petit Bourgoisie: Comparative Studies of the Uneasy Stratum*. London, Macmillan, 1981.

Beckson, K., *London in the 1890s: A Cultural History*. London, Norton, 1992.

Beetham, M., *A Magazine of Her Own: Domesticity and Desire in the Woman's Magazine 1800-1914*. London, Routledge, 1996.

Benjamin, W., *Charles Baudelaire: A Lyric Poet in the Era of High Capitalism*. London, Verso, 1989.

Benson, J., *The Rise of Consumer Society in Britain 1880-1980*. London, Longman, 1994.

Benson, J. and G. Shaw (eds), *The Evolution of Retail Systems C. 1800-1914*. Leicester, Leicester University Press, 1992.

Bernheimer, C., *Figures of Ill Repute: Representing Prostitution in Nineteenth Century France*. Cambridge, Mass., Harvard University Press, 1989.

Birley, D., *Land of Sport and Glory: Sport and British Society 1887–1910*. Manchester, Manchester University Press, 1995.

Blanchard, M., *In Search of the City: Engels, Baudelaire, Rimbaud*. Saratoga, Anma Libri, Stanford University, 1985.

Bloom, C., *Literature and Culture in Modern Britain Vol. 1: 1900–1929*. London, Longman, 1993.

Booker, J., *Temples of Mammon: The Architecture of Banking*. Edinburgh, Edinburgh University Press, 1990.

Boscagli, M., *Eye on the Flesh: Fashions of Masculinity in the Early Twentieth Century*. Oxford, Westview Press, 1996.

Bourke, J., 'The Great Male Renunciation: Men's Dress Reform in Inter-war Britain', *Journal of Design History*, vol. 9, no. 1, 1996.

Bowlby, R., *Just Looking: Consumer Culture in Dreiser, Gissing and Zola*. London, Methuen, 1985.

Bratton, J. S. (ed.), *Music Hall: Performance and Style*. Milton Keynes, Open University Press, 1986.

Bratton, J. S., *Acts of Supremacy: The British Empire and the Stage 1790–1930*. Manchester, Manchester University Press, 1991.

Breward, C., *Images of Desire: The Construction of the Feminine Consumer in Women's Fashion Journals 1875–1890*, unpublished MA Dissertation, Royal College of Art, 1992.

Bristow, J. (ed.), *Empire Boys: Adventures in a Man's World*. London, Unwin Hyman, 1991.

Buck Morss, S., *The Dialectics of Seeing: Walter Benjamin and the Arcades Project*. Cambridge, Mass., MIT Press, 1989.

Byrde, P., *The Male Image: Men's Fashion in Britain 1300–1970*. London, Batsford, 1979.

Cain, P. and A. G. Hopkins, *British Imperialism: Innovation and Expansion 1688–1914*. London, Longman, 1993.

Cambell Orr, C. (ed.), *Women in the Victorian Art World*. Manchester, Manchester University Press, 1995.

Camplin, J., *The Rise of the Plutocrats: Wealth and Power in Edwardian England*. London, Constable, 1978.

Cannadine, D., *The Decline and Fall of the British Aristocracy*. New Haven, Yale University Press, 1990.

Carey, J., *The Intellectuals and the Masses: Pride and Prejudice among the Literary Intelligentsia*. London, Faber, 1992.

Carnes, M. and C. Griffen (eds), *Meanings for Manhood: Constructions of Masculinity in Victorian America*. Chicago, University of Chicago Press, 1990.

Carre, J., *The Crisis of Courtesy: Studies in the Conduct Book in Britain 1600–1900*. Leiden, E. J. Brill, 1994.

Cassis, Y., *City Bankers 1890–1914*. Cambridge, Cambridge University Press, 1994.

Chapman, R. and J. Rutherford (eds), *Male Order: Unwrapping Masculinity*. London, Lawrence & Wishart, 1988.

Chapman, S., 'The Innovating Entrepreneurs in the British Ready-made Clothing Industry', *Textile History*, vol. 24, no. 1, 1993.

Chauncey, G., *Gay New York: Gender, Urban Culture and the Making of the Gay Male World 1890–1940*. London, Flamingo, 1994.

Chenoune, F., *A History of Men's Fashion*. Paris, Flammarion, 1993.

Chesney, K., *The Victorian Underworld*. Harmondsworth, Penguin, 1972.

Childs, M. J., *Labour's Apprentices: Working Class Lads in Late Victorian and Edwardian England*. London, Hambledon Press, 1992.

Chinn, C., *Poverty Amidst Prosperity: The Urban Poor in England, 1834-1914*. Manchester, Manchester University Press, 1995.

Christ, C. and J. O'Jordan (eds), *Victorian Literature and the Victorian Visual Imagination*. Berkeley, University of California Press, 1995.

Clarke, J., C. Critcher and R. Johnson (eds), *Working Class Culture: Studies in History and Theory*. London, Hutchinson & Co., 1979.

Cohen, E., *Talk on the Wilde Side: Towards a Genealogy of a Discourse on Male Sexualities*. London, Routledge, 1993.

Cohen, E., 'Ma(r)king Men', *Victorian Studies*, vol. 36, no. 2, winter 1993.

Cohn, N., *Today There Are No Gentlemen*. London, Weidenfeld & Nicolson, 1971.

Colley, L., *Britons: Forging the Nation 1707-1837*. New Haven, Yale University Press, 1992.

Collini, S., *Public Moralists: Political Thought and Intellectual Life in Britain 1850-1930*. Oxford, Clarendon Press, 1991.

Craik, J., *The Face of Fashion: Cultural Studies in Fashion*. London, Routledge, 1994.

Crompton, R. and G. Jones, *White Collar Proletariat: De-skilling and Gender in Clerical Work*. London, Macmillan, 1984.

Crossick, G. and H. G. Haupt, *The Petit Bourgoisie in Europe 1780-1914*. London, Routledge, 1995.

Crozier, M., *The World of the Office Worker*. Chicago, University of Chicago Press, 1971.

Cruise, C., 'Building Men, Constructing Images', *Oxford Art Journal*, vol. 19, no. 2, 1996.

Cumming, V., *Royal Dress: The Image and the Reality*. London, Batsford, 1989.

Cuppleditch, D., *The London Sketch Club*. Stroud, Alan Sutton, 1994.

Curtin, M., *Propriety and Position: A Study of Victorian Manners*. New York, Garland, 1987.

Davidoff, L., *The Best Circles: Society, Etiquette and the Season*. London, Century Hutchinson, 1986.

Davidoff, L. and C. Hall, *Family Fortunes: Men and Women of the English Middle Class 1780-1850*. London, Hutchinson. 1987.

Davies, A., *Leisure, Gender and Poverty: Working Class Culture in Salford & Manchester 1900-1939*. Buckingham, Open University Press, 1992.

Delamont, S. and L. Duffin, *The Nineteenth Century Woman: Her Cultural and Physical World*. London, Croom Helm, 1978.

De Marly, D., *Fashion for Men: An Illustrated History*. London, Batsford, 1985.

Evans, C., 'Street Style, Subculture and Subversion', *Costume*, vol. 31, 1997.

Evans, C. and M. Thornton, *Women and Fashion: A New Look*. London, Quartet, 1989.

Feldman, D. and G. Steadman Jones (eds), *Metropolis London: Histories and Representations since 1800*. London, Routledge, 1989.

Felski, R., *The Gender of Modernity*. Cambridge, Mass., Harvard University Press, 1995.

Fishman, W. J., *East End 1888: A Year in a London Borough Among the Labouring Poor*. London, Duckworth, 1988.

Flugel, J. C., *The Psychology of Clothes*. London, Hogarth Press, 1966.

Gagnier, R., *Idylls of the Marketplace: Oscar Wilde and the Victorian Public*. Aldershot, Scolar Press, 1986.

Gaines, J. and C. Herzog (eds), *Fabrications: Costume and the Female Body*. London, Routledge, 1990.

Garelick, R. K., *Rising Star: Dandyism, Gener and Performance in the Fin de Siècle*. Princeton, NJ, Princeton University Press, 1998.

Gillis, J., *Youth and History: Tradition and Change in European Age Relations*. New York, Academic Press, 1981.

Gilmour, R., *The Idea of the Gentleman in the Victorian Novel*. London, Allen & Unwin, 1981.

Ginsburg, M., *An Introduction to Fashion Illustration*. London, Pitman, 1980.

Ginsburg, M., *Victorian Dress in Photographs*. London, Batsford, 1982.

Girouard, M., *The Return to Camelot: Chivalry and the English Gentleman*. New Haven, Yale University Press, 1981.

Gourvish, T. R. and A. O'Day, *The Rise of the Professions in Later Victorian Britain 1867-1900*. London, Macmillan, 1988.

Haley, B., *The Healthy Body and Victorian Culture*. Cambridge, Mass., Harvard University Press, 1978.

Hall, D. (ed.), *Muscular Christianity: Embodying the Victorian Age*. Cambridge, Cambridge University Press, 1994.

Harris, J., *Private Lives, Public Spirit: Britain 1870-1914*. Harmondsworth, Penguin, 1993.

Hartman Strom, S., *Beyond the Typewriter: Gender, Class and the Origins of Modern American Office Work*. Chicago, University of Illinois Press, 1992.

Harvey, J., *Men in Black*. London, Reaktion, 1995.

Hebidige, D., *Subculture: The Meaning of Style*. London, Methuen, 1979.

Hilton, B., *The Age of Atonement: The Influence of Evangelicalism on Social and Economic Thought 1785-1865*. Oxford, Clarendon Press, 1991.

Humphries, S., *Hooligans or Rebels: An Oral History of Working-class Childhood and Youth*. Oxford, Blackwell, 1981.

Hyam, R., *Empire and Sexuality: The British Experience*. Manchester, Manchester University Press, 1991.

Jackson, A., *Semi-detached London*. Didcot, Wild Swan, 1991.

Jarrett, D., *British Naval Dress*. London, J. M. Dent, 1960.

Joyce, P., *Democratic Subjects: The Self and the Social in Nineteenth Century England*. Cambridge, Cambridge University Press, 1994.

Kaplan, J. H. and S. Stowell. *Theatre and Fashion: Oscar Wilde to the Suffragettes*. Cambridge, Cambridge University Press, 1994.

Keating, P., *The Working Classes in Victorian Fiction*. London, Routledge, Kegan & Paul, 1979.

Kirkham, P., *The Gendered Object*. Manchester, Manchester University Press, 1996.

Kosofsky Sedgwick, E., *Between Men: English Literature and Male Homosocial Desire*. New York, Columbia University Press, 1985.

Kynaston, D., *The City of London: Vol. 1, A World of its Own*. London, Chatto & Windus, 1994.

Lambert, M., 'The Dandy in Thackeray's *Vanity Fair* and *Pendennis*', *Costume*, vol. 22, 1988.

Lancaster, B., *The Department Store: A Social History*. Leicester, Leicester University Press, 1995.

Landsell, A., *Fashion a la Carte 1860-1900*. Princes Risborough, Shire, 1985.

Landsell, A., *The Victorians: Photographic Portraits*. London, Tauris Parke, 1993.

Latham, R. W. *Cavalry Uniforms*. London, Blandford Press, 1969.

Leach, W., *Land of Desire: Merchants, Power and the Rise of a New American Culture*. New York, Pantheon Books, 1993.

Le Manos, N. and M. J. Rochelson (eds), *Transforming Genres: New Approaches*

to British Fiction of the 1890s. London, Macmillan and New York, Pantheon Books, 1994.

Lemire, B., *Fashion's Favourite: The Cotton Trade and the Consumer in Britain 1660-1800.* Oxford, Oxford University Pres, 1991.

Light, A., *Forever England: Femininity, Literature and Conservatism Between the Wars.* London, Virago, 1991.

Linkman, A., *The Victorians: Photographic Portraits.* London, Tauris Parke, 1993.

Lockwood, D., *The Blackcoated Worker: A Study in Class Consciousness.* Oxford, Clarendon Press, 1989.

Loeb, L., *Consuming Angels: Advertising and Victorian Women.* Oxford, Oxford University Press, 1994.

Lowe, G., *Women in the Administrative Revolution.* Cambridge, Polity Press, 1987.

MacInnes, C., *Sweet Saturday Night.* London, MacGibbon & Kee, 1967.

Maitland, S., *Vesta Tilley.* London, Virago, 1986.

Mander, D. and J. Golden, *The London Borough of Hackney in Old Photographs 1890-1960.* Stroud, Alan Sutton, 1991.

Mangan, J. A., *Athleticism in the Victorian and Edwardian Public School: The Emergence and Consolidation of an Educational Ideology.* Cambridge, Cambridge University Press, 1981.

Mangan, A. and J. Walvin (eds), *Manliness and Morality: Middle-class Masculinity in Britain and America 1800-1940.* Manchester, Manchester University Press, 1987.

Marsh, M., *Suburban Lives.* New Brunswick, Rutgers University Press, 1990.

Mason, P., *The English Gentleman: The Rise and Fall of an Ideal.* London, Deutsch, 1982.

McDowell, C., *The Man of Fashion: Peacock Males and the Perfect Gentleman.* London, thames & Hudson, 1997.

McKendrick, N., J. Brewer and J. Plumb, *The Birth of a Consumer Society; The Commercialisation of Eighteenth Century England.* London, Europa, 1982.

McRobbie, A., *Feminism and Youth Culture from 'Jackie' to 'Just Seventeen'.* Basingstoke, Macmillan, 1991.

Miles, A. and D. Vincent, *Building European Society: Occupational Change and Social Mobility in Europe 1840-1940.* Manchester, Manchester University Press, 1993.

Montgomery Hyde, H., *Mr and Mrs Beeton.* London, Harrap, 1951.

Morgan, M., *Manners, Morals & Class in England 1774-1858.* New York, St Martin's Press, 1994.

Mort, F., *Cultures of Consumption: Masculinities and Social Space in Late Twentieth Century Britain.* London, Routledge, 1996.

Munch, A., *Queen Victoria's Secrets.* New York, Columbia University Press, 1996.

Murphy, S., *The Duchess of Devonshire's Ball.* London, Sidgwick & Jackson, 1984.

Nava, M. and A. O'Shea (eds), *Modern Times: Reflections on a Century of English Modernity.* London, Routledge, 1996.

Nead, L., *Myths of Sexuality.* Oxford, Blackwell, 1988.

Nelson, C., *Invisible Men: Fatherhood in Victorian Periodicals 1850-1910.* Athens and London, University of Georgia Press, 1995.

Nevett, T. R., *Advertising in Britain.* London, Heinemann, 1985.

Nixon, S., *Hard Looks.* London, University College Press, 1997.

Norton, R., *Mothers Clap's Molly House: The Gay Subculture in England 1700-1830*. London, Gay Men's Press, 1992.

Partridge, E., *A Dictionary of Slang and Unconventional English*. London, Routledge, 1984.

Pearson, G., *Hooligan: A History of Respectable Fears*. London, Macmillan, 1983.

Perkin, H., *The Rise of Professional Society: England since 1880*. London, Routledge, 1989.

Perrot, P., *Fashioning the Bourgeoisie: A History of Clothing in the Nineteenth Century*. Princeton, NJ, Princeton University Press, 1994.

Pile, S., *The Body and the City: Psychoanalysis, Space and Subjectivity*. London, Routledge, 1996.

Pollock, G., *Vision and Difference: Femininity, Feminism and Histories of Art*. London, Thames & Hudson, 1988.

Porter, R. (ed.), *Rewriting the Self: Histories from the Renaissance to the Present*. London, Routledge, 1996.

Porter, K. and J. Weeks (eds), *Between the Acts: Liver fo Homosexual Men 1885-1967*. London, Routledge, 1991.

Porter Benson, S., *Counter Cultures: Saleswomen, Managers and Customers in American Department Stores 1890-1940*. Chicago, University of Illinois Press, 1986.

Pyckett, L. (ed.), *Reading Fin de Siècle Fictions*. London, Longman, 1996.

Reid, A. J., *Social Classes and Social Relations in Britain 1850-1914*. London, Macmillan, 1992.

Ribeiro, A., *Dress and Morality*. London, Batsford, 1986.

Richards, T., *The Commodity Culture of Victorian England: Advertising and Spectacle 1851-1914*. London, Verso, 1991.

Ritchie, B., *A Touch of Class: The Story of Austin Reed*. London, James & James, 1990.

Roberts, R., *The Classic Slum: Salford Life in the First Quarter of the Century*. Manchester, Manchester University Press, 1971.

Roche, D., *The Culture of Clothing: Dress and Fashion in the Ancien Regime*. Cambridge, Cambridge University Press, 1996.

Roper, M. and J. Tosh (eds), *Manful Assertions: Masculinities in Britain since 1800*. London, Routledge, 1991.

Rose, C., *Children's Clothes Since 1750*. London, Batsford, 1989.

Royston Pyke, E., *Human Documents of the Age of the Forsythes*. London, Allen & Unwin, 1969.

Rubinstein, W. D., *Men of Property: The Very Wealthy in Britain since the Industrial Revolution*. London, Croom Helm, 1981.

Rubinstein, W. D., *Elites and the Wealthy in Modern British History*. Brighton, Harvester Press, 1987.

Russell, N., *The Novelist and Mammon: Literary Responses to the World of Commerce in the Nineteenth Century*. Oxford, Oxford University Press, 1986.

Ryan, D., *The Ideal Home Through the Twentieth Century*. London, Hazar, 1997.

St George, A., *The Descent of Manners: Etiquette, Rules and the Victorians*. London, Chatto & Windus, 1993.

Samuel, R., *Theatres of Memory: Past and Present in Contemporary Culture*. London, Verso, 1996.

Samuel, R. (ed.), *East End Underworld: Chapters in the Life of Arthur Harding*. London, Routledge & Kegan Paul, 1981.

Sennett, R., *Flesh and Stone: The Body and the City in Western Civilisation.* New York, Norton, 1996.

Showalter, E., *Sexual Anarchy: Gender and Culture at the Fin-de-Siecle.* London, Virago, 1992.

Siegel, J., *Bohemian Paris: Culture, Politics and the Boundaries of Bourgeois Life 1830-1890.* New York, Viking, 1986.

Sinfield, A., *The Wilde Century: Effeminacy, Oscar Wilde and the Queer Moment.* London, Cassell, 1994.

Sparke, P., *As Long As It's Pink: The Sexual Politics of Taste.* London, Pandora, 1996.

Steedman, C., *Childhood, Culture and Class in Britain 1860-1931.* London, Virago, 1990.

Still, J. and M. Worton, *Textuality and Sexuality: Reading Theories and Practices.* Manchester, Manchester University Press, 1993.

Stokes, J., *In the Nineties.* London, Harvester Wheatsheaf, 1989.

Stokes, J. (ed.), *Fin de Siecle/Fin du Globe: Fears and Fantasies of the Late Nineteenth Century.* London, Macmillan, 1992.

Storch, R. (ed.), *Popular Custom and Culture in Nineteenth Century England.* London, Croom Helm, 1982.

Stratton, J., *The Desirable Body.* Manchester, Manchester University Press, 1996.

Styles, J., 'Clothing the North: The Supply of Non-elite Clothing in the Eighteenth-Century North of England', *Textile History* vol. 25, no. 2, 1994.

Sussman, H., *Victorian Masculinities: Manhood and Masculine Poetics in Early Victorian Literature and Art.* Cambridge, Cambridge University Press, 1995.

Tebbutt, M., *Making Ends Meet: Pawnbroking and Working Class Credit.* Leicester, Leicester University Press, 1983.

Tester, K. (ed.), *The Flâneur.* London, Routledge 1994.

Thompson, D., *Queen Victoria: Gender and Power.* London, Virago, 1990.

Thompson, F. M. L. (ed.), *The Rise of Suburbia.* Leicester, Leicester University Press, 1982.

Trudgill, E., *Madonnas and Magdalens.* London, Heineman, 1976.

Vance, N., *The Sinews of the Spirit: The Ideal of Christian Manliness in Victorian Literature and Religous Thought.* Cambridge, Cambridge University Press, 1985.

Walcowitz, J., *City of Dreadful Delight: Narratives of Sexual Danger in Late Victorian London.* London, Virago, 1992.

Walsh, C., 'Shop Design and the Display of Goods in Eighteenth Century London', *Journal of Design History*, vol. 8, no. 5, 1995

Waters, C., *British Socialists and the Politics of Popular Culture 1884-1914.* Manchester, Manchester University Press, 1990.

West, S., *Fin de Siècle.* London, Bloomsbury, 1993.

Wharton, E., *The Age of Innocence.* London, Wordsworth, 1994.

White, C., *Women's Magazines 1693-1968.* London, Michael Joseph, 1970.

Wiener, M., *English Culture and the Decline of the Industrial Spirit 1850-1980.* Harmondsworth, Penguin, 1981.

Williams, R. H., *Dream Worlds: Mass Consumption in Late Nineteenth Century France.* Berkeley, University of California Press, 1982.

Wilson, E., *Adorned in Dreams.* London, Virago, 1987.

Wilson, E., *The Sphinx in the City.* London, Virago, 1991.

Wolff, J. and J. Seed (ed), *The Culture of Capital: Art, Power & the Nineteenth Century Middle Class.* Manchester, Manchester University Press, 1988.

Index